ART AND HUMAN VALUES

Revised Edition

Edited by Gregory Gurley
University of Oregon

San Diego, CA

Bassim Hamadeh, CEO and Publisher
Christopher Foster, General Vice President
Michael Simpson, Vice President of Acquisitions
Jessica Knott, Managing Editor
Kevin Fahey, Cognella Marketing Manager
Jess Busch, Senior Graphic Designer
Stephanie Sandler, Licensing Associate

First published in the United States of America in 2013 by Cognella, Inc.

Trademark Notice: Product or corporate names may be trademarks or registered trademarks, and are used only for identification and explanation without intent to infringe.

Printed in the United States of America

ISBN: 978-1-62131-166-9

www.cognella.com 800.200.3908

CONTENTS

ECONOMICS

RELIGIOUS-SPIRITUAL

ETHNICITY

Art as a Human Behavior: Toward an Ethological View of Art

Ellen Dissanayake

It should be a matter of some interest and concern to those who teach and contribute to humanistic studies such as the philosophy of art that their work is founded on a heritage of philosophical speculations about the nature of knowledge and the mind that was formulated by men who had no reason to suspect that human consciousness and mental activity have had a long evolutionary history. Although modern linguistic philosophy postulates inherited predispositions for language and hence for mental functioning, most branches of philosophy continue their investigations without regard for the implications of recent paleo-anthropological discoveries which imply that the human mind is of a remote antiquity or that it has evolved (and is evolving) within certain biological limits and that its varied abilities have necessarily and primarily been of importance to man's survival as a species.[1]

Aesthetics is one of the branches of Western philosophy that has generally, even resolutely, held itself aloof from scientific encroachment or scrutiny. In Western thinking art resists methods of science such as categorization, definition, or precise measurement. Its complex workings whether of construction or appreciation are private, unobservable and usually fleeting, and therefore do not lend themselves to scientific perusal.

Ellen Dissanayake, "Art as a Human Behavior: Toward an Ethological View of Art," from *Journal of Aesthetics and Art Criticism*, Vol. 38, No. 4; Summer, 1980, pp. 397–406. Published by Blackwell Publishing, 1980. Copyright by John Wiley & Sons, Inc. Permission to reprint granted by the rights holder.

Viewing art from the perspective of biological evolution, as in the present paper, is not quite the same thing as subjecting it to scientific analysis. More accurately, it is a *way of looking*[2] at art as a human behavior, based on the assumption that human beings are a species of animal like other living creatures, which further implies that their behavior like their anatomy and physiology has been shaped by natural selection. Such a viewpoint may suggest new avenues for thinking about some of the problems with which aesthetics has traditionally been concerned: the nature, origin, and value of art, not as an abstraction, not *sui generis*, but as a universal and intrinsic human behavioral endowment.[3] As this is, as far as I know, the first attempt to examine art closely in this way, my effort is in the nature of a preliminary inquiry, with the hope that others will be encouraged to modify, refine and extend the ideas presented here.

I. ETHOLOGY AND ART

The biology of behavior—or as it calls itself, ethology—is a relatively new science that is concerned with what living creatures *do* in their normal, everyday existence. General and specific activities, particularly those that contribute to the unique way each animal fits into its larger world of natural environment and other creatures, can be defined and observed. Recognizing that behavior is as characteristic of and dependent on an animal's way of life as his anatomy and physiology, ethologists observe (and compare, in order to better understand an individual species) universal behavioral phenomena and tendencies such as courtship and mating, territorial maintenance and spacing mechanisms, or communicatory behavior.

It is possible to view human beings from an ethological perspective if one accepts—as seems undeniable—that man is an animal species who has evolved and whose behavior as well as his biological organs and systems has had adaptive or selective value in that evolution. Human ethologists propose that certain ubiquitous behavioral features or tendencies in man's life are an intrinsic, relatively unchangeable part of his nature and have arisen and been retained because they contribute positively to his evolutionary success, his survival as a species.

Those who attempt to view humans ethologically are often dismissed as being sensationalists, reductionists, or mechanists. They are accused of being slipshod, or simplistic, or spinning theories heavier than the facts will bear. It is easy to find counterexamples that appear to refute broad, speculative theories, particularly where man is concerned, who for the last 25,000 years has—unlike any other animal—displayed a prodigious *cultural* evolution whose amazing variety of manifestations has tended to obscure the more broadly-based limits of biological evolution on which they are undoubtedly based.

Yet limits undeniably exist, and in order to understand these it is necessary to collect and compare examples of universal human behaviors from many societies. Accounts from anthropological studies of a wide variety of human groups show that in spite of wide lability in details, human beings universally display certain general features of behavior that

ethologists have identified in most animal societies as well. For example, both human and animal societies tend to form and maintain some kind of social hierarchy. Both humans and animals (including reptiles, birds, and even insects) use ritualized nonverbal communicatory signals that formalize emotional responses, channel aggression, and reinforce social bonds. Like many young animals, all human children play. Fundamental universal human patterns and behavioral sequences have been observed in courtship and mating practices or in the mother-infant association, although these are overlaid with individual cultural variations. Similarly, in both animals and humans, an individual zone of physical distance from others is maintained, and relaxed with certain intimates or in certain situations.[4]

There are in addition behaviors that seem unique to the human species. Among these is art.[5] No human society has been discovered that does not display some examples of what we, in the modern West, are accustomed to call "art." It is worth investigating whether we can identify a universal "behavior of art" and, if we can, attempting to determine what its selective value has been in human evolution. Such an approach may seem distasteful or irreverent: the field of thinking about art, now that the subject matter of theology is usually handed over to the social and behavioral sciences, remains the last bastion of those who assume that man and his works are "above" or at least unconcerned with biological imperatives. One may argue, however, that regarding art as a fundamental manifestation of human nature with its roots in biological processes is not to reduce it to these roots, or to denigrate it, but rather to better appreciate its essential value. Awareness of man's connectedness with all life need not mean a denial of his uniqueness. Indeed it indicates more clearly where that uniqueness lies.

The paper will address three aspects of an ethological view of art: (1) the setting out of fundamental assumptions that such a view demands; (2) the attempt to identify a "behavior of art"; and (3) a discussion of the posited contribution of art to human evolutionary success.

II. ASSUMPTIONS

1. The ethological view of art presumes that the history of art as a behavior predates by far what is today considered to be the history of art. Chipped stone tools, cave paintings, and fertility statues may be the earliest artistic artifacts that are extant, but they are not the beginning of art as a behavior, whose origin must be at least in the pre-palaeolithic phase of hominid evolution. Art is a manifestation of culture and in that sense is a concern of anthropologists, but one can claim that like other specific cultural behaviors such as language or the skillful making and use of tools it will have its roots in earlier, less differentiated, genetically determined behavior and tendencies. An ethological approach should attempt to examine and delineate these.[6]

2. Another assumption, alluded to in the introduction, is that the behavior of art has (or has had) selective value, that it in some way enhances the survival of a species whose

members possess that behavior. Such an assumption appears to controvert the premiss that generally obtains in modern views of art since Kant, i.e., that it is "for its own sake" and has no practical or extrinsic value. An ethological view generally assumes that any widely prevalent behavior has a function and is the way it is for a reason. Art would not exist universally if it did not possess positive selective value, and we must ask ourselves what it could be about art that is essential to the survival of the human species or to individuals in it, or to the genes of individuals.[7]

3. Although the qualifying features of a behavior of art remain to be identified and discussed in the next section, we must mention here that the concept of art as a behavior does not refer only to specific artistic acts of making and enjoying artworks. Instead it comprises a broad general phenomenon which (like other general "behaviors," e.g., aggressive behavior or sexual behavior) is characteristic of all human beings, not just the special province of a minority called "artists."

4. Similarly, all human societies will have art, although it is accepted that no society need demonstrate or emphasize equally all the kinds of manifestations of this behavior.

5. Concern with the nature, origin, and history of the behavior of art does not include any assumption about the value (other than "selective value") of its result. "Art" does not, as in so many discussions of aesthetics, presuppose or mean "good art."

6. The manifestations of a universal behavior in one human group in one spot in time and space are certain to be limited. Art in our Western view will have to find its place as one of a number of manifestations that have existed and do exist.

7. Making art and recognizing (or "appreciating") and responding to art are more easily considered separately, although they are related and must each be understandable within the ethological purview.

III. ART VIEWED ETHOLOGICALLY

The Problem

At one time discussions of art by philosophers and critics assumed that it was defined by a quality (e.g., beauty, harmony, proportion, representational accuracy, significant form) inhering in an object that was recognized by a kind of predisposition in the attitude of the beholder. As aesthetic theory has developed, the number of apparently undeniable qualities or characteristics of art that have been suggested and must somehow be incorporated into any definition has become decidedly unwieldy,[8] and today it is generally agreed that definitions of art, if one desires them at all, must be either injunctive or open-textured.

Although the attendant problems and difficulties are of a different kind, an ethological approach to art is perhaps no less complex or daunting—at least initially—than a philosophically-based inquiry. To begin with, the assumptions listed above must not be contravened. What we call art must be universally applicable to all men (not only "artists") and societies past and present (not only modern Western society), and must have plausible

adaptive value. At the same time we must hope that what we eventually choose to regard as artistic behavior will be neither so labored nor so broad that it is meaningless.

Secondly, one who proposes an ethological view of art is as it were breaking new ground.[9] To be sure others have made suggestions about the origin of art and about its significance or necessity to mankind. However, these offerings have rarely come from evolutionists or biologists (who tend to omit art from their speculations), but from writers on philosophy, history, criticism, and aesthetics. On inspection they turn out to be of little use to an ethological inquiry, for they are not based on the essential premise that art is a behavior that is the handiwork of biological evolution, and therefore they do not meet the assumptions listed above.

Regarding art's origin, for example, quasi-evolutionary views in the past have tended to trace it to one source: to play,[10] to body ornamentation,[11] to a "configurative urge,"[12] a creative or expressive impulse,[13] to sympathetic magic,[14] to relief from boredom,[15] or to motives of self-glorification[16]—any one of which can be shown to be inadequate to explain the genesis of more than a few of the varieties of art. Attempts to decide what art is, not by speculating about its origin but by isolating some essential X-factor that art provides to human life (e.g., adornment or decoration; "practice" for real life, "escape" from real life; sensuous or "aesthetic" satisfactions; order; disorder) have been made, but on inspection are partial and thus inadequate as well.

It is art's stubborn and irrepressible variety—of objects, activities, attitudes, effects—that causes grief to ethologists in search of first principles no less than to hapless philosophers of art. This variety is so in other human societies no less than in our own.

When we survey primitive societies in the Americas, in Africa and in Oceania we discover a wide variety of artistic and aesthetic conceptions.[17] For some societies art is extremely important and in others it has little or no importance. In some groups artists are specialists; in others art is considered to be an ability of everyone. Art may be in the service of specific communal ends or performed as a personal expression of feeling. Art objects may be carefully looked after or casually discarded; they may be considered sacred and valuable in themselves, or their value may reside in the supernatural power they embody. Value may accrue to novelty or to conventional formulaic repetition of tradition. Depiction may be abstract or representational. The artist may be admired or revered, or he may be regarded as deviant or socially inferior. Some groups consider that art comes from a special or divine realm, or that it is widespread, occurring gratuitously. Although usually one person creates one work, in some groups several persons may work on the same object.[18]

Our own Western notion of art is far from uniform or clear. When one examines writings on art he finds that, depending on the author, the word refers to a bewildering array of meanings. Art may be viewed variously as *artifice* (both in the sense of skillfulness or craft and of artificiality); as *fantasy* (make-believe, wish-fulfillment, illusion, the ideal, play); as *creativity* (exploration, invention, innovation, self-expression); as *form or order* (the psychological, perceptual and mental need to discover or impose a formal order on experience; pattern-making; recognition of beauty as order); as *heightened existence*

(emotion, ecstasy, extraordinary experience, entertainment); as disorder (deviance or dishabituation); as *sense* (the immediate fullness of sense-experience as contrasted with abstract thought, or the sensuous qualities of things such as color or sound); as *revelation* (or innately-compelling symbols, of God, of reality); as *adornment or embellishment* (the wish or tendency to beautify, a decorative or configurative urge); as *self-expression*, as *significance or meaning* (interpretation) and as combinations of two or more of these.

It is evident that art is somehow concerned with all these things, but when they are more carefully examined from an ethological standpoint, the concept "art" tends to evaporate. Each of the above-mentioned aspects of experience can be subsumed under another psychological or biological need or propensity, without invoking a special behavior, "art," at all. For example, the well-studied behavior of play is able to cover all nonutilitarian making, as well as fantasy, illusion, make-believe, ornamenting and decorating. Exploratory and curiosity behavior can account for instances of innovation and creativity, if they are not simply called problem-solving behavior. Sensory experiences can be studied as examples of perception. All animals require formal order and predictability: cognition cannot occur without them, and some would say that cognition *is* perceiving or imposing order. Similarly, all animals require disorder and novelty: behaviors that include or provide these need not be called art. Heightened existence is frequently sought and obtained in experiences few would call artistic or aesthetic—e.g., sexual orgasm, successful acknowledgement or exercise of power, achieved ambition, sporting events, catastrophes, carnival rides, even childbirth. Revelation and a sense of significance are components of religious experience, or of loving and being loved—not only of art.

It would seem that by assuming any of these is art or is provided by art, a specific identifying feature still eludes us. To say that art is any of these one must say what it is that is *different* about "artistic" play, "artistic" order, "artistic" perception, "artistic" significance. In other words, one must still determine what is artistic about art.

Identifying a Behavior of Art

If there is such a thing as a "behavior of art" we must assume that it developed in human evolution from an ability or proclivity that our pre-palaeolithic ancestors could have shown. I should like to suggest that this root proclivity is the ability to recognize or confer "specialness," a level or order different from the everyday.

In every case, even today, when giving artistic expression to an idea, or decorating an object, or recognizing that an idea or object is artistic, one gives it (or acknowledges) a specialness that without one's activity or regard it would not have. One renders it special, recognizes that it is extraordinary. This characteristic of art has been referred to by other names by other thinkers, e.g., transformation,[19] aesthetic transposition or promotion.[20] It is a sort of "jacking-up," a saltation or quantum leap[21] from the quotidian reality in which life's vital needs and activities occur, to a different order, an "aesthetic order"[22] which has its own kind of motivation or intention and a distinctive attitude or response.

This root proclivity may also be identified in two other kinds of behavior whose similarities to art have indeed frequently been noted: Play and Ritual. For example, in most instances both play and art[23] use make believe, illusion, and metaphor; neither is directly concerned with primary ends of direct survival (like eating, fighting, escaping danger) but is performed "for its own sake"; as behaviors they are labile and relatively unpredictable; they make use of novelty, incongruity, surprisingness, complexity, change, variety; they have an inherent dynamic of tension and release, arousal and relief, deviation and recurrence or restatement.[24]

As behaviors, ritual and art[25] are similar in that both formalize and shape emotion; communicate in a symbolic "language"; and for expressive effect make use of out-of-context elements, of exaggeration, and of repetition. Many rituals are expressly concerned with another level or realm from the ordinary, and art is used by ritual as a means to the end of revealing this special, extraordinary reality.[26]

The close relationship even today between art and play and art and ritual suggests that in human evolutionary history they were once intimately related if not indistinguishable. Acted upon by different evolutionary requirements and molded by different emergent physical and mental endowments, the root proclivity of making special could diverge into related but usually distinct currents: play, ritual, and art.

Art as we are accustomed to think of it, then, should be considered as an instance of the broader proclivity of making special. In our ethological view, *artistic behavior shapes and/or embellishes everyday reality with the intention[27] of constructing or manifesting (or recognizing) what is considered to be another "level" from quotidian practical life.*

Yet, although according to this view all societies and people have art, we cannot assume that all societies and people regard works of art with the distinctive aesthetic attitude that is usually presupposed by modern Western theories of art. The usual human responses to art, to things made special or the act of making special, are reactions such as being impressed by power or size or opulence or skill or monetary value; sharing the excited reactions of a crowd; feeling satisfaction at the carrying out of a known practice or observance; sensuous or kinaesthetic pleasure; vicarious enjoyment; catharsis; and so forth.

Although these may be ingredient in our Western response to art as well, we usually insist that there be an added "aesthetic" regard—that the work of art be experienced not only as it has been translated into another plane, set apart from the everyday world, but by an awareness and acknowledgement of the *way* in which this has been done. Although non-Western peoples are certainly capable of making such judgments (e.g., recognizing that a tale is not only a good tale, but that it is "well told";[28] agreeing that a dispute is not only settled, but "settled artfully,"[29] and some persons of leisure and cultivated taste in all higher civilizations have most likely been able to appreciate the "art" in art), such discrimination is in general not observably a widely-held ability or proclivity.

In other words, we can propose that it is the behavior of making things special and appreciating that some things are special which is fundamental, universal, and which has had selective value, but not the ability to appreciate how this specialness is achieved.

Appreciating "how," the *way* something is done, demands a cognitive awareness—a more or less self-conscious discriminating, relating, recognizing and following manipulations within an acquired code. This type of awareness is of course biologically useful in human communication and in the processes of cognition and perception generally. But it seems safe to say that when developed to the degree necessary to appreciate a Bach fugue or Cézanne landscape, such an ability is biologically irrelevant.

IV. THE VALUE OF ART

Although it has just been stated that art as we are accustomed to understand the term—the fine arts—is not biologically necessary, there are those who would claim that art is still in some sense vital. Apart from biologists who might attribute a general adaptive value to art, poets and philosophers have often expressed their conviction that art is necessary, that it makes a qualitative difference to human life.

Let us examine some of the ways in which art has been said to have functional or selective value to human societies, and thus presumably to the human species.

Anthropologists frequently claim that art contributes essential social benefits to primitive societies: it expresses or relieves or canalizes feelings, reiterates social values, mirrors the social code, provides an avenue for shared experience, and the like—all of which are socially useful activities.[30] In historic times in the West, too, art has served social ends such as documentation, illustration of precepts and stories that are significant to society, pictorial reinforcement of traditional beliefs, distraction and entertainment, impressive display of wealth and power, facilitation in a group of a dominant mood, and so forth. Even today with much of art existing ostensibly for its own sake, art has socially observable practical and social as well as aesthetic consequences.

Yet there arises a difficulty with attributing the selective value of art to these or other social functions that it serves. The ethological view of art is not surprised that art is socially useful. But it is interesting to note that in some instances the socially significant function of art is to represent custom and tradition, that is, to uphold the status quo and maintain concord; in others, art provides an "escape valve" through license and heightened or diverted feeling. Art may be orderly and disorderly, immanent and ideal, emotional and intellectual, Apollonian and Dionysian—which suggests that it can be all things to all social and individual requirements.

Additionally, the biologically adaptive functions that have often been proposed for art (like the oft-cited characteristics of art that were mentioned above) refer upon closer examination not to *art*, but to characteristics art shares with other behaviors or to these behaviors themselves. Thus, for example, when people suggest that art is therapeutic,[31] or gives us direct unselfconscious experience,[32] provides paradigms of order,[33] trains our perception of reality,[34] gives a sense of significance or meaning to life,[35] and so forth, it is arguable that what is being referred to is not what is "artistic" about art, but rather what art shares with play, exploration, ritual, order-giving, and so forth.

It might be suggested that although other behaviors may contribute to our practical life, our sense of fulfillment and meaning, our psychological or social integration, it is the *degree* to which art embodies and communicates experience that makes it unique[36] and irreplaceable. For those who are receptive to works of art in the modern sense this is probably so. Yet, as we have implied, great numbers of people appear to get along psychologically and practically without assistance from the more complex and refined arts, and in addition they seem to find their greatest emotional sense of significance to come from nonaesthetic experiences such as parenthood, achievement and successful practice of a skill, power, recognition, being praised and needed, and so forth.

It has been only a very short time, speaking in evolutionary terms, that art has been detached from its affiliates, ritual and play, and that its various components have coalesced to become an independent activity. Until less than a hundred years ago the primary tasks of artists were not to "create works of art" but to reveal or embody the divine, illustrate holy writ, decorate shrines and private homes and public buildings, fashion fine utensils and elaborate ornaments, accompany ceremonial observances, record historic scenes and personages, and so forth. The artist, in our terms, made these things "special," but specifically aesthetic considerations were no more important to most observers than other functional requirements—although it is not to be denied that artists of all times have been highly skilled in marrying the two.

Although space does not allow a detailed reconstruction of the way in which the behavior of art could have originated and evolved, it is my contention that only in historic times did the behavior of art become increasingly detached from the rest of life, regarded and valued primarily for its own sake. Although today in advanced Western society we acknowledge that it is possible to shape and embellish other human behaviors—sex, eating, communicating by word or gesture—in order to make them special, and the relationship of art and life can be said to be a major preoccupation in advanced contemporary thought,[37] it is not often appreciated that in a quite unselfconscious way art actually appears to inform all of life in some traditional societies.[38]

It would seem that in its rudimentary beginnings, the activity of giving shape to and embellishing life was not an impractical, leisure-time activity, but the way the human mind worked: it was a way of prehending and comprehending the world. Looked at in this way it was not separated from the activities of formalization (embodied in such activities as cognitive orientation, conceptualization, cognitive structuring, systematizing, giving narrative relationship in time or perceptual shape in space) and of the propensity—inherent in the ability to symbolize—to recognize or imagine an order other than the mundane. Such a proclivity demonstrates simply that man cannot bear, individually or as a species, senselessness or lack of meaning.

Our minds still "work" the same way. We still need a sense of meaning. But rather than finding this meaning exclusively in explanations provided by traditional social institutions (e.g., tribe, clan, family, caste, religion, a body of tradition, language, rituals) that are expressed and reinforced in symbols which have been given artistic form and embellishment,

as have most human beings throughout the ages, many of us in the modern world are in a position of not accepting traditional meanings, or finding that they are inadequate.

The ways in which meaning was apprehended by our ancestors were not divided into separate entities called "art," "science," "metaphysics." Our attribution of the name "art" to tribal singing or dancing or to cave paintings is artificial and misleading. More simply, these are ways of finding meaning in life or giving it, making it special, ways that were inextricably bound to social institutions and practices whose fundamental assumptions are no longer accepted unquestioningly. By looking back and identifying elements, activities, and artifacts that suit our categories of what is artistic, we are in danger of giving an interpretation that was not known to the people who used these elements, engaged in these activities, and produced these artifacts.

Is there any reasonable way in which we can assign selective value to a behavior—making special—that was not independent? Only by acknowledging that what *has* had selective value is "giving meaning" so that aesthetic elements, activities, and artifacts, insofar as they have accompanied and reinforced meaning-giving have themselves had selective value.

Another way of looking at it is to recognize that *meaning is aesthetic*. Ordinary day-to-day life is formless, incoherent. When shaped and embellished or transformed as in ritual or play or art it takes on a greater or more significant reality so that when we find something to have coherence it seems to be "aesthetic." When we feel something to be aesthetic we recognize that it is coherent. This seems such a fundamental part of man's nature that the question of its "selective value" is beside the point. What is unprecedented today is that for modern man aesthetic meaning, bracketed, and removed from everyday life, does not invariably reflect a reality shared by his fellows, as it has for most of the human species throughout human history. In large part modern man must be his own artist and find or create his own meanings, meanings which do not necessarily cohere with other meanings.

It is my suspicion that the widespread Western axiomatic notion of the incompatibility of art and life, as well as the more recent concern with the shared boundaries and interpenetration of the two, are symptoms or results of this broad and gradual change in the locus of human meaning. Although their congruence with the concerns and values of human life remains an important consideration in our response to works of art, some persons in the twentieth century in the modern West have nevertheless been able to accept self-contained objects or events, isolated from the rest of experience, as art and to respond to them "aesthetically."

Indeed, this attitude—that detached self-containment is a defining and even universal feature of art (at least "great art") and that one's response to works of art is primarily or preferably a detached one—seems to be strongly embedded in contemporary advanced Western thought. I would like to suggest that although writing and theorizing about art in this sense may well be a fascinating and satisfying endeavor, it is however likely that like its subject it is a self-referential activity performed for its own sake and ultimately has no bearing on the wider consideration of art as a universal human behavior. We must be aware that our pronouncements about the nature of art derived from the culture-bound

preconceptions of modern Western aesthetics may apply only to art produced and appreciated by persons of an infinitesimal number in both time and space, who appear in their conceptual framework and way of life to be unprecedented and without parallel in human evolutionary history.[39]

END NOTES

1. J. Z. Young, *Programs of the Brain* (Oxford University Press, 1978).

2. J. H. Crook, "Social organization and the environment: aspects of contemporary social ethology," in C. L. Brace, and J. Metress (eds.), pp. 100–115 *Man in Evolutionary Perspective* (New York, 1975), p. 112.

3. This paper does not address the fascinating and important question of the possibility of innate "biological" propensities for considering certain things to be beautiful. Investigations of preferences for certain proportions, colors, musical intervals and the like suggest that there may be some very broad, general innate or universal bases for taste and judgment, but these are not likely to illuminate our understanding of "aesthetic" responses to works of art which seem to be responses to subtle complexities that inhere in specific or even unique circumstances and that do not lend themselves to precise analysis and measurement. What is generally called "aesthetic" response seems to be based upon at least tacit acquaintance with a "code" of symbolic representations—i.e., requiring an intellectual learned or cognitive element—which in itself suggests that reflexive or innate actions would be of limited significance in the total response, though they may well influence its general outlines.

4. These and other fundamentals of human behavior can be found described, with an extensive bibliography, in L. Tiger, and R. Fox, *The Imperial Animal* (New York, 1971). Also see D. Morris. *Manwatching* (London, 1977) for a compendium of universal human gestures and signals.

5. Whether or not animals make art is, essentially, a matter of definition. Some have claimed that the decoration of his nest by the bower bird, or bird-song itself, are examples of a rudimentary artistic sense. But see below, note 27.

6. There is not space for such an endeavor here, though in a still unpublished manuscript I have attempted to identify and draw together art's antecedents.

7. Resolution of the current controversy concerning the basic unit of evolution—gene, individual, or species—will not affect the theory presented here of the selective value of art.

8. See. e.g., H. Kreitler, and S. Kreitler, *Psychology of the Arts* (Duke University Press, 1972). Definitions of art usually include at least some of the following elements, claiming that art: is the product of conscious intent; is self-rewarding; tends to unite dissimilar things; is concerned with change and variety, familiarity and surprise, tension and release, bringing order from disorder; creates illusions; uses sensuous materials; exhibits skill; conveys meaning; conveys a sense of unity or wholeness;

is creative; is pleasurable; is symbolic; is imaginative; is immediate; is concerned with expression and communication. None of these, however, is characteristic only or primarily of artistic behavior, Monroe Beardsley's insistence on the presence of elements such as these "to an unusual degree" in a work of art (see M. Beardsley, *Aesthetics* [New York, 1958], p. 528) seems to me the only way to include these ingredients, which art shares with other human activities and attitudes, in a definition of art. The present analysis of artistic behavior does not deal with such traditionally ascribed attributes of art.

9. Others have treated art from bio-evolutionary perspective but do not attempt to identify what their subject includes, or to treat it within a specifically ethological framework. See, e.g., A. Alland, Jr., *The Artistic Animal* (Garden City, N.Y., 1977); R. Joyce, *The Esthetic Animal* (Hicksville. N.Y., 1975).

10. Authors who have espoused "play" theories of art include F. Schiller, *Letters on the Aesthetic Education of Man* (1795), E. H. Wilkinson and L. A. Willoughby, eds., (Oxford University Press, 1967), 14th Letter; H. Spencer, *Principles of Psychology*, 2nd ed. (London, 1870–72); S. Freud, *Creative Writers and Daydreaming* (1908) (London, 1959); J. Huizinga, *Homo Ludens* (London, 1949).

11. A number of authors who hold this view are listed in O. Rank, *Art and Artist* (New York, 1932). p. 29.

12. H. Prinzhorn, *Artistry of the Mentally Ill* (1922) (New York, 1972), p. 13.

13. See O. Rank., op. cit., and Yrjo Him, *The Origins of Art* (London. 1900).

14. This view is espoused by numerous investigators of Upper Palaeolithic cave painting. See the discussion in P. Ucko, and A. Rosenfeld, *Palaeolithic Cave Art* (London, 1967).

15. P. Valery, *Aesthetics* (London. 1964), p. 214.

16. Proposed by W. Perceval Yetts. *The Cull Chinese Bronzes* (London, 1939), p. 75.

17. Many primitive societies have no word for or concept of art, although many others do. Until art is defined ethologically we have no recourse but to look at their activities and artifacts and identify what we in the West are accustomed to call works or kinds of art; e.g., carvings, paintings, decorated vessels, dancing, singing, theatre, and the like.

18. A provocative discussion of philosophical and other questions raised by considering the manifestations of art in primitive societies can be found in Richard L. Anderson, *Art in Primitive Societies* (Englewood Cliffs, N.J., 1979). Accounts of various non-Western attitudes towards and practices of art may be found in Carol F. Jopling, (ed.), *Art and Aesthetics in Primitive Societies: A Critical Anthology* (New York, 1971); Charlotte M. Otten, (ed.). *Anthropology and Art: Readings in Cross-Cultural Aesthetics* (Garden City, N.Y.. 1971); and in Warren L. d'Azevedo, (ed.). *The Traditional Artist in African Societies* (Indiana University Press, 1973).

19. A„ Alland, Jr., op. cit., p. 32 *et seq.*

20. G. Charbonnier, (ed.) (1961) *Conversations with Claude Lévi-Strauss* (London, 1969), pp. 123–24.
21. My use of the terms "up" and "leap" and "more" does not imply that I consider this different order to be higher in the sense of more exalted than everyday reality. It means, really, "removed from" everyday reality.
22. P. Valery, op. cit., pp. 148–49.
23. In the Gola of northwest Liberia, one word is used to designate the two kinds of activities that we call art or play. To the Gola, the distinguishing feature of this activity is to be an end in itself, and they include play, festiveness and entertainment, display, pastime, the making of images, elaborate decorated personal adornment, and a strongly desired but frivolous object as instances of this word. See Warren L. d'Azevedo, "Sources of Gola Artistry," pp. 282-340 in Warren L. d'Azevedo, op. cit., p. 306.
24. E. Dissanayake, "A hypothesis of the evolution of art from play," *Leonardo* 7: (1974) 211–17.
25. In most primitive and traditional societies art objects are usually not even to be seen or considered apart from their ritual context.
26. E. Dissanayake, "An ethological view of ritual and art in human evolutionary history," *Leonardo*, 12 (1979) 27–31.
27. According to the present view, art is never produced unintentionally. For this reason as well as others we will not attribute art to animals.
28. J. H. Vaughan, Jr., "*ankyangu* as artists in Marghi society," in W. L. d'Azevedo, (1973) op. cit., pp. 162–93.
29. J. W. Fernandez, "The exposition and imposition of order: artistic expression in Fang culture," in W. L. d'Azevedo, (1973), op. cit., pp. 194–220.
30. This point of view is called "functionalist" and has been criticized as being tautological. The controversy need not concern us here.
31. E.g., A. Stokes, *The Image in Form* (New York, 1972). pp. 80, 86, 96, 105.
32. S. Burnshaw, *The Seamless Web* (New York, 1970).
33. A. Storr, *The Dynamics of Creation* (London, 1972), p. 139.
34. H. Read, *Icon and Idea* (London, 1955); H. Read, *The Forms of Things Unknown* (London, 1960); J. Dewey, *Art as Experience* [1932] (New York. 1958), p. 200.
35. J. Z. Young, *An Introduction to the Study of Man* (Oxford University Press, 1974), p. 360; E. Cassirer, *An Essay on Man* (Yale University Press, 1944), Ch. IX.
36. H. Kreitler, and S. Kreitler, op. cit.
37. For some examples of this preoccupation see A. Berleant, "Aesthetics and the contemporary arts," *Journal of Aesthetics and Art Criticism* (Winter, 1970), 155–68.
38. See, e.g., L. Thompson, "Logico-aesthetic integration in Hopi culture," *American Anthropologist* 47: (1945) 540-53; C. Geertz. *The Religion of Java* (Glencoe, 111., 1960), pp. 233–34.

39. For a discussion of the "cognitive structures" underlying the making and appreciation of much of twentieth-century Western art, see S. Gablik, *Progress in Art* (London, 1976).

Acknowledgement: I am extremely grateful to the Harry Frank Guggenheim Foundation whose support made possible the reading and study that is developed in the present paper.

Censorship and Its Progeny

John Frohnmayer

*Visual art can pounce on you. … That's the great thing
about visual art … its pouncing.*

—Ken Grady, Sculptor

Acknowledging the freedom of conscience that the First Amendment requires us to accept is one thing; actually living with it is quite another. When someone is speaking what we consider blasphemy or disrespect for the flag, our first impulse may be to punch him in the nose, our second is to seek a law that will prevent his behavior. The First Amendment requires just the opposite. It requires us to protect the *right* of the person uttering such words, but it does not require us to agree. In fact, the answer to vicious or wrongheaded speech is always more speech, compelling speech, persuasive speech. The greatest abdication of our duty as citizens is to remain silent in the face of hateful, degrading speech.

Ironically, in spite of the First Amendment, America has a robust history of repression, intolerance and censorship. In fact, the inclination to prevent speech is as old as speech itself. Here is an admittedly superficial romp through the history of censorship. (Note that

most of it relates to art which, because it is both speech—the conveying of ideas—and symbol, tends to pack more of a wallop than ordinary words.)

Thinking was what got Socrates in trouble in 399 B.C. He was charged, found guilty and condemned to death for his democratic teachings. The official complaints—"corrupting the young" and "neglect of the gods"—were sufficiently vague that they would have been thrown out on due-process grounds in the United States today. Still, being forced to drink hemlock is censorship at its zenith. Its modern-day equivalent is the death sentence imposed on Salman Rushdie by the late Ayatollah Khomeni, after the former wrote *The Satanic Verses*.

Trifling with the incumbent religious powers could also separate heads from bodies. Take, for example, the Renaissance's super-censor, Girolamo Savonarola, a monk and spiritual ruler of Florence after the exile of the Medici in 1494. In his zeal to clean up the morals of his fellow citizens, he celebrated the "bonfire of the vanities" in the public square, burning books by Boccaccio, poems by Ovid and paintings by Botticelli and Ghirlandaio. When he ignored warnings from the Pope, he was excommunicated and in 1498 executed as a false prophet. Then, for the twenty years between 1545 and 1565, the Council of Trent, with painstaking detail, spelled out the amount of flesh that could be shown on a woman's ankle or hands. This proscription killed the Renaissance. But the Council of Trent wasn't just talk. In 1565 it instructed an apprentice of Michaelangelo, Daniel daVolterra, to cover up the private parts of some of the figures Michaelangelo had painted on the wall above the Sistine Chapel altar [plates 2 and 3]. For his compliance, daVolterra earned the derisive nickname "Il Braghettone"—the breeches-maker.

But even in this repressive age, there were aberrations. Art historian Robert Tine describes the artist Veronese's commission to paint "The Last Supper" in the Church of San Giovanni e Paolo in 1573. The 42-foot-long mural was to grace the refectory so that the monks, while taking their meals in silence, might have something both entertaining and spiritually enlightening to look at.[1] But Veronese was a hot-blooded Italian, and his "Last Supper," rather than being sedate, formulaic and stylized, instead was filled with beggars, servants, soldiers, a parrot, and a dog—prominently in the foreground—eyeing a cat at Christ's feet. Of course, the Apostles were there, too [plate 4].

The Prior of the church asked Veronese to replace the dog with Mary Magdelene. Veronese refused. The matter came before the Inquisition, and Veronese learned that the dog was the least of his problems. The Inquisition, it seems, was concerned about "Germans" (Inquisition lingo for "Protestants"). A transcript reveals this exchange:

Q: What is the significance of these armed men dressed as Germans, each with a halberd in his hand? ...
A: We painters take the same license the poets and jesters take, and I have represented the two halberdiers, one drinking and the other eating nearby on the stairs. They are placed there so they might be of service because it seems to me

fitting, according to what I have been told, that the master of the house, who was great and rich, should have such servants.

What about the drunkard, the buffoon, the man with a nosebleed, the apostle picking his teeth, they wondered, and then asked:

Q: Do you not know that in Germany and in other places infected with heresy it is customary with various pictures full of scurrilousness and similar inventions to mock, vituperate and scorn things of the Holy Church in order to teach bad doctrines to foolish and ignorant people?
A: Yes. That is wrong; but I return to what I have said, that I am obliged to follow what my superiors have done.
Q: What your superiors have done? Have they perhaps done similar things?
A: Michaelangelo in Rome in the Pontifical Chapel painted our Lord Jesus Christ, his mother, Saint John, Saint Peter and the Heavenly Hosts. They are all presented in the nude—even the Holy Virgin—and in different poses with little reverence.

Enough! Veronese was found guilty and ordered to remove the buffoons, dog, weapons and "other foolishness" within three months.

What happened? Nothing. After 90 days the Germans still ate and drank, the nosebleed was unchecked and the parrot interested the cat. But it was no longer "The Last Supper," said Veronese. It was now "The Feast in the House of Levi" a less sacred scene and one that, according to Luke 5:29, contained publicans and sinners. The Inquisition, curiously enough, was satisfied and the painting—dog, parrot, nosebleed and all—remains to this day for you to see in the Accademia in Venice.[2]

A celebrated episode took place in Mannheim, Germany, in 1853 where the marble statue of Venus de Milo—the statue herself—was put on trial, convicted and condemned for nudity [plate 5]. The account of that story does not tell whether she was represented by counsel, read her rights, asked to testify or even if, without arms, she could have clothed herself had she suddenly been struck with a fit of unscheduled modesty.

In the United States, long before North Carolina's Senator Jesse Helms raised his censorial head, Thomas Bowdler published the "Family Shakespeare" in 1818, in which he attempted to expurgate the racy stuff (although he didn't catch all of it). Then in 1873, Anthony Comstock, a New York grocer and religious zealot, championed laws banning obscene literature from the mails. Comstock's career was long and ardent—a crusade to protect the nation's youth from "obscene, lewd and indecent photographs commonly, but mistakenly, called art." He railed against so-called artists, shielding themselves in the cloak of free expression while producing material that "fans the flames of secret desires."

Comstock found a congress eager for distraction from a deepening depression, credit scandals and charges of bribes to prominent politicians. (Does this sound curiously

contemporary?) Overnight, Comstock was a Washington celebrity and within a short time Congress passed laws prohibiting the selling through the mails or advertising of obscene literature and items "for the prevention of conception." President Ulysses S. Grant named Comstock a special postal inspector and, shortly before his death in 1915, President Woodrow Wilson appointed him to the International Purity Congress. Books and art reproductions were confiscated from booksellers and art dealers. Art schools were raided, particularly if they employed nude models. Comstock helped establish the belief that sexual expression is un-American ("a foreign foe," in his words).

Perhaps predictably then, American painter and muralist Thomas Hart Benton caused a fuss in the 1930s with his paintings "Susanna and the Elders" [plate 6] and "Persephone." As one dismayed viewer exclaimed, "The nude is stark naked!"

Censorship, of course, has not been limited to visual art. In the Middle Ages, the tri-tone in music was such an anathema that it was called "Diabolus in Musica"—the "devil in music"—and the composer Thomas Morley said that it was "against nature." (The song "Maria" from *West Side Story* starts with a tri-tone). The Austrian Archbishop Piffle found Richard Strauss' opera *Salome* so abhorrent when it played in 1905 in Vienna that a restraining action prevented it from being seen again until 1918 [plate 7]. In the United States, the Metropolitan Opera's board, after allowing its premiere in 1907, acceded to critics and barred further performances on the grounds that "this diseased" work was "detrimental to the opera's interests."

In the 1920s, the great age when jazz matured, there was an anti-jazz movement to censor this new form of American music. A professor "proved" that pregnant women who listened to jazz were likely to have deformed children. Jazz was viewed by its critics as "decadent," the devil's music and composed of "jungle rhythms "Even serious critics had problems with the art form, stating that since jazz is improvised, it is contrary to discipline. In 1921, Zion City, Illinois, banned jazz performances along with smoking and other sinful practices. In Chicago, no trumpet or saxophone playing was allowed after dark.

You might think the following is an attack on rap music:

> A wave of vulgar, filthy and suggestive music has inundated the land … with its obscene posturing, its lewd gestures. Our children, our young men and women, are continually exposed … to the monotonous attrition of this vulgarizing music. It is artistically and morally depressing and should be suppressed by press and pulpit.

Surprisingly not. It is from a musical publication in 1899 railing against the evils of ragtime. Similar apocalyptic pronouncements were made about rock and roll, Elvis and the Beatles in the 1950s and 1960s. Today they seem tame, which is precisely why we should check the natural human impulse to suppress that which inflames us. Two very different values are involved here: The first is to argue forcefully against something, the second is to ban it. The first is absolutely consistent with our freedom. The second undermines it.

THE ALASKA EXPERIMENT

From 1989 to 1992 Robert Mapplethorpe, Andres Serrano and performance artists Holly Hughes and Karen Finley were household names. Congress received more mail on federal funding of the arts than it did on the savings-and-loan scandal, even though the former involved pennies and the latter billions. This culture war is still very much with us, because the conflict between tolerance, on the one hand, and respect for sensibilities and deeply held beliefs, on the other, is totally unresolved. In an effort to bring some sense to this struggle, the Visual Arts Center in Anchorage, Alaska, put together a show of approximately sixty works, all of which had been censored somewhere in the United States in the last several decades. Not all of these censorial acts were First Amendment violations, because not all of them involved governmental action. (Remember, for the First Amendment to apply, the government must somehow be involved with the speech, religion, or assembly in question). But in every instance, someone was attempting to prevent others from seeing an artwork.

The common reasons given for an image's removal were either opposition to the ideas expressed or a desire to protect others—children, for example. The artwork depicted nudes, some provocative and some seemingly innocent; defacing or trampling upon the flag; criticism of politicians and policies; oppression of women; issues of sexuality, including homosexuality, condoms and lesbian art; depictions of intolerance, such as Nazi skinheads and the Ku Klux Klan; pregnant women; body mutilation; and unflattering depictions of ethnic groups. Some of the artists were dismayed by the censorship, and others saw it as a daily fact of life.

The Anchorage show drew more than 2,000 visitors in a three-week period, a record for the Visual Arts Center. The accompanying week-long seminar drew many more. Jann Ingram, writing for the *Anchorage Daily News,* remarked that what was shocking to her was not Mapplethorpe's photos or Dread Scott's flag on the floor, but rather how tame much of the work was. How drugstore employees and police managed to read "sexually explicit" into Alice Simms' lyrical "Water Babies," a nude photo of her baby seeming to float with water lilies [plate 8], totally escaped her. On the other hand, Perry Carr, a columnist for the *Anchorage Times,* opined that the exhibit was "dim witted, vacant and amateurish … and hoisted bad taste to a level rarely seen."

An index of the success of this project, however, was the amount of public involvement it provoked. The catalyst for that involvement was Dread Scott's four-year-old piece entitled "What is the Proper Way to Display a U.S. Flag?" The School of the Art institute of Chicago found itself in total chaos when this piece first appeared in a student show in 1988. Expletives and threats filled the comment book, President Bush called the work disgraceful, local legislators passed anti-flag-on-the-floor legislation (later declared unconstitutional), veterans protested, bomb threats were received and the school itself was barely able to function. Even the artistic community was split over the issues of artistic integrity, patriotism and whether the piece was any good as art.

What was this image that stirred such passion? It consisted of an American flag spread on the floor and a small, wall-mounted shelf supporting a comment book in which viewers could respond to the question, "What is the proper way to display a U.S. flag?" Above the shelf was a picture of a flag-draped coffin. To write in the comment book, the visitor could choose to stand on the flag.

The flag art quickly became the focus of the show. At the opening reception, a group of veterans paid the five-dollar admission fee and entered the exhibition. Following prescribed flag etiquette, they picked up the flag, folded it, saluted it, and handed it—along with a book on flag etiquette—to Jan Erickson, the project coordinator [plate 9]. She returned the flag to the floor, saying, "This exhibit is not about disrespect to the flag. It's about the right to free expression. The viewer chooses whether to stand on the flag or not."

The following day, a group of veterans again paid the admission fee to enter the exhibition, but this time they quickly folded the flag and handed Jan Erickson a check for $50, along with a letter stating that the flag was being taken into protective custody. Erickson told them that if they removed the flag, she would have to call the police. Upon leaving the Visual Arts Center, the V.F.W. State Commander and one other man were arrested and charged with larceny, a Class A misdemeanor with a maximum $1,000 penalty. Another flag, purchased by a patron, was placed on the floor within 20 minutes. Erickson said they considered putting glass over the flag or perhaps gluing it to the floor. They checked with the artist in New York, who encouraged them to substitute flags when the original was taken.

The veterans commenced a peaceful protest outside the Visual Arts Center, and inside, the Dread Scott piece did what art is uniquely capable of doing: It quickened people's minds and focused their beliefs. These are some comments from the book:

> I feel—it's just material. But also—I was hesitant to do it—I wondered before I did, if I would.

> I respect what other people believe this flag stands for. It is out of respect for their feelings that I stand on this flag with my shoes off.

> I don't want to walk on it—it was good for me to find this out.

> How interesting. I thought folks who objected to this piece were over-reacting, but as I write, I'm standing to the side of the flag. Thanks for the insight and opportunity.

> Standing here on the flag, I do feel the power to change the 'what is' to the 'what should be' and do feel a tinge of hope.

For some reason I find I can stand on the stripes but couldn't bring myself to stride over the stars.

I felt unearthed, that is, ungrounded. Dizzy. It's helping me realize just how much meaning I have vested personally in this symbol … I am getting a closer understanding of the relationship between the symbol, the truth and myself.

I didn't think that I would want to participate in this until I saw all of the works that had been censored—so ridiculous. So here I stand. Who knows—if the Supreme Court says that my body is not mine, I may burn one.

Move the flag off the floor. I was busy looking at the wall and accidentally stepped on it.

A little more than a week after her father was arrested for taking the flag, 17-year-old Robin Brogan stood to the side of the flag and wrote in the book:

I think this is disgusting. Dread Scott is taking advantage of his rights that my father fought for. The First Amendment only goes so far and this definitely crosses the line …

Then she scooped up the flag, left a $50 deposit that she had been given by a protester outside, and scurried out of the Arts Center. What followed could only be described as surreal. Robert Pfitzenmeier, a former Visual Arts Center staffer who had returned to Alaska to go fishing, was rollerblading outside and saw her as she ran from the center. He started after her, grabbing her shoulders and coat to stop her. While Pfitzenmeier was chasing Brogan, he was "whipped with an American flag" carried by one of the protesters. "The flag … was all over my face," he said. Then Ron Siebels, a Vietnam veteran with boxing and martial-arts skills, chased down Pfitzenmeier and threw him to the ground. Police arrived, and Pfitzenmeier was detained, perhaps to protect him from the fifty demonstrators. Siebels later said in a letter to the editor that he was merely rescuing a young woman in distress and didn't act because he was a veteran. Susan E. Palmer, assistant director of the center, lamented that the protesters and supporters "can't hear each other. It's very frustrating."

Another flag was donated, and the next day the game of capture-the-flag continued. Protesters twice paid admission to the Visual Arts Center and emerged with neatly folded American flags, the third and fourth taken. The police made no arrests. After that, a Vietnam veteran brought five U.S. flags to the gallery for use in the exhibit.

In more than seventy-five letters to the editor printed in the Anchorage papers, citizens spoke out. "How can we teach values when we stand on the flag?" asked one. "I resent those who are willing to trample on the Constitution in the name of patriotism, and I'm

saddened by those veterans who missed the point of why they were fighting," responded another. "As a veteran I swore an oath to defend the Constitution, not symbols. The Constitution guarantees freedom of speech," said a third.

An Air Force veteran wrote:

> … When I first arrived I had not intended to stand on this flag at all while I wrote. This is because I respect what it stands for and I understand why the veterans do not call it 'just a piece of cloth.' But by their action [taking the flag] they have rendered this flag *meaningless* and it is only a piece of cloth as long as they suppress the freedom of speech and expression which belongs to all of us. I hope I never have to do this again.

Others thought the display polluted the memory of those who had died. A member of the Alaska State Council for the Arts wrote:

> You are truly a pathetic excuse for an artist. These rights and freedoms you take so lightly aren't free. Rather they were secured by brave citizens who were brought home beneath the very symbol you choose to disrespect. *Being legal* should not be confused with having something worth saying. I feel quite sorry for you and hope that, with time, you might even progress to the point of mediocrity.

What would *you* have done? Recite the First Amendment (which you have memorized) and use it to analyze the following citizen responses. The question is not whether you agree or disagree, but where, if at all, speech becomes action and loses its protected status.

1. We Americans are losing our cherished values by blindly following the 'freedom of everything' minority.
2. I am boycotting the Visual Arts Center.
3. I recommend all citizens counter this disrespectful display by flying their flags on June 14 (Flag Day).
4. Citizens should rise up against the businesses that sponsor this offensive display.
5. When one steps on the flag he steps on us all. It's a sacred symbol. It's a nerve and it hurts. Laws are made to stop one person from hurting another …
6. I cheer the Vietnam veteran who confronted a flag burner and said 'if you have the right to burn the flag, I have the right to punch you in the nose.'
7. I support the veterans who removed the flag from the exhibit.

Personal opinion, personal boycotts, countering symbolism with symbolism, economic boycotts and even false logic are protected speech. And perhaps expressing support for violence and breach of the peace are protected, too. But nose-bashing is not a protected

First Amendment activity, and while the veterans who took the flags were taking it into "protective custody," had they been prosecuted, the First Amendment would not have saved them from a larceny conviction.

Now analyze these letters to the editor, which were, by the way, in the minority.

1. The veterans who stole the flag should be arrested for theft. It is ironic that a show on censorship should itself be censored [by stealing the flag].
2. The flag is just cloth. It is what it stands for [liberty, expression and choice] that is important.
3. Left to run its course censorship becomes an ideological battleground where every faction of our diverse society attempts to control the thoughts of everyone else.
4. I found the Mapplethorpe to be disgusting. But disgust is within the realm of what's conveyed by art.
5. To make art possible is not to condone it.

ANATOMY OF A CENSOR

The show accomplished, perhaps beyond the organizers' wildest expectations, what it intended. The vigorous dialogue lasted well after the show closed. Seeing these works together was a stunning revelation of the anatomy of censorship. The work was so diverse that even the most ardent censors would not have agreed upon what should have been banned. Kriste Lower of The American Family Association, a group vigorously opposed to obscenity said "there are 10 pieces in there that I don't consider art." Amazing. Fifty of the censored pieces apparently passed muster with her. Censorship is whimsical. It is triggered as much by what the censor brings to the work as by what the work, itself, is.

The censor, above all, is impatient. All artwork involves ideas, and the life of a half-baked idea is very short indeed. The censor's zeal often prolongs that life rather than shortening it. For example, Robert Mapplethorpe's photos now sell for $60,000—far above what they brought during his lifetime.

The censor favors order over freedom. Freedom is imprecise, inefficient, ambiguous and often annoying. To the censor, order is of a higher magnitude, particularly when the censoring is done in the name of protection of the young, the impressionable or the sensitive. And once a censor starts, there is no logical stopping point. The censor is a literalist, not seeking context or intended meaning and often not even wanting to know the content of that which he would prohibit. "You don't have to be in the sewer to know that it smells," remarked one. The world is black or white, good or evil, with no shades of gray.

Usually the subject of a censored work is unsympathetic. Nazis, perceived blasphemers and flag-burners are hard to stomach for many people. And yet it is precisely minority opinion, unpopular opinion, that the First Amendment most strenuously protects. The reason is that if we don't protect everybody, then nobody is safe. If we can't win a battle by logical argument and persuasive speech, then America is not safe.

The left of the political spectrum is as intolerant as the right and neither, when it comes to censorship, can claim the moral high ground. In this show, a substantial number of works did not pass muster with what might be deemed the more liberal side of the political landscape. The KKK robe, the Nazi subject matter or what was deemed by the censor to be an inappropriate treatment of women and ethnic minorities are examples. State-enforced intolerance, whatever its justification, is contrary to our belief in freedom.

The battle over whether an artwork will or will not be allowed to speak its own message is often a battle for public opinion. The arguments that it is too indecent, too blasphemous or too wretched for the public to see are notions that we often find buried in ourselves. They trigger our own internal war over standing up for what we think is good, on the one hand, and defending the rights of others to express their opinions about what they think is good, on the other. A crucial distinction is that, in supporting a person's *right* to speak, we can still vigorously disagree with the message.

Finally, censorship is an issue of control, of power over what others will or will not have the opportunity to experience. Most of us would find censorship irresistible if we were the only ones making the decision. But democracy listens to all voices and exists, always, with the tension that different views produce. The process of speech is the process of growth, of understanding and enlightenment, and like a muscle, speech grows stronger with exercise and atrophies with disuse.

Particularly in times of societal stress, such as economic hard times or political uncertainty, the urge to be ethically pure, morally superior and intolerant of "filth" is almost irresistible. Anthony Comstock and Jesse Helms played to that siren, each in his own generation, and both claimed to be patriots. To the extent they succeed, we all fail, for in the words of the historian Henry Steele Commager: "… [Censorship] creates, in the end, the kind of society that is incapable of exercising real discretion … incapable of appreciating the difference between independent thought and subservience."

PROPHYLACTIC MEASURES AND RULES OF ENGAGEMENT

How can we protect the First Amendment in the inevitable and necessary debates on divisive issues? For the artist—particularly the artist using public funds—or for the journalist or public-school teacher, there is an obligation to provide some context when confrontational or difficult work is presented. This doesn't mean that the work has to be explained, but rather that some background be available, so that the audience or class can share the artist's creative journey or the teacher's intent in presenting challenging materials. Art instructor Carol Becker, in her lecture at the Anchorage symposium, said: "Nobody talks about audiences in art school. We need to provide students with enough information so they are not afraid of questions." Not all artists seek dialogue, and that is fine. But if an artist accepts public money, then that dialogue is part of the bargain. And the teacher who presents difficult subjects for discussion is doing her job, but the First Amendment better

enhances reasoned discussion if the class is (or parents are) not immediately shocked into opposition. Debate, in short, is enhanced by preparation.

Another rule of engagement in art-inspired controversy should be that the work not be taken out of context—that is, that it not be deliberately misunderstood. A fundamental rule of fairness, in both art and ethics, is to get the facts right, insofar as the facts are discernible. Sometimes they aren't. As the philosopher Bertrand Russell pointed out in 1950: "The most savage controversies are those about matters as to which there is no good evidence." Issues of faith are a good example. In politics, however, it is an old and disreputable technique: Misstate your opponent's position, and then attack it relentlessly. It is hard to see, in either democracy or art, how misinformation helps us.

Before a controversial art work is to be presented, the presenter should, by a series of discussions or lectures, remind us of the First Amendment and what it means to protect unpopular ideas and how it helps preserve our ever-evolving democracy. We can't presume that the issues the artists dealt with in the Alaska show were simple or simply resolved. The artist often intentionally juxtaposes the sacred and profane, wades into taboo or challenges the established order. This irreverence, this outrageousness, this grabbing and flaunting our anxieties, seldom goes down easy, and often, as is the privilege of free expression, it is so much drivel and foolishness. But even in its reflection of life's absurdities, art moves us forward as a society, and that is precisely what the First Amendment is meant to allow. Supreme Court Justice William O. Douglas said in 1949 that free speech "… may indeed best serve its high purposes when it induces a condition of unrest, creates dissatisfaction with conditions as they are, or even stirs people to anger. …"

Controversial work, when presented, ought to be accompanied with an opportunity for dialogue. The symposium in Anchorage and the exchange of letters compel us to respect the strongly held views on all sides of the issue. Hearing those views with which one might violently disagree is a privilege, not a burden, of freedom. In this sense, the artist represents the society to itself.

But what about the genuine offense? What about the person who has confronted the work, lived within the truth in examining it, and is morally repulsed nonetheless? The answer is that the First Amendment protects all forms of speech, even those which are repulsive, unless they rise to the level of judicially declared obscenity. Moreover, democracy guarantees no insulation from the unpleasant, the difficult or the annoying. In fact, it demands just the opposite—that we not be islands, but rather that we share the action and passion of our time. Democracy requires self-definition, which is an extension of the strongly individualistic and action-oriented history of Western thought expressed by Rabbi Hillel in the twelfth century:

> If I am not for myself, who will be for me?
> If I am not for others, what am I?
> And if not now, when?

The Alaska show, with all its trials and triumphs is summarized in a single letter to the editor:

> After an emotional protest, the veterans gently picked the flag up from the floor, cradled it lovingly, saluted it, respectfully folded it and handed it back to Jan Erickson, one of those responsible for the exhibit and the seminars on censorship. I was warmed by the dignity of both the veterans and Erickson as she in turn defended freedom of speech and returned the flag to the floor. It took courage and patriotic conviction for the veterans to march into the VAC and likewise for the center's staff to defend their exhibit. The Visual Arts staff educated us on censorship issues and provided the stage for this performance on democracy. Neither side should be silenced.

POSTLOGUE

You may wonder what happened to the Visual Arts Center after the show. Anchorage mayor Tom Fink vowed to veto its municipal appropriation. In July 1992, a month after the show closed, four members of the Alaska State Council for the Arts supported a motion to cut off all funding for the Visual Arts Center, claiming that the censorship exhibition had offended a majority of Alaskans. Although the motion failed six to four, executive director Verne Stanford and his staff were laid off in late September 1992, and the Visual Arts Center closed. Three months later, its equipment was sold at an auction to help pay a longstanding $100,000 debt. None of those arrested were prosecuted. The Anchorage Visual Arts Center is now only, a memory. Perhaps this proves the old adage that no good deed goes unpunished.

QUESTIONS FOR DISCUSSION

1. *Are there circumstances in which censorship is justified?*
2. *Do we need to protect the young and impressionable? If so, how?*
3. *How do we respond to the person who is genuinely offended?*
4. *Should public art be acceptable to the majority? What about minority views?*
5. *Can you give an example of when censorship has been or would be considered appropriate and successful?*
6. *Collect a variety of art books of generally accepted artists that include nudes or other potentially controversial art. Share these books with small groups of students. Remind them of how music that was once considered controversial is now considered acceptable. Have them discuss the art in terms of potential censorship. Make the argument for the censor; the artist; the Visual Arts Center.*

7. *Think about the situation at the Visual Arts Center. Should the flag stealers have been prosecuted?*
8. *Does supporting a show mean that the VAC agrees with the artists viewpoints? Is it possible to truly know an artist's viewpoint?*
9. *Was Robin Erogan (the 17-year-old who took the flag) right? Does the First Amendment only go so far?*
10. *Was it appropriate for the Alaska arts council to retaliate by cutting the budget?*
11. *What do you think would happen if the show were mounted in your community?*
12. *Given that the censored art show led to the permanent closure of the Visual Arts Center, was it worth the cost?*
13. *Is all art speech?*

SOURCES

Frohnmayer, John. *Leaving Town Alive.* New York: Houghton Mifflin, 1993.

Gablik, Suzi. *The Reinchantment of Art.* NewYork: Thames and Hudson, 1991.

Heins, Marjorie. *Sex, Sin and Blasphemy.* New York: The New York Press, 1993.

Hentoff, Nat. *Free Speech for Me—But Not for Thee.* New York: Harper Perennial, 1992.

NOTES

1. Robert Tine, "Artist Outwits Inquisition," *The New York Times* (Nov. 12, 1990).
2. The entire transcript of Veronese's harrowing brush with the Inquisition is in *Veronese: The Supper in the House of Levi* by Giuseppi Delogue (Transbook Co., Inc., New York/Milan).

Performance, Community, Culture

Baz Kershaw

THE ROOTS OF A THEORY

Whatever judgement is passed on the social and political effects of British alternative and community theatre, it must be informed by the fact that the movement was integral to a massive cultural experiment. From this perspective the leading edge of the movement was not stylistic or organizational innovation (though both these were fundamental to its growth); rather, its impact resulted from a cultural ambition which was both extensive and profound. It was extensive because it aimed to alter radically the whole structure of British theatre. It was profound because it planned to effect a fundamental modification in the cultural life of the nation. Hence, the nature of its success or failure is not a parochial issue of interest only to students of theatre. In attempting to forge new tools for cultural production, alternative theatre ultimately hoped, in concert with other oppositional institutions and formations, to re-fashion society.

[In order to] construct a theory which will facilitate our investigations into alternative theatre's potential for efficacy, both at the micro-level of individual performance events and at the macro-level of the movement as a whole [we need to] address a number of basic questions about the relationships between performers and audiences, between performance and its immediate context, and between performances and their location in cultural

formations. The answers will show how the nature of performance enables the members of an audience to arrive at collective 'readings' of performance 'texts', and how such reception by different audiences may impact upon the structure of the wider socio-political order. The focus will be on oppositional performances because the issue of efficacy is highlighted by such practices, but the argument should be relevant to all kinds of theatre.

My central assumption is that performance can be most usefully described as an *ideological transaction* between a company of performers and the community of their audience. Ideology is the source of the collective ability of performers and audience to make more or less common sense of the signs used in performance, the means by which the aims and intentions of theatre companies connect with the responses and interpretations of their audiences. Thus, ideology provides the framework within which companies encode and audiences decode the signifiers of performance. I view performance as a transaction because, evidently, communication in performance is not simply uni-directional, from actors to audience. The totally passive audience is a figment of the imagination, a practical impossibility; and, as any actor will tell you, the reactions of audiences influence the nature of a performance. It is not simply that the audience affects emotional tone or stylistic nuance: the spectator is engaged fundamentally in the active construction of meaning as a performance event proceeds. In this sense performance is 'about' the transaction of meaning, a continuous negotiation between stage and auditorium to establish the significance of the signs and conventions through which they interact.

In order to stress the function of theatre as a public arena for the collective exploration of ideological meaning, I will investigate it from three perspectives, drawn in relation to the concepts of *performance, community,* and *culture.* I will argue that every aspect of a theatrical event may need to be scrutinized in order to determine the full range of potential ideological readings that it makes available to audiences in different contexts. The notion of 'performance' encompasses all elements of theatre, thus providing an essential starting point for theorizing about theatre's ideological functions. Similarly, the concept of 'community' is indispensable in understanding how the constitutions of different audiences might affect the ideological impact of particular performances, and how that impact might transfer (or not) from one audience to another. Lastly, theatre is a form of cultural production, and so the idea of 'culture' is a crucial component in any account of how performance might contribute to the wider social and political history.

Viewed from these perspectives, British alternative and community theatre between 1960 and 1990 provided an exceptionally rich field of investigation, for three main reasons. Alternative theatre was created (initially, at least) outside established theatre buildings. Hence, every aspect of performance had to be constructed in contexts which were largely foreign to theatre, thus making it easier to perceive the ideological nature of particular projects. Next, the audiences for alternative theatre did not come ready-made. They, too, had to be constructed, to become part of the different constituencies which alternative theatre chose to address, thus providing another way of highlighting the ideological nature of the movement's overall project. Finally, alternative theatre grew out of and augmented

the major oppositional cultural formations of the period. Particular performances were aligned with widespread subversive cultural, social, and political activity, with the result that they were part of the most fundamental ideological dialectics of the past three decades.

This is particularly the case because, besides being generally oppositional, many individual companies and, to a large extent, the movement as a whole, sought to be popular. As well as celebrating subversive values, alternative theatre aimed to promulgate them to a widening span of social groupings. Hence, the movement continually searched out new contexts for performance in a dilating spectrum of communities. And often—particularly in the practices of community theatre—alternative groups aimed to promote radical socio-political ideologies in relatively conservative contexts. Thus, complex theatrical methods had to be devised in order to circumvent outright rejection. Inevitably, the whole panoply of performance came into play as part of the ideological negotiation, and all aspects of theatre were subject to cardinal experiment so that its appeal to the 'community' might effect cultural—and socio-political—change. In an important sense, then, we are dealing with a rare attempt to evolve an *oppositional popular culture*. [...] Whilst it is obvious that alternative theatre did not bring about a political revolution, it is by no means certain that it failed to achieve other types of general effect. As Robert Hewison (1986:225) argues, the possibility that it did contribute significantly to the promotion of egalitarian, libertarian, and emancipatory ideologies, and thus to some of the more progressive socio-political developments of the last three decades, cannot be justifiably dismissed. [...]

PERFORMANCE AND EFFICACY

In all forms of Western theatre the gathering phase is designed to produce a special attitude of reception, to encourage the audience to participate in the making of the performance in a particular frame of mind. In other words, the conventions of gathering for a performance are intended to effect a transition from one social role into another, namely, the role of audience member or spectator. A crucial element in the formation of the role is the 'horizon of expectation' which performative conventions create for the audience; that is to say, the framework within which a piece of theatre will be understood as one type of performance event rather than another (a pageant, a pantomime, a classical tragedy) (Bennett 1990). So the precise nature of the audience's role will vary. However, the anthropologist Victor Turner has pointed out that in some respects the role is always similar to that experienced by participants in ritual. It is a *liminal* role, in that it places the participant 'betwixt and between' more permanent social roles and modes of awareness. Its chief characteristic is that it allows the spectator to accept that the events of the production *are both real and not real*. Hence it is a *ludic* role (or frame of mind) in the sense that it enables the spectator to participate in playing around with the norms, customs, regulations, laws, which govern her life in society (Turner 1982:11). Thus, the ludic role of spectator turns performance into a kind of ideological experiment in which the outcome has no *necessary* consequence

for the audience. Paradoxically, this is the first condition needed for performance efficacy. [...]

Theatrical performance [is linked] to carnival and other forms of public celebration which are designed to produce what Victor Turner has called *communitas:* primarily 'a direct, immediate and total confrontation of human identities' (Turner 1982:47). As, according to Turner, *communitas* is the foundation of community cohesiveness, then the paradox of rule-breaking-within-rule-keeping is crucial to the efficacy of performance in its contribution to the formation of (ideological) communities. It is when this paradox is operating at its most acute—when a riot of anger or ecstasy could break out, but does not—that performance achieves its greatest potential for long-term efficacy. For the 'possible worlds' encountered in the performance are carried back by the audience into the 'real' socio-political world in ways which may influence subsequent action. Thus, if a modification of the audience's ideology (or ideologies) is induced by crisis, whether as a confirmation or a radical alteration, then the function of the rhetorical conventions of dispersal is to effect a re-entry into society, usually in ways which do not lead to immediate efforts to influence the existing socio-political order, in whatever direction. In this respect, theatre which mounts a radical attack on the status quo may prove deceptive. The slow burning fuse of efficacy may be invisible.

It should also be noted that audience members always have a *choice* as to whether or not the performance may be efficacious for them. For the ludic role of spectator permits the participant to treat the performance as of no consequence to her or his life: it's only a fiction, only a 'possible world', with no bearing on the real one. It also follows that if the spectator decides that the performance is of central significance to her or his ideology then such choice implies a commitment. It is this commitment that is the source of the efficacy of performance for the future, because a decision that affects a system of belief, an ideology, is more likely to result in changes to future action. It is in this respect that the collective impact of a performance is so important. For if a whole audience, or even a whole community, responds in this way to the symbolism of a 'possible world', then the potential of performance efficacy is multiplied by more than the audience number. To the extent that the audience is part of a community, then the networks of the community will change, however infinitesimally, in response to changes in the audience members. Thus the ideology of communities, and so their place in culture, may begin to have a bearing on the wider socio-political make-up of a nation or even a continent. [...]

CULTURE AND PERFORMANCE

The idea of community as a process of ideological meaning-making helps to explain how individual performances might achieve efficacy for their audiences. However, we need also to determine how different communities might be similarly changed by a single show, or a series of shows, even given the complex variability of readings resulting from contextuality[1] and inter-textuality[2]. We must acknowledge, too, that this problem—which encompasses

the issue of how a theatrical movement may influence society—is bound to be exacerbated in contemporary societies which are subject to postmodernist pluralism. To express this, for the moment, in terms of a post-structuralist analysis: if signs are indeed in arbitrary relationship to what they signify, then (Pace Esslin 1987:21)? all we can anticipate is a riot of individual readings whose disparate nature can only reinforce the pluralistic and fragmented society which produced them in the first place.

My purpose now is to defend the possibility of common collective readings of performance on an inter-community basis, to suggest how different performances for different communities might successfully produce consonant effects in relation to society as a whole. [...] I will adopt [Raymond Williams's] notion of culture as a 'signifying system', by which he means the system of signs via which groups, organizations, institutions, and, of course, communities recognize and communicate with each other in the process of becoming a more or less influential formation within society. In other words, 'culture' is the medium which can unite a range of different groups and communities in a common project in order to make them into an ideological force operating for or against the status quo.

The British alternative and community theatre movement was a cultural formation in the sense adopted above. However, to establish the potential significance of the movement to British society as a whole we need to investigate its place in the cultural organization of post-war Britain. That significance is partly a question of scale, and [...] it was by no means negligible in this respect; but even more important were the ways in which the movement was part of the great cultural shifts of the 1960s, 1970s, and 1980s. For its cultural alliances clearly have a bearing on the possible extent of its ideological influence; its potential efficacy cannot be accurately assessed if it is isolated from the very forces that brought it about in the first place. Thus, it is crucial to my argument that British alternative theatre was, at least initially, part and parcel of the most extensive, and effective, oppositional cultural movement to emerge in Western countries in the post-war period: the international counter-culture of the late 1960s and early 1970s.

Much of the debate about the nature of the counter-culture (and later similar formations) has focused on its relationship to the class structure of society [...] but 'class' is an inadequate concept for explaining exactly *how* the counter-culture might have achieved such extensive socially disruptive potential.

A number of cultural critics have argued that generational membership may provide a better explanation for the extensive influence of countercultures. That is to say, a full-blown counter-culture is ultimately the product of a whole generation, in that all members of a particular generation may be decisively affected by their historical positioning. [...] This perspective has profound implications for our assessment of the socio-political status of the institutions of the counter-culture, including the alternative theatre movement. For a start, it moves those institutions from the margins of historical change to somewhere closer to the centre, for those institutions then represent a changed generational awareness both to the generation and to the rest of society. In addition, the institutions are a concrete embodiment and a widespread medium for the promulgation of alternative,

and usually oppositional, ideologies. In addition, the generational locus provides a basis for the popularity of the institutions and their forms of production. Hence, the idea of the counter-culture thus conceived enables us to understand how the 'alternative' may become 'popular', how the socially marginal impulse of middle-class youth may become ideologically central to a whole society.

We can gain a measure of what this may mean historically by considering the nature of the cultural movements that in large part issued from the late 1960s counter-culture in the 1970s. [...]

The late 1960s counter-culture was a major stimulus to, and a partial source for, the ideological orientations of the great emancipatory and libertarian movements of the 1970s and 1980s. These included the gay rights and black consciousness movements, the women's and feminist movements, the community activist movement and the various movements that fought for the rights of people with disabilities, the elderly, the hospitalized, and other types of socially disadvantaged group, and it may include even the campaign for a popular, grass-roots-based culture that was fought in the mid-1980s.

I am not suggesting, of course, that the late 1960s counter-culture *caused* these movements, for they have their sources in a widespread and continuing dissatisfaction with the inadequacies of late-capitalism in providing for the needs of minorities and marginalized groups. However, that initial counter-culture did provide a 'model' for oppositional action against hegemony, on a grand scale. [...] But how could a phenomenon that was so socially diffuse and historically distended possess anything like an identifiable ideology?

Theodore Roszak [...] identifies the ideological foundation of the counter-culture as an opposition to hegemony by a utopianist idealism which promoted an egalitarian ethic through the advocacy of participative democracy on a localized level (Roszak 1969:200).

Now the profound simplicity of Roszak's interpretation indicates how this ideological root for the counter-culture provided the formation with three major advantages for its oppositional promulgation. Firstly, the ideology was amenable to adaptation and elaboration in a phenomenally wide variety if different cultural practices. [...] Secondly, it provided the counter-culture with the principle of non-bureaucratic institutional organization. [...] Thirdly, the formulation was adaptable and was adopted by the subsequent cultural formations as a central element of their ideologies. Despite their sometimes profound differences, and the contradictions between them, they can be related to a singular ideological tendency which was in deep opposition to the status quo. So, at the very least, these movements were united by resistance to the dominant order; but also they maintained at least a modicum of ideological coherence through their commitment to egalitarianism and participatory democracy.

Thus, the idea of the counter-culture provides us with a key theoretical component for understanding how particular performances connected with general social change from the 1960s to the 1980s. For the British alternative theatre movement was only one, relatively small, part of the counter-cultural and emancipatory movements of the 1960s, 1970s, and 1980s. As such it played, I think, a key role in promoting and popularizing oppositional

ideologies. [...] Its chief tactic was allied to the emergence of the aesthetics of anti-nuclear, anti-war, and civil rights demonstrations in Britain and the USA. This is best described as a carnivalesque resistance to the oppressions of affluence, as promoted by the capitalist, technocratic, and meritocratic status quo. [...] A new mode of *celebratory protest* [...] challenged dominant ideologies through the production of alternative pleasures that were particularly attractive to the generations born in the 1940s and 1950s. And, inevitably, its audacity was greeted with an ambiguous embrace by the dominant socio-political order.

NOTES

1. Contextuality: the propensity of a performance text to achieve different meanings according to the context in which it occurs. The 'ideological relativity' of a text results from contextuality.
2. Inter-textuality: the ways in which the codes (conventions/signs) of a performance text gain meaning for an audience through its relationships with other texts.

The Politics of Art

Gabriella Coslovich

A rtists, curators and critics argue that all art is political. But should public money be used to support artists with a political message, especially one that offends parts of the community? Gabriella Coslovich reports.

Artists have a habit of offending people, of tackling explosive political issues, of defying authority and challenging the mainstream. From Picasso's *Guernica*, one of history's great anti-war protests, to Ivan Durrant's dumping of a freshly slaughtered cow on the forecourt of the National Gallery of Victoria in 1975—his ghastly response to senseless killing and the Vietnam War—to John Heartfield's scathing photomontages of Hitler, art has shocked, provoked and riled governments across the political spectrum.

Artists, curators and critics argue that all art is political—the status quo installation—featuring the Israeli flag and a debatable list of statistics about the plight of Palestinians since the creation of the Israeli state in 1948—was is either reinforced, rejected or rendered invisible. But should public money be used to support artists with a manifestly political message, especially one that offends and alienates a large sector of the community? The question has been fiercely debated this week in the wake of the controversy surrounding an art installation in a Flinders Street shopfront-artspace, funded by the Melbourne City Council.

Gabriella Coslovich, "The Politics of Art," 2004. Permission to reprint granted by the rightsholder.

Until last week, Azlan McLennan was a relatively unknown, 28-year-old, final-year art student at the Victorian College of the Arts. But his work, *Fifty Six*, guaranteed him the sort of notoriety and publicity money can't buy. The controversy ignited by his work was being covered in newspapers as far afield as Christchurch, London and Jerusalem.

McLennan's installation—featuring the Israeli flag and a debatable list of statistics about the plight of Palestinians since the creation of the Israeli state in 1948 - was removed before it was completed. The furore that erupted around the work left the director of the art space, Mark Hilton, no choice but to end the exhibition.

Many in Melbourne's Jewish community were outraged by McLennan's work and believed it to be anti-Semitic—a charge the artist denies.

In the ensuing media storm, Melbourne city councillor Kimberley Kitching declared the work wasn't art, Victorian Premier Steve Bracks said he wasn't sure whether it was art, and Arts Minister Mary Delahunty ironically declined to comment. This is despite her record of championing freedom of speech and knocking Opposition arts spokesman Andrew Olexander's frequent outbursts against art he deems unsavoury.

The resulting ruckus was a windfall for Kitching, who seized the opportunity to push her public art agenda. Kitching, the chair of the council's public art committee, argued that Melbourne's ratepayers did not want to fund "political art", nor art that leant towards the obscure and avant-garde. "We should fund art that the majority of the rate base don't have a problem with," says Kitching, who is a member of the Labor Party. "We should direct funding towards art that enhances the city's reputation."

Leaving aside, for the moment, the question of the artistic merit of McLennan's work, it is not the first time that "art" has triggered such heated discussion. Last year's Melbourne Festival bete noire was the Belgian theatre production *I Am Blood*, which Olexander puffed mightily against. This year, it was indigenous artist Gordon Hookey and his savage lampooning of the chummy relationship between Prime Minister John Howard and US President George Bush that had Olexandar fuming. Hookey's three-panel work is on view at the National Gallery of Victoria, at Federation Square.

So how does the NGV deal with works that are potentially controversial? Case by case, says director Gerard Vaughan. "In no way will we condone censorship, but we do need to draw the line occasionally."

Despite Olexander's calls for Hookey's painting to be removed, Vaughan stood firm. The painting, titled *Sacred nation, scared nation, indoctrination*, is still on display and is now flanked by a video featuring an interview with the artist.

"Our position is straightforward," says Vaughan. "As a publicly funded art gallery, we must be apolitical, but we defend our right to display work by individual artists that does have a political message."

So where does the NGV draw the line? While Hookey's flagrant politics have not been censored, early this year the antifashion statements of '70s British punk doyenne Vivienne Westwood were, to put it generously, toned down. One of Westwood's garments, *Destroy Bondage* Shirt, from 1976, had been turned around so that a large swastika on the design

was not visible. Vaughan this week confirmed that the gallery had decided to conceal the swastika from public view, following a complaint from the grand-daughter of an elderly visitor who had suffered under the Nazis and found, even in the context of 1970s punk, the appearance of the swastika upsetting.

"This became an issue for us because, on the one hand, as historians of the taste and visual culture of the punk movement, this was an aspect that needed to be recorded," Vaughan says. "On the other hand, it had caused great offence to a visitor, and we were deeply sympathetic.

"We can't go out of our way to offend people in the community, because we are a public institution. We need to be courageous and we should not shrink from displaying work that is provocative . . . But they are very, very treacherous waters for any gallery director to navigate," Vaughan says.

Just how treacherous the director of a much smaller, much less significant artspace discovered last week. Mark Hilton, who has directed 24seven in Flinders Street for three years, walked into a media storm last Tuesday as he arrived back in Melbourne from Japan.

Driving home with his father from Tullamarine airport, he made a detour past the Flinders Street site and was astonished to see Opposition Leader Robert Doyle giving a press conference out front. The statistics quoted by McLennan's work were widely disputed and the artist admits to one mistake—his reference to the "200,000 settlements" that had been created since 1948 should have read 200,000 "settlers".

"This error we acknowledge and take full responsibility for, but in no way apologise for the creation or the intention of the art work," McLennan wrote, in an email to *The Age*. His intention was to present "an alternative to the perceived pro-Israeli bias taken by the Liberal Government".

To make matters worse, the person who was directing the space in Hilton's absence had forgotten to notify the Melbourne City Council that McLennan's art work was potentially controversial—as 24seven's contract requires it to do.

Kitching told *The Age* that the breach was so serious that 24seven should have its $8000 annual funding rescinded. So far, that has not happened, although Hilton does not like his chances of getting a grant next year.

He maintains it was his decision to close the offending show: "If the statistics were right, then we would have left the show as is."

Inaccuracy in such a charged political work was indefensible, says the NGV's contemporary art curator, Jason Smith. "Factual errors are insupportable if an artist wants to make such a strident statement about the horrors of war and conflict."

However, Smith is equally critical of politicians decreeing what is and isn't art. "On the one hand, people in the public realm will say, 'this is not art', and when they are asked 'what is art?', they will say, 'that's not for me to decide', but they have already made a judgement."

If anything, Smith is surprised that more Australian artists aren't engaging in political commentary, particularly given the current climate of global conservatism and the horrors

of the Iraq war: "Good political art is very important art, especially in an atmosphere of conservatism."

While many in Melbourne's Jewish community were insulted by McLennan's work, the visual arts community was outraged by the Melbourne City Council's knee-jerk response to the controversy and the threat of changes to funding for public art. As news of the Melbourne controversy spread, the head of the Sydney-based National Association for the Visual Arts, Tamara Winikoff, sent an urgent letter to Mayor John So asking to speak to him about proposed changes to art funding guidelines.

"Art is not valium. One of the legitimate roles of art is to stimulate public reflection and debate about the key issues of our time," Winikoff says in a media release.

The backlash from the arts community had the council toning down its message. At an informal meeting on Tuesday, the views of councillors with a more measured response to the 24seven incident prevailed.

This week, the council sent out its 2005 arts grants program with an addendum noting two main changes: council decisions on the allocation of arts grants will now be made in open sessions, and a community representative will be appointed to the council's cultural arts advisory board. But the arts program otherwise remains intact.

Meanwhile, other art offerings by McLennan will be on show at the Next Wave Festival, which opens next week and is funded by the council and the State Government.

Su Baker, the head of art at the VCA, where McLennan studies, says she would be "very sorry if people were personally offended by Azlan's work".

"There is a lot of very robust opinion in the world—particularly in the art world—and somehow in a democracy we have to negotiate these opposing points of view. If we censor opinion to such an extent that artists can't speak, then things go underground and we could end up with a very oppressive situation."

But what of McLennan's Flinders Street installation? How does one assess its artistic merits? Chris McAuliffe, artistic director of the University of Melbourne's Ian Potter Museum, sees it as strategically weak.

"It's art because that's the claim it made for itself, but it probably didn't have the sophistication needed to negotiate the politics effectively.

"I think the people who are attacking the work are acting very simplistically as well, but they have been invited to react simplistically."

Emma Kranz, co-director of Span Galleries in Flinders Lane, questioned the work's artistic credentials.

"You can't really define art in a single sentence … but I think in the end you have to look at the intention of the piece, and was that to create art or to put a political view and call it art?

"If somebody brought me work into the gallery that racially vilified the Aboriginals or any other group, I would not show it." Leading Melbourne gallery director Anna Schwartz was also unimpressed: "It's certainly not *Guernica*, is it? I don't believe in censorship, but I

do believe in intellectual rigour. It's not enough that it just takes its location and proclaims itself as art."

In the end, who decides what is art? Politicians? Can they really be expected to offer an objective view on art, especially since artists typically critique those in power?

Even those in the art world who disagree on the merits of McLennan's work, agree that the Australian governments' traditionally hands-off approach to funding, with artistic peers rather than politicians assessing the value of work, must be preserved.

If anything, the advice of contemporary art experts should be sought more vigorously by local governments, says Schwartz: "Then we would not be having this discussion in particular, nor, hopefully, the endless discussion about the very dubious quality of most of our urban art works."

Marcus Westbury, artistic director of the Next Wave Festival, fears for a society where funding of the arts is linked to the politics of the day: "We would all be in a much sadder situation … it would lead to bland and boring art and it would be worse for the community."

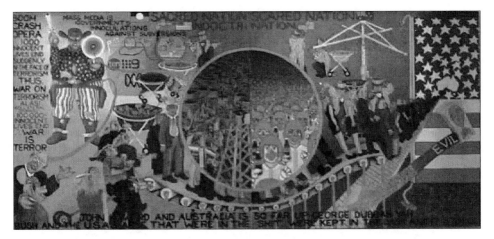

Gordon Hookey's *Sacred nation, scared nation, indoctrination*. Photo: Paul Harris

Re-examining the Rhetoric of the "Cultural Border"

Heewon Chang

This essay examines the territory-based rhetoric of the cultural border, boundaries and borderlands. Critiquing the essentialist view that presumes fixed boundaries for a culture, the author suggests the constructivist view that assumes individuals power of defining and redefining their cultural identities in a multicultural society. The author illustrates different multicultural make-ups that a multiracial, an adoptee, a U.S.-born and an immigrant individual develop despite their common tie to Korea.

> border: the extreme part or surrounding line; the confine or exterior limit of a country, or any region or track of land
> boundary: a limit, a bound, anything marking a limit
> borderland: land on the frontiers of adjoining countries; land constituting a border*

Constructing a topology of a multicultural society is never simple. Although cultural diversity is often defined by seemingly clear-cut categories such as ethnicity, race, class, religion, gender, sexual orientation, and exceptionality[1], sorting out "culture" intertwined with these multicultural categories is a complex process. I am not even sure whether

* (Webster's New Universal Unabridged Dictionary, 1979)

anyone sees the value of taking on the challenge because different categories of people are considered synonymous with cultural differences. It is common to hear references to Asian-American culture, Black culture, Muslim culture, female culture, homosexual culture and ADD culture as if they have clear boundaries and are distinguished entities. It is also assumed that if an Asian meets an African-American their presumed cultural differences are expected to form a cultural border. Or if a White teacher has a group of minority children in her classroom, the formation of a cultural border between them is considered inevitable. However, if the focus switches from a society (or group) to individuals, the power of the cultural border rhetoric seems to lose its potency. For example, the Korean and the African-American may share many cultural traits, so their racial and ethnic difference may not have such an enduring effect.

In this essay I attempt to probe into the assumptions of the cultural border rhetoric and assess the underpinning view of culture here I identify it as the essentialist view in the context of multiculturalism. Then I will introduce the constructivist view of culture by switching our focus from societal culture to individual culture so that we may see the cultural differences as an embracing factor rather than as a divisive factor.

CULTURAL BORDER AND CULTURAL BOUNDARY

The terms "border" and "boundary" are physical in origin (Johnson and Machelsen, 1997). The original imagery is not quite abandoned and is even intentionally played out when the terms are used in reference to culture. Cultural border and boundary often connote the border and boundary of a nation, a state or a tribal community, which are clearly identifiable markers. The equation between a culture and a territory has dominated the discourse in anthropology (Erickson, 1997; Ewing, 1998; Goodenough, 1981; Lugo, 1997; Wax, 1993). The assumption is that as long as two distinct societies remain separate from each other, their boundaries exist and cultural distinctiveness is expected. It is further assumed that if two societies, identified with two distinct cultures, come in contact, a cultural border is expected to form between them. If an individual from Culture A is to voluntarily or involuntarily[2] become part of Culture B, she/he is expected to literally leave his/her own society, cross the border and enter a new society. This physical implication of the cultural border is fully entertained by scholars of Mexican immigrants, for whom crossing the border is a literal as well as a figurative experience (Delgado-Gaitan & Trueba, 1991; Johnson & Michaelson, 1997).

To many scholars a border is not a neutral demarcation line. It is a symbol of power that imposes inclusion and exclusion. The more privileged dominant, hegemonious side will actively control the border to keep border-crossers out. Erickson (1997) accentuated the political nature of a border by differentiating it from a boundary:

A cultural boundary refers to the presence of some kind of cultural difference cultural boundaries are characteristic of all human societies, traditional as well as modern. A border

is a social construct that is political in origin. Across a border power is exercised, as in the political border between two nations. (p. 42)

A cultural border connotes a barrier that a more powerful side constructs to guard its own political power, cultural knowledge and privileges.

The cultural border rhetoric is grounded in the essentialist view of culture. This view makes several assumptions regarding culture: (1) a culture is viewed as a bounded system which is separate and distinguishable from others; (2) a culture is expected to be "homogeneous" (Lugo, 1997, p. 54); (3) a culture is expected to be shared by members of the society.

The first assumption is evident in the work of many anthropologists. The cultural boundary is viewed as coterminous with a nation, a state, a tribe, a community or an organization that is clearly defined by an identifiable marker; often physical borders. Goodenough (1981) attributed this notion of culture to Franz Boas, a pioneer German-American anthropologist:

At the end of the nineteenth century, Franz Boas began to use "culture" to refer to the distinctive body of customs, beliefs, and social institutions that seemed to characterize each separate society. (Stocking, cited in Goodenough, p. 48)

The notion of one-distinct-culture-for-each-separate-society suggests that one culture represents a society and vice versa. This close match makes the conceptual interchange of culture and society acceptable. Henze and Vanett (1993) further explore this assumption of culture in the metaphor of "walking in two worlds" in their study of native Alaskan and Native American students.

The second assumption of cultural homogeneity suggests that a homogeneous, patterned prototype of a culture can be abstracted. It implies that a "pure" form of a culture exists. Any variation from the pure form is treated as an exception, peripheral to "the culture." This assumption ignores the dynamic nature of culture, in which people of a society change at different rates for different reasons. The diffusionist view of culture argues against this notion of cultural homogeneity, for all cultures include elements borrowed from other cultures (Linton, 1937; Wax, 1993).

The third assumption of the cultural border is that a culture is "shared" by members of a society. The extent of sharedness is debatable, yet sharedness is considered a trademark of culture. This assumption suggests that people within a cultural system share a set of traits unique to their group membership. Sharedness is considered a product of cultural transmission and acquisition which often take place through personal interactions among members of physical proximity. In other words, an Asian is expected to share with other Asians traits unique to Asian culture. When a group is small and specific, the extent of sharedness among members may be higher. However, if a group presents a large, cross-sectional or cross-national cultural identity, such as "female culture," "middle-class culture" and "Muslim culture," the sharedness of that particular culture is blurred by other cultural identities. Ewing (1998) examined how the cultural identity of Muslims shifts relative to national borders and the gender line.

This territory-oriented rhetoric of culture, cultural border and boundary faces a great challenge in a multicultural society because intense contacts between various cultural carriers blur the clarity of demarcation lines.

CULTURAL BORDERLAND

"Cultural borderland" is a notion created to accommodate a multicultural society. Foley (1995) explores the cultural borderland as a "space" created when two or more cultures and races occupy the same territory. He considers the space psychological and political: [According to Rosaldo and Clifford, the borderland] generally refers to a psychological space at the conjuncture of two cultures. A cultural borderland is also a political space in which ethnic groups actively fuse and blend their culture with the mainstream culture (p. 119).

The borderland is viewed as a psychological space in which border-crossers struggle with their bicultural or multicultural identities. In this borderland individuals decide how much they want to identify with their cultures of origin or of adoption. Too much of either can be the subject of ridicule. Saenz (1997) compared two distinguished Mexican-American writers who try to come to terms with their ethnic identities. He argued that Gloria Anzaldua is "completely mortgaged to a nostalgia" a nostalgia to the Aztec origin of the Mexican culture (p. 87). Richard Rodriguez, on the other hand, "is completely mortgaged to an ideology that privileges the category of individual" (p. 87). In the eyes of Saenz, Rodriguez has taken too much of his adopted culture. In between lies Saenz's Mexican-American college student who refused to read "gringo" (White) poetry and Saenz himself who insists on his identity as a Chicano writer.

The borderland is also highly political. The borderland is never on center stage. It is often viewed as a marginal space for cultural hybrids—those who have adopted "foreign," distinctly different, cultural traits—who therefore do not fit the homogeneous prototypes of their original cultures. In Foleys Mesquaki Indian study the borderland is viewed as a threat to the integrity of the Indian culture. It was a space for Indian progressives (who proposed to modernize the Indian community and to collaborate with Whites), White "wannabes" (who tried to adopt the Indian culture) and "mixed-bloods" (biracial individuals of White and Indian parents).[3]

The borderland rhetoric is still embedded in the essentialist view of culture. For example, Foleys notion of cultural borderlands creates an image of three separate zones: the "pure" Indian culture that is being guarded by "traditionalists" (Let's call it Culture A); the "pure" White culture that is distinguished from the Indian (Culture B); and the borderland between them, a space for border-crossers. (Graphic Illustration 2: click here.) Chang (1997) questions this essentialist presumption of culture by wondering, "just where the Indian culture ends and the White culture begins for border crossers" (p. 385).

HOW REAL IS CULTURAL BORDER

The cultural border and boundary rhetoric focuses on a societal culture. If cultural diversity is viewed at the societal level, cultural borders seem authentic and real. Skin color, national origin, gender, religious affiliation, identification of disability, and group membership all serve as identifiable markers for subgroups. Since these categories are socially constructed and validated, cultural differences are assumed and expected. But when the cultures of individuals are under scrutiny, it becomes clear that cultural borders do not hold their dividing power. Cultural boundaries within individuals become blurred as components from diverse cultures become incorporated into their individual cultural identity, instead of remaining separate from each other.

Let us take a close look at four multicultural individuals who had a close connection with Korea but who live in the pluralistic U.S. society.

Jean Kohl, a 9-year-old daughter of a German father and a Korean mother, was born and raised in the United States. Her parents, fluent speakers of German and Korean respectively, adopted English as the primary language at home. "I am an American," proclaimed she, but she often ended her proclamation with an addendum that she was also German and Korean. For several summers she traveled to visit her maternal or paternal grandparents in Korea or Germany, during which she was exposed to her parents native cultures and languages. The German, Korean and U. S. heritage blended in her cultural repertoire. For Jean, where does the "American" cultural border end and other cultural borders begin?

Carrie Baumstein, a 20-year-old woman, was born in Korea and adopted by a Messianic Jewish-American couple when she was 2 years old. She has lived in the States ever since. She was not exposed to much Korean culture and language when she was growing up, but was instead surrounded by her parents Jewish tradition. Despite her primary identity with the Jewish culture, she was often reminded by her relatives and neighbors of her Korean or Asian linkage. She was in an identity search for Asian ness when she was attending a small Christian college on the East Coast. For Carrie, where do the cultural borders lie between the Korean and the American and between the Messianic Jew and the Christian?

Peter Lee, a 15-year-old, was born in the States to immigrant parents from Korea. His parents own and operate a dry cleaning shop in a suburb of Philadelphia. Their English is functional for the business but they prefer speaking Korean on all other occasions. Peter's family attends a Korean church regularly, which usually serves as a cultural community as much as a religious one. Peter's Korean is so limited that he usually speaks English, although his parents speak Korean to him. He is definitely an American in his mind and heart, perhaps a Korean-American occasionally. But his preference of Korean-American peers to others is a curious phenomenon. Where lies the cultural border that divides the Korean and the "American" for Peter?

Elaine Sook-Ja Cho, 50 years old, immigrated to the States 30 years ago to marry a Korean bachelor 10 years her senior. Her husband came to the States as a student and found employment upon completion of his study. Elaine was a housewife for 20 years

before undertaking a small grocery business. She speaks "Konglish" (a mixture of Korean sentence structure and English words) but she seems to be at ease speaking English. She is Korean in her heart but "Americanized" in her own words and by her life style. For Sook-Ja how far does the Korean cultural border stretch to meet the "American" culture?

I wonder how I would map the cultural topology (again a physical metaphor) of Jean Kohl, Carrie Baumstein, Peter Lee and Elaine Sook-Ja Cho. How would I draw up the boundary of the Korean culture for each case? Would they cross cultural borders from the Korean to the German and so on daily? How cognizant would they be of crossing? Would it be possible for one to become culturally more Korean in the morning, German for lunch, "American" in the afternoon, and back to Korean in the evening?

The early illustration of an individual leaving his/her society, crossing the border and entering a new society may shed light on the problem with the cultural border rhetoric. Once you acquire cultural traits, whether in a certain territorial context or not, leaving the territory does not make an individual "lose" the culture. Sook-Ja is not any less Korean culturally now because she left her homeland 30 years ago. Carrie's minimal identity as a Koreanis not surprising despite her origin. Peter and Jean who were born and raised in the States have acquired Korean cultural traits from their parents. In other words, the physical proximity or distance to Korea does not serve as an accurate gauge for their Korean-ness in culture. It is also hardly imaginable that Jeans notion of the Korean culture is similar to that of Sook-Ja, although both claim to be Korean. What would Peter share about the Korean culture with others and to what extent? How would I compare these peoples Korean culture with that of Koreans who have never left the country? The essentialist image of culture in particular, the Korean culture seems to lose the clarity of its boundary as I probe into each individual's personal version of culture.[4]

CONCLUSION

Everyone is cultural and multicultural (Erickson, 1997; Goodenough, 1976): "cultural" in that culture is not a property of an exotic people but "standards" that all human beings adopt for their daily operations; "multicultural" in the sense of being competent in multiple macro or micro-cultural systems.

In a pluralistic society in which people from diverse cultures come in constant contact, the cultural metamorphosis takes place noticeably in individual cultures. Thus the Boas-Benedict legacy of the "plural, separate, distinct, historically homogeneous" culture offers little help in understanding the multicultural society and its residents (Wax, 1993, p. 108). Rosaldo also critiqued the fallacy of cultural homogeneity, especially in the pluralistic setting:

[H]uman cultures are neither necessarily coherent nor always homogeneous. More often than we usually care to think, our everyday lives are crisscrossed by border zones, pockets and eruptions of all kinds (Rosaldo, quoted in Logo, 1997, p. 51).

It also becomes clear that a culture is not bounded by a territory as earlier anthropologists believed. Rather, people are the carriers, movers, consumers, and inventors of a culture. When they move from one place to the other, they carry their cultures their personal outlooks with them. Goodenough (1981) coined a term, "propriospect," to refer to the "private, subjective view of the world and of its content," which includes the various standards for perceiving, evaluating, believing, and doing that an individual attributes to other persons as a result of his or her experience of their actions and admonitions (p. 98). Wolcott (1991) elaborated on the meaning of the term "propriospect" to illustrate how individuals develop personal versions of a culture through personal contacts with others with different sets of standards. Through these contacts they acquire some of the new standards. As a result, they become increasingly multicultural.

This concept of culture sheds light on cultural differences. Since everyone has a unique cultural make-up, cultural differences are not really divisive and separable. Individual cultural differences are really different combinations of standards. Once different standards are embraced by individuals, the differences are incorporated into their individual cultures. In other words, the cultural differences are reframed into multiculturalism. It seems logical to me that we understand our individual multiculturalism as a pathway to understand our societal multiculturalism. The constructive view of individual cultures would be too useful and insightful to ignore.

NOTES & ACKNOWLEDGMENTS

The earlier version of this essay was presented at the 1998 American Anthropological Association Annual Meeting in Philadelphia, December 2–6. I acknowledge Dr. Harry Wolcott and Cynthia Tuleja for their careful reading of this essay and valuable comments.
1. These are frequently discussed topics in textbooks of multicultural education (Banks and Banks, 1997; Gollnick and Chinn, 1998).
2. Obgu differentiated between "voluntary" and "involuntary minorities" (Ogbu and Simons, 1998). The former refers to immigrants and the latter refers to historically oppressed minorities.
3. Multiracial individuals (offspring of biracial marriages) also experience the politics of recognition in the borderland of U. S. society (Root, 1996).
4. Goodenough (1981) and Wolcott (1991) call the individual version of culture "propriospect."

REFERENCES

Banks, J. and Banks, C. A. M. (1997). Multicultural education: Issues and perspectives. Boston, MA: Allyn and Bacon.

Chang, H. (1997). [Review of the book The Heartland Chronicles]. Journal of Contemporary Ethnography 26, (3), 382–385.

Erickson, F. (1997). Culture in society and in educational practice. In J. A. Banks and C. A. M. Banks (Eds.), Multicultural education: Issues and perspectives. (pp. 32–60). Boston, MA: Allyn and Bacon.

Delgado-Gaitan, C. and Trueba, H. (1991). Crossing cultural borders. New York: The Falmer Press. Ewing, K. P. (1998). Crossing borders and transgressing boundaries: Metaphor for negotiating multiple identities. Ethos 26 (2), 262–267.

Foley, D. E. (1995). The heartland chronicles. Philadelphia, PA: University of Pennsylvania.

Gollnick. D. M. and Chinn, P. C. (1998). Multicultural education in a pluralistic society. Upper Saddle River, NJ: Merrill.

Goodenough, W. (1976). Multiculturalism as the normal human experience. Anthropology and Education Quarterly 7 (4), 4–6.

Goodenough, W. (1981). Culture, language, and society. Menlo Park, CA: The Benjamin/Cummings Publishing Company.

Henze, R. C. and Vanett, L. (1993). To walk in two worlds or more? Challenging a common metaphor of native education. Anthropology and Education Quarterly 24 (2), 116–134.

Johnson, D. E. and Michaelsen, S. (1997). Border secrets: An introduction. In D. E. Johnson and S. Michaelsen (Eds.), Border theory. (pp.1–39). Minneapolis, MN: University of Minnesota.

Linton, R. (1937). The one hundred percent American. The American Mercury, 40, 427–429. (reprint).

Lugo, A. (1997). Reflections on border theory, culture, and the nation. In D. E. Johnson and S. Michaelson (Eds.), Border theory. (pp.43–67). Minneapolis, MN: University of Minnesota.

Ogbu, J. & Simons, H. D. (1998). Voluntary and involuntary minorities: A cultural-ecological theory of school performance with some implications for education. Anthropology and Education Quarterly 29 (2), 155-188.

Root, M. P. (1996). The multiracial experience: Racial borders as the new frontier. Thousand Oaks, CA: Sage.

Saenz, B. A. (1997). In the borderland of chicano identity, there are only fragments. In D. E. Johnson and S. Michaelson (Eds.), Border theory. (pp. 68-96). Minneapolis, MN: University of Minnesota.

Wax, M. L. (1993). How culture misdirects multiculturalism. Anthropology and Education Quarterly 24 (2), 99–115.

McKechnie, J. L. (1979). Webster's new universal unabridged dictionary (2nd ed.). New York, NY: Simon and Schuster.

Wolcott, H. F. (1991). Propriospect and the acquisition of culture. Anthropology and Education Quarterly 22 (3), 251–273.

Heewon Chang, Assistant Professor of Multicultural Education at Eastern, has studied adolescents from the U.S., Korea and Germany. Her Adolescent life and ethos (1992) is based on the U.S. study.

The Hair Parties Project
Case Study: Urban Bush Women

Caron Atlas

"Everything I know about American history I learned from looking at black people's hair. It's the perfect metaphor for the African experiment: the price of the ticket, the toll of slavery and the costs of remaining. It's all in the hair."

—LISA JONES, JOURNALIST, FROM
Hair Story: Untangling the Roots of Black Hair in America

PREFACE

In living rooms, beauty salons, community centers, restaurants, and theaters in Brooklyn, people have been talking about hair. Not just hair, but also race, economic and social status, education, and employment—and not just talking, but also dancing and telling stories. These hair stories about whether to straighten, curl, color, press, or tease are providing a creative avenue to dialogue about the broader social and political issues that surround hair, particularly natural African American hair.

Hair Parties is a project of the Brooklyn-based, internationally recognized Urban Bush Women, working in collaboration with 4W Circle of Art and Enterprise and 651 Arts. The project uses public dialogue to stimulate artistic ideas, and artistic work to stimulate

dialogue. It puts into practice UBW's belief that dance is "a celebration, a solution, and a necessity," and that art is a catalyst for social change. And it also addresses the civic context of UBW's neighborhood in Brooklyn which is confronting issues of development and gentrification. These issues involve politics, culture, and race as well as economics, and they play out more often through debate than through dialogue.

In 2004, UBW celebrated its 20th anniversary by going through a period of rebirth and renewal and rooting itself in a new home community. As dialogue became an opportunity to build new relationships in Brooklyn, it also becomes a means of learning and meaning-making inside the company. The company began to codify what it had been doing intuitively and became more deliberate about transferring knowledge. UBW affirmed itself as a process-oriented learning organization and has quickly incorporated the lessons learned from this project into its subsequent work.

The case study, written by site liaison Caron Atlas in collaboration with Urban Bush Women, is drawn from experiences of the project, written materials, and videos, as well as interviews with UBW Artistic Director, Jawole Zollar; Managing Director, Amy Cassello; Special Projects Director, Vanessa Manley; dialogue consultant, Tammy Bormann; community partner, Selma Jackson; presenter, Maurine Knighton; *HairStories* co-director, Elizabeth Herrn; and UBW company members Maria Bauman and Wanjiru Kamuyu.

Together, the contributors explore the powerful combination of art, dialogue, and social analysis in the Hair Parties. How does embodying dialogue within dance deepen the dialogue? Can a party format encourage candid, from-the-heart "kitchen talk?" What is the role of conflict, passion, and point of view in these exchanges? How does the seemingly personal topic of hair lead to critical thinking about challenging societal issues, and how can this dialogue further social justice?

BACKDROP

"When the Lions Tell History" is an African proverb that reminds us that when the lion tells his story, it is from an entirely different perspective than that of the hunter. UBW's work has always offered the lion's perspective, focusing on untold and under-told stories.

—Jawole Willa Jo Zollar

Urban Bush Women is an internationally recognized performance ensemble based in Fort Greene, Brooklyn that engages a diverse audience through bold and life-affirming dance theater works inspired by women's experiences, African American history, and the cultural influences of the African Diaspora. Company activities include the creation and performance of works for the stage; artist training in dance and community engagement; and public projects that encourage cultural activity as an inherent part of community life.

Community engagement residencies are designed to respond to specific issues that are important to the host community. The focus in Tallahassee, Florida, for example, was HIV/AIDS awareness and prevention; in Flint, Michigan it was incorporating the arts as a vital part of Flint's revitalization process. During these residencies, Urban Bush Women company members partner with local artists and

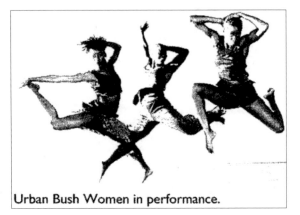

Urban Bush Women in performance.

residents through dance classes, workshops, trust-building exercises and a creation process that culminates in a community-wide performance.

Some of the basic concepts and assumptions that inform UBW's community engagement work include:

- Each community is unique and has the answers it seeks to uncover
- The community engagement process that UBW uses must help people gain a sense of their own power
- In order to move powerfully into the future, a community must "own" its history, for better or for worse
- All change starts within
- Accountability is key to working with communities

Artistic Director Jawole Willa Jo Zollar describes her founding vision for UBW: "My dream was to have a dance company that reflected my concerns for social justice, spiritual renewal, and the power that comes through connection to community." Why do this through hair? The power and significance of hair has been evidenced over the years by the experience of UBW. As strong black women offering striking performances and powerful messages, the company makes a lasting impression. Years later people comment on how profoundly they were moved and ultimately changed by the company. Immediately, however, one of the most common reactions to UBW is to the various hairstyles of company members.

Zollar recognized that these comments went far beyond superficial curiosity, but rather reflected the complex relationship of African Americans to their hair. Hair had recently been a catalyst for debate on a civic level in Brooklyn. A white school teacher resigned as a result of protests by black parents who were incensed about her introducing the book, *Nappy Hair,* by Carolivia Herron (which celebrates nappy hair) to her third grade students.

Based on these experiences, Zollar was inspired to create the multi media performance *HairStories* to explore the concept of nappy hair and its relationship to images of beauty, social position, heritage and self-esteem. The Hair Parties began as way to collect stories

for the *HairStories* piece and to present scenes from the work in progress in an informal setting. UBW quickly discovered that the parties had the potential to go far beyond collecting and trying out material; they could also provide a creative framework for dialogue that transcended the *HairStories* performance.

> *"When our parents were straightening their children's hair it was to make them acceptable and to avoid the abuse they themselves had endured."*
> —QUOTE FROM A HAIR PARTY

In 2000 Urban Bush Women moved to Brooklyn to the Alliance of Resident Theater/NY's South Oxford Space, which offers subsidized office and rehearsal space. Zollar had lived in Brooklyn for 14 years and felt strongly connected to the borough. The move was an important shift for the company, as it was the first time they had a home community. Their previous space in Manhattan was no more than an office, and their community engagement work took place on the road, in other people's communities. They acknowledged the significance of becoming rooted in a home community by changing their mission statement to describe UBW as a Brooklyn-based organization.

The Hair Parties provided a vehicle for building new relationships in Brooklyn. Stakeholders were identified as residents of the adjacent communities of Fort Greene, Clinton Hill, Bedford Stuyvesant, and Park Slope. The first three have large African American populations as well as significant artist, family, and working class populations. Park Slope is the most racially and economically diverse. It also has a significant family population as well as a sizeable lesbian and gay community.

These Brooklyn neighborhoods face significant cultural, economic, and social issues, which provided a civic context to the Hair Parties. Fort Greene, for example, is responding to a cultural district proposed by the Brooklyn Academy of Music Local Development Corporation. The LDC plan sparked concerns about gentrification and questions about how to carry out equitable development that builds on neighborhood cultural and economic assets. Moreover, some residents had concerns about how decisions were being made and the transparency of the process. A group called the Concerned Citizens Coalition, led by local African American churches, came together to ensure that the cultural district reflect the needs and interests of community members. When the developer involved in the LDC purchased the New Jersey Nets and proposed to build a new stadium on the border of Fort Greene, the questions about development became even more intense.

Against this backdrop, and with support from Animating Democracy, UBW took their Hair Parties and *HairStories* performance to a new phase.

THE HAIR PROJECT

"When my brother 'locked his head, he was told by my mother that he was not a part of the family. When he got a promotion at work he cut off his hair and visited our mother. Evidently she said, 'Now this is my child.'"
—QUOTE FROM A HAIR PARTY

The Hair Parties had multiple and wide-ranging goals. These included:

Artistic:
- Developing further an aesthetic model for using public dialogue as a means of stimulating artistic ideas

Dialogic:
- Exploring the relationship between African Americans and hair
- Engaging diverse groups of people to learn something more about an unfamiliar perspective
- Creating an environment where people can feel comfortable talking about hair, both on a personal level and as it connects to civic issues of race, class, education, and work
- Addressing civic issues of community development and gentrification

Organizational:
- Broadening the audience base for the Brooklyn presentation of *HairStories*
- Building a base in Brooklyn, UBW's new home base, and developing lasting community partnerships there
- Increasing UBW's effectiveness as an arts organization committed to social change and justice
- Developing leadership skills in the company through training in dialogue and facilitation, and greater knowledge and ownership of the mission and core values of the company
- Using hair parties as a fundraising tool

During the period of January 2002 through March 2003 UBW held 10 Hair Parties in private and public spaces, primarily in Brooklyn communities. Framed as parties to easily engage people, they focused on a subject about which everyone has an experience and opinion: hair. Whether the parties happened in living rooms or corporations, they included food and informal time, and often got neighbors talking to neighbors (See Appendix for a list of all Hair Parties at the end of this case).

UBW held a men's Hair Party at the Bedford Stuyvesant Family Health Center; a Hair Party for teenaged girls at the Children's Aid Society, and one for seniors at the Fort Greene Senior Center. Other Hair Parties included mothers and daughters, employees of Chase and Fleet banks and members of the Fifth Avenue Committee, an active local group addressing issues of displacement and community development. The Performance Dialogue

at the "Grand Open those funding the work to experience it in their own workplace context.

"I saw 'the ritual between men in the barbershop. I never saw a fight in there. People would disagree and storm out, but there was a line you didn't cross."
—QUOTE FROM A HAIR PARTY

Each Hair Party was unique but all incorporated small and large group discussions, performance excerpts that stimulated dialogue, and interactive games to prompt memories and associations from participants. They began with a mutual agreement that participants would be open and receptive to each other's experiences, and would have fun. Some parties began with participants introducing themselves and giving a "weather report" about their hair. Some had participants write down three things that make their hair distinctive, three things you notice about someone else's hair, and three hair fantasies. At times party participants acted out these hair fantasies.

One of the *HairStories* performance excerpts that got the greatest response at Hair Parties was the "Hot Comb Blues" which, with humor, physicalized the burn of a hot comb, the itch of a perm, and the yanking and tugging of a mother combing her daughter's hair. The performance evoked visceral memories in hair party participants and inspired them to tell stories about their own "hair hell moments." These stories stimulated dialogue about what people put them selves through to have "good hair." Further questioning led the group to consider the social pressures behind "good hair" and "bad hair" and the origin of our values about acceptable forms of beauty.

The Hair Party for children combined visual art, movement and dialogue. Kids drew their fantasy hairstyles, danced the Jheri Curl and cornrows, and talked about where people get ideas about what kind of hair is ideal. This inspired UBW to incorporate hairstyle charades in subsequent parties for adults. At the "Hair Club for Hen" party, men discussed their influence on women's hair choices, the hair issues that affect men in the workplace, and the ritual between men at the barbershop, where "you can have a politician, drug dealer, preacher, doctor, and a police officer all sitting next to each other at the same time."

Some of the Hair Parties were more performance oriented, and others more dialogue oriented. Each format had advantages and disadvantages. Smaller parties engendered in-depth dialogue and intimacy and worked well to build community, but they often were held in spaces like living rooms where movement was challenging. Some small groups, because of the intimacy factor, according to Zallar,

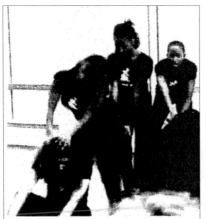

UBW Dancers perform the Hot Comb Blues at a Hair Party.

were "very self conscious." Larger "Performance-Driven Dialogues" allowed for less dialogue, but were often held in spaces more conducive to movement where complete scenes of *HairStories* could be shown. This allowed for multiple characters to represent different points of view, and offered participants more of a common experience. The performance framework helped people become less self-conscious, more open, and able to speak from the heart.

> *"It's good that we're being honest. It's amazing that we're still even tripping about texture. People are saying 'good hair and bad hair,' even young people. And I'm not even talking about light skin/dark skin."*
> —Quote from a Hair Party

A HAIR PARTY

By Maria Bauman, UBW Dancer

As people ring the doorbell, streaming into the house one by one, sometimes in small groups, they seem unsure what to expect. There is a certain air of optimistic expectation and anticipation that permeates the kitchen and living room as people chat and eat with each other. Eventually the host calls everyone to attention and introduces the Urban Bush Women and the idea of the Hair Party: that the various friends, colleagues, and acquaintances of the host have been gathered to use hair as an entry point to engage in dialogue about racial, socioeconomic, and gender issues, among others. All of these people who came from various places to ring the same doorbell now have a tenuous bond, a common purpose for the evening. Although individuals may still be unsure how the night will unfold or what it will reveal, they invariably look forward to the performance excerpts by UBW. And so the evening begins.

After various ice-breaking introductory questions and anecdotal sharing, the Bush Women stand in the center of the living room in a tight formation. They are conjuring up the idea of riding in an elevator, an activity everyone in the room likely does more than once a day. The room erupts with laughter as the guests recognize the uneasy feeling of being stared at in the elevator. The performers present two scenarios. In the first, white women passengers in the elevator stare at a black woman passenger's bald head, nearly falling over one another to gawk at what they seem to have never seen before. They are careful to look away, though, when the bald passenger turns around suspiciously. The second scenario seems to highlight one of the differences between black and white American culture. While the white passengers were afraid of appearing rude, the black passengers in the second vignette are extremely vocal and seem indignant that the bald woman would have the audacity to (not) wear her hair in such a way. The onlookers, who sit in chairs and on pillows throughout the living

room, now have more food for thought. Why were the white passengers' and black passengers' reactions so different? Have I ever been the one being stared at? Have I been the starer? Was I judging or making assumptions about the person based on his or her hairstyle, or was I just curious?

As the performers sit down to join in the lively dialogue again, another veil in the room seems to have been lifted. After having laughed together, the guests' bond is a bit less tenuous. Now, they have all gathered one evening for a like purpose, and they have also reacted in a similar way to performance bits. Men and women who have not known each other prior to the Hair Party are now sharing their own "hair hell moments" and elevator experiences. As the evening proceeds with more talking, punctuated by brief dance excerpts, the guests delve deeper and deeper into the subjects presented by the UBW co-facilitators.

When it is time to leave, people seem to gather their coats and coordinate taxi rides home in larger, and more boisterous groups than the ones and twos that they arrived in. The bond between the guests, while still fragile, has been intensified. Some people won't see each other again. Some have plans for lunch dates. In any case, the Hair Party seemed a great way to spend an evening. The house feels heady with new ideas and connections.

A party that many described as a success combined both characteristics. The Fifth Avenue Committee (FAC) party took place in a spacious apartment where many participants already knew one another and there was plenty of space and time for both performance and dialogue. FAC was also an effective host as the organization was in the process of exploring how to better weave arts and culture into their ongoing work.

An additional nine gatherings relating to the Hair Parties Project were also held, including a "Five Boroughs in Five Days" event throughout New York City that served as a teaser for a staged *HairStories* performance in October 2002. This performance ran for five shows at Long Island University (LIU), all of which were sold-out and standing room only. The performance was a climactic moment two thirds of the way through the project and provided an opportunity to reconnect with Hair Party hosts and other partners. UBW held post-performance dialogues after every show, which addressed many of the themes of the Hair Parties and elicited reflection and engaged discussion from audience members. These dialogues were framed as an exchange rather than a Q&A, were facilitated by the presenter, and built on the enthusiasm of the audience and their shared experience of the performance.

UBW's presenting partner was 651 Arts, a Brooklyn-based arts presenter and producer with programming that focuses on contemporary artistic expressions of artists of the African Diaspora. 651 Arts presented *HairStories* at LIU, organized two of the Hair Parties, introduced the idea of doing hair parties at foundations, and made introductions to others in the neighborhood. 4W Circle of Art and Enterprise, a Fort Greene-based cooperative

incubator for small businesses, played an important role in the project as a community partner. 4W Circle owner Selma Jackson helped UBW organize Hair Parties and helped them build trust and new relationships in Brooklyn. In addition, UBW worked with local businesses, neighborhood organizations, and neighborhood colleagues to reach diverse groups of people. (See sidebar for a list of partners.) Hair Party hosts helped frame the events and bring people to the dialogue.

A key partnership developed over the course of the project was the one between UBW and Tammy Bormann and David Campt. Initially cautious about working with dialogue consultants, UBW appreciated that Campt and Bormann had a background working in race relations, worked as a team, and responded well to working with artists and the creative process. When Zollar first met Campt she felt that he had a good handle on how artists could adapt their skills to doing dialogue work; he used the analogy of a jazz-structured improvisation. After they experienced the consultants in action they invited them to work with the company. Bormann debriefed UBW after the Mother and Daughter Hair Party and facilitated an evaluation dinner with Hair Party hosts. She and Campt offered a three-day training to build the company's capacity for designing and facilitating dialogue around particular outcomes and purposes.

REFLECTIONS

> *"Dance lies at the point at which reflection and embodiment meet,*
> *at which doing and anticipation are intertwined."*
> —RANDY MARTIN, *Critical Moves:*
> *Dance Studies in Theory and Politics*

Integrating Performance and Dialogue

The Hair Parties used public dialogue to stimulate artistic ideas, and artistic work to stimulate dialogue. Both of these approaches were fairly common in the Animating Democracy Lab. What stands out for UBW was the interplay between the two approaches—how closely art and dialogue were interwoven in the project, and how the ability to be "up on our feet talking" could lead to a deeper level of engagement.

The Hair Parties informed and were informed by the *HairStories* "live stage documentary" performance genre created by Zollar to stimulate dialogue. The *HairStories* piece combines video interviews, conversation with the audience, call and response church testimonials, and storytelling, with dance. The multiple characters featured in the vignettes bring forward multiple points of view, in a *New York Times* review on August 28, 2001, Jennifer Dunning described the impact of some of these *HairStories* segments.

> *... Everything comes together in a tender duet for sisters and a group section in*
> *which the dancers hop through the choreography patting at heads that itch from curl*

relaxers and hot irons but cannot be scratched without ruining the hard-won do. In a strangely powerful dance, women in a lineup, in large flings of the arms, pull straight the hair of a woman who sits before them on the floor. The stage temperature heats up in dances in which Ms. Zollar's six extraordinary performers—bodies and spirits taut yet resilient—abandon everything but their tightly wound hair to the moment.

Touchingly, Ms. Zollar is torn between admiring the immensely successful entrepreneur Madame C.J. Walker and abhorring the building of Walker's cosmetics empire on "black self-hatred." Even more affecting are the comments of one of the interviewees, a slow-talking, keen-hearted woman, older than the rest, who has seen it all and looks back on the old ways with endearing amusement "We are a people who has been taught that everything about us is ugly, especially our hair," she says reflectively, zeroing in on the heart of the subject in much the same way Ms. Zollar cuts to that heart with a segment on the much discussed "attitude" of the tennis-playing Williams sisters. Times and customs do change for the better, after all.

The dance and movement incorporated into the Hair Parties also influenced the dialogue. Dance helps you be in touch with your authentic self and to understand things more viscerally. Physical warm-ups moved participants into an open state of mind and built community in the group. The use of segments from *HairStories* encouraged participants to tell their own stories, think critically, and make connections between personal and social issues. At the same time, the often humorous performance segments lightened the energy when the dialogue got intense and helped people to feel more comfortable. They provided opportunities to react on creative and emotional levels as well as intellectual ones, and helped to create empathy. As UBW company member Wanjiru Kamuyu reflected, 'The performances allowed participants to breathe and laugh at themselves and others, rather than letting the barriers drain them."

Performing elements of *HairStories* at Hair Parties enabled the company to continue working on the *HairStories* piece after it premiered and it evolved to a place of being "stronger point of view, clearer, more open and honest. … We finally got off the fence, it was about celebrating nappy hair." The *HairStories* performance was a way that UBW could share their point of view as a company, In early Hair Parties, company members had a tendency to dominate the conversation and appear too judgmental. By allowing the art to acknowledge and convey their perspective, UBW became increasingly more comfortable as facilitators of multiple points of view during the dialogues, able to celebrate diverse choices. They recognized the organic nature of the process and the value of leaving it up to the group to make up their own minds.

"We all had to get comfortable with dialogue work. A lot of us have strong personal views on hair. We had to evolve ourselves to a place where we could hear other perspectives on black hair."
—Elizabeth Herron

EXCERPT OF A LETTER TO MADAME C.J. WALKER FROM *HAIRSTORIES*

Dear Madame C.J.,

I have been contemplating writing you this letter for some time. It has been difficult for me to formulate my thoughts because I am so ambivalent about how I feel about you. Here you were this successful entrepreneur, philanthropist and activist and yet this success comes at the price of what I see as the heart of Black Self-Hatred—our hair. I often wonder what the world would be like if you had taught Black women to take pride in their beauty and style with their hair righteously nappy. I think of all the little Black girls I see and remember whose hair meets its demise through the frying process. I see the cry in that little twist of damaged hair, pulled tight with a ribbon, trying to make it something it is not and never will be. I imagine that same little girl with her hair short and beautifully nappy. Nappy so you can see how gracious each little kink is on the head, curling up to claim its own territory yet defining itself in relation to the whole. I love feeling this mass of unruliness in my hands and it reminds me of who I am and what I come from. I love it when I see all the beautiful textures of nap, curly nap, hard nap, wavy nap, kinky nap, rambling nap and I wonder if those little beautiful Black girls will ever see the beauty I see in nappy hair.

Sincerely,
Jawole

Initially, the *HairStories* piece included a character called Dr. Professor, who helped clarify references that diverse audiences might not understand, explain history, and engage in a social and political analysis. Dr. Professor was a frequent guest at the Hair Parties. Over time, however, Dr. Professor "outlived her purpose," Zollar says, and was cut from both the show and the Hair Parties. UBW no longer needed a purely didactic character, and relied more on their audience and dialogue participants to draw their own conclusions.

UBW's increased knowledge of dialogue is enhancing UBW's artistic work. Pieces such as *Give Your Hands to Struggle,* highlighting people fighting for justice, are being used in workshops to spark dialogues about why people choose to vote or not vote in UBW's upcoming election project. Zollar is imagining a new series of dialogue parties drawing from *Batty Moves,* a previous work that celebrates women's buttocks in relation to questions of

notions of physically attractiveness and appropriate moves. And in UBW's newest piece, *Walking with Pearl,* about the legacy of Pearl Primus as an artist dedicated to social change, Zollar is working from an intimate and deeply emotional heart place, a place that she describes as the essence of dialogue.

TRANSFORMING THE PRACTICE

"We began the Hair Party effort to gain source material for the concert piece *HairStories.* In the beginning, it was an "in group sista girl" conversation that became a self conscious, awkward and stiff attempt at dialogic learning. With practice, healthy self-critique and your help, we are moving closer to developing a consistent methodology. At each Hair Party, we realize something new and powerful about what we are doing that works."

—letter to Hair Party hosts inviting
them to a debriefing dinner

With the help of dialogue facilitators Tammy Bormann and David Campt, UBW company members came to distinguish between debate and dialogue, and were trained as facilitators and in working as teams. UBW, in turn, encouraged Bormann and Campt to further incorporate movement and nonverbal expression into their workshops.

Bormann and Campt offered UBW a common language about dialogue, giving form to impulses the company already had, but had not developed. This was much like the company's training with the Peoples' Institute for Survival and Beyond that had previously given them a common language about undoing racism. Bormann described it as helping UBW to "bridge artistry with another skill set, which has an art of its own." Initially concerned that formal dialogue approaches could squelch the natural, informal conversation that they valued, UBW concluded that a meaningful exchange was more likely to happen by being intentional and establishing boundaries. The parties, which had started out free form, became more deliberately structured as a container for dialogue—both organic and purposeful.

UBW explored with Bormann and Cam pt the role of conflict in dialogue and in their own process. Their training in facilitation helped them make sense of conflict, not run away from it, and be aware of what's on the table and what's under the table. Company members described the most successful parties as those that included candid conversation and passion and at the same time did not shut people down. They learned to respond to cultural references and identify the ways that people could feel outside of the story. Rather than avoiding discomfort, the dialogue could create a space for people to sit with it awhile, and look to other participants to help them navigate it. For example, when in mixed-race groups where white participants don't understand some of the vocabulary or humor, they facilitated the dialogue so that the translation could grow out of the group.

UBW aspired to what they describe as "kitchen talk" in their Hair Parties, the kind of real, honest, straight-up conversation that you have in the kitchen. This was in contrast to sugar-coated living room conversation that is too polite to get to the heart of the matter. While everyone agreed that the conscious shift to ensure dialogue rather than debate greatly advanced the parties, and was needed to ensure safety, there was also concern that parties could become overly polite. Said Kamuyu, "The format was great, but how would you revamp it to go deep, to be OK with kitchen talk?" One of the ways the company tried to

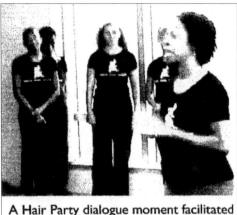

A Hair Party dialogue moment facilitated by Jawole Willa Jo Zollar.

address this was to add the distinction between kitchen talk and living room talk into the dialogue agreements.

The company began to conduct dialogue-based debrief sessions where members could reflect on what was working and what wasn't, and make appropriate changes. An example followed the Mother and Daughter Hair Party, where the mothers had dominated the event and had spoken on behalf of their daughters. In reflecting on the party with Bormann, UBW agreed that it would have been good to separate the mothers and daughters into affinity dialogue groups before bringing them all together. At their subsequent Mother and Daughter Hair Party in Flint, Michigan, UBW incorporated this improvement and others, such as a ground rule that mothers don't speak for or correct their daughters. Another, more external opportunity for a debriefing was the evaluation dinner dialogue with Hair Party hosts. Some of the hosts also provided valuable feedback through post-Hair Party one-on-one discussions with their guests.

"My mother and I did not have a good relationship growing up; the only time we bonded was when she did my hair."
—QUOTE FROM A HAIR PARTY

Recognizing that all Hair Parties were not alike, the company developed each one to respond to the interests and needs of the hosts and their communities. They codified a template for approaching prospective Hair Party hosts to learn about their intentions and their group's dynamics, and come to a mutually agreeable framing of the party. In addition to a Hair Party prep sheet; they developed a primer for planning, implementation, and follow-up; a facilitator's guide and checklist; a tip sheet; and a set of Hair party agreements. Using these new tools, making clear key concepts and assumptions, scheduling regular debriefs, and integrating dialogue into residency activities all contributed to the success of subsequent projects in Chicago and Flint. UBW was also able to try out new curriculum

based on the values and assumptions surfaced during their internal dialogues (See the sidebar, *Urban Bush Women's Organizing Principles*).

MOVING FROM THE PERSONAL TO THE CIVIC (AND BACK AGAIN)

URBAN BUSH WOMEN'S ORGANIZING PRINCIPLES

"Critical moves. Steps we must take. Movement that informs critical consciousness. Dance lies at the point at which reflection and embodiment meet, at which doing and anticipation are intertwined."

—RANDY MARTIN, CRITICAL MOVES

Urban Bush Women—
Striving for an active unity of theory and practice:
Value driven and process oriented.

Validating the Individual

Our individual histories are authentic in and of themselves. Collectively, our histories and identities create a rich and diverse palette from which to do our work. Each individual has a unique and powerful contribution to make.

Catalyst for Social Change

UBW's work helps people make sense out of the world and prepare to take action in it. We offer bold and provocative viewpoints in our performance work. Our work encourages critical, creative and reflective thinking.

Process Driven

The answers to many challenges and creative investigations can be found within a group of people who share a commitment to working together. Building work and strategies together enhances learning, organizational development and creative works. We acknowledge the need for Leadership to provide vision and give focus to the inherent creativity within a group. The Leadership is responsible for outlining and directing the process.

Entering Community and Co-Creating Stories

No two communities are alike. Each community is unique and has the answers it seeks to uncover. In our Community Engagement Project (CEP) work, we are not doing the thinking for a community but helping to facilitate its thinking through listening and bringing to the table what we are hearing. We then interpret what we hear through the use of our artistic medium, inspired by work like historian Howard Zinn and his book *A People's History*, our work gives voice to untold and undertold stories and perspectives.

Celebrating the Movement and Culture of the African Diaspora

UBW is committed to highlighting the power, beauty and strength of the African Diaspora. Dance from the African continent values the whole body in motion through a sophisticated use of polyrhythm, weight, pelvic and spinal articulation. The Urban Bush Women technique builds upon these principles.

"I fundamentally believe active dialogue is increasingly important in a world where we seem too focused on how to destroy one another. It is my heart's desire that this dialogue around hair will serve as a reminder to us to respect our differences—to learn something from an unfamiliar perspectives—as we actively work for the societal changes we believe in."

—Jawole Zollar

UBW's multi-layered approach allowed the dialogues to move back and forth from the personal to the civic, from the micro to the macro. The topic of hair provided a bridge to such challenging topics as race, social status, gender, sexuality, educational equity, the impact of media and popular culture, economics, and the workplace. UBW developed probing questions that were customized to specific groups to encourage critical thinking. These questions, combined with excerpts from *HairStories,* helped to connect personal experiences to their historical and social contexts and root causes. The questions ranged from exploring the motivations for black women to straighten their hair; dominant paradigms and where they come from; the legacy of slavery; the influence of family, church, community and work place on hair choices; and what lies underneath concepts of "good hair" and "bad hair." After a scene of sibling rivalry such as "The Zollar Sisters," where the sister with long straight hair has privilege over the sister who doesn't; the question might be "Where do you think this inequity comes from?" The question "Why don't we see black women on TV getting their hair shampooed," stimulated a discussion about the impact of the mass media.

How the Hair Party was framed, the context in which it took place, and the purposes of the hosts could make a significant difference in the content of the dialogue. Host intent included integrating culture into activism, connecting mothers and daughters, and providing an opportunity for seniors to stretch their bodies and their minds. One couple hosted a party at their home after seeing UBW perform *HairStories* to bring this experience to diverse neighbors to stimulate a dialogue about race and identity.

Hair Parties in corporations proved to be particularly challenging. The physical space limited performance and participants were fearful of disagreeing with their bosses. There was too much risk and consequence for speaking honestly, in one case, the host was zealous about her belief that natural hair was the only option for African American women, an admission not made until two-thirds of the way through the event. UBW learned how important it was to access the particular intents and circumstances of hosts prior to the Hair Party in order to create a safe space conducive to dialogue. They spent time with Bormann and Campt discussing how to recognize and address host agendas and deal with uneven power relationships in corporate settings.

"My headhunter said, "You know what … You look great from the neck down … I can't send you to an investment bank with your hair like that. Do you think you could wear a wig?"
—QUOTE FROM A HAIR PARTY

Whether the Hair Party was all African American or racially mixed also had an impact of the conversation. A goal for racially mixed Hair parties was to remain rooted in and true to the particular experience of African Americans, while being inclusive of others. This involved knowing what the issues mean historically and then making a space for people to make linkages to their own experiences. This could be difficult. For example one of the company's prompts related to "hair hell moments" contrasted between the mostly cosmetic stories of white people, and the stories of African Americans that reveal a construct about hair in America and a history of injustice. Some Jewish participants took issue with this distinction, and at an early Hair Party a participant offered the example of the oppression of Orthodox Jewish women related to their hair. It was an important contribution, but felt out of place in a moment focused on the specific experience of slavery. It would have been a challenging moment for even the most experienced facilitator and reflects the complexity of cross-cultural work. It also became a learning opportunity for the company as they became more adept at letting participants move the agenda, while maintaining the focus of the dialogue.

One of the original goals of the Project was to use the Hair Parties to further the civic dialogue in Brooklyn about development and gentrification. This proved to be an overly ambitious goal. While several of their partners were involved in these issues, UBW was just becoming knowledgeable about them. The prompts in the Hair parties did not, for the most part, address these issues, and participants usually didn't take the conversation in that direction. An exception was at the YWCA Hair Party when a city councilwoman spoke

against the stadium as a part of her welcome. Her remarks also illustrated the tension inherent in a party that aspires to deal with serious issues. As described by a participant, the speech served less to spark civic dialogue than to "cast a pall of crashing reality."

The Fifth Avenue Committee party was another likely location for a dialogue about the impact of development and gentrification, given that FAC joins community development with anti-displacement activism. But instead of directly addressing these concerns the Hair Party provided activists with a welcomed opportunity to explore the human, and often personal dimensions of the issues, and the context of race and class that influences all of their work.

This is not to say that the issues of development and gentrification in Brooklyn were absent from the Hair Parties. Hair Parties have two parts, one formal and the other informal. Local civic issues were often discussed during the informal part as people ate and talked. The formal Hair Party dialogue often functioned to stimulate this broader civic dialogue. Though difficult to document, it would be beneficial to learn more about the conversations that happen following the Hair Parties, and about the continued ripple effect of a dialogue that begins with the topic of hair.

Ultimately UBW concluded that the civic goal of addressing development and gentrification was unrealistic for a project that was more catalytic than sustained. *HairStories* co-director Elizabeth Herrón said it this way, "We put a reality check on ourselves. We thought we could save the world talking about hair. We came to a place of realizing that the big mission for the Hair Parties is that dialogue happens when we leave, internal dialogue and dialogue with one another." Zollar concluded that, "going from individual empowerment to systemic change can't be done in a one-and-a-half hour dialogue. That needs to be done through sustained dialogue." She also noted that it would have required being tied into an ongoing effort such as that of the Concerned Citizens Coalition in Fort Greene, something that was not able to happen during the project. She does anticipate that as UBWs relationships grow and develop in Brooklyn, and as they develop ongoing and sustained programs there, the company can increase its impact as a social justice organization.

ESTABLISHING A HOME IN BROOKLYN

"It's not a one shot relationship. They show their commitment by being part of Brooklyn."

—Selma Jackson

In March of 2004 UBW hosted a Brooklyn Breakfast that included representatives of many of the groups that they had developed relationships with during the Hair Parties Project. This gathering was a step toward establishing an advisory group of "women who care" who could help UBW advance their work in Brooklyn. UBW acknowledged that the

Hair Parties only scratched the surface of what is possible, spoke about their continued commitment to the work, and asked for feedback on their upcoming programs in borough.

UBW built on a long history of collaborative work when they carried out the Hair Parties Project in Brooklyn. Through the years the company has learned how important it is to create reciprocal community partnerships. This is illustrated in Brooklyn with their partnership with 4W Circle. Selma Jackson was critical to the Brooklyn work as a connector who could make contacts and vouch for the company. She attended many of the Hair Parties and, drawing on this experience, recommended additional hosts.

Not only did Jackson make a strong connection with UBW, she also benefited from her active participation in the Animating Democracy Learning Exchanges. They helped to validate what she was already doing at 4W Circle, and challenge her to imagine how this work could be strengthened. She linked the Learning Exchanges experience to the recent 13th anniversary celebration for 4W Circle, where community members talked about how important the organization has been for them. These experiences strengthened her commitment, and raised for her the question "How can I make this an institution and make it last if people feel like that?"

On UBW's staff, Vanessa Manley played a key community-building role. She not only attended other group meetings in Brooklyn to increase UBW's profile in the borough, she also supported the work of their partners, going so far as to become a volunteer mentor in a high school mentorship program. The fact that Manley and Cassello both live and work in Brooklyn was very important and helped compensate in part for the fact that Zollar was teaching in Florida and the company was frequently on tour.

UBW took on a greater role in Fort Greene and laid the groundwork for valuable ties with the Brooklyn Borough President's Office; and the offices of City Council members, the late James Davis, Letitia James and David Yassky; and State Senator Veimanette Montgomery. In March of 2004 they made a presentation to the New York City Council.

UBW has learned that the stakes are much higher when you work in your home community. They are determined to build credibility, to carry out their work with integrity, and, as Cassello says, to "live up in every aspect of our organization to what we put out publicly." The opportunity is to continue and deepen partnerships in an ongoing manner, and to see the impact of the work over time. The challenge is to sustain the work and address growing local expectations for Hair Parties and collaborations when this community work is no longer funded and there is a lack of infrastructure to support it.

In July of 2004 UBW held their 10-day Summer Institute, "Building Community Through the Arts," for the first time in Brooklyn. The Institute offers an immersion in dance training and in learning UBW's community engagement techniques, of which dialogic learning is one part. Participants will partner with local artists and cultural groups to create a piece around the theme of voter education, registration, and voter turnout. Out of questions and dialogue UBW will create an "empowered dance" that will confront the barriers to participating in the democratic system. From this work, Zollar aspires to

generate a series entitled, "Are We Democracy?" as ongoing dialogues that will lead to a point of action.

UBW is also holding classes at Atlantic Terminal housing project, a partnership growing out of the Hair Parties that involves one of the groups threatened by stadium development plans. And the company is continuing its partnership with the Brooklyn YWCA, whose mission, "fighting racism and empowering young girls and women," is a good match with the company's. After a hair party at the YWCA they received a letter from Leonard Marks, the Bureau Chief at the Brooklyn V. Division of Parole who had attended with a group of female parolees." ... I hope that you and your performers recognize that among the many groups of women you deal with are those who have been degraded, abused, taken advantage of and often humiliated by a system that rarely if ever celebrates what they are, where they come from and what they've done. Your show turned some of that around and I thank you for that."

What is needed for UBW to carry forward the civic engagement work in Brooklyn as it should be done? The company replies: sustained support for the full-time staff member whose focus is community engagement, new board and advisory board members from Brooklyn, deeper partnerships, an expanded Institute, and regular programming in the borough.

For the long term, Zollar dreams of establishing a cultural center in Brooklyn as a home for UBW and other local artists working around community issues and social change. Having this kind of space in Brooklyn would provide the company an anchor and a focus. It would help keep African dance traditions alive by filling a gap in spaces that allow for drumming. And it would make it possible for UBW to engage with its Brooklyn community on an ongoing basis—and grow by being simultaneously challenged and nurtured by its neighbors.

TRANSFORMING THE COMPANY

> "To what extent is UBW willing to infuse dialogue in their internal and external work? What will you gain and what will you sacrifice to do that? What will be the risks to the mission of the company?"
>
> —Tammy Bormann

The Hair Parties Project took place during a time of revitalization and rebirth for UBW. The company's work with Bormann and Campt, and the embrace of their concept of dialogue as a learning process and tool for meaning making, played a role in this transformation. Bormann and Campt facilitated a session that explored the culture of Urban Bush Women, focusing on the company's core values and helped the company move forward in a process of empowering leadership and codifying their work.

For Zollar, dialogue enabled the company to include feelings and experiences as well as facts, and as described by Managing Director Amy Cassello, "(It) made all of us more conscious of and responsible for word choices, for not making assumptions, for seeking clarity and making a commitment to building better communication networks, both internally and externally." Artistically UBW had always learned new artistic work by doing it. They now extended this process to the rest of their work, furthering their ability to be self-conscious and function as a learning organization. UBW was able to consolidate their learning into their planning for their Summer Institute in Brooklyn. They codified a more detailed methodology for working with the community and for training members of the company to engage in this work.

Challenges included the economic and personal realities that could make it difficult for dancers to remain in UBW. Like most dance companies, UBW cannot afford to pay its company members for full time work, yet their busy touring schedule makes it difficult for dancers to take on additional jobs. Also, in some cases, dancers were less interested in, or suited for, community engagement work. After significant time spent training dancers, only two remained as core members. These members took on leadership roles in training new dancers. In the case of Maria Bauman, her development as an artist paralleled her development as a dialogue leader. She started as an apprentice documenting the Hair Parties, went through the dialogue workshops with Bormann and Campt, became a facilitator in the Hair Parties, and ultimately trained new company members in dialogue skills.

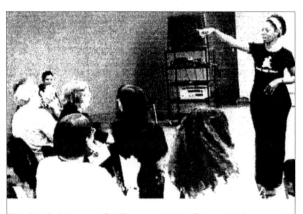

Elizabeth Herron facilitates a Hair Party dialogue.

The four new members, who were chosen in part due to their ability to respond to something new, were able to build dialogic learning into the foundation of their experience with UBW. Former members continued with the company on special projects, often those that involved dialogue. They also brought their new skills to work outside of the company. Many of the dancers involved in Urban Bush Women are teaching artists and have found good use of their dialogue facilitation skills when working in schools.

Practicing dialogue, given the time and economic pressures of managing arts organizations, is challenging. UBW is working to integrate dialogue into the internal decision making process, a challenge made more difficult by the logistical fact that the company is often on the road and away from the office. Yet Zollar has become convinced that "you have to go slow to go fast." UBW administrative staff is taking the time to set goals with more clarity, acknowledge assumptions, and hold regular debriefings. Manley's and Cassello's

dialogic approach in these ways has paid off, for example, in building and strengthening relationships with local partners.

UBW's organizational structure changed to reflect company transformations. Initially, Managing Director Cassello was responsible for project oversight. As the project developed, it became clear that the organization needed to make a more specific, substantial and sustained commitment to their work in Brooklyn. Manley was promoted to Special Projects Director, a job with a clear set of expectations around raising UBW's Brooklyn profile and building relationships with the community. Bormann was invited to join the UBW board. Her acceptance demonstrates her expectation that the company will continue on its path of dialogic learning.

Zollar describes the 2004 season, with its celebration of the company's 20th anniversary, as being about making connections, "It brings me and Urban Bush Women full circle: a reflection on the past, an attempt to seek assurance in the present, and a determination to invest in the future."

The company will connect to role models from the past like Primus from whom they draw strength and inspiration, and pass this wisdom along to young artists of the next generation. New work commissioned from emerging choreographers and new board members will further UBW's artistic and administrative transformations. Their new connections with Brooklyn partners and community members will help root and renew the company in their new home. Drawing on the experiences of the Hair Parties Project, and an ongoing process of dialogic learning, UBW will be an even more powerful catalyst for social change. Says Zollar, "I feel that Urban Bush Women's time is coming. The work is strong. The commitment is strong. We're coming of age."

Caron Atlas is a Brooklyn-based freelance consultant working to strengthen connections between community based arts, policymaking, and social change. Caron is the founding director of the American Festival Project and worked for several years with Appalshop, the Appalachian media center. She is the Animating Democracy project liaison with Cornerstone Theater, Intermedia Arts, SPARC, and Urban Bush Women, and coordinates Animating Democracy's Critical Perspectives reflective writing program. Other recent consultancies include the Leeway Foundation, National Voice, 651 Arts, Urban institute, and A Cultural Blueprint for New York City. Caron writes frequently about cultural policy and teaches at New York University's Tisch School. She has a master's degree from the University of Chicago and was a Warren Weaver fellow at the Rockefeller Foundation.

APPENDIX: HAIR PARTIES AND HOSTS

UBW held Hair Parties in a wide range of settings including those *that were core to the Brooklyn-based effort and others held during the project period.*

BROOKLYN-BASED

Urban Bush Women Board of Directors and guests
Hosted by Sylvia Vogelman, UBW Board Chairperson

Children's Aid Society of Brooklyn Hosted by Leonie Shorte
Hosted by April Chapman and Phillipe St. Luce at their Brooklyn home

Fort Greene Senior Citizens Center, Brooklyn
Hosted by Joan M. Eastmond

Hair Party for Men at Bedford Stuyvesant Family Health Center Inc., Brooklyn
Hosted by Ulysses Kilgore III

Hair Party for Brooklyn Youth
Participants from Lafayette Presbyterian, Emanuel Baptist, St. Paul Community Baptist, Berean Baptist

Hair Party for Mothers and Daughters at BRJC (Brooklyn Information & Culture) Studios
Hosted by Maurine Knighton & 651 Arts

J.P. Morgan Chase Metro Tech Center, Brooklyn
Hosted by Ujima Diversity Group

Fifth Avenue Committee (Park Slope)
Hosted by Ibon Muhammad at her Brooklyn home

Brooklyn YWCA
Co-hosted by The YWCA, Griot Circle (Gay, Lesbian, Transgender and Trans-spirited Senior Citizen Story-Tellers) and The Center for Anti-Violence Education

OTHER

Fleet Bank-Manhattan Hosted by Bernell Grier
J.P. Morgan Chase, Manhattan
Hosted by Ujima Diversity Group (Michelle S. Hall, director)
Boise City Arts Commission & Boise State University, Idaho
Hosted by Julie Numbers Smith, executive director, Arts Commission
Association of Performing Arts Presenters Members' Conference
Ford Foundation
Hosted by Roberta Uno of Media, Arts, and Culture

The Ethics and Anxiety of Being with Monsters and Machines

Matthew Causey

*Twice, especially since 1900, scientists and their ideas have generated a transformation so
broad and deep that it touches everyone's most intimate sense of the nature of things. The first
of these transformations was in physics, the second in biology.*

HORACE FREELAND JUDSON, *The Eighth Day of Creation* [8, 17].

INTRODUCTION

Eduardo Kac is an Associate Professor of Art and Technology at the School of the
Art Institute of Chicago and a Ph.D. research fellow at the Centre for Advanced
Inquiry in Interactive Arts (CAiiA) at the University of Wales, Newport, United
Kingdom. An internationally recognized artist using new technologies to create interactive and telepresent installations, he is currently involved in what he calls Transgenic Art.
According to Kac,

> Transgenic art, I propose, is a new art form based on the use of genetic engineering techniques to transfer synthetic genes to an organism or to transfer natural
> genetic material from one species into another, to create unique living beings.

Molecular genetics allows the artist to engineer the plant and animal genome and create new life forms. The nature of this new art is defined not only by the birth and growth of a new plant or animal but above all by the nature of the relationship between artist, public, and transgenic organism. Organisms created in the context of transgenic art can be taken home by the public to be grown in the backyard or raised as human companions. With at least one endangered species becoming extinct every day, I suggest that artists can contribute to increase global biodiversity by inventing new life forms. There is no transgenic art without a firm commitment to and responsibility for the new life form thus created. Ethical concerns are paramount in any artwork, and they become more crucial than ever in the context of bio art. From the perspective of interspecies communication, transgenic art calls for a dialogical relationship between artist, creature/artwork, and those who come in contact with it [10].

Kac has genetically altered a rabbit, fish, mice, bacteria and plant-life so that they generate green fluorescent protein, which causes the entity to glow green when placed under UV light. These animals, bacteria, and plants are placed in installations where they sometimes interact with machines known as 'bio-bots' and where local and telepresent spectators can interact or alter them in some manner.

Firstly, the goal of this essay is to ask some very basic questions about how Kac's transgenic and interactive work operates in the tradition of modern art. Secondly, it is to begin an inquiry into the philosophical and ethical issues that Eduardo Kac's art raises, namely, the elimination of the borders between art and life, virtual and embodied spectatorship, aesthetic genetic-engineering, the ethics of robotics and the responsibilities of the artist to the art of monsters and machines.

I. THE RE-MATERIALISATION OF THE ART OBJECT: FROM CONCEPTUALISM TO INSTALLATION TO BIOLOGICALLY-BASED WORK

Although Eduardo Kac's transgenic art is establishing new frontiers of art practice that challenge the boundaries of biology, robotics and aesthetics, the manner in which the artworks generate meaning and construct spectatorship are similar to the practices of much conceptual and installation art of the twentieth century. In conceptual and installation art, idea and process are promoted over representation and object through a dematerialisation of the art object in a contextualised space. While the goals of transgenic art and conceptualism and installations share certain concerns, the biological and mechanical certainty of objecthood in Kac's work represents a radical re-materialization of the art object—are-materialization with certain problems.

Art critic Lucy Lippard modeled the trajectory of modernist art as a process of the dematerialization of the art object [15].* From abstraction to action painting, from happenings to conceptualism, installations, video and performance, the effect has been

to challenge the representational element and objecthood in art in favour of its conceptualisation and process. The deconstruction of the object and its location in space and time in the paintings of the Futurists and Cubists in the early twentieth century was the opening salvo of the battle to eliminate the problem of representation from the discourse of art. Multiple planes of space and accelerated depictions of time reordered the ways in which both the object and the subject were constructed as coherent and chronological phenomena. During the post-World War II era the process of ridding art of representation and object status was pursued in the action paintings of Jackson Pollock where the trace of the artist's gesture was as critical as its painterly accident on the canvas. Further, the incorporation of performance in art practice by artists working in happenings presented the penultimate attack on the object. At the point that performance superceded objecthood in the production of art, conceptualism and installation were established as central modalities of art production.

Succinctly and reductively defined, conceptual art, through its insistence on idea and process over object, offers a critique of art production and institutions of the culture industry that evaluate and market the art product. The spectator's commodity fetishism is likewise challenged in the conceptual art that forgoes artifact. Simultaneously, conceptual works pose philosophical questions regarding the nature of art. When John Baldassari in 'I Am Making Art' (1971) stands before a video camera making simple gestures while repeating the phrase 'I am making art' for twenty minutes, the viewer is invited to dialogue with the work about the truth of his statement. The statement raises the question as to whether or not he is creating art, which requires a definition of art, which requires some philosophical reflection. The loss of the object opens a space for thought.

Installations found favour with those artists during the 1950s and 1960s who wished to structure a context in which their concepts could be played out. Distinct from sculpture or theatre, installation art offers a presentation of conceptual matter that remains outside of simple objecthood. The work of installation represents the staging of an art concept through the creation of a spatial context. The saleable and knowable object is still disenfranchised from the art moment as the environment of an installation is a presence always already in the process of dematerialization, given its performance in a timed manner. In the last decade artists' use of video and interactive installations has risen dramatically indicating an interest in establishing a performative space for the virtual environments of electronic communications.

Eduardo Kac's transgenic art carries with it the remembrance and the results of the temporary disappearance of the art object into concept and the performance of that loss in installation. This may seem a strained relation to model, as the objects of transgenic art are biological and mechanical. The art object is very much there. Yet, this is the very point I wish to make. The biological subjects and performing machines of Kac's transgenic art are constructed as idea and placed within installations for philosophical reflection. Therein lies the rub: animal bodies and machine bodies revealed not within their own destiny but altered within and serving unknowingly an aesthetic discourse. In an interview included

on the Eighth Day web site Kac states that, 'A lot of the art I make is both an attempt for me to grapple with an issue, to try to develop an understanding for myself and create a context, not in which I convey my understanding to the public but always create a context in which the public can develop his or her own understanding, their own understanding of an issue.' What is at issue in transgenic art is an aesthetics of conceptualism housed in installation, which is built on the bodies of altered animals and articulated through machines. The animals and machines are fuel for the art engine.

This is not necessarily a bad thing. I am offering a structural analysis of the signifiers of transgenic art. I am not at all interested in making a moral judgement or drawing ethical lines within Kac's work. Given the volatile nature of his art he strives to foreground the ethical ramifications of the process. I am not trying to decide if he is right or wrong. His exploration of biological and mechanical transgressions give us a remarkable path to think through the current revolutions of science that are unmaking and redoing our bodies, subjectivity and identity.

II. AS POSTHUMAN SUBJECTS

In a short comment featured in this publication, I attempted to reflect on the performance work of art technologist Stelarc through the conceptual model of posthumanism. I wrote,

Posthumanism, under a variety of names, is an ongoing project initiated in the late nineteenth century. As a counter-argument to the notions of humanism, which tend to essentialise categories of gender and race, defer difference and construct a 'family of man' as the centre of all things, strands of posthumanism have been promoted in the writings of Nietzsche, Freud and Marx. The scheme of dethroning a centralised 'man' in favour of more marginalised concerns has continued in poststructuralist, feminist and postmodern thought. More recently, posthumanism, as a component of digital culture and theory (developed and critiqued most clearly in the work of Donna Haraway and N. Katherine Hayles), argues for a model of identity that is dramatically altered within technological cultures. Posthumanism argues that western industrialised societies are experiencing a new phase of humanity 'wherein no essential differences between bodily existence and computer simulation, cybernetic mechanism and biological organism, robot teleology and human goals, exist. ... Embodiment is seen as an accident of history and consciousness is an evolutionary newcomer' [5]. Both the body and its conscious (no separation intended) and the spaces it inhabits are challenged and reconfigured. The technologies of scientific visualisation of the body through magnetic resonance imaging, the territorialising of the body through genome mapping and genetic engineering, and the alteration of the body through aesthetic and sexual reassignment surgery and mechanical, electronic and biological prosthetics, mark the speed of change in the ways the body

is seen, controlled and constructed. Additionally, this posthuman body 'lives' within new spaces of virtual environments and ubiquitous surveillance [2].

My thumbnail sketch of posthumanism is designed to demonstrate that humanism, an invention of the Enlightenment (or Renaissance, depending on the history you rehearse), is being reconfigured through digital culture, new scientific visualisations, and the body and genetic alterations of biology. In Kac's transgenic work, art object and spectator function as posthuman (or post-biological in the case of the genetically altered animals).

ANIMAL OBJECTS

Kac works with fish, amoebae, mice, rabbits and plants genetically altered with green fluorescent protein (GFP), which is isolated from Pacific Northwest jellyfish. Under UV light, the animals will glow green. Regarding the process of aesthetic genetic engineering, Kac writes,

> Genes are made of deoxyribonucleic acid (DNA) molecules. DNA carries all the genetic information necessary for a cell's duplication and for the building of proteins. DNA instructs another substance (ribonucleic acid, or RNA) how to build the proteins. RNA carries on the task using as its raw material cellular structures called ribosomes (organelles with the function of bringing together the amino acids, out of which proteins are made). Genes have two important components: the structural element (which codes for a particular protein) and the regulatory element ('switches' that tell genes when and how to perform). Transgene constructs, created by artists or scientists, also include regulatory elements that promote expression of the transgene. The foreign DNA may be expressed as extrachromosomal satellite DNA or it may be integrated into the cellular chromosomes. Every living organism has a genetic code that can be manipulated, and the recombinant DNA can be passed on to the next generations [10].

What is of interest, and perhaps a bit dangerous, is not the process of genetic engineering, although that has enough people up in arms, but that in transgenic art life is framed as art. The animals carrying the transgene are framed as aesthetic objects within Kac's model. The problem of conflating art and life has a rich theoretical history. In the eighteenth century Denis Diderot wrote in his *Encyclopedia* that 'In the arts of imitation the truth is nothing, verisimilitude everything, and not only does one not ask them to be real, one does not even want the pretence to be the exact resemblance' [4, p. 289]. Heidegger in outlining the aesthetics of Nietzsche suggested that 'Art is worth more than "the truth"' [6, p.75]. What all three philosophers are stating is that the convergence of art and life is a corruption of both phenomena. If you believe that art is life and life art, then you do not

understand either one or the other. The lies that form art, the dissimulation that constructs its beingness, the illusions that build its world, mysteriously open to an appearance of the truth. Nietzsche would argue that the real, or the 'truth,' simply leads to more illusions. Aesthetics as an autonomous activity shows us the truth of life. Life has a tendency to be devalued when it stands in for the goals of art. Walter Benjamin suggested a further problem when he argued that aestheticising politics is the performance of fascism. Conversely, he suggested that politicizing aesthetics is exemplary of communism.

Is the framing of altered animal life as an aesthetic a similar problem?

THE POSTHUMAN SPECTATOR

The spectator in Kac's interactive and transgenic art is positioned, in part, as a disembodied participant. Entry to the work is either through traditional appearance in a gallery space or through virtual participation online. Kac describes how telepresence offers interaction with his work *Uirapuru* (1999):

> 'Uirapuru' merges virtual reality with telepresence through the internet. Virtual reality offers participants a purely digital space that can be experienced visually and in which one can be active, in this case the VRML forest populated by six flying fish. Telepresence provides access and a point of entry to a remote physical environment [12].

The insistence on a virtual spectator is one of Kac's more interesting constructions. Traditionally, spectatorship in art and performance has been identified with presence. The present spectator brings with her choice, agency and self-determination. The object of art is constructed by the viewer's perception. Kac's transgenic art offers a model of spectatorship based on internet interactivity activated by streaming media, virtual simulations of the actual art environment and telepresence through computer-mediation. The telepresent spectator inhabits a virtual environment where agency, choice, and responsibility are available, but challenged. Clicking the javascript switch for an action one cannot witness 'in person' can invite an 'impersonal' attitude to the activity.

In Kac's interactive and transgenic installation, *Genesis* (1999), present and telepresent spectators are offered the opportunity to effect a change in the biological entity (*E. coli* bacteria) through computer-mediated manipulation. Kac describes the work:

> The key element of the work is an 'artist's gene,' a synthetic gene that was created by Kac by translating a sentence from the biblical book of Genesis into Morse Code, and converting the Morse Code into DNA base pairs according to a conversion principle specially developed by the artist for this work. The sentence reads: 'Let man have dominion over the fish of the sea, and over the fowl of the air, and over every living thing that moves upon the earth.' It was chosen

for what it implies about the dubious notion of divinely sanctioned human-ity's supremacy over nature. The Genesis gene was incorporated into bacteria, which were shown in the gallery. Participants on the Web could turn on an ultraviolet light in the gallery, causing real, biological mutations in the bacteria. This changed the biblical sentence in the bacteria [11].

The spectator of *Genesis* is then able, with the click of a mouse, to engage in a ru-dimentary biological alteration. Hardly earth shattering, but evocative of the effortless activities of virtual action performed daily throughout the datasphere of digital culture. The California-based machine performance group, Survival Research Lab (SRL) is using similar technologies that permit online users to fire a real cannon during their perfor-mances. It is not difficult to compare these aesthetic practices with contemporary weapon systems, whose strategy consists of disengaging both the soldier and spectator from the 'real' component of the action, namely the target. The impersonal nature of the telepresent user alters both engagement with the activity and the ethics of behaviour in that action.

THE POSTHUMAN (?) ARTIST

Perhaps it is only the artist who evades the posthuman, postbiological condition. He remains in control while offering irreversible body alterations for the animals and virtual multiple choice and javascript off/on switches for a telepresent and disembodied specta-tor. The ironic use of biblical phrases that Kac has borrowed from the Judeo-Christian tradition point toward a construction of the artist as a god over his genetically engineered world. The old question of whether the artist is offering a critique or promotion of a particular problem by re-enacting that dilemma arises in thinking through transgenic art. As I argued above, the work offers us the opportunity to think through some of the more pressing issues of the day. The artist's intentions are interesting, but not central.

III. WRITING, SPLICING AND BUYING THE BODY (HUMAN GENOME PROJECT)

The construction of Kac's interactive and transgenic artwork *Genesis* as described above in section two consists of an 'artist's gene' created through a translation process (Morse Code to DNA pairs) linking a biblical sentence to a gene. The work resonates in several interesting and troubling ways. The language of the biblical quotation transposed and linked through the primitive technology of Morse Code to the new technology of genetic engineering through the bacteria points toward the ways in which the body and subjectiv-ity are being reconceived and rewritten through biological interventions. As we know, the human genome project to identify all the approximately 30,000 genes and determine the sequences of the 3 billion chemical base pairs that make up human DNA, will be completed in 2003. The mapping of the human DNA is leading to patenting and market-ing of the human code of life. The U.S. Human Genome Project states on its web site

that, 'Another important feature of the project is the federal government's long-standing dedication to the transfer of technology to the private sector. By licensing technologies to private companies and awarding grants for innovative research, the project is catalyzing the multibillion-dollar U.S. biotechnology industry and fostering the development of new medical applications' [7]. Like the California Gold Rush, the human genome project has led to claims being staked and territory marked out for ownership of our interiority. The human is being portioned and purchased.

Genesis depicts the constructed character of the Judeo-Christian model of nature as natural and essential while demonstrating the mutable structure of our biological coding. Kac's installation implies that life is a game of chance, but in this artwork, who controls the aleatory experience? The telepresent spectator of *Genesis* is offered the opportunity to engage in the switching on of the alteration technology. They are not witness, nor are they required to take responsibility for their actions. Is there a cost to such telepresence?

In another reading, *Genesis* might be seen as a model of the unconscious, structured as language, as Lacan argued, and set to dreaming, connected to a responsive virtual dreamscape wherein the body of the dreamer is reformed. The copula between language and biology is orchestrated by a third element of information flow engendered through the surveillance and interaction of internet users logged into the system. In both readings there is a technology that when switched on creates a chain reaction of chance systems for which no model has been formed. The results of these bio-alterations are unknown.

IV. TAKING CARE OF THE ANXIETY AND ETHICS OF BEING WITH MONSTERS AND MACHINES

Transgenic art must be created 'with great care, with acknowledgment of the complex issues at the core of the work and, above all, with a commitment to respect, nurture, and love the life thus created' [13].

Recently, critics have made much of the performativity of animals and machines [16]. In an article for *Theatre Research International,* I attempted to understand the use of the supplemental performers of children, animals, and machines in the performance work of the Italian collective, Socìetas Raffaello Sanzio. I wrote:

> The presence of the machines brings an uncanny charge to the stage as they are always already 'in performance.' The human performer walks on and off the stage, begins and ends a performance, but the performing machine or object is always 'on.' The timelessness of the machine, the inexhaustible performativity of the object, summons forth a revealing of the timed nature and fatigued performance of the human. Mortality is brought back to the stage through the immortal nature of the machine [3].

The simple point I am trying to make in the above text is that the 'permanence,' steady state and constant performativity of the machine foregrounds the impermanent, fluid

state and negotiable performativity of the human.** The performativity of the animal is similarly placed in question as its consciousness of performance is limited and task oriented. An animal wandering through a stage set may or may not have any reference understanding of the act. The animal's unreflective act of being points to the always already doubled nature of a human on stage. The human's consciousness of performance indicates agency on the one hand, but a confinement in representation on the other. Kac's use of animals and machines operates in a less dramatic system of difference, but suggests useful ways of thinking through how humans construct the world through the assistance of these animals and machines.

In *The Eighth Day*, Kac and his associates at Arizona State University have devised a biologically driven robot known as a biobot. The artist explains,

> A biobot is a robot with an active biological element within its body which is responsible for aspects of its behavior. The biobot created for 'The Eighth Day' has a colony of GFP amoeba called Dyctiostelium discoideum as its 'brain cells.' These 'brain cells' form a network within a bioreactor that constitutes the 'brain structure' of the biobot. When amoebas divide the biobot exhibits dynamic behavior inside the enclosed environment. Changes in the amoebal colony (the 'brain cells') of the biobot are monitored by it, and cause it to slowly go up and down, or to move about, throughout the exhibition. Ascending and descending motion becomes a visual sign of increase (ascent) and decrease (descent) of amoebal activity. The biobot also functions as the avatar of Web participants inside the environment. Independent of the ascent and descent of the biobot, Web participants are able to control its visual system with a pan-tilt actuator. The autonomous ascent and descent motion provide Web participants with a new perspective of the environment [14].

Kac writes of an 'ethics of robotics' that will need to be considered as the links between machine, animal and human are solidified. The biobot is a crude example of how the biological organisms and machine forms might create co-dependent entities. In a piece called *A-Positive* Kac designed a system that would draw oxygen from the blood of an individual to power a flame [9]. The traditional master/slave narrative of human and machine are troubled in Kac's work and suggest the time is ripe for a reconsideration of our ethics in regards to machines. As the machines are invited into our bodies and biological organisms introduced into machines, the neat boundaries of what marks a human are being complicated. Andy Warhol's wish to be a machine is becoming a reality.

The *GFP Bunny* 'Alba' is one of Kac's first transgenic creations. Fixed with the gene that codes for the green fluorescent protein, Alba glows green under a UV lamp. Kac writes on his web site that the life of Alba is an artwork in three stages.

The first phase of the 'GFP Bunny' project was completed in February 2000 with the birth of 'Alba' in Jouy-en-Josas, France. … The second phase is the ongoing

debate, which started with the first public announcement of Alba's birth, in the context of the Planet Work conference, in San Francisco, on May 14, 2000. The third phase will take place when the bunny comes home to Chicago, becoming part of my [Kac's] family and living with us from this point on [13].

The art is not placed in a physical or virtual installation but framed through the existence of the rabbit. The art is not performed, presented or represented. It exists. The boundaries of art are extended to a presence that will only stop at death.

Martin Heidegger's notion of human existence as a phenomenon of 'being-in-the-world' might be a useful model for understanding the problem that transgenic art offers us. Heidegger's 'being-in-the-world' exists through an operation of 'care.' Caring is structured as a three-part process of projection wherein 'being-in-the-world' 'projects upon or towards its possibilities to be,' throwness 'into and among these possibilities,' and fallenness among the possibilities 'to the neglect of [the being-in-the-world's] own deepest possibility to be itself' [1, p. 227]. These movements are experienced in the 'being-in-the-world' as anxiety. The human is responsible for her life and must take care of it. The artist is responsible for her creation. She must take care of it. As the infinite quality of our possibilities accelerates in the advent of new science and technology, we must take care not to be overtaken by the anxiety of fallenness and find that both ourselves and creations are incapable of revealing our separate and unified destinies.

As Dr. Frankenstein learned, that which we create desires our care and responsibility. We are animals, and our machines are our extensions, supplementing and sometimes, displacing, ourselves. Transgenic art is a process for the manufacturing of monsters and machines and thereby must become the 'care-taker' of these other beings. Without a concerned 'care-taking,' these monsters and machines will return with desires and demands no posthuman can supply.

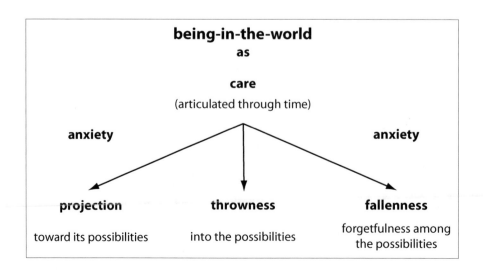

NOTES

* As I was reminded by an editor for *Crossings*, it is important to remember that like all historical outlines, Lippard's model is reductive and fails to address the multiple critiques (language, technology, politics, etc.) inherent in conceptualism in favour of a privileging of the crisis of representation.

** I am using the term of 'performativity' in this essay not in terms of a deconstructive reading of Austin's work on iterability, but as a signifier for a 'condition of performance.'

REFERENCES

[1] Caputo, John. 'Heidegger.' In *A Companion to Continental Philosophy*, ed. Simon Critchley and William R. Schroeder, 223–236. Oxford: Blackwell, 1998.

[2] Causey, Matthew. 'Posthuman Performance.' *Crossings: eJournal of Art and Technology* 1.2 (2001). Available at http://crossings.tcd.ie/issues/1.2/Causey/; accessed 23 March 2002.

[3] Causey, Matthew. 'Stealing from God: The Crisis of Creation in the Work of Societas Raffaello Sanzio's *Genesi* and Eduardo Kac's *Genesis*.' *Theatre Research International* 26.2 (2001): 119–208.

[4] Diderot, Denis. 'Encyclopedia.' In *Dramatic Theory and Criticism: Greeks to Grotowski*, ed. Bernard F. Dukore. New York: Holt, Rinehart, Winston, 1974.

[5] Hayles, N. Katherine. *How We Became Posthuman: Virtual Bodies in Cybernetics, Literature, and Informatics*. Chicago: The University of Chicago Press, 1999.

[6] Heidegger, Martin. *Nietzsche*. Translated by David Farrell Krell. San Francisco: Harper Collins, 1979.

[7] Human Genome Management Information System. 'About the Human Genome Project.' Available at http://www.ornl.gov/hgmis/project/about.html; accessed 23 March 2002.

[8] Judson, Horace Freeland. *The Eighth Day of Creation: Makers of the Revolution in Biology*, expanded ed. Plainview, NY: CSHL Press, 1996.

[9] Kac, Eduardo. 'Art at the Biobotic Frontier.' 1997. Available at http://www.ekac.org/apositive.html; accessed 20 November 2001.

[10] Kac, Eduardo. 'Transgenic Art.' *Leonardo Electronic Almanac* 6.11 (1998). Available at http://mitpress.mit.edu/e-journals/LEA/; accessed 20 March 2002. Also available at http://www.ekac.org/transgenic.html; accessed 20 March 2002.

[11] Kac, Eduardo. 'Genesis.' September 1999. Available at http://www.ekac.org/geninfo.html; accessed 20 November 2001.

[12] Kac, Eduardo. 'Uirapuru.' October 1999. Available at http://www.ekac.org/uirapuru.html; accessed 20 November 2001.

[13] Kac, Eduardo. 'GFP Bunny.' 2000. Available at http://www.ekac.org/gfpbunny.html; accessed 20 November 2001.

[14] Kac, Eduardo. 'The Eighth Day, a Transgenic Net Installation.' 2001. Available at http://www.ekac.org/8thday.html; accessed 20 November 2001.

[15] Lippard, Lucy R. *Six Years: The Dematerialization of the Art Object from 1966 to 1972*. London: Studio Vista, 1973.

[16] Read, Alan, ed. *On Animals*. *Performance Research* 5.2 (2000).

[17] Rawls, Alan and Jeanne Wilson-Rawls. 'Biologists' Statement.' *The Eighth Day*. October 2001. Available at http://isa.hc.asu.edu/eighthday/about_description.html#biologists; accessed 23 March 2002.

ABOUT THE AUTHOR

Matthew Causey is a lecturer in Drama at Trinity College Dublin. A theatre and new media artist, he has directed, designed and written numerous theatre, video and multi-media works. He is a contributing author to the anthology *Cyperspatial Textuality*, the *Routledge Encyclopedia of Postmodernism* and the *Oxford Encyclopedia of Theatre and Performance*. His theoretical writings have appeared in journals such as *Theatre Research International*, *Theatre Journal* and *Theatre Forum*. Currently, Dr. Causey is at work on a book titled *Posthuman Performance: Theatre in the Virtual's Mediation of Illusion*.

The Prelude to the Millennium: The Backstory of Digital Aesthetics

Sherry Mayo

Figure 1

INTRODUCTION

The artist and scientist have been depicted as polar opposites since Michelangelo claimed that Leonardo da Vinci was wasting time with foolish inventions (see figure 1) while his art suffered. However, the artist taking on the role of the researcher has precedent. In the 1960s, Experiments in Art and Technology (E.A.T.), led by Bell Labs' engineer Billy Klüver, aided artists such as Robert Rauschenberg in pushing the avant-garde to utilize technology. Sullivan asserts that the time has come to

Sherry Mayo, "The Prelude to the Millennium: The Backstory of Digital Aesthetics," from the *Journal of Aesthetic Education*, Vol. 42, No. 1; Spring 2008, pp. 100–115. Copyright © 2008 by University of Illinois Press. Permission to reprint granted by the publisher.

examine art as data and artistic practice as research.[1] The digital revolution produced a new artist model for today's avant-garde and has been described as a type of Merlin—a trickster magician.[2] Perhaps a more plausible model is the artist-scientist who is creating a paradigmatic aesthetic shift. Digital art, new media, net-art, or computer art are new art forms that have arrived on the art scene. In order to make sense of digital-based artworks, it is necessary to understand both their predecessors and the technology that makes them possible.

WHEN NEW MEDIA WAS "NEW"

New media began in the late 1960s with computer-assisted design (CAD) programs that were implemented in building engineering (see figure 2). Computer imaging came from military research but later became a tool of expression in the hands of artists. Simulation and interaction are attributes that differentiate a digital experience from an analog one. The Sputnik (1957) space race and fascination with *Star Wars* (1977) infused the public imagination with technology as a possible solution to all societal problems.

Figure 2.

1960s Spheres of Influence

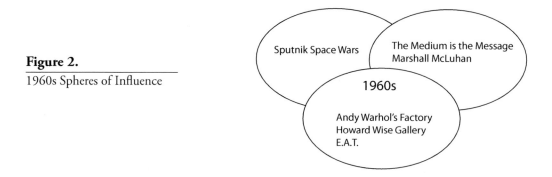

Reproduction and distribution of audiovisual data differentiated the latter half of the twentieth century from any other time. The advent of photography (see figure 3) and film made significant cultural impact. From the Moviola to cinema and video gaming, the development of image manipulation, real-time interactivity, 3D animation, and immersive simulation environments has been the focus of computer graphics for more than forty years. Since 1969 the Association for Computer Machinery Special Interest Group in Computer Graphics and Interactive Technology (ACM-SIGGRAPH) has held annual conferences focused on combining the research and development of both artists and scientists. These forums have successfully fused C. P. Snow's "two cultures" and fostered interdisciplinary collaborations.[3]

E.A.T. began in 1966 when Klüver's passion for film drew him into the art scene.[4] He befriended Jean Tinguely and built one of the first kinetic sculptures for the Museum of Modern Art (MoMA)—*Homage*, a self-combusting sculpture.[5] Robert Rauschenberg met the engineer at the exhibit's opening and enticed him to work on *Oracle,* an

environmental sound sculpture. The apex of these collaborations was *9 Evenings: Theatre and Engineering*. This event was held at the historic 69th Regiment Armory, where Duchamp's futuristic nude once descended its staircase, shocking audiences in 1913.

In addition to E.A.T., an important forum for arts-technology experimentation was the Howard Wise Gallery in New York City.[6] This 57th Street space supported the kinetic art movement of the 1960s and followed its course through the birth of video art. Howard Wise exhibited Nam June Paik and other pioneers incorporating technology. Wise had mounted a 1969 exhibition entitled *TV as a Creative Medium* (see figure 4). Wise's exhibition was seminal and featured video works by Paik and *Wipe-Cycle* by Frank Gillette and Ira Schneider. This stack of nine TV monitors confronted the viewers coming into the gallery and repeated their image of surveillance. Marshall McLuhan contributed to the brochure for the show because Wise was interested in his ideas regarding electronic media being a vital social instrument. Ben Portis, assistant curator of contemporary art at the Art Gallery of Ontario, refers to Paik as the "George Washington" of video art.[7] Yet Warhol's black and white films were the early precursors for video art.[8] On December 16, 1970, Howard Wise closed his gallery due to the extensive resource demands of these experiments. In the 1980s painting moved back into the spotlight and many of the earlier arts-technology experiments were abandoned—but only until video art and new media became visible again in the 1990s.

Figure 5.

1970s Spheres of Influence

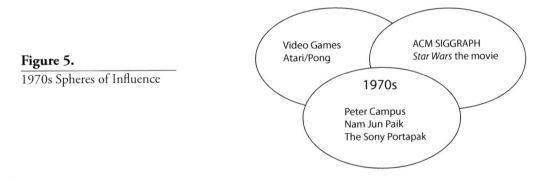

The writings of Youngblood and Enzensberger were concerned about the lack of interactivity in media consumption.[9] Enzensberger maintained that if the receiver is passive, they are not exercising political control over what is being projected upon them (see figure 5). They worried about the repressiveness of the media and its ability to wash over the masses and inhibit cybernetic feedback. Youngblood blamed the competition between the arts and entertainment for the death of the avant-garde.

> The notion of experimental art, therefore, is meaningless. All art is experimental, or it isn't art. Art is research, whereas entertainment is a game or conflict. We have learned from cybernetics that in research one's work is governed by one's

strongest points, whereas in conflicts or games one's work is governed by its weakest moments.[10]

Enzensberger objected to old media such as TV and radio because of its one-way transmission, but does power shift with interactivity in newer forms of media such as the Internet or multiuser games? While Enzensberger was not a McLuhan fan, he did admit to the effectiveness of his memes.[11] McLuhan, a slogan-driven technophile, resonates loudly in the age of globalism. Technology brought third-world cultures into conflict with first-world ones. The process of connecting everyone everywhere enabled "have nots" to gain a distorted view of what the "haves have." Internet networks have fostered xenophobia instead of projected reciprocity via connectivity.

Benjamin, who laid the groundwork for future media theorists in 1936, remains exalted in the stripping of the bride to make mass use of symbols in service to semiotic conditioning.[12] The promiscuity of a historical rerepresentation of iconography does not lead to critical digestion but to an emptying out, which enables propaganda through familiarity achieved through repetition and accessibility. Anything that disrupts this process subverts consumerism. Enzensberger's description of the *Consciousness Industry* has a sense of foreboding about new media but maintains hope that the receiver will participate as a manipulator and become subversive to the media.[13] Youngblood felt that the art world would sell out to the entertainment industry for survival and lose its opportunity for social agency.[14]

AN AESTHETIC SHIFT

As these theorists set the stage for later forms of techno-entertainment, a larger market of consumption was being constructed. In the 1980s (see figure 6) virtual reality and simulations were available in entertainment parks. Movies such as *Jurassic Park* are examples of the type of computer graphics special effects that emerged. Compositing motion graphics in music videos showed the viewer a new range of possibilities within storytelling, as epitomized by Chris Cunningham's work in the 1990s, such as Björk's *All Is Full of Love*.[15] The key points in defining this era were the quest for realism, the development of simulated experience, and image manipulation in postproduction.

Figure 6.

1980s Spheres of Influence

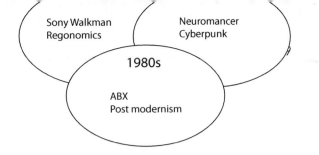

Sony Walkman
Regonomics

Neuromancer
Cyberpunk

1980s

ABX
Post modernism

Image manipulation was made possible by programs such as Adobe PhotoShop™, which allows the end-user to change an original image. Image synthesis is best exhibited in 3D animation where the end-user simulates dimension and movement of a form through space. The development of these art forms was primarily funded and accomplished by movie companies such as Industrial Light and Magic (ILM, George Lucas), Digital Domain (lighting effects and fur textures), and Pixar (Disney, 3D animation division).

Interactivity, the cornerstone of computer games whose development began in MIT in the 1960s, indicates another paradigmatic shift. From *Pong* (1960s) to *Space Invaders* (1970s) there has been a massive consumption of computer games. By the early 1980s computer gaming reached private homes. The design of gaming interfaces has come a long way from the gobbling abstract forms of *PacMan*™ to levels-based gaming with 3D animation on X-box™. The level of real-time interactivity and kinesthetic simulation has advanced dramatically in multiuser games such as *Quake* (1996).

Darley postulated that a paradigmatic aesthetic shift that has taken place that coincides with the development of digital imaging.[16] The return of illusionism is accomplished by perceptual reality achieved through projected light and motion. Theater preceded the camera-still and then came film. Early film mimicked theatrical conventions, relying on representation and symbolism to yield storytelling. The direct stimulation of the senses was not as effective as relying on devices to convey emotion in the abstract. Conventions such as the death mask in theater were translated into the knife dripping with blood in film. Today we are able to simulate a kinesthetic experience that makes the viewer feel as if he is hurtling along the Indianapolis Speedway. Hollywood was born in the 1930s and boomed making film the dominant popular cultural form by the 1950s. Radio became outmoded, as *Video Killed the Radio Star* (The Buggles, 1979) and broadcast TV came into every home. TV in the 1950s and 1960s displaced radio and live performance and became the mass media form of entertainment. Today's spectator demands real-time, high-resolution, and simulated hyperreality within which she has control. Interactivity enables the viewer to make decisions to remodel his own virtual reality. These controls shift our notions of power and are more radical than the depthless surface play that Darley suggests.[17] The quest to depict space and illusionism has returned from the Renaissance. Singular point perspective and the flatland of modernist aesthetics have been surpassed.

There has been an explosion of exhibition venues that create new modes of spectatorship with the advent of the Internet, personal computer, cell phone, and Blackberry.™ These are new surfaces for display, and content for these venues is evolving. Privatization of spectatorship of radio, TV, and home video through computers is evident. The spectator is increasingly choosing a mono-to-monitor experience with audiovisual media. From the 1960s through the 1980s, the emergence of the rock concert and the movie-goer reinforced an idea that people desired a mass-collective experience. This human need has

shifted toward a removed social network experience, such as MySpace, where people connect to other strangers interested in the same experience. The virtualization of spectacle has transformed aesthetics significantly.

WHAT'S NEW ABOUT NEW MEDIA?

What is new media art (see figure 7)? Manovich answers this question by defining it as the "digital material itself, its material and logical organization."[18] Manovich's argument is that the human-computer interface is a cultural interface and that software interfaces are mimetic and dependent upon earlier communication forms. The human-computer interface is expanding with portable digital assistants. The new media logic differs from the pan-distribution of mass media. The Internet enables the viewer to select, transmit, and receive information. The act of selection is a demonstration of power. The ability to communicate and socially organize in new ways subverts previous models of information distribution and social control. Manovich's language for decoding new media art is useful in a Greenbergian[19] sense. If it is made of pixels, variable in scale, and transmitted across the Internet, then it is new media. Manovich looks at the screen in Renaissance painting—an illusory static removed screen; the film projection—a dynamic screen; TV-real time; and the Internet—an interactive interface—to unravel its differences. Time is the distinguishing attribute in the aesthetics of new media; ideally, it is a time-based, audiovisual, and networked medium.[20] Its other important aspect is that all other types of media, from sculpture and painting to the book and record, also have a relationship to it. Today integrated media is what is making cultural impact, not purity of form.

Figure 7.

1990s Spheres of Influence

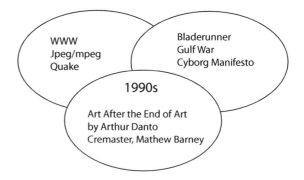

WWW
Jpeg/mpeg
Quake

Bladerunner
Gulf War
Cyborg Manifesto

1990s

Art After the End of Art
by Arthur Danto
Cremaster, Mathew Barney

Magda Sawon, Postermasters Gallery codirector, stated that the gallery's curatorial premise is media neutral. She and her partner, Tamas Banovich, have been pioneers in showing new media artworks since the groundbreaking exhibition in 1996 entitled Can You Digit? In 1996 much of the art world shunned a gallery of twenty screen-based digital works. New media art was ghettoized into strictly new media spaces until recently. According to Sawon, "There are specific things to new media art, for instance you cannot

make a nonlinear painting. It is very different when someone actually works with the parameters of a medium than simply outputting through a medium."[21]

BitStreams, a 2001 exhibition at the Whitney Museum curated by Larry Rinder, was dedicated to the digital impact on American contemporary art. Perhaps the most pertinent perceptual difference between the digital arts and earlier art forms is its nonlinearity. Painting serves as a big influence for many artists using computers in studio practice. The point was made that to be a digital artist is to be a hybrid. According to Rinder, the digital age is not just restricted to bits and bytes:

> I looked for works that both used computers at some stage in their development, manufacture, or expression and which expressed, thematically, some perspective on life in our "Digital Age." By "digital age" I mean that we now live in a world saturated by digital practices and effects. One doesn't have to know how to use a computer, let alone know how one works, to be impacted by the effects of digital media. It is omnipresent, in the images we see everyday, in the ways we communicate, in our medical practices, in the ways farmers plant their crops, etc. … In terms of visual imagery specifically, I believe that digital technologies have given artists extraordinary new powers of control of image production and expression both in 2 and 3 dimensions (as well as moving images, of course). *BitStreams* dealt very specifically with these issues.[22]

There was no pretense of purity, as Rinder defined the digital age. The tools of production are beside the point; it is the resultant art object that counts.

In *Data-Dynamics*, a separate exhibition shown simultaneously with *BitStreams*, were interactive works. It was a fully embedded visceral experience with technological-based works. The viewer could move around in space and was not tied to a monitor and mouse for point of access. Christiane Paul made use of five pieces of net-art that "were comprised of projection systems, multi-user interfaces, and robotics that created an installation based on 'models that visualize data flow' to allow viewers to immerse themselves."[23] She broke down interactive work into the following four categories: gaming, 3D simulation, navigation, and point-of-view. These categories included artists who made games, such as Natalie Bookchin's *Intruder and Metapet,* John Klima's *ecosystm2,* Eric Zimmerman's *Sissyfight,* and an immersive 3D experience, *Osmose,* by Char Davies.

The lessons of the video artists of the 1960s and 1970s have become so widespread that they no longer pertain solely to electronic media as such. The lessons of self-reflexivity, truth-to-materials, openness to media culture, and the "freedom not-to-paint" have become absorbed into virtually every dimension and media of art practice. Even in the realm of painting, artists today paint with "the freedom not-to-paint."[24]

Beyond painting as a model, cross-disciplinary fertilization combined with new tools of manipulation have certainly prompted collaboration in developing these new media works. Collaboration and collectives happened well before the pixel. Similarly, the notion

of interactivity is not novel to the Internet but was very much part of the language of earlier artistic expressions. What is new is the ability to integrate media and have global network access for distribution, collaboration, and research.

THE BODY POLITIC

Stelarc, an Australian cybernetic artist, puts his own body in a cage. He explains that "Bodies are both Zombies and Cyborgs and we have never had a mind of our own and we often perform involuntarily—conditioned and externally prompted."[25] Stelarc's performance work surrounds the domination of the body by the machine and a giving up of control. While Kurzweil would support this exploration in machine control, another cybernetic theorist, Paul Virilio, would sharply disagree:[26]

> To invent something is to invent an accident. To invent the ship is to invent the shipwreck; the space shuttle, the explosion. And to invent the electronic superhighway or the Internet is to invent a major risk which is not easily spotted because it does not produce fatalities like a shipwreck or a mid-air explosion. The information accident is, sadly, not very visible. It is immaterial like the waves that carry information.[27]

Virilio, a cyber resistance fighter, is fearful of our worship of the computer. He is concerned with the corporate and governmental controls through cybernetics and the near collapse of the distinction between the human body and technology. Haraway, a cyberfeminist, spins a utopian myth of the cyborg:

> High-tech culture challenges these dualisms in intriguing ways. It is not clear who makes and who is made in the relation between human and machine. In so far as we know ourselves in both formal discourse (for example, biology) and in daily practice (for example, the homework economy in the integrated circuit), we find ourselves to be cyborgs, hybrids, mosaics, chimeras. Biological organisms have become biotic systems, communication devices like others. There is no fundamental, ontological separation in our formal knowledge of machine and organism, of technical and organic. The replicant Rachel in the Ridley Scott film *Blade Runner* stands as the image of a cyborg culture's fear, love, and confusion.[28]

In this new world order, homework economy equals technocracy; sex is genetic engineering; hygiene is maintained by psychotropics; and reproduction is accomplished by replication. Haraway sees the cyborg as a savior for a world beyond gender. In the case of *Blade Runner*'s Rachel, she is questionably empowered as a cyborg since she is raped by Harrison Ford and has a preset termination date. Cyborgian visualizations, such as

that in figure 8, repeatedly vandalize the female form for techno-erotic and violent ends. These cyberpunk fantasies have not shifted the poetic association of death and the maiden depicted throughout art history.[29] Sadly, the female cyborg is no more liberated than Keppler's 1940s glamour housewife (see figure 9).

The era of our cyborgs, ourselves, has arrived in the posthuman age. Hayles fears a prosthetic limbo version of a posthuman race, whereby humans disintegrate into information pattern versus interference.[30] Portable assistants, such as the cell phone, have developed new body-machine relationships that qualify us as cyborgs. SecondLife and MySpace are just two examples of numerous sites dedicated to social interaction in which you place your avatar representation into a database that distributes information to others. Today's screen is Narcissus's lake filled with mimetic pixels intimately projecting upon us from the computer. Whether painting, film, TV, or cyberspace, the act of psychologically projecting into new spatial relationships removes you from your visceral body and enables an alternate experience. As Turkle noted, the gap psychologically closed on talking to a virtual symbol of someone and being connected to that person.[31] It is this leap of faith that makes it possible for us to become cyborgs, not high-tech prosthetics.

The millennial body is left hovering below cyberspace. The hydremic lover, our flesh, somehow winces at the onset of our virtual lives. Burroughs describes a virtual reality achieved through drugs—ingestive technology—that leaves meat dangling helplessly behind in search of an ever-higher aesthetic experience.[32] This is analogous to the aesthetic shift caused by ephemeral media networks that have brought McLuhan's embedded tribal human back into vogue.[33] The aesthetic shift driven by digital technology has shaken our notions of reality, hierarchy, and power, as best illustrated in the toppling of the World Trade Towers in 2001—a global simulcast event that created a broadcast spectacular on September 11th. This tragedy engaged the entire world through TV and Internet broadcast. Individuals with cell phones and digital cameras recorded their own versions of September 11th and shared them. Enzensberger's aesthetic wish for receiver interaction has been achieved. But has it surpassed Youngblood's benchmark of experimentation, or is it mere entertainment by-product? Does receiver participation mark a true power shift and a democratization of the media?

REQUIEM FOR THE CONSCIOUSNESS INDUSTRY

In the practice of new media there exists a postproduction phase that distinguishes this group of artists as manipulators of the real, the unseen, and the subversive (see figure 10). The new media artists may not make the raw data themselves; they may sample it. The artist working in this setting is most powerful as an editor of mediation rather than as a producer of cultural objects. Enzensberger stated, "cutting, editing, dubbing—these are the techniques for conscious manipulation without which the use of the new media is inconceivable."[34] These techniques have created aesthetic devices such as the sample and the loop. The artist incorporating the computer into his practice is a manipulator of

data. The fusion of the artist and the engineer as the new "interfacers," as Johnson suggested, provides society with new workers for cultural production as the human-computer interface evolves.[35]

Figure 10.

Milliennial Spheres of Influence

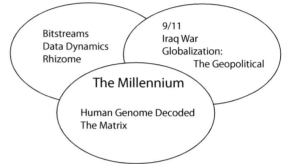

Bitstreams
Data Dynamics
Rhizome

9/11
Iraq War
Globalization:
The Geopolitical

The Millennium

Human Genome Decoded
The Matrix

The medium is not simply the message but rather those who manipulate and control the vehicles for mediation dictate the message. Baudrillard states, "everyone has become a manipulator," and thus everyone has the capability of an artist.[36] At this point the cacophony of postmodernist pastiche results in reproduction diluting context (making authenticity meaningless) and the annihilation of the individual. The modernization of the art object for mass consumption liberated it from function and ritual[37] and made it both democratic and capitalist propaganda. It allows the receiver to float in a miasma of decontextualized symbols where signification becomes crisscrossed, inversed, and re-associated. Virtual interface is powerful architecture signifying to the surfer throughout cyberspace where to point and click.

Lanier, a humanist technologist, critiques the "champions of cybernetic technology as culture," in particular Kurzweil.[38] Lanier objects to "cybernetic totalism."[39] Moore's law,[40] which is the exponential doubling of computing speed over time, is Kurzweil's point of contention. Kurzweil feels that the narrow definition of a human being will have to expand by 2020 to include machines that exceed our computing power.[41] "The slippery slope of including machines in 'our circle of empathy,' is to remove responsibility of human individuals that subjugate themselves to mighty technology."[42]

The digestion of information in a cybernetic system is never complete. Instead, it continues on from surveillance of figures in space, to an upload of data that is translated and then transmitted back onto the receiver by projection. This process should not escape critical consciousness in which a mass collective sharing of an experience can deconstruct its own environment. However, with the vast amount of information and feedback out there, who can make sense of all this data? As Bell predicted, society will not be able to afford to regulate its technology.[43] The result is the requiem for the consciousness industry or the elusion of a critical feedback loop to an extent that people search for their own identity through what is projected onto them. The search for self and meaning, then, is subjugated to the machine.

ARTIST-RESEARCHER MODEL

Hickey's disbelief in the sunset over the Vegas strip sums up art as being about magic, beauty, and illusionism.[44] If this were true, the new media artist would be nothing more than a magician whose works are puff, smoke, and mirrors. Instead, I argue that artists incorporating postproduction practices provide critiques of the technology they use and actively create new knowledge within their art making. Today the art market deals with digitally based works seamlessly. Artistic processes have been increasingly digitized but retain their ability to communicate with other media and diverse cannons. As artists tackle new surfaces for display, they will continue to build new relationships with the viewer.

There exists advocacy for the artist as agent of social transformation and for art production as a form of research in Youngblood's writings, which set solid precedence for Sullivan's argument that artistic practice is indeed a form of research that should be actively excavated.[45] But it is the flirtation of art and entertainment that reinforces a historic barrier for the artist entering academia. The artist playing the role of court jester for the masses is nullified but no longer on the fringe of the market place. The entertainer-entrepreneur takes part in a global competition for cultural imperialism. Artists with valuable visual skills become a part of the cyberfactory. These facts aid academic skepticism of the artist inside the academy. In order to maintain that art education was more than a frill and could serve the democratic ideology needed in schools, art educators as early as 1942 disavowed self-expression as a pedagogical objective. Culture will not be saved by a retreat to Shangri-La, real or imagined; sheltered artists and escape art are neither sound culturally nor valuable as a social force.[46]

The media space has engulfed all of us with computer access; reality has been fused again—making the virtual real. The aftermath of September 11th created paranoia propaganda such as "if you see something, say something" posters depicting diverse eyeballs staring at train passengers requesting information about their neighbors.[47] Google™ has new street views of any location you would like to stake out, adding to our sense of remote control. On the flipside, millennial youth have a fresh response to the private being public. Sixty-one percent of youth aged thirteen to seventeen have online profiles.[48] Their relationship to privacy has shifted with the onset of the digital age and their human need to connect to others, which is outweighing our culture of fear (see figure 11). Wolf asserts the need for cultural studies "to use those theories that seem to work when exploring the cultural formation of identity and to work with the bricolage of cultural events and moments through which the experience of culture is mediated and in which it is encapsulated."[49] The amount of personal fragments available to the researcher through online social networks is tremendous. These archives provide the evidence of identity formation impacted by digital culture. The annotation, photo, or self-expression encapsulates cultural DNA that could provide the next meme of our time. What appears as diaristic folly or, worse, self-expressive exhibitionism is perhaps vital psychosocial and cultural data that needs to be mined for the benefit of a democratic future. It is this intersection of digital

lifestyles, metaspaces for personal annotation, social networking, and cultural production that offers the artist a role as researcher and resurrects the avant-garde.

Dr. Sherry Mayo has been engaged with integrating technology into her studio art practice since 1993 and has been exhibiting in New York, nationally, and abroad. Mayo is an artist whose studio practice and critical writings examine perceptual shifts in how we envision bodily interfaces with artificial environments.

NOTES

1. G. Sullivan, *Art Practice as Research* (Thousand Oaks, CA: Sage Publications, 2005).
2. D. Hickey, *Air Guitar: Essays on Art and Democracy* (Los Angeles, CA: Art Issues Press, 1997).
3. C. P. Snow's 1959 Rede Lecture, "The Two Cultures" (in C. P. Snow, The Two Cultures [Cambridge: Cambridge University Press, 1998]), made the argument that the separation of the sciences and humanities was a barrier to progress.
4. P. Miller, "The Engineer as Catalyst: Billy Klüver on Working with Artists," 1998, Institute of Electrical and Electronics Engineers, http://www.spectrum.ieee.org/select/0798/kluv.html (accessed September 1, 2003).
5. E.A.T. Archives, http://www.fondation-langlois.org/html/e/page.php?NumPage =306.
6. Howard Wise archives, EAI: Electronic Arts Intermix, http://www.eai.org/kinetic/ch1/wise.html.
7. "TV as a Creative Medium," Howard Wise Gallery, New York, Exhibition Brochure, 1969, http://www.eai.org/kinetic/ch1/creative.html. Ben Portis, "The Fulcrum: TV as a Creative Medium," n.d., see http://www.eai.org/kinetic/ch1/creative.html#.
8. S. Koch, Stargazer: *Andy Warhol's World and His Films* (London: Calder and Boyars, 1973).
9. G. Youngblood, "Art, Entertainment, Entropy," in *Expanded Cinema* (London: Studio Vista, 1970); Hans M. Enzensberger, *The Consciousness Industry* (New York: Seabury, 1974).
10. Youngblood quoted in J. G. Hanhardt, ed., *Video Culture: A Critical Investigation* (Layton, UT: Visual Studies Workshop Press, 1986), 230.
11. Richard Dawkins, *The Selfish Gene* (New York: Oxford University Press, 1976). Memes are ideas or aphorisms that replicate through society; they are akin to a gene sequence in DNA. See also http://www.rubinghscience.org/memetics/dawkins-memes.html.
12. W. Benjamin, *Illuminations* (New York: Schocken Books, 1968).
13. Enzensberger, *The Consciousness Industry.*
14. Youngblood, "Art, Entertainment, Entropy."
15. For Chris Cunningham's All Is Full of Love music video see, http://www.director-file.com/cunningham/bjork.html.

16. A. Darley, *Visual Digital Culture: Surface Play and Spectacle in New Media Genres* (New York: Routledge, 2000).
17. Ibid.
18. L. Manovich, *The Language of New Media* (Cambridge, MA: MIT Press, 2001), 11.
19. Clement Greenberg's essay "American-Type Painting," Partisan Review 22, no. 2 (Spring 1955): 179–96, reduces painting to its formal qualities.
20. Manovich, *The Language of New Media.*
21. Interview with the author, April 7, 2003.
22. Personal communication with the author, September 22, 2002.
23. Personal communication with the author, October 5, 2002.
24. Rinder, personal communication.
25. See the Web site for Australian performance artist Stelarc: http://www.stelarc. va.com.au/ (accessed September 13, 2003).
26. R. Kurzweil, *The Age of Spiritual Machines: When Computers Exceed Human Intelligence* (New York: Viking, 1999); quoted in D. Dufresne, "Cyberesistance Fighter—An Interviw with Paul Virilio by David Dufresne," Après-Coup Psychoanalytic Association,http://www.aprescoup.org/mt/archives/title/2005/01/ cyberesistance.html (accessed November 28, 2002).
27. Ibid.
28. Donna Haraway "A Cyborg Manifesto: Science, Technology, and Socialist-Feminism in the Late Twentieth Century," in *Cyborgs and Women: The Reinvention of Nature* (New York: Routledge, 1991), 149–18. Retrieved on November 28, 2002, fromhttp://www.stanford.edu/dept/HPS/Haraway/CyborgManifesto.html.
29. J. Wolf, *Resident Alien: Feminist Cultural Criticism* (New Haven, CT: Yale University Press, 1995).
30. K. N. Hayles, *How We Became Posthuman: Virtual Bodies in Cybernetics, Literature and Informatics* (Chicago: University of Chicago Press, 1999).
31. S. Turkle, *Life on the Screen: Identity in the Age of the Internet* (New York: Simon and Schuster, 1995).
32. W. Burroughs, *Naked Lunch* (New York: Grove Press, 1959).
33. M. McLuhan, *Understanding Media: The Extensions of Man* (Cambridge, MA: MIT Press, 1998).
34. Quoted in Hanhardt, *Video Culture,* 121.
35. S. Johnson, *How New Technology Transforms the Way We Create and Communicate: Interface Culture* (New York: Basic Books, 1997).
36. Quoted in Hanhardt, *Visual Culture,* 139.
37. Benjamin, *Illuminations.*
38. J. Lanier, "One Half of a Manifesto," *The Third Culture,* http://www.edge.org/3rd_ culture/lanier/lanier_index.html, 2000, part 1 (accessed November 27, 2002).
39. Ibid., part 2, note 30.

40. Gordon E. Moore (1965), cofounder of Intel, wrote a paper "Cramming Moore Components onto Integrated Circuits," *IEEE Journal of Electronics* 38, no. 8 (1965), that observed an exponential growth (doubling every year) in the number of transitors per integrated circuit and predicted that this trend would continue.

41. Kurzweil, *The Age of Spiritual Machines.*

42. Lanier, "One Half of a Manifesto," part 6, note 30.

43. D. Bell, *The Coming of Post-Industrial Society: A Venture in Social Forecasting* (New York: Basic Books, 1973).

44. Hickey, *Air Guitar.*

45. Youngblood, "Art, Entertainment, Entropy"; Sullivan, *Art Practice as Research.*

46. Arthur D. Efland, *A History of Art Education: Intellectual and Social Currents in Teaching the Visual Arts* (New York: Teachers College Press, 1990), 231.

47. MTA, *Eyes of New York Campaign,* http://www.mta.info/mta/news/newsroom/eyesecurity.htm.

48. E. Nussbaum, "Say Everything," *New York Magazine,* February 12, 2007, 24–102.

49. Wolf, *Resident Alien,* 35.

Partnerships, Policies, and Programs: Ideological Constructions in Federal Youth Arts and Drama

Lori L. Hager

n this paper I consider ways in which community youth arts and drama[1] have intersected national political, economic, and social agendas, and how federal funding strategies have constructed an ideological base out of which youth arts and drama are practiced, researched, and theorized. Federal strategies position youth arts to serve non-arts goals through partnerships that link youth arts programs with non-arts agencies such as the Departments of Housing and Urban Development, the Department of Justice, and the Department of Economic Development. Partnerships between the National Endowment for the Arts (NEA) and non-arts agencies bring important resources and funding to arts programs, provide access to social service dollars, and justify and define the arts goals within social service agendas.

As community artists and youth arts organizations compete for funding, the role of the arts in the community is justified and legitimized in social service practices. A recent report by the Rockefeller Foundation recognized that community arts programs are "constantly reinventing arguments to convince funders of the legitimacy of their efforts, constantly reframing their work to fit the guidelines of social service" (Adams and Goldfarb 4). As well, the *Arts and Cultural Funding Report* recommends that "government and nonprofit leaders incorporate the arts into social problem-solving" ("Increased" 7).

The NEA, as the only federal funding program for the arts, is critical to the existence of community youth arts and drama, and leads national arts policy and programs. NEA policies and programs support, and perhaps lead, arts funding in programs that are purposively linked to solving social problems. I examine the contexts out of which federal youth arts funding emerged, and discuss federal youth arts programs during the Nixon and Carter presidential administrations when youth arts were formalized through the Department of Education arts-in-education programs, and subsequently through programs with other federal agencies. I then discuss contemporary changes in the NEA youth arts programs that have created an ideological platform for youth arts in social service practice.

The NEA is the sole federal support program for youth arts in this country. During the first thirty years of the NEA arts education efforts, school-based arts education programs provided a rallying point for all youth arts efforts, including programming, research and policy, and funding. Arts education was understood to include both school based and non-school based programs (United States, *1990* 17). School-based arts education efforts were administered from the NEA Education Program and in partnership with the U.S. Office of Education. Most of the community based, or nonschool arts programs with youth, were funded through the Expansion Arts Program, which changed over time from a community arts support program to a minority support program. School based and non-school based arts education with youth had separate trajectories informally, but these were neither explicit nor clearcut.

NEA SCHOOL BASED ARTS EDUCATION PROGRAMS

Since 1965, the NEA has worked with the U.S. Office of Education to sponsor programs in the schools in support of arts education. The NEA enables partnerships with other federal and private agencies, artists, state, or "other public performing and nonperforming arts and educational institution or organization, association, or museum in the United States" in order to "foster and encourage exceptional talent, public knowledge, understanding, and appreciation of the arts" (United States, *1990* 17). Activities that were supported in 1965 included arts instruction and training for youth, teacher preparation, arts faculty resources, development of curriculum materials, and evaluation and assessment of programs and instruction (United States, *1990* 18). Specifically, the NEA legislation called for cooperation with the Department of Education, which began as early as 1965 with the Elementary and Secondary Act (ESEA), and continues with the current No Child Left Behind Act.

The 1965 ESEA made funds available for research and development in arts education, and was the first time in the history of government legislation that a partnership between arts and education was initiated (Arts, Education, and Americans Panel 219). The 1965 Act also supported and encouraged partnerships, "between arts and education agencies at state and local levels, arts organizations, business colleges, and universities" (United States, *1990* 18). In addition to supporting local arts councils and agencies, this act supported

partnerships between the various branches of government including the Departments of Justice, and Housing and Urban Development These departments have, as does the Office of Education, long-standing partnerships with the NEA, which have been instrumental and influential in youth arts program designs and goals.

Prior to the 1965 ESEA, research in education was a low federal priority compared to research in the sciences and social sciences. Due to the 1965 ESEA, millions of dollars became available for research and development in education, which applied in part to arts education. This money amounted to "a shot in the arm for arts and humanities education in general, which began to receive unprecedented support" (Murphy 2). Funds allowed arts researchers to broaden and deepen studies, and Harvard's Project Zero[2] was one research effort that benefited from this initial "infusion."

Nancy Hanks, who was NEA Chairman during the Nixon administration, stimulated the beginnings of important youth arts programs in the Education and Expansion Arts Programs, which formed the core structure for arts programming with young people for the next decades. Hanks oversaw the artists-in-schools program, which "represent[ed] the single largest Arts Endowment program which [had] as its primary purpose—defined by policy, as opposed to legislation—the support of arts education-related projects" (Arts, Education, and Americans Panel 222). In 1969, the Office of Education transferred $100,000 to the NEA to be used in the Artist-in-Schools program (which had begun with the 1966 New York City Poets in the Schools program named P.E.N.), and then $900,000 in 1970. By 1974, the NEA allocated $4 million to the Artist-in-Schools program, and had more than 2,000 artists reaching 7,500 schools (Arts, Education, and Americans Panel 222).

NEA COMMUNITY YOUTH ARTS—A BEGINNING

One of the first community youth art projects undertaken by the NEA was the result of a 1966 proposal titled "The Smaller Community and the Rural Arts Project." Robert Gard was the founder of the Wisconsin Idea Theatre at the University of Wisconsin, and a significant figure in the community arts movement. The rural arts project was a three-year program that was designed to assist five small communities develop theatre and other arts programs, and to stimulate the creation of local arts agencies. The NEA saw this project as an opportunity to extend its reach beyond "the current small minority of middle and upper middle class patrons" (Mark 118), and to create a program under which small community based, or grassroots organizations could apply:

> [...] the future growth and solid foundation for cultural progress had to be formed from the grassroots activities of the general populace. As long as arts activities were enjoyed, supported, and controlled by the current small minority of middle and upper class patrons, our cultural life would be a sometime thing. If we truly believe the arts were essential to the human spirit, could make our

lives fuller and richer, then we were obligated to try and bring them to the people who had been ignored until now. (Mark 118)

Another significant early community youth arts program arose as a result of riots that broke out in 1968 in response to the murder of Martin Luther King. Vice-President Hubert Humphrey came up with a summer arts project for inner cities to help "combat violence" during the summer of 1968. (Mark 160). It was decided that 16 of the cities most likely to erupt in violence in the summer would be awarded grants of $25,000 for arts projects for young people characterized as "at-risk." The project was described as:

> [...] kind of loosely organized exposure of poor youngsters (mainly non-white) to enriching experiences from the Western middle-class cultural tradition, intended to compensate for presumed deprivation in their lives and backgrounds. One does not have to deny the true richness of the Western cultural tradition to point out the presumptuousness, arrogance, and racism inherent in this simplistic approach to the culturally different person in our pluralistic society. (qtd. in Mark 162)

This project "changed the attitude of many funding arts agencies, including the Endowment" (Mark 163). The summer project was significant in that it represented the first real effort by the NEA to involve the arts directly in addressing the particular challenges of the inner city neighborhoods: "First, until the 16-city program was undertaken no federal agency had put its money squarely on the principle of direct involvement in the processes of the arts by young people in poverty neighborhoods" (qtd in Mark 163). The "Smaller Community and Rural Arts Project," and the 16-cities projects established precedents in federal arts efforts whose goals were to reach as many Americans as possible, to include arts forms outside the mainstream, large arts institutions, and to utilize the arts for political and social purposes.

An important federal community arts program was Expansion Arts, which was begun in 1971 in recognition of the changing demographics of the country (Spellman). Expansion Arts was designed to assist "ethnic and rural minorities whose cultures had been inadequately supported in the past" (Smith 413). Inner cities and rural areas, both of which had rarely enjoyed access to the arts (as defined by federal support programs), were especially targeted, furthering the NEA's mission to promote access. Expansion Arts also functioned as a training program for artists:

> One important shared trait was that many organizations which produced art also taught it. Other groups designed their projects for nontraditional audiences, which until then had not had much to do with the arts. Many organizations did both. Thus, the largest Expansion Arts categories have been Instruction and

Training and Arts Exposure. [...] In fiscal 1979, those two categories alone accounted for nearly two-thirds of the entire program (United States, *1979* 51).

Expansion Arts recognized that it was "a point of entry for developing arts groups that are established in and reflect the culture of minority, blue collar, rural, and low-income communities" (United States, *1979* 51), and was designed to assist community arts groups to leverage local and private funds. It was an important support program for the many community arts organizations that were established throughout the 1970s and early 1980s.

During the Nixon administration, youth became an explicit focus of arts programming and related social goals. However, it was during the Carter administration that this policy would really be put into effect through extending partnerships with other federal agencies in the interests of supporting national civic, economic, and social goals.

The Carter Administration encouraged federal agencies such as the Department of Labor, the Department of Commerce, and the Department of Education to "incorporate the arts in their efforts to effect social, environmental, and economic progress" (Wyszomirski 25). It enhanced programs between the NEA and other government agencies such as the Department of Labor, and the Department of Housing and Urban Development—partnerships that continue to this day. During the Carter administration the linkages between arts and social and civic development programs for youth were advanced, laying a foundation for many of the current arts education programs.

The NEA became linked with the Department of Labor during the Carter administration, as well as with the economic growth of cities and cultural tourism. The Comprehensive Employment and Training Act (CETA) Arts and Humanities Program put thousands of artists to work from the mid-1970s until Reagan defunded it,[3] and was the first federally-supported comprehensive employment program for artists since the Federal Theatre Project.[4] The focus of the program was on "those who are unemployed, underemployed or in school, *and* economically disadvantaged." (Gibans 173). In addition to supporting the training of artiste and arts administrators and fostering the organizational development of arts institutions, CETA's Arts and Humanities Program supported the development of "cultural industry" skills [skills artists employ] that were found to be "easily transferable to other occupational areas" (Morgan X), thus supporting economic development goals.

CETA's Arts and Humanities Program laid a foundation for the continuing investment in the "cultural worker" by connecting the arts to quality of life in cities and to job training. The economic argument for support of the arts was linked with the larger issues of jobs and economy, and the Carter administration used this link to create a rationale for a policy that might otherwise have been difficult to support in a period of tight money and budgetary cutbacks (Wyszomirski 25).

Ex-actor Ronald Reagan with Vice President running mate George W. Bush (who voted against the NEA reauthorization in 1967) appointed Frank Hodsoll as Chairman of the NEA in 1980. During his Chairmanship, Hodsoll generally maintained support of the larger arts organizations, while curtailing "outreach" programs such as Expansion

Arts, and others that served minorities and disadvantaged populations. In 1984, he elimi-nated CETA's Arts and Humanities Program, putting hundreds of artists out of work and numerous arts organizations into serious financial crises. He also oversaw a 13% budget reduction in 1984 (Jonasse 55), modified from Reagan's original 50% budget reduction proposal. Hodsoll and Reagan supported increased private spending for the arts, assuming that if there were limited federal support then private support would take over. This tactic relied heavily on the philosophy "that fewer government grants may prove salutary rather than debilitating," and as one budget supporter said, "When an institution or a program relies too heavily on one source of funding, it makes itself unnecessarily vulnerable" (qtd. in Green 11). Hodsoll continued the economic and civic impact arguments for the arts from the Carter years, but with a fiscally conservative slant.

By the time the country's leadership made a shift from the Reagan-Bush Republican conservatism to Clinton's Democratic domestic reforms, the damage to the NEA had already been done. In 1996 the NEA's annual budget was cut by 40% as. a result of political pressure from right-wing conservatives in response to the so-called "NEA Four" controversies, precipitating a massive restructuring unprecedented in the NEA. In re-sponse, the NEA sponsored a series of forums across the nation designed to identify "the most pressing problem facing the arts today: in an era of dwindling public resources, how might communities best support the arts at a local level?" (Larson 6). Four topic areas guided the national forums in 1996: the Artist and Society; Lifelong Learning in the Arts; Arts and Technology; and New Ideas for Federal Arts Funding (Larson 8). The forums included representatives from arts communities, business and education, as well as representatives from social services and civic affairs, but significantly none of the panelists were self-described fulltime practicing professional artists.

Each of the six participating cities was asked to help "frame the course of action for improving the climate for culture in the 21st century" (14). A central theme in the report concerned the marginal role of arts organizations in the communities where they were located. One panelist suggested that what arts organizations have done successfully is cultivate "relationships with individuals of relative wealth (audiences and boards), dead individuals of wealth (foundations), and the business community" (qtd. in Larson 78). Barriers between arts organizations and communities are "rooted in larger socio-economic factors," such as "poverty, segregation, and illiteracy," which "arts organizations alone are powerless to change" (79). Regardless, the panel reported that a growing numbers of arts organizations were trying to change these factors by turning to a "variety of social service and community-outreach programs" in a monumental shift *that has no precedent in American culture"* (79).

The panel reported that by reaching out to social service and community programs, arts organizations both developed new audiences, and secured additional essential funding sources, "as a means of survival" (80). This coincided with an increasing push in private giving for social justification in granting (80). However, the "sincerity of arts organizations that endeavor to contribute to the social welfare" may have reflected "more than a trace of

desperation—the recognition that ours is not a society that places a sufficiently high value on the arts to support them for their aesthetic contributions alone" (Larson 81).

This represented a "new pragmatism" on the part of arts communities, which accepted "the need to 'translate' the value of the arts into more general civic, social, and educational terms that [would] be more readily understood, by the general public, and by their elected officials" (81). Unfortunately, the necessity for such pragmatism reflects the disheartening reality that fewer people than ever experience the arts in their school years. Then, what does this signify for the position of arts in communities?:

> [...] arts organizations [cannot] afford to assume that in their new role as 'catalysts for change and renewal,' they'll be any more successful than the failed (and/ or curtailed) public-sector social-service programs that saddled the arts—among other sectors—with the burden of becoming social problem-solvers in the first place. (Larson 89)

The panel argued that arts organizations that have been working (and thus are experienced) in these areas should be well supported. However, arts organizations who are "caught up in the communitarian spirit" and turn to social work "as a means of staying afloat," are going to run into trouble (89). The report cautioned arts organizations against "putting ourselves into a situation where we cannot succeed" (90), such as rescuing failing social agendas.

The panel's assertion that community development reflected the "fastest growing program and service area of local arts agencies" (84), was represented in statistics about Local Arts Agencies (LAAs), which help to disburse federal funds, administer local projects, and work in tandem with other community organizations such as schools, city parks and recreation programs, social service departments, law enforcement, and other community organizations (Larson 85). One hundred percent of LAAs in the 50 largest American cities "use the arts to address community development issues" (Larson 84). Cultural/Racial awareness was listed as the most important LAA community development issue, followed by youth at-risk, economic development, crime prevention, illiteracy, substance abuse, and homelessness (84).

The irony of positioning artists and arts organizations as social service providers is inescapable when viewed in light of the impetus behind the *American Canvas* study, which was to strategize about creating an environment in which American arts will survive and thrive. Programs that link the arts to solving social problems and "community development issues" are ideologically complex. When the arts and artists must mediate between the agendas of different social service agencies, unanticipated and unprovoked crises will erupt—for which the artist may be untrained and unprepared. This creates a tenuous position for the arts, placing it in the center of opposing forces, and with no way to really "win." As long as youth arts serve social welfare goals, artistic contributions may be preempted by the "more important" social considerations. However, to argue against

the arts in service to social welfare opposes a socially conscious and politically responsible position for the arts.

Positioning the arts in service to social welfare agendas leaves the purposes of the arts dependent upon the goals of the social service programs, while severely restricting the ability of the arts to leverage funds for artistic purposes. By positioning the arts as fiscally desperate, some of the most important artistic values and outcomes are "dumbed down" to arts-poor politicians and funders. Does this serve the arts community in the long term?:

> All of a sudden, as Ruby Lerner has expressed it, the arts are valuable if they can solve social problems, and of course, God knows we couldn't solve social problems in the social arena, but now it's expected that in the cultural arena we'll be able to solve all these problems—'and, by the way, we won't be able to give you many resources to do this.' (qtd. in Larson 89)

American Canvas interrogated arts organizations' participation in social service goals, asserting that oftentimes, though motivated by humanitarian goals, arts organizations align themselves with social services as a pragmatic funding strategy. This raises the question of whether social service goals for youth arts indeed strengthen the arts' position in American society, or whether by linking to social service goals, the arts are then valuable only for their ability to transform and change the lives of troubled youth.

Youth arts have been increasingly constrained by the very arguments used to strengthen them. Since the establishment of the NEA and federal arts funding, partnerships with the Departments of Education, Housing and Urban Development, and Juvenile Justice have helped to shape youth arts goals and have influenced arts research and policies. This increased reliance on federal partnerships has generated a youth arts environment where arts goals are often subordinated to the "more important" social, educational, and economic goals. The extent to which arts practitioners participate in advancing a position for the arts as a form of social service has yet to be articulated. Research and practice arising out of this ideological climate has tremendous ramifications for Theatre for Youth and arts education, both in school and during after-school hours.

NOTES

1. Community youth arts/drama refers to arts programs that link arts organization and artists with community youth organizations during non-school hours.
2. Project Zero was founded at the Harvard Graduate School of Education in 1967 to study and improve education in the arts.
3. CETA was part of a work relief and employment package designed to assist disadvantaged citizens train for, and find work. While the Arts and Humanities Program

was unique in that it was designed specifically for artists, CETA programs benefited a wide range of constituencies such as Vietnam Veterans and the handicapped.

4. "There are many parallels between the period 1975 to 1980, when CETA funds were most heavily utilized in the arts and humanities, and that of the Works Progress Administration of the 1930s. Both responded to a straining national economy and quickly rising unemployment Both recognized the need to help individuals, whether artists or carpenters, humanists or mechanics to survive while providing opportunities for expanding their skills and exercising their talents in productive work for their local communities. Most significantly, the WPA established, and CETA reaffirmed, the importance of 'creative work' to the social and economic fiber of the nation. They also demonstrated the power of the cultural arena to provide jobs for thousands of unemployed Americans" (Morgan X).

WORKS CITED

Adams, Don and Arlene Goldfarb. *Creative Communities: The Art of Cultural Development.* New York: Rockefeller Foundation, 2001.

Arts, Education, and Americans Panel. *Coming to Our Senses: The Significance of the Arts for American Education.* New York: McGraw, 1977.

Gibans, Nina Freedlander. *The Community Arts Council Movement: History, Opinion, Issues.* NY: Praeger, 1982.

Green, Kevin W. "Artsedge." *American Arts.* (January 1982): 10–12.

"Increased Funding for the Arts Would Strengthen Society, Report Finds." *Arts and Culture Funding Report: The Monthly Newsletter on Federal and Private Funding for Arts and Culture Programs.* 12.8 (January 2001): 7–9.

Jonasse, Richard. "The National Endowment for the Arts and the Public Sphere." Diss. U of Oregon, 1992.

Larson, Gary O. *American Canvas.* Washington, D.C.: National Endowment for the Arts, 1996. (available in PDF from http://arts.endow.gov/)

Mark, Charles Christopher. *Reluctant Bureaucrats: The Struggle to Establish .the National Endowment for the Arts.* Dubuque, Iowa: Kendal/Hunt, 1991.

Morgan Management Systems, Inc. *CETA (Comprehensive Employment and Training Act) and the Arts and Humanities: Fifteen Case Studies.* Springfield, VA: U.S. Department of Commerce National Technical Information Service (NTIS), 1981.

Murphy, Judith and Lonna Jones. *Research in Arts Education: A Federal Chapter.* U.S. Washington, D.C.: Department of Health, Education, and Welfare, 1978.

Smith, David Andrew. "Covered Wagons of Culture: The Roots and Early History of the National Endowment for the Arts." Diss. U of Missouri, 2000.

Speliman, A.B. Personal Interview. 25 September 2002.

United States. National Endowment for the Arts. *National Endowment for the Arts Annual Report 1979.* Washington, D.C.: NEA, 1980.

—. *National Endowment for the Arts Annual Report 1990.* Washington, DC: NEA, 1991.

Wyszomirski, Margaret J. "Controversies in Arts Policymaking." *Public Policy and the Arts.* Eds. Kevin Mulcahy and C. Richard Swaim. Boulder, CO: Westview, 1982.

The Economics of Latin American Art: Creativity Patterns and Rates of Return

Sebastian Edwards

The Latin American countries are famously known for their economic and political travails. Most of the region has a long history of authoritarian politicians, successive coups d'état, galloping inflation, and financial crises. The literature attempting to explain Latin America's political and economic developments is voluminous and covers most angles of the region's social problems.

Politics and economics, however, are not the only aspects of the Latin American nations that have attracted the attention of intellectuals from around the world. Indeed, there has traditionally been keen interest in Latin American literary and artistic accomplishments. For example, the works of novelists Gabriel García Márquez and Mario Vargas Llosa and of poets Pablo Neruda and Octavio Paz have been exhaustively analyzed by critics and academics, as have the works of artists Fernando Botero, Frida Kahlo, and Diego Rivera.

Studies on Latin American economic and artistic developments have proceeded along separate paths. Very few economists, if any, have used economic methods and data to analyze issues related to Latin American literature or arts. And only a few authors—mostly of a Marxist persuasion—have attempted to relate the creative process to the region's economic developments or prospects.

In this paper I use a large data set and economic methods to analyze two rather different aspects of the Latin American arts: namely, the nature of the artistic creative process and Latin American art as an investment. I am particularly interested in using data on art auctions to understand the relation between artists' age and the evolution of their work. I also use these data to investigate the historical rates of return obtained by buyers of Latin American art. This research is part of a new and growing field on the economics of art and cultural economics, whose pioneers include Orley Ashenfelter, William Baumol, Richard Caves, Bruno Frey, David Galenson, and Victor Ginsburgh.[1]

Latin American art auctions have a number of advantages as a subject of study. First, regular and dedicated international auctions for Latin American art have been held since 1979. Although Sotheby's and Christie's dominate the market, a number of smaller houses are quite active, in both Europe and the United States. Second, museum activity in this area of collecting is still limited. Thus—in contrast with American artists or the impressionists, for example—the market is not subject to the bias introduced by big museums, which tend to buy and retire some of the best works from the market. Third, the market for many of the most important Latin American artists is also quite liquid, with a large number of works by many of the masters being sold each year.

The rest of the paper is organized as follows. The next section discusses the main issues addressed in this paper and provides a brief review of the literature on the economics of art. I then describe the data set (the artists included in this study are listed in the appendix). A subsequent section is devoted to analyzing the creative process. The point of departure is Galenson's pioneering work on creativity patterns.[2] The paper then addresses Latin American art as an investment. Here, I discuss methodological issues and calculate hedonic price indexes to compute the rates of return of different art portfolios. The concluding section discusses directions for future research.

THE ISSUES AND THE LITERATURE

Over the years, a small number of economists have analyzed problems related to cultural issues. Some of the most important works in this field deal with the economics of museums, artistic competitions, artists and stardom, art auctions, investing in the arts, and, more recently, aspects of the creative process. Although the economics of art has never made it into the mainstream, many of the authors involved in it are quite prominent in other fields.[3]

1. The number of authors using data on auctions to analyze the art market is growing rapidly. For a list of contributors to this literature, see the recent review by Ashenfelter and Graddy (2003).

2. Galenson (1997, 2001).

3. Prominent economists who have made their reputation in other fields and have published on the economics of art include Orley Ashenfelter, William Baumol, Richard Caves, and Sherwin Rosen.

THE CREATIVE PROCESS OF ARTISTS

In a series of recent works, David Galenson uses data on auction prices and regression techniques to investigate creativity patterns among French and American painters from the nineteenth and twentieth centuries.[4] In particular, Galenson uses these data to determine at what age different artists did their best, or most important, work. In his regression analyses, the dependent variable is the log of the price at which each work was sold; the independent variables include a polynomial on the age at which the work was executed and data on the year the work was sold. Additional covariates include the work's support (canvas, board, or paper) and its size.[5] From this analysis, Galenson is able to trace how prices for a particular artist's work are related to the age at which the artist painted it. Galenson argues that it is possible to distinguish two broad patterns of creativity among artists: experimental and conceptual. Experimental artists peak late in life, doing their best work at a relatively old age. For experimental artists each work is an experiment, and it constitutes a step in a process of trial and error. Experimental artists work slowly, and "rarely make preparatory sketches or plans for a painting."[6] Paul Cezanne is an example of an experimental artist; according to Galenson's analysis, he did his best work in 1906, when he was sixty-seven years old.[7] Conceptual artists work in a very different way from experimental artists. They conceive an idea—an artistic concept—and work on it until they reach the desired result. During the creative process, these artists do a number of sketches and studies as they refine their concept and move toward the finished work. Conceptual artists are—or desire to be—sudden innovators, and they tend to do their best work early on in their careers. According to Galenson, Picasso is a very good example of a conceptual artist. Galenson's regression analysis suggests that Picasso did his best work in 1907, when he was twenty-six years old. That was the year he finished *Les Demoiselles d'Avignon.*

In an important paper, Galenson and Weinberg use auction data to analyze creativity among American artists born between 1900 and 1940.[8] They divide their data set into two cohorts: artists born between 1900 and 1920 and those born between 1921 and 1940. They find, based on a number of panel data regressions, that artists belonging to the second cohort tended to do their best work at a younger age than artists born before 1920.[9] For the pre-1920 cohort the estimated peak age (or age when the most important

4. Galenson (1997, 1999, 2001). See also Galenson and Weinberg (2000); Galenson and Jensen (2002).

5. A number of economists have analyzed creativity within the context of R&D, innovation, and productivity. See, for example, Bartel and Sicherman (1998). Psychologists have had a long interest in understanding the dynamics of creativity; for a recent effort, see Kanazawa (2003).

6. Galenson (2001, p. 50).

7. Galenson (2001).

8. Galenson and Weinberg (2000).

9. Their data set includes 1,109 observations for the pre-1920 cohort and 3,286 observations for the post-1920 cohort.

work was executed) is fifty-one years; for the younger (post-1920) artists it is only twenty-nine years of age.

Galenson and Weinberg argue that this significant shift in creativity patterns stemmed mostly from a sudden increase in the demand for contemporary art in the 1950s and 1960s. This change in the demand for works by contemporary American artists—many associated with Abstract Expressionism—was partially the result of the increasing influence of critics such as Clement Greenberg, together with a new structure in the gallery system. More and more galleries were willing to represent and support American artists; some of the most prominent early galleries include those of Peggy Guggenheim, Julien Levy, and Pierre Matisse.[10] Consequently, collectors began spending increasing amounts on contemporary works. In the 1950s and 1960s many young artists discovered that they didn't have to hold other jobs in order to survive. The increasingly dynamic gallery system allowed them to devote all of their time to pursuing their artistic careers.[11]

Economists readily accept the proposition that, on average, prices reflect the value and quality of works of art. This view, however, is extremely controversial among the public, in general, and among art historians, in particular. Galenson has made a major effort to show that the quality assessment extracted from a careful analysis of auction prices is not very different from what one obtains from an exhaustive reading of scholarly works by art historians and critics.[12] To do this, Galenson analyzes a large number of scholarly works on art history published in the United States and Europe, in which he focuses on identifying which works from specific artists are reproduced and discussed most often by the experts.[13] He argues that this procedure allows him to extract information on which works and periods in an artist's creative life are considered most important by scholars in the field. His analysis indicates that critics' judgments on artists' best periods and best works are extremely similar— almost identical, in fact—to those obtained from his regression analysis.

ART AS AN INVESTMENT

Because works of art are unique, it is difficult to compare art prices at different points in time. Consequently, measuring the rate of return of art as an investment is nontrivial, and it entails making a serious effort to compare the evolution of prices of very similar

10. On the Julien Levy gallery, see Levy (1977); Schaffner and Jacobs (1998). On the Pierre Matisse gallery, see Russell (1999), and on the Art of This Century gallery run by Peggy Guggenheim in New York, see Guggenheim (1997).

11. The galleries tended to pay their artists a modest stipend that allowed them to devote themselves fully to their artistic work. The stipend was paid back as their works were sold,

12. Galenson (1997, 1999, 2001).

13. This methodology, which is sometimes called historiometry, has been used by a number of authors to evaluate intellectual accomplishments and eminence. See, for example, Murray (2003).

objects. Economists have used two basic approaches to address this issue: repeated sales and hedonic prices.

The repeated sales methodology consists of comparing prices of works that have been sold more than once. By doing this, the analyst ensures that the characteristics of the asset—in this case, the work of art—are exactly the same at different points in time. In a pioneering article, Baumol uses this methodology to analyze the rate of return of art generally defined; he concludes that the annual return for the three centuries 1650 to 1960 was and in that sense, it was equivalent to a writer's advance. A very small number of Latin American artists who were connected to New York's art world participated in this system, receiving a stipend from their galleries. See Russell (1999) for the case of Cuban painter Wifredo Lam and Pierre Matisse's gallery. 0.55 percent per year.[14] Pesando calculates the rate of return on modern prints, and Pesando and Shum analyze the case of Picasso prints.[15] More recently, Mei and Moses use the repeated sales technique to estimate rates of return on American paintings, old masters, and impressionists.[16] Although the repeated sales methodology has the advantage of calculating price indexes on the basis of strictly comparable assets, it has the limitations of not using all available information and of averaging across artistic schools and artists in computing a single rate of return.[17] One of the main limitations of this approach is that many works of art are sold only once within the sample period.

The use of hedonic prices allows the researcher to use information on all transactions for which there are data, even if they refer to single sales. The hedonic price methodology was developed in the 1930s as a way of comparing prices of automobiles with different characteristics, and it has been used since to calculate price indexes of heterogeneous commodities, including houses, computers, and works of art. By using hedonic regressions, the researcher is able to construct a price index for the average painting. Average, in this case, is defined by maintaining constant a series of characteristics of the work, including the year it was painted, the support (paper, canvas, or board), the size, and whether the painting was signed by the artist.[18]

Most studies based on hedonic prices calculate the rate of return for very broadly defined portfolios. For example, Anderson; Buelens and Ginsburgh; and Chanel, Gérard-Varet, and Ginsburgh compute the rate of return on paintings in general.[19] Their results yielded

14. Baumol (1986). To exclude speculative transactions, Baumol only includes works that had been sold at least twice, at a minimum interval of twenty years.

15. Pesando (1993); Pesando and Shum (1996).

16. Mei and Moses (2001).

17. This last criticism also applies to analyses based on the hedonic prices approach.

18. On hedonic prices in general, see Berndt (1991) and the bibliography cited therein; on hedonic prices and the computation of price indexes for works of art, see de la Barre, Docclo, and Ginsburgh (1994); Ashenfelter and Graddy (2003); Chanel, Gérard-Varet, and Ginsburgh (1996).

19. Anderson (1974); Buelens and Ginsburgh (1993); Chanel, Gérard-Varet and Ginsburgh (1996).

an average (real) rate of return ranging from 2.6 to 4.9 percent. Buelens and Ginsburgh use hedonic prices to analyze the rate of return on five painting portfolios: English painters, non-English painters, Dutch painters, Italian painters, and impressionists.[20] De la Barre, Docclo, and Ginsburgh look at impressionists, while Czujack calculates the rate of return on Picasso paintings.[21] No researchers have undertaken a hedonic price study—or repeated sales studies, for that matter—on Latin American painters.

From an investment strategy perspective, an important question is the degree of correlation of returns from investing in art and from investing in other assets. More specifically, what is the effect of adding works of art on a portfolio's level of risk? A number of authors address this question, including Goetzmann, Pesando, and Mei and Moses.[22] While some authors analyze the correlation of returns on art portfolios and securities portfolios, others estimate different versions of the capital asset pricing model (CAPM). Most of these studies find that returns on (broadly defined) art portfolios have a low correlation with more traditional investment portfolios comprising marketable securities only.

THE DATA SET

In this paper I use a large data set on international auctions of Latin American works of art to analyze issues related to the creative process and to investigate the performance of Latin American art as an investment. The total number of observations is 12,690. The data set covers 115 artist from seventeen countries, for the period 1977 to 2001. In addition to data from international auctions, I have assembled biographical data on all 115 Latin American artists included in the sample, including their nationality, date of birth, date of death (when relevant), artistic school, and training. Nationalities are generally given by place of birth; for a few artists, however, nationality is defined by the country where the artist lived and did most of his or her work. For instance, I have classified Remedios Varo as Mexican although she was born in Spain, and English-born Leonora Carrington is similarly classified as Mexican. A complete list of artists is given in the appendix.

The data on auctions are from two sources. For 1977 through 1986, I used *Leonard's Price Index of Latin American Art at Auction;* for 1987–2001 I used the Artprice CD-ROM.[23] The following data were obtained from these two sources: the price at which the work was sold (excluding the buyer's premium);[24] the year and month of sale; the place of sale; the auction house, classified as Sotheby's (which pioneered Latin American art

20. Buelens and Ginsburgh (1993).

21. De la Barre, Docclo, and Ginsburgh (1994); Czujack (1997).

22. Goetzmann (1993); Pesando (1993); Mei and Moses (2001).

23. Theran (1999); Artprice (2002).

24. The original *Leonard's Index* data include the buyer's premium. To make the data compatible with those obtained from Artprice, I subtracted the premium from prices obtained from *Leonard's Index*.

auctions in 1979), Christie's, or other; the year in which the work was executed (when the work was done over a period of several years, I used the year it was finished); the size of the work, measured as length and width; whether the work in question is a drawing or a painting;[25] whether paintings are on canvas, board, or paper; and whether the artist signed the work in question.

To be included in the data set, an artist must have sold at least thirty-five works at international auctions during the period under study.[26] The mean number of works sold by each artist is 260, and the median is 117. Since not every work auctioned has information on every variable listed above, the number of observations used in the regression analysis was typically of the order of 6,000 to 7,000.

The artists with the largest number of pieces in the data set are Fernando Botero, Leonor Fini, Wifredo Lam, Roberto Matta, Carlos Mérida, Rene Portocarrero, Diego Rivera, Rufino Tamayo, Francisco Toledo, Joaquín Torres-García, and Francisco Zuñiga. Artists whose works sold in excess of U.S.$1 million are Tarsila do Amaral, Fernando Botero, Frida Kahlo, Wifredo Lam, Roberto Matta, Diego Rivera, Rufino Tamayo, and José María Velasco. Table 1 contains summary data for the most important variables in the data set.

While occasional auctions of works by Mexican artists were held in the United States in the mid-1970s, it was not until 1979 that a system of international auctions was established.[27] The first international auction exclusively dedicated to Latin American art was held at Sotheby's in New York in October of 1979. The total for that sale barely exceeded U.S.$1 million.[28] Christie's launched its own dedicated Latin American auctions in 1981, and since then both major houses have had semiannual auctions (May and October) in New York. In addition, smaller houses schedule regular auctions in other parts of the United States and in Europe.

The fact that it was not until 1979 that periodic and dedicated international auctions were held does not mean, however, that there was no interest in the United States or Europe in Latin American art. Contrary to what Martin asserts, a number of galleries in

25. In this paper paintings are defined as work on canvas, board, and paper, including watercolors, gouaches, and pastels.

26. This criterion for inclusion in the data set is completely objective and data driven. Most earlier studies on the economics of art rely on subjective criteria for including certain artists in the sample; for a discussion, see de la Barre, Docclo, and Ginsburgh (1994, p. 149). Since the data set contains relatively few Brazilian artists, I included two artists from that country with a smaller number of works sold at international auctions.

27. Martin (1999).

28. By comparison, each of the four yearly auctions currently held in New York by the two major houses tends to bring in between U.S.$6 million and U.S.$7 million.

TABLE 1. Latin American Art Data Set: Summary Statistics, 1978–2000

Summary statistic	Value
Number of artists	115
Number of countries	17
Average number of paintings per artist	206
Median number of paintings per artist	117
Average price (in 1995 U.S. dollars)	39,996
Median price (in 1995 U.S. dollars)	10,978
Percentage sold by Sotheby's and Christie's	78.9
Total number of observations	12,690

Source: Data on prices are from Artprice (2002) and Theran (1999). Data on artists' lives and careers were obtained from a variety of sources, including Lucie-Smith (1993), Traba (1994), Theran (1999), Ades (1989), Barnitz (2001), Cardoza y Aragón (1974), and Castedo (1969).

the United States had shown works by artists from Latin America as early as the 1930s, and many collectors were interested in their work.[29] For instance, Julien Levy exhibited Rufino Tamayo (Mexican) in 1937 and 1938, Frida Kahlo (Mexican) in 1938, Roberto Matta (Chilean) in 1940 and 1943, Jesús Guerrero Gal ván (Mexican) in 1943, and René Portocarrero (Cuban) in 1945. The Museum of Modern Art in New York had a number of large exhibits devoted to Latin American artists, including a major retrospective for Diego Rivera in 1931 and a large show for Roberto Matta in 1957, which was curated by William Rubin. In 1963 the Guggenheim Museum had a major show on promising young Latin American artists entitled *The Emerging Decade,* and in 1966 the San Francisco Museum of Art held a major exhibit on Latín American art from 1810 to 1960.[30] European galleries and museums also showed Latin American artists throughout the years. Jesús Rafael Soto (Venezuelan) had a one-man show at the Stedelijk Museum in Amsterdam in 1968, Antonio Seguí (Argentine) was shown at the Musée d' Art Moderne de la Ville de Paris in 1979, and Matta had a major retrospective at the Pompidou Center in Paris in 1985.

29. Martin (1999).

30. The show was entitled *Art of Latin America since Independence;* it was also shown at the Yale University Art Gallery, the Jack S. Blanton Museum of Art at the University of Texas at Austin, the La Jolla Art Museum in southern California, and the Isaac Delgado Museum of Art in New Orleans. See Yale University Art Gallery (1969) for details.

PATTERNS OF CREATIVITY: COMPARING THE PERIPHERY AND THE CENTER

Scholars have long been interested in understanding patterns of creativity. Why are some people more creative than others? What makes someone a genius? At what age does creativity peak? Is there a common age pattern in creativity? While psychologists have traditionally shown the most interest in understanding the creative process, scholars from other disciplines—including economists—have also dealt with this issue. In particular, a number of economists interested in understanding productivity growth have investigated the relationship between creativity and innovation.[31] As pointed out earlier in this paper, Galenson and also Galenson and Weinberg meticulously analyze the issue of creativity among American and French artists in a series of pioneering contributions that use auction prices of works of art.[32] An earlier article by de la Barre, Docclo, and Ginsburgh also relies on auction prices to analyze at what point in their careers a group of six artists did their best work; the aim of the paper, however, is more limited than that of Galenson and Weinberg, and it does not attempt to relate the age at which artists did their best work with specific creativity patterns.[33]

In this section I use auction data to analyze creativity patterns among Latin American artists. Specifically, I investigate the age at which Latin American artists—both individual artists and groups of artists organized by cohorts—did their most important work, to determine whether the age-creativity pattern of Latin American artists experienced a shift similar to that observed among U.S. painters. As documented by Galenson and Weinberg, the age at which Latin American painters executed their best work declined significantly for artists born after 1920.[34] The rest of this section proceeds as follows. First, I describe the empirical methodology used to construct indexes of creativity patterns. Second, I present results obtained from the computation of creativity patterns for what I call the big six Latin American artists: Fernando Botero, Frida Kahlo, Wifredo Lam, Roberto Matta, Diego Rivera, and Rufino Tamayo. Third, I estimate age-creativity patterns for Latin American artists in three age cohorts: artists born before 1900, those born between 1900 and 1920; and those born after 1920. Finally, I discuss future work on creativity patterns of Latin American artists.

31. See, for example, Griliches (1979, 1994).

32. Galenson (1997, 1999, 2001); Galenson and Weinberg (2000).

33. De la Barre, Docclo, and Ginsburgh (1994). Table 5 of that paper (p. 161) includes date ranges when the six authors in their sample experienced "good and bad spells."

34. Galenson and Weinberg (2000). Whether the creativity patterns of Latin American artists changed depends on the evolution of the demand for Latin American art during the second half of the twentieth century. In contrast with the United States, no major influential critics championed the younger regional artists. The possible exception was Marta Traba, an Argentine critic based in Bogotá. Her influence varied across countries, however, because Latin America's artistic world was—and, to a significant degree, continues to be–largely fragmented. Traba died in an airplane accident in 1983. In 1994 the Inter-American Development Bank published her magnificent posthumous work, *Arte de América Latina: 1900–1980*.

The Empirical Model

To identify the age at which artists did their best, or most important, work, I estimate regression equations that relate the log of the price of a particular work to a number of characteristics of the work in question, including a polynomial on the age at which quations of the following type were estimated:

(1) $\ln PRICE_{jt} = \alpha_1 AGE_{jt} + \alpha_2 AGE^2_{jt} + \alpha_3 AGE^3_{jt} + \alpha_4 AGE^4_{jt}$
 $+ \alpha_5 \ln HEIGHT_{jt} + \alpha_6 \ln WIDTH_{jt} + \alpha_7 PAPER_{jt}$
 $+ \alpha_8 SIGNED_{jt} + \sum \beta_i YEAROFSALE$
 $+ \sum \gamma_i ARTIST + \sum \sigma_i DECADE + \varepsilon_{jt},$

where the subscripts *jt* refer to painting *j* sold in period *t*. $PRICE_{jt}$, is the price expressed in 1995 dollars. AGE is the artist's age when the painting was executed, HEIGHT and WIDTH capture the painting's size. PAPER is a dummy variable that takes a value of 1 if the support is paper and zero otherwise (when the support is canvas, board, or other material). SIGNED is a dummy variable that takes the value of one if the piece has not been signed by the artist, and takes a value of zero if it has been signed. The regressions also include a year-of-sale dummy, an artist dummy, and a decade dummy that captures the possible existence of vintage effects. Finally, ε_{jt} is an error term. As discussed below, I make alternative assumptions regarding this error term in the estimation of the panel regression in equation 1.

The α_1 through α_4 coefficients on the AGE polynomial determine the pattern of creativity, or the relation between the artist's age when the painting was executed and the painting's price. To determine the actual order of the polynomial, I estimated models with polynomials of degrees 2 through 4 and then selected the specification with the highest polynomial for which all estimated coefficients turned out to be significant.

Before I present the results, it is important to discuss some of the limitations of auction prices for this type of analysis (these limitations also apply to the rate-of-return calculations presented later in the paper). Possibly the most important limitation is that the data entail a selection bias. By definition, the analysis includes only those works that have been sold—and excludes those that are "bought in" or are not put on the block. The data set thus tends to exclude prices that are on the upper and lower ends of the distribution. The data set is also subject to an omitted variables problem, in that it does not include some characteristics of the pieces sold such as their specific style or whether they have been included in major exhibitions or retrospectives.[36] Moreover, auction prices exclude

35. Following Galenson (1997, 2001); Galenson and Weinberg (2000).

36. The style, however, is closely related to the year in which the piece was painted; the data set includes information on dates when paintings were executed.

transaction costs—both the buyer's premium and the seller's commission. The data set has no direct information on the supply of works of art, such as how many works each artist produced per year or the artist's overall production.[37] And, as argued by Rosen, hedonic price regressions do not capture demand characteristics; the coefficients obtained from hedonic estimations reflect both demand and supply forces.[38]

Two additional limitations are particularly relevant for the analysis of rates of return presented later. First, auctions are subject to very high transaction costs in the form of buyer's and seller's premiums, transportation costs, and insurance. This is not the case for financial assets. Second, works of art yield a dividend in the form of satisfaction from owning them and being able to enjoy their beauty. The data do not measure this dividend, however. The presence of these limitations does not mean that auction prices have little information value, but simply that results obtained using these data should be interpreted carefully.

Individual Creativity Patterns of the Big Six

I estimated equations like equation 1 for the six individual artists who are usually considered the most important in Latin America: Fernando Botero, Frida Kahlo, Wifredo Lam, Roberto Matta, Diego Rivera, and Rufino Tamayo. With the exception of Botero, who was born in 1932, all were born before 1920—and Rivera and Tamayo were born before 1900. Table 2 summarizes some basic data for each of them, including the number of paintings in the sample, the average and median sale prices (in 1995 U.S. dollars), the percentage of paintings executed on paper, and the order of the estimated polynomial (for date of birth and death—if relevant—see the appendix).

Figure 1 presents the estimated price-age profiles for these six artists. The data on the horizontal axes refer to the artist's age; those on the vertical axes are on the log of prices and are not comparable across artists. The age-price patterns are quite different for the big six artists. For Mexicans Diego Rivera and Rufino Tamayo and for Cuban Wifredo Lam, the schedule is first rising with age, until it reaches a peak; it then declines into a trough, which is followed by a new ascending segment. For Tamayo and Lam, the recovery continues until the time of their death. For Rivera, on the other hand, there is a plateau at sixty-five years of age, followed by a new decline; according to these calculations his latest works are the least important of his overall oeuvre. Although these three artists did their most valuable work at different ages, they all did it during the first half of their careers: Rivera's best work was done when he was thirty-one years old; Tamayo did his most valuable work at forty-four years old; and Lam did his best work when he was thirty-nine years old, which corresponds approximately to the time when he painted his famous piece, *The*

37. Including variables related to supply—such as whether the artist is alive or the year of the artist's death—does not change the results in any significant way.
38. Rosen (1974).

TABLE 2. Summary Statistics for the Big Six Artists

Artist	Number of paintings	Average price (1995 U.S. dollars)	Median price (1995 U.S. dollars)	Percentage of paintings on paper	Degree of polynomial
Fernando Botero	374	138,507	93,018	11.8	3
Frida Kahlo	40	576,702	149,391	14.6	4
Wifredo Lam	495	69,417	22,397	26.1	3
Roberto Matta	436	81,294	34,565	11.5	3
Diego Rivera	471	108,392	27,932	52.4	4
Rufino Tamayo	386	177,208	80,134	31.6	3

Source: Artprice (2002); Theran (1999).

Jungle, currently in the permanent collection of the Museum of Modern Art. All in all, then, these three artists peaked quite early in their careers and, according to the discussion above, can be classified as conceptual artists.

Mexican artist Frida Kahlo did her most valuable work at thirty-eight years old (in 1945), when she painted some of her most famous self-portraits, including *Self-Portrait with Small Monkey,* and some of her best-known allegorical paintings, such as *Tree of Hope* and *The Broken Column.* In contrast with Rivera, Tamayo, and Lam, Kahlo's creativity profile in figure 1 shows that the (log of the) price of her work declined initially. As may be seen, her creativity schedule reaches its lowest level when she is in her mid-20s. From that point on, the value of her work—as captured by auction prices data—increases steadily, until it reaches a maximum at age thirty-eight. Indeed, because her work peaked at such a relatively young age, it is possible to classify her as a conceptual artist.

A simple visual comparison of the age-price profiles for Chilean Roberto Matta and Colombian Fernando Botero shows that these are very different—both from the previous group of artists and from each other—and they are quite extreme. While Matta's work exhibits a continuous decline in prices with age, Botero shows a continuous increase in prices with age. The relationship is not linear for either artist, but the direction is unmistakable in both cases, and the maxima are at the extremes—at a very early age for Matta and at a fairly old age for Botero. Matta thus appears to be a quintessential case of a conceptual artist; Botero, on the other hand, is a prime example of an experimental artist.

According to these results, Matta's most important work was done in the late 1930s and very early 1940s, when he painted his psychological morphologies and psychological inscapes, and before he introduced the robotic-type characters that began to populate his work in the late 1940s and 1950s.[39] The pattern of strict decline that is evident in Matta's

39. He sometimes referred to these creatures as the Great Transparents, an allusion to characters that appear in some of Andre Breton's writings.

FIGURE 1. Creativity Patterns of the Big Six

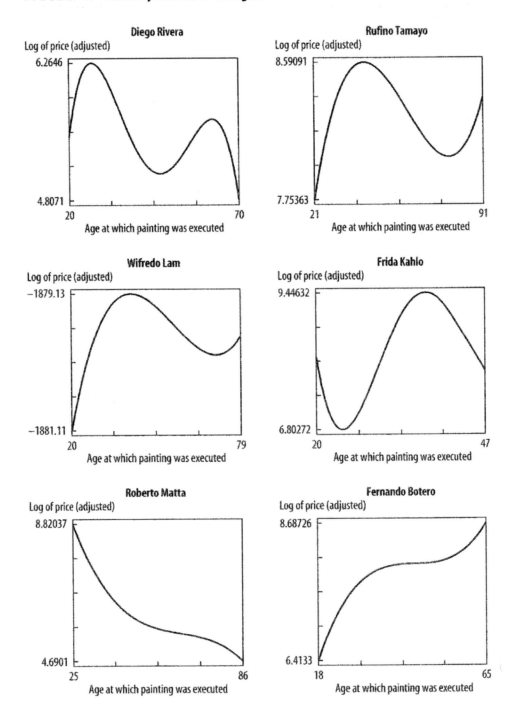

creativity pattern is quite unusual: only five of the thirty-one American artists analyzed by Galenson show this kind of behavior.[40] Even artists such as Jasper Johns, whose pattern exhibits an overall decline through age, have marked inflections and local maxima at an older age.[41] The case of Botero is almost exactly the opposite of that of Matta. His early works—including his still lifes and early portraits—are less important than his very recent works, in which the motifs revolve around Colombian society and people and in which a local narrative always lies at the center of the composition. As depicted in figure 1, Botero is a very clear case of an experimental artist. Indeed, in a recent interview he acknowledges that his work process does not include developing a series of preparatory sketches.[42]

Age Cohorts and Creativity Patterns of Latin American Artists

To investigate whether creativity patterns of Latin American artists have changed through time, I estimated a series of panel regressions based on equation 1 for three age cohorts.[43] The first cohort corresponds to artists born before 1900. Most—but not all—of these artists' work is traditional, and it follows the European artistic canon. Many artists in this group produced landscapes that capture the big vistas of their countries, as well as marine subjects. José María Velasco, from Mexico, is perhaps the most prominent of this traditional group. A second group of pre-1900 artists ventured into the late nineteenth and early twentieth century European trends, including impressionism, fauvism, and cubism. Consider, for example, the early work by Diego Rivera. Finally, a small number of pre-1900 artists developed very personal styles that, in some cases, became quintessential representatives of Latin American art. This is the case of the work by Rufino Tamayo, Joaquín Torres-García, Carlos Mérida, and the Mexican muralists (namely, Diego Rivera, David Siqueiros, and José Clemente Orozco).

The second cohort corresponds to artists born between 1900 and 1920, and it includes a wide variety of artists. Some of these have become iconic, including Frida Kahlo and Wifredo Lam. Some of the better known artists in this group spent much of their careers away from their home country. Wifredo Lam, for example, lived mostly in France, except for a period in the 1940s and 1950s. Roberto Matta left his native Chile in the mid-1930s and he only returned to it briefly after a prolonged period of time. Matta's estrangement from his native country was so deep that some critics have referred to him as a French

40. Galenson (1997).
41. Galenson's results indicate that Johns did his best work at the very beginning of his career, when he was twenty-five years old, but he exhibits a local maxima in his mid-fifties.
42. Serena (2003).
43. In addition to the three cohorts discussed here, I used alternative breakpoints to define the age groups. The results obtained, however, were very similar to those reported in this subsection.

FIGURE 2. **Creativity Pattern for the Pre-1900 Cohort**

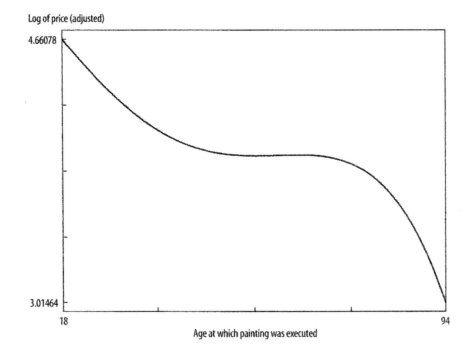

Log of price (adjusted)

4.66078

3.01464

18 94

Age at which painting was executed

artist, born in Chile.[44] In terms of artistic schools, this cohort exhibits a wide variety that includes abstract expressionism, figurative, surrealism, and constructivism.

The third cohort corresponds to artists born after 1920. As in the previous two cases, this group includes representatives from a variety of artistic schools. There are some very prominent artists, such as Fernando Botero, Francisco Toledo, and Claudio Bravo, and some that have played an important conceptual and intellectual role in the development of Latin American art. This is the case of Mexican José Luis Cuevas, who in 1956 wrote a manifesto criticizing the then-predominant trend in Mexico of painting almost exclusively nationalistic—and revolutionary—scenes. In many ways, Cuevas's manifesto, which was entitled *The Cactus Curtain,* marked the beginning of the so-called neofiguration school among Mexican and Latin American artists. Cuevas's manifesto provided a new intellectual framework for the very old debate among Latin American artists: should their work attempt to capture the region's realities, or should it be more universal in its themes and subjects? Most scholars and art historians that deal with Latin American art discuss this issue, in one way or another. The history of the region's art movements is replete with manifestos that address questions such as the nature of Latin American art and the artist's relation to Latin America's social realities. Some intellectuals have argued that Latin American artists should aim at producing a synthesis between European esthetic and artistic principles (especially modernism) and regional realities. Possibly the most influential movement along these

44. Fletcher (1992).

lines was *antropofagia,* developed by Oswald de Andrade and Tarsila do Amaral in Brazil. The legendary *Week of Modern Art* that took place on 13–18 February 1922 in São Paulo gave the movement a great thrust. In 1924—the same year André Breton published his *Surrealist Manifesto*—Oswald de Andrade published his *Manifiesto da Poesía Pau-Brasil.*

Figures 2 through 4 present the creativity patterns estimated for the three cohorts. These figures were constructed from regression results estimated using weighted least squares, where the total number of works sold at auction by each artist are used as weights.[45] The results show very different patterns across the three age groups. The relation between the age at which the work was executed and prices exhibits an overall declining trend for the pre-1900 and 1900–20 cohorts. This suggests that conceptual artists dominated these two cohorts. The patterns are different for these two groups, however. While the maximum occurs at a very early age for the pre-1900 cohort (twenty-three years old), the maximum takes place at thirty-one years of age for the 1900–20 cohort. Furthermore, the group born before 1900 displays a decline in prices between ages twenty-three and forty-one; the schedule then exhibits a plateau of sorts through the age of sixty-five. Finally, for the cohort born after 1920, the price schedule is clearly upward sloping. The maximum is achieved at sixty-six years of age, indicating that experimental artists dominate this cohort.

FIGURE 3. Creativity Pattern for the 1900–20 Cohort

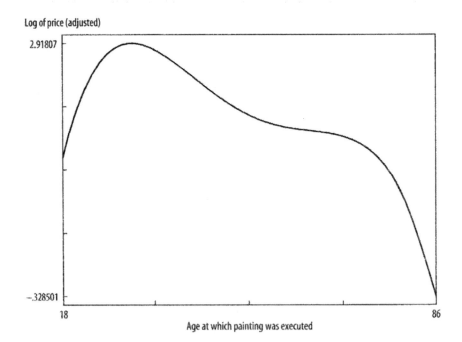

Log of price (adjusted)

Age at which painting was executed

45. I also estimated regressions using feasible least squares (FLS) and unweighted least squares. The results were very similar to those discussed here.

These results suggest that Latin American artists, as a group, moved from peaking early—a characteristic associated with conceptual artists—to peaking later and later in their careers. Formal tests for the equality of the coefficients of the age variables confirmed that these cohorts of artists have distinct creativity profiles. The F test for the hypothesis of equality of coefficients between the pre-1900 and the 1900–20 cohort has a value of 34.7; the F test for the comparison between the pre-1900 and the post-1920 group is 129.4; and the F test for equality of coefficients for the 1900–20 and post-1920 groups is 73.7. These results are very different from what Galenson finds for American and French artists, for whom the age at which the most important work was done moved progressively earlier in time. Artists born after 1920 did their best work at a significantly younger age than their older colleagues.[46]

The results for Latin American artists presented in figures 2 through 4 imply that creativity profiles in the "periphery" have not changed through time in the same way they changed in the "center." This is not really surprising, as the conditions under which the arts have developed in Latin America have been very different from those in the United States. Indeed, the three factors identified by Galenson and Weinberg as being behind the shift in creativity patterns in the United States—that is, increased demand by collectors

FIGURE 4. Creativity Pattern for the Post-1920 Cohort

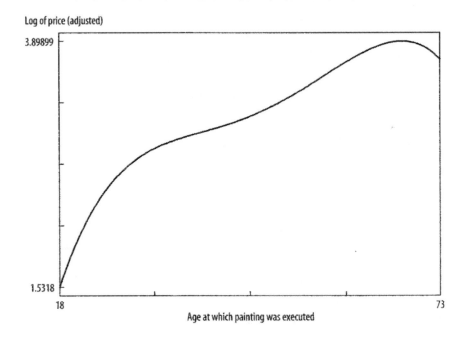

Log of price (adjusted)

3.89899

1.5318

18

73

Age at which painting was executed

46. Galenson (2001); Galenson and Weinberg (2000).

for innovative works, the influence of prominent critics, and a new gallery system—have been largely absent in Latin America.[47]

In contrast with the United States, the history of Latin American art in the second half of the twentieth century has not been the history of artists searching for new ways of innovating. The greatest effort to innovate came early in the twentieth century, when Latin American artists struggled to find a voice of their own; this effort was mostly undertaken by artists born before 1920. During the early decades of the last century, there was great interest in defining a type of art that could genuinely be considered Latin American. This movement was largely based on the idea that the region's artists should find a synthesis between traditional precepts—mostly coming from Europe—and the local realities. This search for a Latin American identity resulted in major artistic innovations in the 1920s, 1930s, and 1940s, including the muralist movement in Mexico, *antropofagia* in Brazil, and the constructivist school in the Río de la Plata. Young artists who were willing to break with the academician heritage of Europe were at the forefront of this trend, and they created new ideas of what Latin American artists should do. In Galenson's terms, these artists were largely conceptual. They developed an artistic concept of what was genuinely Latin American, and, although they were by no means a homogeneous group, they had in common the development of new visions that integrated artistic trends coming from the center and the periphery. Tarsila do Amaral, Dr. Atl, Frida Kahlo, Wifredo Lam, Diego Rivera, and Rufino Tamayo are representatives of this group of artists who helped define Latin American art.

By the mid-twentieth century, a well-defined Latin American artistic voice had been established, and collectors began looking for variations of this perspective. As a result, younger artists began to improve on this now well-accepted approach, and they began experimenting with newer perspectives within the Latin American voice. This resulted in a new creativity pattern for younger artists; they did their best work at a considerably older age than their "rupturist" older colleagues. Osvaldo Guayasamín and Fernando Botero are emblematic of this trend. To be sure, many artists in the second half of the twentieth century tried to break away from the Latin American canon developed during the previous decade, in particular with what they considered to be an excessive representation of political—in the case of Mexico, revolutionary—themes. However, even these rebellious artists, such as José Luis Cuevas and his neofiguration colleagues, continued to rely on technique and craftsmanship—two characteristics associated with experimental artists. To this day, collectors of Latin American art favor works with a strong regional content, based on distinctive Latin American voice and imagery. As documented by Traba, the Latin American public continued to prefer more traditional works throughout the 1950s, 1960s, and 1970s, in contrast with the case of the United States.[48] Only a very small group

47. Galenson and Weinberg (2000).
48. Traba (1994).

of adventurous collectors pursued and purchased works by artists who were pushing the global creative envelope.[49]

Artistic Creativity in Latin America: Directions for Future Work

Future work in this area should go beyond using the year of birth as the main organizing principle for analyzing patterns of creativity among Latin American artists. Indeed, the distinction between artists born before and after 1920 appears not to be very relevant, since the 1950s and 1960s were not characterized by any major changes in the demand for Latin American art or in the Latin American gallery system. More promising lines of exploration are related to other characteristics of artists, including the following three.

—The artistic (or esthetic) inclinations of the artist in question. In particular, comparing traditional (or indigenist) artists whose themes are unequivocally Latin American with universalist artists is a promising avenue. The Mexican muralists, Tarsila do Amaral, Fernando Botero, and Francisco Zuñiga, are representatives of the traditionalist-indigenist trend; examples of universalists include José Luis Cuevas, Gunther Gerszo, and Roberto Matta.

—Artists with and without formal training abroad. This type of comparison will provide an indication of the effects of artistic and cultural exchanges on creativity patterns. It will also shed some light on whether those who are trained abroad experience a noticeable learning curve.

—Female artists versus male artists. Psychologists have traditionally argued that the creative pattern is different for men and women. In the case of Latin American art, this comparison is particularly interesting in light of the tremendous posthumous success of Mexican artist Frida Kahlo.

Preliminary results suggest that artists who have received formal training abroad tend to do their most important works at an older age than those with no foreign training. While the former group achieves its maximum (conditional) price of paintings at thirty-seven years of age, the latter group reaches the maximum at twenty-three years of age. These results also suggest that artists with formal training experience a very steep learning curve: between the ages of eighteen and thirty-seven, the price of their paintings increases very sharply with every additional year. With respect to universalists and traditionalists, a preliminary regression analysis indicates that the former group's most valuable work was done at age thirty-four. Traditionalists, on the other hand, exhibit a virtual plateau, and their highest-priced work is done between the ages of twenty-three and sixty-two years of age.

49. By this I don't mean to say that there were no true innovators among the younger artists. Jesús Rafael Soto is an important example. The arguments made above refer to the general trend among Latin American artists of different generations.

LATIN AMERICAN ART AS AN INVESTMENT

In this section I use the data set described above to analyze Latin American art as an investment. As pointed out earlier in this paper, the literature employs two basic approaches to analyze the rate of return of works of art: the repeated sales approach and the hedonic prices approach. This paper is based on hedonic prices, as this technique allows me to use all the available information and thus to obtain more precise estimates of the coefficients of interest.[50] More specifically, I use panel regressions to compute hedonic price indexes for thirteen different national portfolios. I then use these national results to calculate the rate of return (and standard deviation) of an overall portfolio of Latin American works of art. I finally analyze whether adding Latin American art reduces the overall level of risk of an international portfolio composed of marketable securities.

Examples of individual paintings that were sold more that once during the period under study include Mexican artist Gunther Gerszo's *Rojo, Azul y Amarillo,* executed in 1966, which was sold in 1985 for U.S.$12,000 and in 1992 for U.S.$38,000. Wifredo Lam's 1943 painting, *La Mañana Verde,* was sold in 1987 for U.S.$380,000, in 1990 for U.S.$550,000, and in 1992 for U.S.$870,000. Finally, Roberto Malta's 1942 canvas, *The Disasters of Mysticism,* was sold in 1983 for U.S.$160,000, in 1990 for U.S.$1.12 million, and in 1999 for U.S.$2.4 million.

Hedonic Price Indexes and Rates of Return on National Portfolios

The first step in the computation of rates of return consists of calculating a hedonic price index for a comparable average work of art. I used panel data to estimate equations of the following type for artists from thirteen different countries:[51]

$$
\begin{aligned}
\ln \text{PRICE}_{jt} = &\sum \beta_i \text{YEAROFSALE} + \alpha_1 \text{AGE}_{jt} + \alpha_2 \text{AGE}^2_{jt} + \alpha_3 \text{AGE}^3_{jt} \\
& + \alpha_4 \text{AGE}^4_{jt} + \alpha_5 \ln \text{HEIGHT}_{jt} + \alpha_6 \ln \text{WIDTH}_{jt} \\
& + \alpha_7 \text{PAPER}_{jt} + \alpha_8 \text{SIGNED}_{jt} \\
& + \sum \gamma_i \text{ARTIST} + \sum \sigma_i \text{DECADE} + \varepsilon_{jt}.
\end{aligned}
$$

(2)

The estimated β_i coefficients are the variables of interest. They provide information on the evolution through time of the log of the price of a work of art, maintaining constant (at their mean values) the characteristics of all other covariates included in the hedonic regression 2. To construct the hedonic price index, the β_i coefficient for the first year in the

50. Chanel, Gérard-Varet, and Ginsburgh (1996) compare the estimates obtained using the repeated sales and hedonic prices techniques. They find that while the coefficients obtained using both methods are unbiased, those obtained using hedonic prices have a significantly smaller standard deviation.

51. I estimated hedonic price indexes for twelve national portfolios and for a thirteenth portfolio that included artists from all other nationalities. See figure 5 for details on the national portfolios.

sample (1980 in this case) is normalized to one, and the rest of the coefficients are adjusted accordingly.[52] I used this procedure to construct hedonic price indexes for the following national portfolios: Argentina, Brazil, Chile, Colombia, Cuba, Ecuador, Guatemala, Haiti, Mexico, Peru, Uruguay, Venezuela, and all other nationalities. I then used these data on national hedonic price indexes to compute rates of return of an equal-value Latin American portfolio composed of all thirteen individual national portfolios.[53]

The results obtained from this exercise are summarized in figures 5 through 7. Figure 5 presents the evolution of the hedonic price indexes for selected national portfolios. Figure 6 shows the evolution of the real rate of return in U.S. dollars of the equal-value overall—or total—portfolio of Latin American works of art from 1981 through 2000. Figure 7 depicts the rates of return and standard deviation for the thirteen national portfolios, as well as for the overall portfolio. As may be seen from figure 6, annual (real) rates of return for the overall Latin American art portfolio were always positive and quite high between 1982 and 1990. Between 1991 and 2000, the rates of return were significantly lower, more volatile, and often negative. For the total portfolio and the complete 1981–2000 period, the overall mean annual (real) return was a hefty 9 percent, with a standard deviation of 12.6 percent.[54] To put these figures in perspective, during the same period the following real rates of return (and standard deviations) were observed in selected emerging stock markets: Argentina: 3.8 percent (standard deviation of 57.3 percent); Brazil: 7.3 percent (54.0 percent); Chile: 7.3 percent (41.0 percent); South Korea: 1.1 percent (55.0 percent); and Mexico: 5.5 percent (56.0 percent).

Figure 6 shows that, as expected, there is a positive relation between mean returns and risk. National portfolios with higher mean returns for the period under study tend to be precisely those with a higher standard deviation of returns. This figure also shows that, as expected, the diversified overall portfolio has a much lower degree of risk than the individual national portfolios. The important issue of the correlation between the rate of return of the Latin American portfolios and overall diversified world portfolios is addressed below.

52. This procedure assumes that the coefficients of the other covariates in equation 2 are stable through time. This need not be the case, however. It is possible to compute hedonic prices assuming that these coefficients change through time. This requires using some type of chain rule that links the different panel regressions for different periods.

53. Using equal weights across national portfolios for calculating the total or overall portfolio's rate of return may provide figures that are not very realistic, because the prices of individual pieces vary widely for each of the national portfolios. For instance, average prices are quite high for the case of Chile, and relatively low for the case of Haiti.

54. These figures are gross; they do not net out transaction costs.

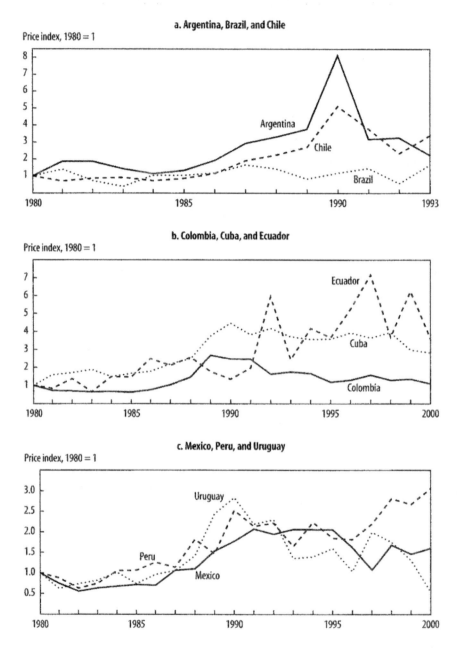

FIGURE 5. Hedonic Price Indexes for Selected Portfolios

a. Argentina, Brazil, and Chile

Price index, 1980 = 1

b. Colombia, Cuba, and Ecuador

Price index, 1980 = 1

c. Mexico, Peru, and Uruguay

Price index, 1980 = 1

Thematic and Other Portfolios

In addition to the national portfolios discussed above, I also computed hedonic price indexes, rates of return, and standard deviations for a number of thematic portfolios, including portfolios for (a) traditionalist artists (or artists whose motives and imagery

FIGURE 6. Annual Real Rates of Return on Overall Portfolio of Latin American Artists

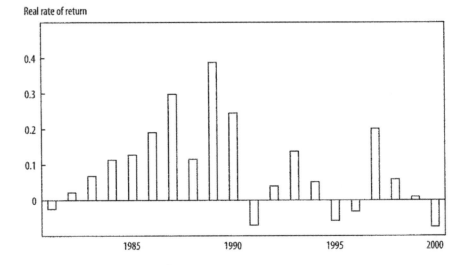

FIGURE 7. Risk and Return on National Artist's Portfolios, 1980–2000

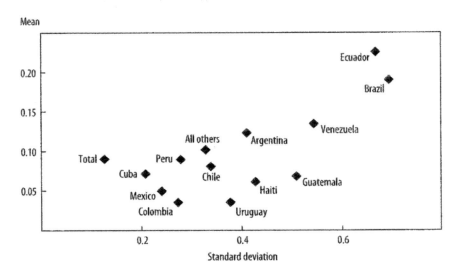

are quintessentially Latin American); (b) universalist artists; (c) older artists (born before 1900); (d) intermediate artists (born between 1900 and 1920); (e) younger artists (born after 1920); (f) artists with formal training abroad; (g) artists with no formal training abroad; and (h) women artists, excluding Frida Kahlo. The results obtained are presented in table 3; they may be summarized as follows:

—Traditionalist portfolios had a higher mean rate of return than universalists;

—A portfolio of younger artists (born after 1920) had higher rates of return than portfolios of older artists, together with a lower standard deviation;

—Artists with formal training abroad had a slightly higher rate of return and slightly lower standard deviation than portfolios of artists without such training; and

—A portfolio of women artists (excluding Frida Kahlo) had by far the highest annual mean rate of return—a quite remarkable 32.04 percent—but it also had a significantly higher standard deviation than the other portfolios.

The Correlation Between the Rate of Return on Latin American Art and International Portfolios

An important issue for anyone developing an investment strategy is the degree of correlation between returns on art and returns on other assets. The critical point involves identifying the effect of adding works of art to a diversified portfolio on the portfolio's level of risk. Some authors address this question by analyzing the correlation of returns on art portfolios and securities portfolios; others estimate different versions of the capital asset pricing model (CAPM). Most of these studies find that the correlation between returns on art portfolios and returns on more traditional investment portfolios made up of marketable securities only is low.

TABLE 3. Rates of Return for Portfolios of Latin American Art, 1981–2000 and 1985–2000

	1981–2000		1985–2000	
Portfolio	Mean	Standard deviation	Mean	Standard deviation
Traditionalists	0.0583	0.2190	0.0811	0.2140
Universalists	0.0396	0.1909	0.0584	0.1934
Older artists (pre–1900)	0.0390	0.2071	0.0566	0.2001
Intermediate artists (1900–20)	0.0412	0.2144	0.0644	0.2015
Younger artists (post–1920)	0.0554	0.1826	0.0735	0.1877
Foreign training	0.0525	0.2053	0.0726	0.2105
No foreign training	0.0491	0.2166	0.0618	0.2128
Women (except Kahlo)	0.3205	1.4000	0.2324	0.5010

Source: Author's calculations.

I deal with this issue by estimating equations for the well-known CAPM, which measures the degree of correlation of a particular asset (or asset class) and the market return. The standard CAPM equation regresses the excess return of the asset in question—measured

as the difference between its return and that of a risk-free asset—and the excess market return:

$$(3) \qquad R_t^{LA} - r_t^F = \alpha + \beta \, (R_t^M - r_t^F) + \varepsilon_t$$

where R_t^{LA} is the rate of return of the portfolio of Latin American artists, r_t^F is the return on the risk-free asset, R_t^M is the rate of return on the market portfolio, and ε_t is a white-noise error term. The coefficient β measures the degree of correlation between the art portfolio and the market portfolio. The lower the estimated beta, the lower the correlation between the two portfolios and the more attractive the Latin American portfolio will be. The reason for this is that low-beta portfolios (or securities) tend to lower the risk of a particular portfolio. I estimated equations similar to equation 3 for a number of Latin American art portfolios. I used the three-month real return on U.S. Treasury bills as a measure of the risk-free rate; the (real) return on the Morgan Stanley Capital International (MSCI) World portfolio as a measure of the market return; and the overall Latin American portfolio as a measure of R_t^{LA}. The following result was obtained when equation 3 was estimated using ordinary least squares:

$$R_t^{LA} - r_t^F = 0.0548 + 0.108(R_t^M - r_t^F),$$
$$(1.82)(0.58)$$

where the Durbin-Watson statistic is 1.4 and the number of observations is twenty. The estimated beta coefficient is significantly lower than one and not significantly different from zero. This indicates that adding Latin American art will reduce the riskiness of an international portfolio composed of equities.

CONCLUDING REMARKS

In this paper I have used data on auction prices to investigate two aspects of the economics of Latin American art: the relationship between age and creativity and Latin American art as an investment. The data set has more than 12,600 observations, and it includes prices and other characteristics on sales of works by 115 artists from seventeen countries during the period 1978–2001.

The analysis on creativity suggests that Latin American artists have followed very different patterns than American artists. Strong evidence suggests that American artists born after 1920 did their best work at an earlier age than their colleagues born before 1920. Exactly the opposite is true for the case of Latin America: the results reported in this paper suggest that Latin American artists born after 1920 did their best work at a significantly older age than their colleagues from earlier cohorts. This difference in creativity patterns among these two groups of artists reflects differences in the market for American and Latin American art. Galenson and Weinberg argue that the demand for contemporary art

increased significantly in the United States in the 1950s and 1960s.[55] Following the lead of influential critics, a new generation of American collectors began purchasing more and more works by American painters. These collectors put a big premium on innovation, thus pushing artists to do significant work at a relatively young age. The evolution of Latin American art has been very different. During the first half of the twentieth century, Latin American artists struggled to find a voice of their own. This effort was largely based on the idea that Latin American artists should find a synthesis between traditional precepts—mostly coming from Europe—and the region's realities. This search for a Latin American identity resulted in major artistic innovations in the region in the 1920s, 1930s, and 1940s. Young artists who were willing to break with the academician heritage of Europe undertook most of these innovations, including Tarsila do Amaral, Dr. Atl, Frida Kahlo, Wifredo Lam, Diego Rivera, and Rufino Tamayo. These revolutionary artists did their best—and most innovative—work early on in their careers. By the 1950s, a well-defined Latin American artistic voice had been established, and collectors and critics began looking for variants of this perspective. This led younger artists to strive to improve on the well-accepted approach. Improvement came slowly and took time. This resulted in a new creativity pattern for younger artists, such as Osvaldo Guayasamín and Fernando Botero, who did their best work at a considerably older age than their older colleagues. Many artists in the second half of the twentieth century tried to break away from the established Latin American style, but most collectors continued to favor works with a strong regional content based on distinctive Latin American imagery.

The analysis of art as an investment was based on the estimation of hedonic price indexes. It indicates that Latin American art has had a relatively high rate of return—much higher than that of other types of paintings. That return comes at the cost of high volatility, however. The standard deviations of national portfolios of Latin American art are quite high. The analysis presented here suggests that a thematic portfolio of female artists (excluding Frida Kahlo) had the highest rate of return in the sample; it also had the highest standard deviation. From an investment strategy perspective, an important question involves the effect of adding works of art to a diversified portfolio. The results reported in this paper indicate that returns on Latin American art have a very low degree of correlation—that is, a very low beta—with an international portfolio composed of equities. This means that adding Latin American art will lower the overall risk of an international portfolio.

55. Galenson and Weinberg (2000).

APPENDIX. Artists in Data Set

Artist	Country	Dates	Artist	Country	Dates
Abela, Eduardo	Cuba	1889-1965	Escobar, Marisol	Venezuela	1930-
Alfonzo, Carlos	Cuba	1950-1991	Fernández, Agustín	Cuba	1928-
Angu'iano, Raúl	Mexico	1915-	Figari, Pedro	Uruguay	1861-1938
Atl, Or. (Gerardo Murillo)	Mexico	1875-1964	Fini, Leonor	Argentina	1908-96
Bazile, Castéra	Haiti	1923-66	Gerszo, Gunther	Mexico	1915-2002
Bermudez, Cundo	Cuba	1914-	Gourgue, Jacques	Haití	1930-98
Berni, Antonio	Argentina	1905-81	Enguerrand		
Bigaud, Wilson	Haiti	1931-	Grau, Enrique	Colombia	1920-
Bonevardi, Marcelo	Argentina	1929-94	Greenwood, Marion	U.S., Mexico	1909-70
Botello, Angel	Spain,	1913-86	Guayasamín, Osvaldo	Ecuador	1919-99
	Puerto Rico		Guerrero Ga Iván, Jesús	Mexico	1910-73
Botero, Fernando	Colombia	1932-	Hernández, Daniel	Peru	1856-1932
Bravo, Claudio	Chile	1936-	Hoyos, Ana Mercedes	Colombia	1942-
Bush, Norton	U.S., Panama	1834-94	Hyppolite, Hector	Haiti	1894-1948
Cantú, Federico	Mexico	1908-89	Iturria, Ignacio de	Uruguay	1949-
Cardenas, Agustín	Cuba	1927-2001	Izquierdo, María	Mexico	1902-55
Carreno, Mario	Cuba, Chile	1913-99	Kahlo, Frida	Mexico	1907-54
Carrington, Leonora	U.K., Mexico	1917-	Kingman, Eduardo	Ecuador	1913-97
Castañeda, Alfredo	Mexico	1938-	Kuitca, Guillermo	Argentina	1961-
Castañeda, Felipe	Mexico	1933-	Lam, Wifredo	Cuba	1902-82
Chariot, Jean	France, Mexico	1898-1979	Larraz, Julio	Mexico	1944-
Clausell, Joaquín	Mexico	1866-1935	Laville, Helene Joy	Mexico	1923-
Col unga, Alejandro	Mexico	1948-	Leuus, Jesús	Mexico	1931-
Coronel, Pedro	Mexico	1923-85	Lohr, August	Germany,	1843-1919
Coronel, Rafael	Mexico	1932-		Mexico	
Corzas, Francisco	Mexico	1936-83	Lynch, Albert	Peru	1851-1930
Costa, Olga	Germany,	1913-93	Mabe, Manabu	Brazil	1924-
	Mexico		Manuel, Victor	Cuba	1897-1969
Covarrubias, Miguel	Mexico	1904-57	Martínez, Ricardo	Mexico	1918-
Cuewas, José Luis	Mexico	1934-	Matta, Roberto	Chile	1911-2002
Del Campo, Federico	Peru	1837-1923	Mérida, Carlos	Guatemala,	1891-1984
De Szyszlo, Fernando	Peru	1925-		Mexico	
Di Cavalcanti, Emiliano	Brazil	1897-1976	Meza, Guillermo	Mexico	1917-97
Oo Amaral, Tarsila	Brazil	1886-1971	Mijares, José	Cuba	1922-
Duffaut, Prefete	Haiti	1923-	Molina Campos,	Argentina	1891-1959
Enríquez, Carlos	Cuba	1901-1957	Florencio		
Montenegro, Roberto	Mexico	ca. 1881-1968	Ramos Martinez,	Mexico	1871-1946
Montoya, Gustavo	Mexico	1905-2003	Alfredo		
Morales, Armando	Nicaragua	1927-	Rentería Rocha,	Mexico	1912-72
Morales, Darío	Colombia	1944-88	Horacio		
Nierman, Leonardo	Mexico	1932-	Reverán, Armando	Venezuela	1889-1954
Normil, Andre	Haiti	1934-	Rivera, Diego	Mexico	1886-1957
Obin, Philomé	Haiti	1892-1986	Rodo Bouianger,	Bolivia	1935-
Obln, Seneque	Haiti	1893-1977	Graciela		

Obregón, Alejandro	Colombia	1920-92	Rodríguez, Mariano	Cuba	1912-90
O'GormanJuan	Mexico	1905-82	Rojas, Elmar	Guatemala	1939-
O'HIggins, Pablo	Mexico	1904-83	Romañach, Leopoldo	Cuba	1862-1951
Oiticica, Helio	Brazil	1937-80	Sánchez, Emilio	Cuba	1921-
Orozco, José Clemente	Mexico	1883-1949	Sánchez, Tomás	Colombia	1948-
			Seguí, Antonio	Argentina	1934-
Orozco Romero, Carlos	Mexico	1898-1984	Siqueiros, David Alfaro	Mexico	1896-1974
Pelaez, Amelia	Cuba	1896-1968	Soriano, Juan	Mexico	1920-
Penalba, Alicia	Argentina	1918-82	Soto, Jesús Rafael	Venezuela	1923-
Pettoruti, Emilio	Argentina	1892-1971	Tamayo, Rufino	Mexico	1899-1991
Pierre, Andre	Haiti	1914-79	Toledo, Francisco	Mexico	1940-
Poleo, Héctor	Venezuela	1918-89	Torres-García, Joaquín	Uruguay	1874-1949
Ponce de León, Fidelio	Cuba	1895-1949	Várela, Abigail	Venezuela	1948-
Portinari, Cándido	Brazil	1903-62	Varo, Remedios	Spain, Mexico	1908-63
Portocarrero, Rene	Cuba	1912-86	Velasco, José María	Mexico	1840-1912
Quinquela Martín, Benito	Argentina	1890-1977	Velásquez, José Antonio	Honduras	1906-83
Ramos, Domingo	Cuba	1894-1967	Víllacres, CésarA.	Mexico	1880-?
Ramos Catalán, Benito	Mexico	ca. 1890-?	Zárraga, Angel	Mexico	1886-1946
			Zuñiga, Francisco	Costa Rica	1912-98

REFERENCES

Ades, Dawn. 1989. *Latin America: The Modern Era, 1820–1980.* Yale University Press.

Anderson, Robert C. 1974. "Paintings as an Investment." *Economic Inquiry* 12(1):13–26.

Artprice. 2002. Fine Art CD-ROM. St. Romain au Mont D'or, France.

Ashenfelter, Orley, and Kathryn Graddy. 2003. "Auctions and the Price of Art." *Journal of Economic Literature* 61(3): 763–87.

Barnitz, Jacqueline. 2001. *Twentieth Century Art of Latin America.* University of Texas Press.

Bartel, Ann P., and Nachum Sicherman. 1998. "Technological Change and the Skill Acquisition of Young Workers." *Journal of Labor Economics* 11(1): 162–83.

Baumol, William J. 1986. "Unnatural Value: Or Art Investment as Floating Crap Game." *American Economic Review* 76 (May, *Papers and Proceedings, 1985*): 10–14.

Berndt, Ernst R. 1991. *The Practice of Econometrics: Classic and Contemporary.* Reading, Mass.: Addison-Wesley.

Buelens, Nathalie, and Victor Ginsburgh. 1993. "Revisiting Baumol's 'Art Investment as Floating Crap Game.'" *European Economic Review* 37(7): 1351–71.

Cardoza y Aragón, Luis. 1974. *Pintura contemporánea de México.* Mexico City: Era.

Castedo, Leopoldo. 1969. *A History of Latin American Art and Architecture.* Praeger.

Chanel, Olivier, Luis-Andre Gerard-Varet, and Victor Ginsburgh. 1996. "The Relevance of Hedonic Price Indices." *Journal of Cultural Economics* 20(1): 1–24.

Czujack, Corinna. 1997. "Picasso Paintings at Auction, 1963–1994." *Journal of Cultural Economics* 21(3): 229–47.

De la Barre, Madeleine, Sophie Docclo, and Victor Ginsburgh. 1994. "Returns of Impressionist, Modern and Contemporary European Paintings, 1962–1991." *Annals of Economic Statistics* 35 (July–September): 143–81.

Fletcher, Valerie J. 1992. "Matta." In *Crosscurrents of Modernism: Four Latin American Pioneers.* Washington: Smithsonian Institution Press.

Galenson, David W. 1997. "The Careers of Modern Artists: Evidence from Auctions of Contemporary Paintings." Working paper 6331. Cambridge, Mass.: National Bureau of Economic Research.

----------. 1999. "The Lives of the Painters of Modern Life: The Careers of Artists in France from Impressionism to Cubism." Working paper 6888. Cambridge, Mass.: National Bureau of Economic Research.

----------. 2001. *Painting outside the Lines: Patterns of Creativity in Modern Art.* Harvard University Press.

Galenson, David W., and Robert Jensen. 2002. "Careers and Canvases: The Rise of the Market for Modern Art in the Nineteenth Century." Working paper 9123. Cambridge, Mass.: National Bureau of Economic Research.

Galenson, David W., and Bruce A. Weinberg. 2000. "Age and the Quality of Work: The Case of Modern American Painters." *Journal of Political Economy* 108(4): 761–77.

Goetzmann, William N. 1993. "Accounting for Taste: Art and Financial Markets over Three Centuries." *American Economic Review* 83(5): 1370–76.

Griliches, Zvi. 1979. "Issues in Assessing the Contribution of Research and Development to Productivity Growth." *Bell Journal of Economics* 10 (Spring): 92–116.

---------. 1994. "Productivity, R&D, and the Data Constraint." *American Economic Review* 84(1): 1–23.

Guggenheim, Peggy, ed. 1997. *Confessions of an Art Addict,* New York: Ecco.

Kanazawa, Satoshi. 2003. "Why Productivity Fades with Age: The Crime-Genius Connection." *Journal of Research in Personality* 21(2): 257–72.

Levy, Julien. 1977. *Memoir of an Art Gallery.* Putnam.

Lucie-Smith, Edward. 1993. *Latin American Art of the 20th Century.* London: Thames and Hudson.

Martin, Mary-Anne. 1999. "The Latin American Market Comes of Age." In *Leonard's Price Index of Latin American Art at Auction,* edited by Susan Theran. Newton, Mass.: Auction Index.

Mei, Jianping, and Michael Moses. 2001. "Art as an Investment and the Origin of the 'Master-Piece Effect.'" Working paper. New York University, Stern School of Business.

Murray, Charles. 2003. *Human Accomplishments.* HarperCollins.

Pesando, James E. 1993. "Art as an Investment: The Market for Modern Prints." *American Economic Review* 83(5): 1075–89.

Pesando, James E., and Pauline Schum. 1996. "Price Anomalies at Auction: Evidence from the Market for Modern Prints." In *Economics of the Arts: Selected Essays,* edited by Victor Ginsburgh and Pierre-Michel Menger, 113-34. Amsterdam: Elsevier.

Rosen, Sherwin. 1974. "Hedonic Prices and Implicit Markets: Product Differentiation in Pure Competition." *Journal of Political Economy* 82(1): 34–55.

Russell, John. 1999. *Matisse: Father and Son.* New York: Harry N. Abrams.

Schaffner, Ingrid, and Lisa Jacobs, eds. 1998. *Julien Levy: Portrait of an Art Gallery.* MIT Press.

Serena, Asunción. 2003. "Fernando Botero, inigualable maestro de las formas." *Nexos* (April-June): 54–59.

Theran, Susan, ed. 1999. *Leonard's Price Index of Latin American Art at Auction.* Newton, Mass.: Auction Index.

Traba, Marta. 1994. *Arte de América Latina, 1900-1980.* Washington: Inter-American Development Bank.

Yale University Art Gallery. 1969. *Art of Latin America since Independence.*

Driven to Explore

R. Wuthnow

W hen contemporary artists embark on a spiritual journey, it is typically a journey into the unknown, rather than one leading along well-traveled paths. Artists interested in spirituality characteristically bring creativity to this quest. The undefined, mysterious aspects of spirituality encourage them to explore beyond the religious traditions with which they are most familiar. Like many Americans, they are influenced by a consumer-oriented culture that emphasizes prepackaged spiritual practices and quick solutions to their personal problems. Yet their quest is often marked by an intensity preventing them from settling for the casual spiritual shopping that pervades our culture. They are driven to explore, almost as if by some design beyond their control, and often at great cost to themselves.

Art criticism and art history generally pay little attention to the details of artists' lives, focusing instead on the art produced as worthy of examination in its own right. Although artists themselves may reveal portions of their biographies in published statements, it is relatively rare to have information from lengthy interviews about the most intimate aspects of their lives. Such information may be of interest because artists are public figures or because it provides a clearer understanding of the intentions shaping their work. But here I want to suggest it may also offer a new perspective on the spiritual searching of so many

Americans. This searching has been roundly criticized, even condemned, by religious leaders and scholars alike. Religious leaders worry that spiritual seekers are making up their own answers to ultimate questions rather than looking to the wisdom of religious communities. Scholars view spiritual seeking with disdain because it offends their penchant for rationally grounded intellectual arguments. Still other critics see it as symptomatic of the casual shopping that pervades American culture and suspect it is driven more by advertising and the desire for easy gratification than by serious interest in religion.

Although these criticisms are often well founded, they overlook an important exception—people who are driven to explore, whether by personal circumstances or by questions and yearnings. For these people, spiritual seeking is not something they pursue to escape boredom, but a kind of pilgrimage that consumes more time and energy than they ever imagined it would. Such people are not uncommon. Social circumstances make it impossible for many people to live comfortably within the religious communities that embraced their parents and grandparents, pushing them instead to explore elsewhere for the sacred. Whether by temperament or because their spiritual searching awakened creative impulses, artists seem to be among those who have found it virtually impossible to ignore the spiritual implications of personal dislocation.

A BEAD ARTIST'S JOURNEY

The personal experiences encouraging artists to be creative in their spirituality are evident in the life of Wendy Ellsworth, a bead artist who is married to David Ellsworth. Her studio is located on the couple's twenty-acre farm in northeastern Pennsylvania. It has floor-to-ceiling windows situated to take full advantage of its southern exposure. As the winter sunlight streams in, it illuminates the beads on her worktable and reflects off the baskets, mándalas, and pouches hanging on her walls. In recent years she has specialized in abstract bead sculptures measuring four to seven inches in diameter and composed of thousands of glass seed beads woven to resemble flowers, shells, geodes, crystals, and waves.

On her twenty-first birthday she drove up from Boulder, Colorado, where she was attending college, to a point on the Continental Divide where she hoped she could feel close to God. War was raging in Vietnam. She could make no sense of people being asked to die. She could make even less sense of what it might mean to live. Sitting on a rock that day, tears streaming down her face, she screamed at God, "I need to understand why I don't understand the meaning of life. Help me. I need direction. I need understanding. I want it. I'm ready." She knew she was ready to follow wherever her spiritual longing might lead.

Wendy Ellsworth had grown up in the comfortable northern Virginia countryside in the 1950s. Her father was a successful Washington attorney, and her mother, a frustrated opera singer, devoted herself to caring for her five children (Wendy has an older brother and sister and two younger sisters). She recalls feeling that her family was a part of Washington "society" and that all her parents' friends were "proper people." Her parents attended an Episcopal church, drawn to it especially by the high quality of its music and

the prestigious occupations of its members. They sent her to a private elementary school, which she remembers fondly: "I was very happy there. I had a wonderful group of friends, and did a lot of singing and dancing. They had a wonderful creative arts program there." She also enjoyed riding her own horse, sauntering aimlessly through the wooded acres of her parents' farm and periodically visiting the owners of an adjacent estate, Jack and Jackie Kennedy.

When she was in ninth grade, her parents sent her to a girls' boarding school. She hated it and considered running away but managed to suppress her impulses for four years, although she became increasingly alienated from her parents and the values they symbolized. Her goal in selecting a college was to get as far away from her parents as possible. She wanted to attend the University of California at Berkeley, where her sister was a student, but her parents vowed they "would not make that mistake again," so she settled for the University of Colorado. She majored in history and, like many of her classmates, became involved in the antiwar movement. Her interest in spirituality was awakened during her senior year when she took a course in philosophy that exposed her to Buddhist and Hindu teachings.

As she sat there in the Rocky Mountains on her birthday, Wendy Ellsworth somehow realized that she would receive the answers she was seeking only if she put herself in a situation where they could come to her. This realization led her to embark on a journey that has permanently shaped her life. When she graduated, she moved in with a man she loved and from whom she felt she could learn. They lived together in a remote canyon, eventually marrying and building a log cabin in which they lived for seven years. He was a skilled bead artist, and she became his student. They filled their days making beaded designs, baskets, sun catchers, and purses. Periodically they loaded up their work and drove to Aspen, where they sold enough to tourists to purchase food. They had two children. It was a good life. Her decision to leave her husband was not precipitated by personal conflict or economic necessity. She was convinced that she simply had to move on if she were to grow.

Her decision was prompted by an inner compulsion that she could understand only in spiritual terms. Often it seemed that her life was governed by karma or by some other supernatural force over which she had no control. She had been persuaded that such a force existed from the day she conceived her first child. That afternoon she was riding her horse on a muddy mountain road when her three companions decided to gallop ahead. Although she was a skilled horsewoman, when she spurred her horse to a gallop, it slipped in the mud and fell. "As she was falling with me, I recognized it as my death. I recognized that I've always known I would die that way. There was an instant of recognition. The only thing I could do was surrender to it. So I did. The last thing I did was in my heart call out the name of the man I was living with."

Even though her lover was now a half mile ahead, he sensed her call and retreated to look for her. He and his companions found her lying in a fetal position in the mud. As they turned her over, her eyes rolled back and she stopped breathing. "What they saw was a death. They saw me die." She felt her soul leaving her body. Then she heard a sound,

and her consciousness started to return. "I can hear you but I can't get back to you," she said over and over in her mind. Eventually she opened her eyes and was able to sit up. Nothing was broken, but she was badly shaken. A few months later she realized that she had conceived that very morning. That day seemed a major turning point in her life, a moment of death and rebirth. She knew she was in the hands of a force larger than herself.

After her divorce, she moved to another valley, where she lived for two and a half years. She continued beading, but with two children to support spent most of her time eking out a meager living. She grew vegetables, picked fruit, and sold homemade cider. Whenever she could she found work in construction, hanging insulation and putting up plasterboard, and in the evenings worked as a barmaid. Deciding again that she had grown as much as she could, she moved on, this time back to Boulder, where she was able to find a full-time job. It was here that her acquaintance with David Ellsworth, whom she had met briefly a few years before, developed into a relationship. Seven months later he persuaded her to move with him to a farm in northeastern Pennsylvania.

Although she still lives on this farm and has seen her beadwork blossom into a stable career, Wendy Ellsworth continues to be a spiritual explorer. For several years after she moved to Pennsylvania, her spiritual practice relied heavily on yoga, which she had learned in Colorado. Eventually she quit yoga but continued to meditate in a way that fit her interests. She searched for answers to her spiritual questions by reading sometimes feeling that books came almost magically to her attention Scott Peck's bestseller *The Road Less Traveled* was one of her favorites Barbara Brennan's *Hands of Light* was another. She took classes on the "new therapies" at a psychotherapy center, experimented with spirit guides who "channeled" messages from spirits, and participated in peace rituals and Native American drumming circles.

The force that drove her to pursue these various spiritual activities was one that she did not understand. She felt restless, dissatisfied with her understanding of life, and sometimes formulated specific questions she wished the universe would answer. Yet it was unclear why her spiritual explorations took on an intensity that seemed lacking in many other people. The answer emerged gradually and painfully, but when it came, everything fell into place. In the early 1980s her youngest sister tried to kill herself. During her sister's recovery in a psychiatric ward, Wendy was the member of the family who supported her most closely. Her sister believed she had been sexually abused as a child and that the abuser had been their father. Wendy found it credible that her sister had been abused, but could not believe the part about their father. Within a few years, she and her sister stopped communicating with each other, partly because of this disagreement. In the meantime, Wendy was suffering from a new round of spiritual anxiety of her own. Her sister's near-suicide had prompted questions about how one finds the will to live. Wendy Ellsworth knew the answer had to do with the spiritual force she believed was inside her. Yet she was having difficulty reaching this force.

She remembers having an argument with her husband David and feeling that she was somehow "shutting down." When David asked her what she was feeling, she realized that

she felt nothing at all. She began asking herself when she had started doing this and decided that it was a lifelong pattern. She could not get at its source. The various spiritual practices she pursued nevertheless helped identify the problem. Reading a book about chakras drove home that her "heart chakra" was dead. On another occasion, a spiritual guide told her the same thing. On yet another occasion, she attended a workshop at which participants drew pictures in hope of gaining insight into repressed aspects of their lives. Wendy drew a beautiful blonde girl crying crocodile tears. She knew it was a picture of herself as a child. Then at another workshop involving Deep breathing and meditation, the breakthrough came. "All of a sudden, what I was experiencing was being a four-year-old in my bed, being molested by my father. I had no idea. I had all the clues in the world. And it was just like somebody had handed me the final piece of the puzzle of life, my life, and it all cleared up. All of a sudden, the whole picture, the whole image became clear, because all these things that had happened to me, all these things that I had drawn into my life, it ail made sense. It all made sense."

She was devastated and angry but also exhilarated by this realization. She immediately phoned her sister. "I said, 'I want to let you know that it wasn't just you. It happened to me, too.' She said, 'What are you talking about?' I said, 'He did it to me, too.' It was just incredible, and it was just a reunion that was so powerful." She said to her husband, "There's no holding me back. I'm pushing through this one. It's a biggie." And every morning for three months the two of them sat together on their porch while she explained the changes she was experiencing.

As in many cases of repressed memory, it is impossible to know exactly what happened when Wendy Ellsworth was four years old. The one thing she is sure of is that her journey toward greater spiritual awareness is not over. She remembers a dream she had several years ago of a wild bird in a cage. The bird was dying. When she woke up, she knew she was the bird. She knows her spirit is too wild to be caged. She knows she needs to keep moving.

Through it all, there has been a connection between Wendy Ellsworth's spiritual explorations and her art. As a child she pursued the arts because they were a way of gaining an identity other than the one her parents represented and from which she felt alienated. She fell into beadwork because of her spiritual pilgrimage, more than from a desire to perfect this particular craft, and later she realized that the mándalas she was making had spiritual significance. Her artist friends and her husband David serve as a network of people who pursue spirituality in unconventional ways. Many of the spiritual practices and therapeutic methods she has followed, such as visualization, drawing, and movement, reflect interests to which artists are attracted. When she was anguishing about her lack of emotions, she was unable to pursue her bead artistry. Having resolved some of those issues, she has resumed her work, finding that the rhythm of beading gives her peace and stability.

For the first time since she was in the children's choir at the Episcopal church, Wendy Ellsworth is able to sing. Yet the relationship between the creativity she has shown in her artistic work and the creativity evident in her spiritual life is difficult for her to describe. She knows only that the phrase "creative force" seems to be the best way to characterize

what she means by spirituality. This is the force that has driven her to keep exploring. Although she has pursued many different spiritual practices, she is scarcely a spiritual dabbler. She is engaged in a serious quest that will take her a lifetime to fulfill.

Many people would not have had the luxury to pursue the bohemian lifestyle that Wendy Ellsworth chose. She benefited from an upper-middle-class background and, as a member of the '60s generation, from a period of relative affluence. In being influenced by the Vietnam War and the counterculture that emerged on the nation's campuses at the time, she resembles the baby boomers who have been characterized as spiritual shoppers. But her story stands as an example of someone who did not simply dabble with spiritual fads. It is a story of perceived abuse, of repressed memory, and of profound alienation. It is also a story of taking the risk of asking God for answers and then paying the cost of searching for those answers. If people such as Wendy Ellsworth have been led to artistic or other creative expressions of their spiritual search, it is because they experienced such personal dislocation that conventional religious organizations seemed incapable of providing answers.

THE IMPETUS OF TRAUMA

Like Wendy Ellsworth, Katie Agresta is an artist whose creative impulse has compelled her into a passionate spiritual journey. In Agresta's experience, however, the connection between art and spirituality seems tighter—indeed, the two seem inextricably entwined. She provides a clearer illustration of how a career in art can itself become the impetus for serious spiritual exploration.

A singer, multi-instrumentalist, composer, author, and lecturer, Katie Agresta was born into a musical family—her mother is a Juilliard graduate in piano; her father was a singer; and a sister and a brother are also professional musicians. She started piano lessons when she was five, continuing them until she was thirteen, when she switched to vocal lessons. Her voice teacher immediately recognized her talent and encouraged her to prepare for a career in opera. By the time she was fifteen, she was singing solos at weddings and funerals, and when she was seventeen she started teaching voice and guitar. She majored in music in college and after graduation pursued her teaching and singing. "I hung out for three years going to the clubs every night," she recalls. "I learned all about monitors and sound stages and equipment and [the singers'] needs and what they were actually doing with the voices and what would go wrong and how to practice. And at the same time I was pursuing a career in classical singing. So I had this double world where I was studying Puccini and teaching people who were singing Led Zeppelin. It was very crazy!"

Although she continued training for opera, she found it difficult financially and psychologically to pursue her classical interests. Meanwhile, the demand for her teaching was growing to the point that she relocated from Long Island to Manhattan. One of her first students there was Cyndi Lauper, and when Lauper became famous, Agresta did too. That year she turned away four hundred students. Still, she became so busy with students that

she abandoned her own singing and nearly worked herself to death. She managed her own school and kept herself and seven other teachers busy training some three to four hundred students at a time.

It was storybook success. Yet from the beginning there were strains. For reasons she does not fully understand, Agresta never related well to her parents. She remembers that her grandfather's death when she was three and a half left a "big hole" because she had been closer to him than to her parents. She thinks she tried to fill this hole by pursuing her musical interests. As she recalls, "There was always a [family] crisis, and so I took refuge in the music. I took refuge actually more in listening to music than I did anything else. I listened to music around the clock; I'd go up to my room and just listen to the radio and my records." Although her parents encouraged her to sing, they gave her mixed signals about music, perhaps because they felt ambivalent about their own careers in music.

Agresta's music and her troubles with her family were integrally tied to her changing interests in spirituality. When her grandfather died, it comforted her to know that he was in heaven. Her parents were devout Italian Catholics, so she found comfort in the teachings and rituals of the church. She especially liked to sit in the church when nobody else was there, looking at the sculptures and candles, and praying. At parochial school she learned Gregorian chants and found support for her singing. But gradually her attitude toward the church changed. "The brutality of the nuns and the priests and the physical bearings took their toll on me. I became very frightened as a child." She hated it too when the Latin Mass was replaced. "I loved how sacred and beautiful it was—the fact that it was mysterious and that it was untouchable."

During high school, she was deeply influenced by the assassination of President Kennedy and by the cultural changes symbolized by the Beatles and the beginning of the counterculture. She was even more deeply influenced by her growing alienation from her father. He was "very brutal at times. Very raging and used to hit us a lot, although he doesn't remember any of it. I turned away from all of it and then felt very much adrift and very lost. Didn't really feel like I had any spirituality, and I didn't care." Whereas the church had once been a source of comfort, it now seemed "evil and mean and hypocritical and violent."

"When I got to college, I took a job in the library and started reading about Buddhism and Zen and Eastern philosophy. I started to embrace anything that wasn't what I came from. Started reading about healers and psychics and spiritual teachers, and the Dalai Lama. The spirituality of the hippie philosophy of peace, love-dove, and everybody love each other and all, that started to become my spirituality, and I got interested in all the stuff that went with that—the crystals, the Tarot deck and the occult, and astrology and the Celtic traditions."

After college, she continued to explore alternative spiritual practices. "I met a woman who turned me on to the whole mystic [world] of the angels and the David Kingdom and the garden in Findhorn, Scotland. Then I met an American Indian who taught me how to read clouds. He said you should be a vegetarian, and he taught me how to do healing

work on people. Then I became a Reiki Master. Eventually I hooked up with this yogi and started practicing tantric yoga."

Over the years, she has pursued other spiritual and therapeutic disciplines. She took courses from Yogi Bhajan, Bayard Hora, and Deepak Chopra; became a Dimensional Macro Structural Alignment instructor; worked with a metaphysical counselor; and participated in twelve-step groups and seminars focusing on healing the inner child. The twelve-step work was particularly helpful: "I was able to reconnect with the original love that I had of Christ and the Mary stuff I'd been brought up on and God. For many years I saw God as my enemy, and then the twelve-step work brought me home to myself again. I took a long journey around to come back, and being as intelligent as I am and as willful and as strong as I am inside, I put up a big fight!"

Indeed, she would have had little inclination to struggle with spirituality at all had she not been pressed to do so by forces beyond her control. At the height of her career, she nearly died. At first, she merely found herself crying and feeling depressed. Then on two occasions she suffered what seemed to be nervous breakdowns. Eventually her doctors came to believe there was a physical cause for her severe symptoms and gave her three months to live. Finally they determined that she was having a serious reaction to birth control pills, so serious that her pituitary gland was badly malfunctioning. At about the same time, her voice teacher, her most stable source of emotional support since college, died. The combination of her physical illness and her emotional trauma forced her to evaluate her entire life. As she started to recover, she realized there must be a reason why her life had been spared. "I sat there for five hours talking to God saying, 'Okay, what do you want? What do you want because I'm supposed to be dying and you're not letting me die, so there must be something you want me to do!' I didn't know what it was, that's for sure. But it was the biggest awakening moment. Those five hours, I think, changed my whole life. Until then I was a wild child. 1 was out there. Party animal and the whole thing. I had always felt tremendous love for my students, but I didn't feel enough love for myself."

The realization that she had to come to a better understanding of herself set her on a path of exploration that she couldn't resist. As she examined who she was, she found not only that her ability to accept herself increased but that her creativity expanded as well. She acknowledges that much of her experience as a child and as a young adult was "brutal" and "awful." In contrast, she says her eclectic approach to spirituality has helped her to be more "open-minded" and "happy." She especially values the insights she has gained about the necessity of creating one's own realities. She still has the strong will that enabled her to survive her many negative experiences, yet she tries to balance that willfulness with an understanding of her need to surrender to the spiritual realities that envelop her. She does not feel that she has found all the right answers, but she thinks she is better able to ask the right questions.

The common factor in Wendy Ellsworth's and Katie Agresta'a stories is that both women experienced trauma as children that alienated them from one or both of their

parents. Because they were reared in church-going families, these women's alienation from their parents caused them to feel distant from the conventional religion of their childhood. Their subsequent spiritual exploration was driven, on the one hand, by their learning to take spirituality seriously and, on the other hand, by a sense that they could not find love or security within their childhood faiths. As baby boomers, both women were helped in exploring new avenues of spiritual expression by attending college at a time when alternative lifestyles and religions were flourishing. Their artistic interests put them in continuing contact with other people who were pursuing alternative forms of spirituality.

During the 1960s and early 1970s, sexual liberation, a new emphasis on self-expression and personal freedom, and the unsettling effects of the civil rights and antiwar protests all had an impact on people's thinking. Many young Americans at the time became disillusioned with their parents' religions and lifestyles, and they never returned to the familiar values of the older generation, even though they eventually settled down to raise families and earn livings of their own. As Katie Agresta muses, "I feel like in many ways I'm still a hippie at heart. I'm a retired hippie. I now work!" Artists like Wendy Ellsworth, who was fortunate enough to have financial backing and privileged schooling, and those like Katie Agresta, who was fortunate enough to work with the right people, managed to gain sufficient economic security from their artistic work to pursue their interests in alternative forms of spirituality. Yet it would be wrong to conclude that the passion for intense spiritual exploration comes only from having the right opportunities, just as it is wrong to assume that spiritual exploration necessarily involves a complete rejection of the faiths in which people are raised. For many artists, the drive to explore is evident even when they remain within established religious traditions.

TWEAKING THE HUMAN FAMILY

Bob McGovern is a passionate spiritual explorer. He is a big man with a kind, gentle face. Surrounded by his books and art, he sits in a wheelchair, his legs paralyzed from a bout of polio at age sixteen. He is a woodcarver, but his artistic interests include painting, sculpture, and pottery. Now in his late sixties, he has raised several children, been widowed, and is increasingly reflective about life. The role of the artist, he muses, is "to tweak the human family and say, 'It is possible to be serious and playful at the same dine.'" At least he tries to.

The counterculture came too late for Bob McGovern; by the 1960s he was already established in his career. But he did not need the counterculture to pry him loose from mainstream culture: polio had been sufficient. Raised Catholic, he pretty much took religion at face value until stricken with the disease in 1947. "When I got polio, it was a real shocker. God and I still have to settle up on that issue! But I did undergo a conversion. I would have liked to undergo my conversion standing on a mountaintop, but I underwent it and I was wretched. I guess I reached out. One mortal human being should never be ashamed to do that. I reached out and I think God was there. A lot of stupid people were

there with him. It was like a Fellini movie. God had all these weirdos with him. There was a menagerie!"

Besides unsettling his views of God, polio gave him the opportunity to become an artist. At the parochial elementary school he attended, he barely passed most of his subjects because of his budding interest in the arts. Public high school furthered this interest. When polio forced him to drop out, he at first had only a home tutor but through a state disability program was soon able to attend art school. "It was magical. I thought I was pretty good, but now I was up against some really good people. That was lovely. My teachers were very caring and demanding."

"I knew basically that I wanted to be expressive and I wanted as much freedom as I could cut away for myself," he remembers. Yet he was from a poor family and knew that he would have to find a way to earn a living, rather than simply expressing himself. He took courses in magazine illustration, which helped him find work almost immediately. His first jobs were with Presbyterian, Baptist, and United Church of Christ magazines, all of which were published in Philadelphia. These jobs put him in contact with seminary students who ran summer and weekend programs for at-risk youth from the inner city. By teaching arts and crafts at these programs, he discovered his interest in becoming a teacher. By age twenty-three, he had been hired by the University of the Arts in Philadelphia.

As his career developed, his repertoire expanded to include a variety of painting styles, sculpting, and woodworking, and he sought a balance between his desire for self-expression and his need to earn a living. The two were inevitably in tension, however, and he found himself on a lifelong quest to make sense of their relationship. He thinks one part of him reflected his rather, a sensitive man who earned a sparse living painting houses and suffered from alcoholism. The other came from his mother, a pragmatic woman who cared for the house and worked as a soda jerk. Both parents were tenacious, giving him a strong sense of "stick-to-it-iveness," yet he regarded both as fragile, vulnerable, and in their own way mysterious.

McGovern characterizes his journey as a struggle to reconcile the mysterious aspects of life with its pragmatic side. He romanticizes his origins, describing his father as a "lover of life" and his mother as "a magical person," and he enjoys emphasizing his descent from the marginalized peoples of Ireland and northern Europe. At the same time, he describes himself as a thoroughly practical man who works hard, plays fair, and tries to be honest. Not wanting to identify too closely with ordinary middle-class values, however, he insists that the "life process" is more complicated than he is able to describe: "Life is really a drama about living. It's participating in a mystery. That came through very early in my life. I had the paradox of a father I loved who was a victim. He crumbled before the onslaught of a little alcohol. And a mother who was so busy keeping things together that she was marvelous, if that makes any sense. I would love to buy the big package of our society's values, but I think life is about living. And you are forced to live it at the level of mystery and desperation. One only gets to the mystery through some desperation."

McGovern was still young when he recognized what he now calls the "double-edged, scary and comforting business of spirituality." He encountered the scary part at his parochial school, where the nuns seemed "cruel and unbearable and stupid." The comforting part appeared in the daily and weekly religious rituals, such as saying the rosary and refraining from meat on Fridays. Like his father, he found the rituals appealed to his poetic, melancholic side and drove him "deeper into the forest." He remembers the nuns making him write "I won't talk in line" in his notebook a thousand times and then going out in the rain, dropping his notebook, and seeing the words, written in soluble ink, disappear. This memory symbolizes the ironic contrast of form and mystery in all spirituality.

While he was hospitalized with polio, McGovern met people who reinforced his conviction that he had to set his own rules to survive. He recalls taking over the kitchen one day in protest against the meals the hospital patients were forced to eat He was particularly influenced by a man in the next bed, an ex-sailor with polio who gave him a copy of Thomas Merton's *Seven Storey Mountain*. He soon became an avid reader of Merton, fascinated by the contemplative aspects of the Catholic tradition. He also remembers the man in his ward who was confined to an iron lung and suffered from indescribable bedsores. Although the man died, his struggle to spend even a few hours out of the iron lung was a lesson in courage. From him McGovern learned that bravery means "you don't necessarily have to win by other people's standards."

McGovern has "never ceased the religion," but his spiritual explorations have been an "odyssey." He thinks the typical pattern for Catholics (unlike Protestants, who focus on a moment of salvation) is to be "imprinted" at an early age and then embark on a pilgrimage. His own journey has been "exquisitely marked with a potpourri of vice and virtue that stretches like a crazy quilt." In retrospect, he believes he has always been guided by Providence, but he thinks it has been helpful to be free-spirited as well.

In early adulthood, he became part of a movement of young artists in Philadelphia known as the Resurgency. They were atheists, Jews, and renegade Catholics who shared an interest in bringing spirituality to the arts. He also belonged to a Jesuit group engaged in contemplative spiritual practices, and through it became friends with the brothers Daniel and Philip Berrigan, Catholic priests whose antiwar activism was starting to draw national attention at the time. When the Berrigans were sentenced to prison, McGovern communicated with them regularly, exchanging poetry, drawings, and letters. About the same time, he fell in love with an "extraordinarily wonderful" woman, married her, and fathered three children. Seven years later she died of cancer.

"How does one pair the torments, as it were, the torments of living an odyssey and at the same time meeting those turns that make the hanging on or even sometimes the celebrating of the life process possible?" he asks. "I would like to know, but it's human arrogance to want to know it. I have to accept the mystery and continue on the journey."

He remembers driving home one winter night after visiting his wife in the hospital. Dirty snow covered the ground, the wind was cold, and he felt as desperate and lonely as he had ever been in his life. Suddenly the scene before him seemed to brighten. It wasn't a

miracle; he knew immediately that it was only the streetlights reflected in the snow. Then he heard a voice. It was his own voice, but it was as powerful as if it had come from an angel: "It doesn't matter; it really doesn't matter." It did not lessen the pain that his wife was dying; that fact still mattered enormously, but he realized there was a larger meaning in life that transcended loneliness and pain. The thought comforted him then and still guides him. He believes with all his heart that the experiences we cannot understand and the events we find difficult to accept do not matter that much because they are part of something larger. This idea is hard for him to communicate, but it is the main message of his art.

By his fortieth birthday, McGovern had married again and was seriously taking stock of himself as an artist. Over a period of several months, while painting a series of autobiographical pictures, he came to think of himself as a "flimflam" man, focusing too much on pleasing the market and too little on what was in his heart. He felt compelled to continue his spiritual explorations, letting them guide him even when there seemed to be no answers to his questions. "I was searching for spiritual nutrients," he recalls. For a while, he followed Merton's lead and turned for inspiration to the religions of China and Japan. He reread with new interest James Joyce's *Portrait of the Artist as a Young Man,* paying particular attention to the passages about the "wretched" condition of the church.

Although he still thinks of himself as a pilgrim, he also realizes, "I'm settled. I've settled into this wretched church. I'm like a sharpshooter sitting in the back of the church. It's terrible. But I'm a Westerner. I'm not about to go do something else that's crazy." Though living within his Catholic tradition, he regards spirituality, more than the church itself, as the center of his faith. "Spirituality is the currency of existence. It's how one barters the moments."

The woodcuts and plaster casts that have accumulated on the shelves of his studio provide rich metaphors of the odyssey he has taken. On one high shelf is a drummer boy from his childhood and an African painting bequeathed by his father. These stand next to a brass candlestick that is slightly askew. On another shelf is a head study of Saint Brigit and the castings for two works commissioned by the writer Andrew Greeley. Closer to the center is a large carving called *Our Lady of Victory.* Other shelves are lined with carvings and figurines. One piece in particular captures his fancy: a cherrywood cross, marred by a large knot. It remains unfinished.

Bob McGovern's story demonstrates the tenacity that is sometimes a part of people's yearning to have a better or deeper relationship with God. All the odds are against them. They could easily resort to despair, drugs, or the narcotic of daily routines and material pleasures. But they are driven by a desire for an authentic form of spirituality big enough to encompass all they have experienced. Not surprisingly, given the devastating emotions they have experienced, they do not settle easily for a faith that emphasizes intellectual arguments. They are drawn to artistic expressions of spirituality because they have experienced life in a way that cannot be reduced to words.

BEYOND BROADWAY

Catholicism provided a big enough tent for Bob McGovern to carry out his spiritual quest within it; although he has learned from other religious traditions, he regards himself as a Christian. For others, reconciling art and spirituality is sometimes harder because their tent is smaller. Clark Sterling is a case in point. Raised Protestant, he was compelled to switch denominations and examine other religions; yet he has been able to follow his spiritual inclinations without abandoning Protestantism entirely.

A singer, actor, dancer, and producer, Clark Sterling has performed on Broadway but resides in the San Francisco Bay Area. Although he could be mistaken for a Wall Street executive because of his clean-cut looks and well-polished manners, he has followed the spiritual path of a restless artist.

As a child, Sterling experienced little of the personal turmoil that encouraged Katie Agresta and Bob McGovern to question their spiritual moorings. He was raised by both parents in the same house in the same southern California community until he went to college. His parents sent him to Sunday school at the Presbyterian church they attended regularly and where his mother was active as a deaconess and on church committees. Instead of experiencing a dramatic conversion, he grew up thinking of himself as a Christian and enjoyed being involved in the church. During his years at Stanford University, where he was a political science major and sang and acted on the side, he still defined himself as a faithful Presbyterian.

Moving to New York to pursue his musical career broadened his religious horizons. The church he attended there encouraged him to think in new ways. It challenged him to pay greater attention to the diverse paths through which people realize their spiritual yearnings. So did making friends with actors and musicians from different religious and ethnic backgrounds. Despite his success in gaining roles on Broadway as well as in regional theaters and commercials, he felt restless about his acting's relationship to his religious identity. Part of him wanted to continue performing, while another part wanted to explore a career change that would take him into religious work.

To resolve his ambivalence Sterling temporarily gave up music and acting in favor of attending the San Francisco Theological Seminary. His decision was prompted by failing to obtain a role in the New York City production of *Les Misérables*. Yet, soon after moving to San Francisco, he obtained a part there. For the next year and a half he devoted his nights to *Les Misérables* and his days to classes at the seminary. "It was pretty strange," he chuckles, "to be sitting backstage reading Kierkegaard and Karl Barth!"

What he learned came less from reading theologians, however, than from experiencing life. "I used to want answers. I used to want my faith, my version of Christianity, to say, 'It's this way. This is how we're supposed to act. This is bad, this is good.' I guess because of the type of Presbyterian faith I was given as a child and a young adult, that was something that I just expected and looked to religion for." Instead, he has become more comfortable with the ambiguities of life. "I think life happens. You go out in life and meet people who see things in other ways. I didn't want to think, 'Oh, well, they're wrong,' because I saw

value and love and meaning and wonderful things in people with different opinions. So this faith that had been so black-and-white without ambiguity became difficult because it didn't seem to be true to who God was showing me I was and who other people around me were."

At first, Sterling was sufficiently troubled by this ambiguity that he tried to find a more structured alternative. Having read some work by the conservative evangelical writer Francis Schaeffer, he traveled to Switzerland to take a seminar from Schaeffer. There he met Schaeffer's son Frankie, a budding writer and artist with broad interests in the arts who was having increasing difficulty with his father's dogmatism. Sterling remembers Frankie telling him about showing some abstract paintings to an audience of conservative Christians: One man in the audience asked, "What's Christian about this painting?" Frankie responded by taking the man outdoors to look at the Alpine landscape and said, "If you don't mind *my* suggesting the comparison, what you just asked me in there would be like looking up at this tree and saying to God, 'What's so Christian about this tree?'"[8]

Sterling returned from Switzerland convinced that ambiguity rather than pat answers was closer to his emerging understanding of spirituality. His seminary training propelled him along the same path. "You don't lose your faith necessarily, but your faith gets turned upside down and you look at it from all different angles. We had this speaker my first year who said, 'I've gone from a religion with answers to a faith with questions,' and that sort of became my mantra throughout the rest of seminary. I would say that's been my journey too. I've come from a much more rigid theology to one that's open to and more comfortable with questions."

In recent years his faith has been deepened by interacting with people from different traditions. "I've settled on less settlement. I've settled on more diversity. I wasn't wanting to sit in a Presbyterian church of the type I was raised in every Sunday—I wanted to go other places, I wanted to experience other faiths, I wanted to worship and interact with people who expressed themselves differently." He has appreciated opportunities to worship in different traditions, not because it is fun, but because he is better able to see the deep spirituality of people he meets. "It's an awareness of the validity of that life."

Sterling emphasizes not only the shift from a religion of answers to a faith of questions but also the continuity that ties his spirituality together. Little in his childhood experience or training encouraged him to explore spirituality on his own. Yet he remembers times of feeling that he was in the presence of the sacred. "Many of them involved music. If I think of what early on struck me as sacred, most often it was something artistic and most often it was beautiful music. It just touched me more than other things. The musical expression of Christianity, whether it was from a contemporary Christian singer with a guitar and a group, or a pipe organ in church, something about the beauty of the music really reinforced the sense of being created by a creative God, that it wasn't just some cosmic accident." Music has remained his most distinct way of relating to the sacred.

Although he is unsure where his music will take him, he is trying to juggle a career that combines recording and acting with singing for church audiences and at religious

conferences. He enjoys singing inspirational music that encourages people to feel closer to God, but he is increasingly recognizing that music can depict the complexities of life and the mystery of God as well. Although he dislikes violence, for example, he believes that it has a place in the arte because it is a terrible fact of life and people need to be confronted with its existence. He feels too that music can give people a greater appreciation of the small details of life, rather than simply directing their thoughts toward die sublime. One of his favorite songs is "Take the Moment," by Richard Rodgers and Stephen Sondheim. It says simply, "Take the moment, let it happen. Hug the moment, make it last."

As he has become more comfortable with questions for which he has no answers and with ambiguity that cannot be resolved, Sterling has experienced criticism from friends and family members who worry that he has become a spiritual dabbler. Like critics of the wider culture, they fear that the explorations of contemporary artists reflect too much of an accommodation with the diverse perspectives and lifestyles that have been championed by the mass media and heightened by information and affluence.

Such concerns are worth pondering, for it is evident that people like Wendy Ellsworth, Katie Agresta, Bob McGovern, and Clark Sterling have been shaped by the pluralistic, market-oriented culture in which they live. Encouraged from early childhood to form their own opinions, many Americans choose to pursue their own understandings of spirituality rather than conforming to the received wisdom of their religious traditions. A society rooted in market transactions encourages its members to shop for spirituality, even if the result is a pastiche of beliefs and practices purchased from a variety of spiritual vendors. Yet there are important differences between the superficial spiritual shopping so prominent in the wider culture and the spiritual explorations evident in the journeys of many contemporary artists.

In Clark Sterling's case it is evident that living in diverse surroundings, straining to figure out the kind of career he wants to pursue, and questioning theological traditions have influenced the very nature of his ideas about religion. He has given up pat answers and come to terms with the reality of ambiguities. Doing so has not required him to leave the church; in fact, it has renewed his commitment to serving the church. But it has also earned him the disfavor of church friends whose views differ from his.

How unusual is Clark Sterling's story? Few people get the chance to sing on Broadway. But millions of people move from one community to another, hit snags in their careers, and search for ways to gain greater meaning from their work. In these respects, he is probably typical of many.

A SERIOUS SPIRITUAL EXPLORATION

The contrast between shopping and serious spiritual exploration is further illuminated in the experiences of Rick Vise. This Pennsylvania-based musician, who specializes in guitar, Celtic harp, and African and Middle Eastern drums, supports himself by driving a track for a private courier service four days a week and working as a massage therapist one day

a week. He quit college in his sophomore year, when his rock band became successful enough to go on tour and make recordings. He toured full time for three years, first with a band called Silk Wind and then with one named Sugar Daddy, but eventually realized he needed to do something different with his life because the rock culture and nightly performances were too much for him. After working at various temporary jobs, taking classes, and traveling, he settled into his present routine. Yet, he admits, his music "remains the most important part of my path." He occasionally performs, composes, and choreographs, and he teaches seminars that integrate art, music, poetry, movement, and spirituality.

Rick Vise's interests in spirituality date from early childhood. As long as he can remember, he has had "an overriding sense of God," which he attributes to his mother's devout Catholicism and the many occasions on which she talked with him about her devotional life (his father was a lapsed Southern Baptist). He remembers walking into the desert near Phoenix, where his family lived while he was in elementary school, and almost literally feeling that he was in God's presence. A periodic heart arrhythmia and several bouts with pneumonia limited his ability to take part in athletics and other physical activities at school, so he became somewhat withdrawn and focused on what he now calls "the inner life." Although he tried to maintain a critical attitude toward them, he was fascinated by his dreams, his reflections, and his experiences of the sacred.

In high school he vowed to overcome his chronic illnesses by becoming a vegetarian and taking karate lessons. His introspective interests continued as he avidly read authors in his father's library, particularly Emerson and Thoreau, and dabbled with Buddhism and yoga. One of the teachers at the Catholic school he attended guided him through these explorations, warning him about extreme diets and pursuing altered states of consciousness, but encouraging him to examine the various practices of the world's major religious traditions. By the time he graduated, he had explored the Catholic mystical tradition and read some of the classic texts in Buddhism, Hinduism, and Islam. He was deflected from these interests while traveling with his band, but in his mid-twenties he took college courses, traveled, and broadened his interests in spirituality to include the healing arts and holistic health.

"For two years I studied and prayed," he recalls. "I went across the country, to Florida, New York, Kentucky, Georgia, Arizona, New Mexico, California. I stayed in monasteries. I studied holistic health and got some certification." Although Vise had some contact with the fundamentalist religious groups that attracted attention in the late 1970s, he soon realized that he needed more freedom than they offered. He settled into a loosely knit group in Philadelphia that attracted him because of its religious and philosophical eclecticism, its philosophy was "you're not supposed to stay in one place for very long; you learn what you can and then you go somewhere else."

During the year he was involved in this group, he was particularly attracted to the Sufi leaders who visited from time to time. "They were very wise, and the methods they taught incorporated not only meditation and prayer, but some of the most advanced movement I've ever encountered. More advanced than anything in the martial arts. Advanced

breathing techniques combined with movement combined with drumming combined with meditation combined with completely opening your heart and being totally vulnerable. All the elements that were only partially present in other approaches were there with these Sufi sheiks. I was very impressed with them."

He read extensively in Muslim and Sufi texts, learned basic Arabic, consumed the poetry of Jelaluddin Rumi, gained further certification as a holistic health practitioner, and supported himself with a job in construction. Like Wendy Ellsworth's departure from the mountains, Rick Vise's decision to leave the group was prompted simply by the conviction that it was time to move on. He found a full-time job as a massage therapist at a holistic health clinic, devoted his spare time to reading religious texts, and learned to play the Celtic harp. He also married, had a daughter, and two years later obtained a divorce, retaining custody of his daughter.

The clinic where he worked soon collapsed from internal friction, and he set up his own practice with clients referred to him by a local chiropractor. Because his income was meager, he lived simply in a small apartment crammed with books and musical instruments. He continued to study Arabic and interacted as much as he could with Muslim and Sufi graduate students. "One thing I've learned about the burgeoning spirituality of our time is this: if you want to taste the essence of a spiritual tradition, you had best learn the etiquettes of that tradition. Because if you don't, you're going to have to sneak in the back door and steal the secrets. And if you're caught, you're going to get lightning bolts thrown as you! Going in the front door is much better and that means knowing the etiquettes."

By "etiquettes," Vise means the daily devotional practices through which people in a religious tradition have learned to express their spirituality. "I wanted to experience the divine presence in their way. So I figured, 'I'll learn all these etiquettes.' Meanwhile, I'm falling in love with them. I was shocked, believe me, I'm thinking, 'Oh, my God. I can't be going in this direction.' So I started doing the formal prayers. For the first time in my life, my spiritual journey took on a conventional form. In the context of this Islamic experience I was being moved in my heart. By doing this prayer that millions and millions and millions of people do, I was experiencing something that was deeper than my own meditation had ever been. And I was shocked by that."

For the past decade, Vise has continued to learn about Sufism and follows some Muslim practices, such as praying five times a day. However, he has "pulled back" from the more structured aspects of Islam and has cultivated a more "open" or eclectic style of spirituality. "I saw that the social structure was something I would have to leave. I would have to leave that garden, but I did so with incredible respect for it." He recalls one of his Sufi teachers saying, "Respect all traditions and transcend them in your heart." His daily prayers, meditation, and reading, as well as his music, serve as the core ("the deep well") of his spirituality; being part of an informal congregation of Christians and Jews who come together for worship and who "contact the divine through a sense of creative ritual" is his way of being open.

Here is an example of someone who has clearly devoted an inordinate amount of effort to a spiritual quest. For critics concerned that spirituality cannot be genuine apart from a religious tradition, it also suggests the value of settling into a tradition. Unlike Bob McGovern and Clark Sterling, who made peace with the broader Christian communities in which they had been raised, Rick Vise turned to a different tradition. His story suggests the value of learning the wisdom inscribed in the practices of a tradition.

The larger point his story illustrates is that an unsettled life is not sufficient in itself to result in a serious and sustained life of spiritual growth. Effort, determination, and perseverance are also required. For Rick Vise, the possibilities of a new tradition were not fully apparent at the start. It was necessary to devote time to it before it became meaningful. When that happened, the journey did not end; instead, it continued to deepen.

MORE THAN SHOPPING

The distinction between spiritual shopping and an intense spiritual journey comes into sharp relief in stories like these. Shopping for forms of spiritual expression can prevail in a society dominated by markets and market transactions. A society based on markets is driven by the need to keep prices low and to reduce the costs of making transactions, and it turns things into commodities. "How-to" books offering easy paths to spiritual enlightenment, flashy television episodes about guardian angels, and sermons providing simple formulas for salvation are examples of spirituality packaged for a society of shoppers. The consumers of such goods are lured with expectations of positive gratification.

Mass markets have become effective at generating and distributing goods, and shoppers are often pleased to have a plethora of choices. Markets nevertheless encourage people to keep their options open and to consider alternatives that may be cheaper or more gratifying, rather than remaining committed to a single course of action for an extended period of time. In the religious marketplace, shoppers switch congregations to find ones more appealing to their immediate interests, and they pursue the latest spiritual fads brought to their attention by savvy publishers or television preachers.

The spiritual explorations of artists like Rick Vise bear some resemblance to spiritual shopping. He has seldom felt obligated to stay in a single church or even a particular religious tradition; when there were teachings he did not understand or practices he disliked, he moved on, only later and after considerable personal investment coming to realize the value of settling into one tradition. Bob McGovern and Clark Sterling have been more faithful to the traditions in which they were raised, yet they have been influenced by the ready availability of spiritual alternatives. Wendy Ellsworth and Katie Agresta have participated in organizations that marketed a blend of popular therapeutic and spiritual practices.

Yet the differences between these artists' intense spiritual exploration and spiritual shopping outweigh the similarities, in their search for truth, beauty, and a deeper experience of the sacred, these artists have made decisions that were personally costly. Each admits it

would have been easier to stay put than to move on. Although they were products of their culture, they generally rejected its conformity and materialistic standards. Their search for spirituality was hardly an efficient one; it required huge investments of time and effort.

In each case, the spiritual journey entailed some shifting from one religious tradition or practice to another, yet the various encounters included significant involvement as well. Whereas shoppers emphasize their freedom to make choices, these artists generally felt they had no choice. They were instead driven by an overpowering need that they could not escape. At the same time they were aware of life's uncertainties, realizing that any decisions about career or marriage might not produce the desired result. Whereas the job of a successful marketer is to persuade shoppers that they have found the right answers to their problems, these artists typically recognized that uncertainty is inevitable and perhaps even desirable.

Rick Vise's view of what it means to be a spiritual explorer illustrates these differences. He thinks a genuine spiritual quest stems more from desperation than from the titillation of dabbling with something new. His exploration beyond his Catholic heritage was one he felt compelled to make. Yet he also thinks people may be pursuing something that is rooted in their early religious experience and for this reason bears more affinity with it than they realize. "What we are looking for is a reflection of what we already have experienced," he explains. "In other words, we're looking for a reflection of something other than the crassness of the world. We want our soul to be reflected back to us."

LIVING WITH DISLOCATION

That the drive to explore is often rooted in some unsettling personal experience cannot be emphasized enough. Wendy Ellsworth was drawn into an alternative lifestyle in reaction to the alienation and possible abuse she experienced in her childhood. Katie Agresta's upbringing included serious tension with her parents. Bob McGovern's polio and Rick Vise's childhood illnesses limited the activities they could pursue and led them to read about spirituality and become interested in the arts. Clark Sterling says he has been remarkably free of personal crises, but it was unsettling for him to move to New York and make friends with people so different from his childhood friends and family.

The trauma that leads some artists to embark on spiritual quests suggests that the creative spark may be (as is sometimes argued) rooted in personal pain wrought by social dislocation. For Jennie Avila, the traumatic spur was leaving home at eighteen; for Jon Davis, being raised by a violent father; for Wendy Ellsworth, coming to terms with remembered abuse. Among all the artists interviewed, 95 percent said they had been deeply influenced by personal crises, of which the most common were parental divorce or fights, loss of a loved one, and an accident or serious illness; nearly half had been afflicted by multiple crises. A high proportion were themselves divorced or separated; more were raised in families that moved around than in families that lived in one place; and a substantial minority had moved frequently. Such crises have played a role in the creativity on which

artistic accomplishments so clearly depend. Although it is possible to be creative without having experienced personal trauma, such experiences often jolt people into asking questions that other people have no reason to ask and gaining a new perspective on realities that other people take for granted.

What most distinguishes these artists, however, is the introspection with which they respond to personal crises, and how their artistic work expresses the resulting emotions. The story of one woman who had been in a serious automobile accident when she was sixteen illustrates a typical response: "It made me much more introspective; actually, since I'm an introspective person anyway, it gave me the opportunity to do more introspection." As she reflected on her life, she decided to be different from her parents and follow her own path, which eventually led her to become a painter. Another painter describes her most traumatic moment as "the volcanic explosion that occurred within me"; she has clearer memories of how she was feeling inside than of any precipitating factors in her environment. A writer observes, "I think all artists are influenced by some trauma or another. I wouldn't be willing to talk about mine, but, yes, there was trauma; it puts you in a position to use your ability as an artist to try to understand the trauma." Without introspection, it is doubtful that crises alone would result in creative work. Introspection involves paying attention to the pain and confusion one feels, rather than blocking it from consideration or dealing with these feelings in purely intellectual terms. Even more important, introspection requires personalizing experiences and thus having to deal with them in unique ways. Creativity is necessary if only because no other person has been in exactly the same situation.

Why personal crises compel some artists to engage in spiritual explorations while others do not may be partly attributable to childhood religious experiences. Artists having no childhood exposure to religion are less inclined than other artists to regard spirituality as a relevant aspect of personal crises. Artists who simply take their religious traditions for granted may have little inclination to explore alternatives when crises occur. Those most likely to embark on spiritual explorations have experienced the sacred in a meaningful way during childhood and, even if they later become disillusioned with formal religion, remain convinced that the sacred may again be experienced through personal explorations.

Katie Agresta recalls a powerful childhood experience of the sacred. Although her parents did not encourage her to explore spirituality, they did send her to church and to parochial school, where she had ample opportunity to think about God. A weekend retreat brings back fond memories: "We had to stay silent for three days in a convent with the nuns, and that was a big turning point for me. I'd never experienced silence, and I sat in the chapel all day long and just prayed the whole time. It was so wonderful." Later in adolescence this experience remained meaningful for her, even though she was repulsed by the harshness of the church's teachings and practices. Clark Sterling's feelings of being close to God when he listened to music and Rick Vise's memories of sacred experiences in the desert reinforced their conviction that spirituality was worth pursuing.

If they take their spiritual exploring seriously, these artists nevertheless emphasize that the passion to explore should be tempered with an element of wonder and thus with an attitude of playfulness. "There needs to be some humor," Bob McGovern asserts, "not humor in the sitcom sense, but humor in the sense of a divine comedy." He believes that the ability to sit back and smile at oneself is the best protection against taking oneself so seriously that one's efforts to do good become evil. A playful attitude makes it possible to focus on the seemingly trivial details of life ("the drift") instead of looking for big battles to fight. "Everyone focuses on the river," he says, paraphrasing something he read, "but we also need to pay attention to the drift."

Paying attention to the drift is his way of saying that God is in the details. To the artist, these details are often an occasion for reveling in the grandeur of life. They are the "whorl of fingerprints" that Jon Davis claims quickens our longing for the sacred. Unlike the river, with its insistent pull toward its final destination, the drift is quieter, less enticing, and easier to ignore.

But noticing the drift may be the key to staying alive, especially for the adventurous wanderer. To illustrate this point, Bob McGovern tells the story of a strapping young man: "David would go out hunting with his buddies on New Year's weekend. He was refreshed with alcohol, but he was the strongest of the group. They pulled up to a little island. He and the other two guys got out of the boat and followed the game. They didn't moor the boat very well, and the boat started to drift out into the river. The other guys are not as strong as David, and David says, 'I'll get it.' David goes out for the boat. The boat teases him further and further and further. So this mighty young man meets his end."

The story is about paying attention to the details as one explores, rather than living unreflectively or focusing only on end goals. It shows the importance of being passionate about one's spiritual quest and of paying attention to the moment-to-moment attractions that can be deadly seductive. "When I talk of drift, I mean something very important. As the story shows, drift is not a little thing. It's a big thing, it's paradoxical, it's ironic, it will trap you. For people in the spiritual life, if you get deadly serious about religion, you'll be very busy about the river. Just don't forget to pay attention to the drift."

Paying attention to the drift is thoughtful advice for spiritual explorers. It means observing the currents that carry one along—whether, for instance, one becomes entranced by the latest spiritual fads or grows so serious about one's faith that life itself slips from view. Many Americans dabble in shallow spiritual waters because the consumer market brings them an abundance of spiritual titillation. Many others work hard at finding an enriching religious tradition or following the dictates of their conscience. An artistic approach to spirituality recognizes the need to settle in, rather than being swayed by a consumer mentality. Being driven to explore means that the search for a spiritual life goes well beyond a trip to the spiritual supermarket to escape the boredom of a lonely afternoon. Intense spiritual exploration involves commitment and sacrifice. It pays heed as well to the value of levity.

Amazing Grace: New Research into "Extraordinary Architectural Experiences" Reveals the Central Role of Sacred Places

Julio Bermudez

Most of our knowledge of the relation of architecture to spirituality addresses the "objective" conditions of sacred buildings: their material, spatial, functional, and other empirical attributes. Long ago we discovered that, if well designed, architecture could evoke the sublime. It is precisely because churches, synagogues, mosques, and monuments can influence consciousness that we build them. And, because objective conditions are perceptually accessible, measurable, and testable, our empirical knowledge of sacred architecture has advanced over time.

Yet holy places are *not* objective constructs existing on their own, "out there." Quite the contrary, the power of such environments lies in how they shape experience. It is their eventfulness in our consciousness that makes them unforgettable, profound, ineffable. Their value comes from how they change us. However, the subjective phenomenology of sacred places makes it hard, if not impossible, to observe, study, and understand them. Our methods to circumvent such a problem include personal testimonies from impeccable sources. If we go through the published record, we can find a good (but not large) number of such reports. However, this approach and its results always remain subject to scientific dismissal and rational skepticism; personal accounts cannot be generalized (and thus become knowledge) because they lack statistical significance and repeatability.

Julio Bermudez, "Amazing Grace: New Research into 'Extraordinary Architectural Experiences' Reveals the Central Role of Sacred Places," from *Faith and Form Magazine*, Vol. 42, Issue 2, pp. 1–6. Published by Guild for Religious Architecture, 2009. Copyright by Faith and Form. Permission to reprint granted by the rights holder.

Lacking a good understanding of the psychology behind the phenomenology of sacred spaces means to see only one side of the relationship between spirituality and architecture.

This article presents results of research designed to address our incomplete knowledge. While the investigation was not originally intended to focus on the experience of places of faith, the findings are heavily weighted toward them. The study walks a fine line between collecting a very large number of experiential accounts using a rigorous methodology (to gain scientific validation) and retaining the freshness and the "thickness" of the reported experiences.

CONDUCTING SURVEYS

From April 2007 to April 2008, two parallel and independent online surveys (one in English, the other in Spanish) were conducted to gather information about people's most profound, lasting, and/or intense experiences of architecture. The surveys defined Extraordinary Architectural Experiences (or EAEs) as:

> ... an encounter with a building or a place that fundamentally alters one's normal state of being. A "fundamental alteration" is a powerful and lasting shift in

one's physical, perceptual, emotional, intellectual, and/or spiritual appreciation of architecture. Contrarily, an ordinary experience of architecture, however interesting or engaging, does not cause a significant impact on one's life.

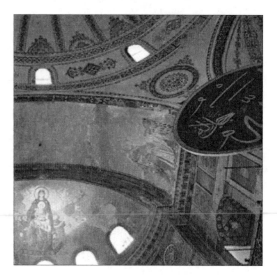

EAEs were selected because their exceptional nature amplifies the experiential effects of architecture and thus makes them easier to study than under normal circumstances; guarantees recall accuracy and thus facilitates data gathering and

reliability,[1] has lasting consequences in the lives of both the public and professionals,[2] and is usually tied to well known places and/or perceptual features that simplify later objective analysis.

Both surveys had the same 36 questions about the experience (25 multiple-choice and 5 open-ended questions) and about the participant (6 questions). The survey was designed to be completed in about 10 minutes and was openly available over the Internet. The surveys produced the largest number of personal testimonies of EAEs ever collected (2,982: 1,890 in English and 982 in Spanish). However, since participation was totally voluntary, open, and unsupervised, the result does not constitute a scientific sample of any particular population. In fact, due to the procedures and instruments employed to produce, distribute, advertise, and complete the poll, the participating populations are skewed versions of the general populations. Respondents predominately have an undergraduate or graduate college education (90% / *90%*); (b) report architecture as their field of study (55% / *69%*); and (c) are between 25 and 40 in age (39% / *39%*) with the 41–55 age bracket (28% / *36.5%*) trailing behind (please note: throughout this article, numbers related to the English survey are noted in roman type, with Spanish statistics following in italic type).

Without denying the limitations of this skewed representation, there are also some advantages. For instance, having a population with a solid understanding of architecture gives us more confidence about the collected data. This is particularly relevant because we

are dealing with issues that are very hard to grasp, measure, and describe. The very large number of responses obtained supports studies with statistical significance within the responding population.

It is impossible to cover the breadth and depth of the survey's results in the space of this article. Therefore, I've limited myself to findings from the study that may be of most interest to *Faith & Form* readers.

PHENOMENOLOGY OF EAES

Let us start with the way in which EAEs unfold in experience and their effects. The beginning of EAEs was said by respondents to be sudden (51.5% / *58.5%*)[3] and surprising (76% / *83%*). Survey participants also reported very high levels of spontaneity in the experience (78.5% / *91%*). With regard to their end, people stated that EAEs tended to finish without their consent (51% / *44%*). However, if we consider the very high level of "don't recall" responses (16% / *19%*) in the termination question, we see support for a non-consensual answer: who would consciously finish something so exceptional and then not recall it? This would put the "finishing-without-consent" statistics at a high 67% / *63%*. In other words, the exceptional experience finished as it started and unfolded on its own!

When probed on how EAEs were felt, respondents reported introspective/silent states (87.5% / *87%*) characterized by no talking (62% / *57%*), strong body reactions (56.5% / *43%*), and a higher level of awareness than normal (92.5% / *78%*). Although only a minority reported weeping (18% / *28.5%*), it is such an incredibly strong response that its relatively strong presence (roughly 20% / *33%*) confirms the power of EAEs. Also, participants overwhelmingly agreed that EAEs were intense (80% / *88.5%*), profound (89% / *91.5%*), and vivid (85.5% / *84.5%*).

There is remarkable consistency among these responses. For example, the powerful emotional tenor of EAEs neatly dovetails with the higher state of awareness claimed. High attention also takes place because the individual cannot predict and/or control what is to occur next. Since the person experiences the event as it happens (i.e., suddenly, surprisingly, spontaneously), she or he must remain vigilant, awake. An experience that is so free yet so alive points towards a suspension of the preconceptions, ideas, and will that individuals bring to most situations. In other words, EAEs are in-progress experiential discoveries based on a certain abandonment to the moment, a "being in the present" open to what the present reveals. Bodily sensations during EAEs (e.g., goose bumps, weeping, trembling, chills, etc.) demonstrate a poignant state devoid of substantial intellectual intervention. These findings suggest that, despite the usual assumption of subjectivity, EAEs seem to move away from an ego-centered experience to plunge consciousness into a unique state that is neither objective nor subjective, but is both simultaneously. This set of experiential qualities must somehow be related to shutting down verbal functioning and the simultaneous opening of other ways of knowing, feeling, and sensing beyond left-brain, neo-cortex, or discursive operations.

QUALITATIVE POWER OF EAES

Although these data provide an initial psychological profile underlying EAEs, such statistical study fails to convey the amazing quality of these exceptional experiences. For example, consider the following descriptions in the words of three survey respondents:

A simple Gothic cathedral in central France: "I walked into this church and was struck by the light and the straight soaring lines of extremely tall walls that curved to form the ceiling. The whiteness of the walls, the absence of stained glass, the lack of ornamentation—just the skeleton really, the stark yet graceful construction exposed—stopped me just inside the door. The lines seemed to fly up to welcome the light, inviting it to shine way down onto the stone floor below. The shafts of light repeated into the distance and their brilliance created elongated rectangles on the floor emphasizing the

vastness of the interior. This visual impact caused an instantaneous physical reaction: quiet shivers of joy, a slow exhalation of an unnoticed held breath, and no desire to move, save for the slow smile I allowed myself. As I had entered from the rear of the church through the main doors, my first impression was that the church had been gutted. Empty yes, yet the space had presence, a fullness of spirit. I was overwhelmed with the light pouring in and the peaceful, glorious space created by the purity of the structure."

Sagrada Familia, Barcelona, Spain: "Passing through a second set of doors, I was immediately overcome by the sheer scale of the structure I had entered. Despite the clutter of scaffolding, I felt somehow lifted into the space. As I entered further I was amazed by the intensity. And I turned and saw a wall of stained glass full of life and color abstracted in form. It became a part of me. Despite its religious context, I felt as though I understood … it … and that somehow … it … understood me. I don't know how to describe the "it" part, but I certainly was unable to ignore the penetrating bond that was created. I sat down where I was able and did what I could to hold back the tears, pretending to blow my nose as the rest of the visitors passed by me. I eventually went back and took a picture of the place, but it serves only as a reminder. The image conjures the fringe of the feelings that were generated, but can't quite simulate the overpowering nature of the event."

Hagia Sophia, Istanbul, Turkey: "As I walked into the narthex of Hagia Sophia I remembered being told that it was a building that had done unprecedented things with the dome, but I hadn't quite "gotten" it in images or slides in art history classes. But then when I walked into the center I was completely overwhelmed because these rays of light were coming through the circle of windows at the base of the dome and filled the space with diffused light. I had been in a lot of religious buildings and I am not a religious person, but nothing quite prepared me for the feeling of mystical awe like that misty bright light that hung in the central space."

These stories are representative of the ones from more than a thousand that people freely recounted in the surveys. Most are narratives describe events as overwhelming, transcendental, or spiritual. There is no denying that people attained an exceptional state of consciousness that was in many ways similar in sensation, emotion, intuition, or insight to that of profound religious or mystical experiences. We need only to go back to William James's 1902 seminal book *The Varieties of Religious Experience*, and review its analysis of the psychology behind holy epiphanies. We can also consider more contemporary studies of the neurobiology of religious experiences[4] to see parallels. And while such resemblance between EAEs and mystical experiences may seem initially strange, it is not so on second thought. Philosophers such as Plato, Plotinus, Kant, Schopenhauer, and Gadamer have recognized the fundamental relationship between beauty and sublime states. Our survey provides scientific validity that not only supports these claims; it also offers a wealth of psychological details about EAEs not well known until now. At its best, the most material of human artifices, architecture, delivers us to the ultimately immaterial. This may not be the case for everyone, but it is true that a vast number of people find EAEs as gateways to the sublime or holy.

Hence, it is not surprising that survey participants unambiguously reported that EAEs forever modified their understanding and appreciation of architecture (81.5% / *80.5%*). Let us remember that these experiences irreversibly and fundamentally changed the interpretive framework of something very dear and well known to most members of the surveyed population (55% / *69%* had architecture as their field of study). Yet EAEs accomplished such feats for a huge majority of people in both surveys! Such a forceful and transformative shift cannot be really explained unless we acknowledge at some level the numinous quality of EAEs.

NATURE AND OUTCOMES OF EAES

The survey inquired about the nature and outcomes of EAEs. EAEs are exceptionally "Emotional," "Sensual-Perceptual-Physical," "Timeless," and "Pleasurable" experiences that deliver "Insight," "Beauty," "Joy/Satisfaction," and "Peace."

From these results, we can interpret that EAEs are aesthetic epiphanies characterized at least initially by their "Sensual/Perceptual/Physical" qualities. They afford a direct and intuitive discernment that, when related to the other survey data, provide profound, vivid glimpses into the nature of ultimate reality. In this context, the reported "Satisfaction/Joy" outcome has to be seen with an EAE's "Pleasurable" nature understood not only as sensual delight but *also* as a multilayered ecstasy that also includes intense feelings, intellectual fulfillment, and even spiritual realization. Finally, "Peace" as an essential result of EAEs has to be seen in the context of the third-ranked "Timeless" quality. Pervading it all is the intense emotional nature of EAEs that enables attention to rise to a peak from which beauty can be appreciated, penetrating insights attained, satisfaction and joy felt, and the attainment of an overall sense of peace.

An unexpected finding was the low ranking of "Analytical/Intellectual" for describing the nature of an EAE (6th / *5th*). This does not necessarily signify a lack or irrelevancy of thought or analysis in EAEs, but that "thinking" comes fifth or sixth in relevancy and needs to be downplayed if the EAE is to unfold uninhibited. EAEs cannot be studied or explained as critical, analytical, or intellectual experiences.

TOP TEN PLACES FOR EAES
The survey asked participants to name the place where they had experienced their EAE. Compiling the responses generated a list of buildings well known for their beauty and power. Notice the significant consistency in the two survey groups.[5]

The fact that so many respondents from different origins, languages, ages, genders, and cultures report EAEs at the same places strongly supports one of the fundamental tenets of scientific discovery: repeatability. Although an absolute replication is not possible due to the experiential nature of the event, the sheer number of testimonies for each one of these places *and* their consistency cannot be disregarded as being "subjective."

Because most of these places are or had originally been religious buildings, it makes sense in the context of the findings of this research that architecture and spirituality naturally find one another during EAEs. Such exceptional events are invited by built beauty and it is logical to expect societies not only to notice such a link over time, but to exploit it as much as possible in their places for holy purposes.

It is significant that many respondents were surprised and changed by EAEs in buildings that they most likely knew intellectually beforehand (e.g., from history courses, travel books, etc.). The presence of these places (Walter Benjamin's famous concept of "aura") was strong enough to break through intellectual familiarity and offer a totally new and therefore surprising and spontaneous experience. This means that quality cannot be indirectly learned but must be directly apprehended, found, tasted in actual experience. If English were Latin, we could say that "*cognoscere*" can never be or replace "*sapere*."

CONCLUSION
Although the research findings presented in this article begin to map the phenomenological structures and processes common to experiencing architecture in spiritual depth, much remains to be done. One important area of work will be to look at the correlation between the reported subjective states and the objective conditions present in a particular environment. For example, how do the psychological states reported by multiple individuals at the Pantheon in Rome correlate to the physical attributes of that place? Are there links between such relationships and those found for other buildings? Can we develop psychological and architectural frameworks or profiles that favor EAEs? What about the impact of gender, age, culture, and the like on EAEs? The answers to such questions could have important

implications in our understanding of the relationship between architecture and spirituality in ways that begin to balance our one-sided knowledge base.

In the meantime, the thrust of the findings gives scientific validity to what the ancients and designers of sacred places for millennia have known intuitively: architecture can touch the soul and fill the spirit. This occurs as an extraordinary aesthetic experience of an inexhaustibly deep, sublime, and spontaneous reality: a reality framed, presented, and built as architecture.[6] The fact that beautiful buildings devoted to such awesome tasks continue to move us across epochs, civilizations, and cultures is testimony of the presence of archetypal conditions at play. While we cannot depend on our analytical abilities to enjoy EAEs (nearly 2,900 individuals agreed that we need to hone our emotional, perceptive, and intuitive skills instead) we can definitely use our intellect to direct a renewed study of sacred places. It is clear that they still hold many secrets that can assist us in the creation of new places that will be extraordinary.

Julio Bermudez is an Associate Professor at the University of Utah College of Architecture and Planning. His research interests are in the phenomenology of aesthetics and the relationship between architecture, culture, and spirituality. The author wishes to thank the thousands of individuals from all over the world who gave their time to participate in the survey. Not only did each selfless act help advance the state of the art of our discipline but, more important, is a living proof of the true and staying power and relevancy of architecture in our lives.

FOOTNOTES

1. When asked about recalling their EAE, the majority of survey participants agreed it to be "Strongly Vivid" (63.5% / *63.5%*) with "Moderately Vivid" a clear second at 33.5% /*34%*. Vague recollection was reported by only 3% / *2.5%* of the people. This remarkably high level of recall convincingly points at the imprinting power of EAEs in memory and brings a high reliability to people's testimonies.

2. Refer for instance to: Tony Hiss, *The Experience of Place* (New York: Knopf, 1990); Lindsay Jones, *The Hermeneutics of Sacred Architecture* (Cambridge: Harvard University Press, 2000); Robert Ivy, "The Essence of Education" (Editorial), *Architectural Record* 07 (2006) p.17; Norman Koonce, "Erasing the Boundary Between the Physical and the Spiritual", the *AIA Journal of Architecture* (July 2005): 2.

3. The fact that the numbers for "gradual arousal" were still high (46% / *39%*) implies that a slower and more steady arrival of the EAE may not necessarily diminish its startling effect.

4. During the 2006 IFRAA Symposium in La Jolla, California, Patrick Russell and Andrew Newberg presented compelling evidence showing that neuro-scientific studies of religious experiences may apply to perceptual phenomena in religious

architecture. See also the work of Richard Davison at the University of Wisconsin Laboratory for Affective Neuroscience.

5. Two buildings in the English Survey and one in the Spanish Survey show some bias toward "local" conditions. These are the Salt Lake City Public Library and the LDS Temple (Utah), and the Banco de Londres in Buenos Aires. This is due to my particular connections with populations in Utah and Argentina, (I estimate a 20/30% presence of the total in each survey). The relatively focused choice of the individuals in these populations deforms a bit the overall result. For the record, I must say, however, that these three buildings are examples of very good architecture.

6. We are reminded of Michael Benedikt's book *For an Architecture of Reality* (New York: Lumen Books, 1987) where he maintains that architecture's fundamental role is to present reality.

The Reverend Howard Finster:
The Last Red Light Before
the Apocalypse

Liza Kirwin

half expected a choir of angels on silvery wings to announce the death of the Reverend Howard Finster, but instead I learned from Roberta Smith in the *New York Times* that Georgia's most prominent artist had died last October 22 at the age of eighty-five. Perhaps it was no less miraculous that a Baptist preacher from the tiny town of Pennville commanded the attention of the art world. Finster loved an audience.

He was a larger-than-life personality with a devoted following long before he appeared on *the Johnny Carson Show* or in an R.E.M. music video. For his speaking engagements, he wore a powder-blue suit and had his banjo at the ready. He sang with a melodious twang, and he could yodel with force, but it was his compelling "sermons in paint" that made him a folk art phenomenon.

Born in Valley Head, Alabama, Finster was one of thirteen children. At sixteen he preached his first sermon. In the 1940s, he hosted a radio program and wrote a column for the local newspaper. He led tent revivals and "pastored" many churches. To support his wife, Pauline, and their five children, he was also a bricklayer, a carpenter, a plumber, and took up the "hard times business" of bicycle and lawn mower repair. He had a great sense of humor, which he used in the service of the Word. He once told me, "When I'm in big

revivals, about the first thing I do a lot of times is get the people tickled a little bit, get their mind off everything, then I get the message over to 'em."

Finster never tired of telling the story of how he came to be an artist. In 1976 he dipped his finger in white paint and saw a perfect human face on the ball of his finger, "and while I was lookin' at it a warm flash kind'a went all over me, all the way down, and it said, 'Paint sacred art.' And I said to it, I said, 'I cain't do that. I know professionals can, but not me.' And it comes to me again and it says, 'How do you know?' I said, 'How *do* I know that I cain't paint.' I tuck a dollar out of my wallet, and I pasted it on a piece of ply-board and went out in front of my shop, and I started drawing George Washington off that dollar bill." Whether true or not, the story stands as a parable of his faith in divine visions, as well as in his ability to make money.

In the 1960s, he began constructing Paradise Garden, a two-acre spiritual environment at his home in Pennville. His plan was to display all the inventions of mankind. Embedded in the garden's cement walls, walkways, and playhouses are Bible verses, accumulated bicycle parts, TV tubes, mirror glass, Coca-Cola bottles, junk jewelry, plastic toys, a mound of cement snakes, and his son's tonsils "put up in alcohol." Finster displayed his paintings and plywood cutouts ("dimensions") of Santa Claus, Abraham Lincoln, famous inventors, and Bible figures in the garden, and it wasn't long before collectors and the curious beat a path to his door to buy his art. "They'd come here and just blow up on it, so I'd just take the crowbar and start pulling it off," he told me. He made thousands of works of art that often combine written words with his own vocabulary of visual images.

At home Finster would kick back on his studio couch with a chaw of tobacco in his cheek and carry on a stream-of-consciousness monologue for hours. Like a perpetual-motion machine, he seemed to gain energy from his own oration. He had lots of ideas, mostly about how to fix things, from TVs to the Middle East crisis. His handyman's sensibility made anything seem possible. For all of his fire-and-brimstone swagger, there was a sweetness about him. He encouraged people to discover their hidden talents; if they didn't, it was "just like takin' a quart of milk and stickin' it in the refrigerator and lettin' it sit there till it spoils." He also talked about his visions—all the strange and beautiful sights on his travels through the twilight zone. He told me that he had walked through hell and had witnessed eternal suffering, that Elvis Presley had appeared to him, and that he'd seen other fantastic scenes as well. The next minute he'd be down to earth. He didn't like buying anything on credit because he couldn't see much difference in paying for something and then waiting a week to pay interest on it. There was a fine line between his religious convictions and pure business savvy; he didn't sign contracts, he told me, because God is a free agent.

One could say that all artists are visionaries, but Finster was tuned to a special frequency. He took on the big topics—life and death, redemption and salvation. In the 1970s and 1980s, that angst-ridden era of few certainties, here was a man of solid convictions, pointing the way. It's no wonder he was a hero to hipsters.

I first met Howard Finster in the summer of 1984, when I interviewed him for the Archives of American Art's oral history program. He was in Washington, D.C, for an exhibition at the Anton Gallery, then on Capitol Hill. The interview almost didn't happen because he wanted to be paid. A novel idea. We negotiated. He agreed to talk and sing and preach for free, for hours. (His words quoted here are all from that 1984 tape recording.) After the interview we had lunch at the cafeteria in the Old Patent Office Building, where the archives were then located. He was so tickled with the choices that he took one of everything. We spent the afternoon in the courtyard under the elm trees feeding his leftover sandwiches to a growing flock of pigeons.

In 1988 I took a film crew to Finster's compound to shoot a segment for the TV program *Smithsonian World,* and we continued to correspond quite a bit in the 1990s. He had a special regard for the Smithsonian Institution, which mirrored his mission to collect the wonders of the world. And he was grateful to the Archives of American Art for microfilming his papers and making them freely available. The film crew and I arrived with the worst snowstorm to hit Georgia in forty years. What bad luck, I thought, as I scraped the frost from the windows, a virtual prisoner of the only motel in town. We had two days to film Paradise Garden, which was buried under a pile of snow. I had little faith, but Finster saved us. With the cameras rolling, it was *more* remarkable to hear him talk about what was under the snow, than to actually see it. It was a striking demonstration of his power to behold the hidden, to show us a world that only he could see. He had spent a lifetime animating the intangible—from the fiery pits of hell to heavenly mansions "beyond the light of the sun."

He thought that good Christians were scarce. In his own words he was "one of the world's last red lights." "I'm not here to live a normal life," he told me. "I'm sent here on a mission. I was fore-predestined for this planet. Just like Henry Ford." I admired his compulsion. He worked night and day with all of his energies bent toward the single-minded purpose of spreading the Word. Recalling his remarkable journey, he said, "It's all been fun, it's all been spiritual, it's all been rejoicing, it's all been a sacrifice. It's been a hard road. It's been an easy road. It's just been everything." With Finster's passing, I will look more closely at his paintings, searching the surfaces for a smear of paint with the perfect face of Howard Finster looking back at me.

Photographing the Sacred Feminine: An Interview with Cindy Pavlinac of Sacred Land Photography

Michael J. Crosbie

Photographer Cindy Pavlinac has captured glimpses of the sacred feminine in her work as she has traveled the world. I sat down with Pavlinac to talk about her photos, her inspiration, and how her images convey an ancient sense of the sacred feminine.

Michael J. Crosbie: How did you choose photography as a medium for your art?

Cindy Pavlinac: I grew up in Michigan and always thought I'd be a scientist. While an undergrad in astrophysics and engineering I found myself in the art department photographing physics experiments. "When I was told I wasn't allowed any more art classes unless I was an art major, I switched. My greatest struggle was the required figure drawing assignments because I didn't like objectifying the human figure. The professors insisted on realistic drawing, so one day out of frustration, I said "If you want a realistic image I'll just take a photograph." I went around the back streets of Kalamazoo photographing old houses and broken-down cars, and suddenly my art teachers began treating my art seriously. Working in black and white, I learned to see light and shadow, scale and texture. I experimented with time exposures, laying the appearance of physical objects and movement on top of each other to form a new shape, otherwise unknowable. Photography captures material objects, yet there is an inherent self-portrait component to every created image. And the viewer brings her own personal history to the photograph so everyone

sees something different. I found that by telling my story, I could bring the infinite into a moment.

Crosbie: The name of your studio is "Sacred Land Photography." How is the land sacred?

Pavlinac: My first encounter with sacred land was at Delphi in Greece. I studied archeology in Athens as an undergraduate for six months on a foreign studies program. Our spring trip was to Delphi, and my assignment was to give a report on the Temple of Apollo at the actual site. As we were driving to Delphi, the road narrowed at a place where the mountain slopes to the sea. One of our professors mentioned that this was where Oedipus had met and killed his father, fulfilling the Delphic Oracle prophesy he had just received. It really struck me for the first time that the ancient myths were based in real places. The modern road became suddenly layered with the present and the mythic landscape. Arriving at the ancient temple precinct of Delphi, I immediately trotted up the Sacred Way to get a photo of this magnificent valley. I wasn't high enough, so I climbed a cliff, and as I looked down the wind wisped my hair and I felt that Apollo was speaking to me. The mythic became real. It was a glimpse of source, an essence, and I had never experienced that in my life. It was an awakening, a shift in my attention. Apollo told me to visit sacred sites. I got my picture, climbed down, and visited a different island every weekend.

My school also had a field trip to Egypt—more ancient sacred places—and I found that there were possibilities in accessing ancient civilizations through their sites. Something about the sites remains real and continuous. When I step into an ancient precinct that has a very deliberate alignment, I find that it aligns me. That's my attraction to the sacred. All the old religious sites are very attuned to the sky; for me they represent a point where the inner and outer worlds connect. It awakens a sense of the sacred in me, and I'm attracted to the idea of human consciousness being preserved at a site. It's enhanced and honored beyond its natural state. I named my studio Sacred Land Photography because I make pilgrimages to places that are set apart; finding and honoring and illuminating the sacred, I return with photos to share.

Crosbie: Is there a feminine dimension there?

Pavlinac: The potential for accessing the sacred from these sites, like Delphi, is there. To me that is a key to the feminine. Every cathedral is built atop a sacred grove of trees, or a well, or a place where people gathered. The potential of its being a sacred place makes it feminine. We feel nurtured there. That's why people gather there and why we build there.

Crosbie: What role do your photographs play?

Pavlinac: Part of my role is to visit those places and to translate them into the modern present through my photography. I'm not a tourist. I'm trying to understand the sites in their terms and translate my understanding into art. Native Americans have a term, "rainbow warrior," for someone who bridges these worlds. I want to show people a glimpse into the mystery and power and beauty of a sacred place. The feminine is there, and it's big enough to hold everything.

Crosbie: Do people respond to your work in ways that suggest that a strong feminine quality is present in the subjects you photograph, or in the way you have photographed them?

Pavlinac: I never think of myself as a woman taking a picture. I am a person alive right now responding to what is in front of me, while trying to touch what has come before. As to how people respond to my work, it stops them. There is a stillness, and they may not say anything at first. Then they want to know where it was. And if they've been there, they want to know when I was there, because it didn't seem like that when they were there. I usually tell people that I wait around a lot. I travel off season and I go when places are misty or in the rain. I don't like crowds. To be alone in a place is a big head start in helping you to experience it. An image can help bring you into the present, while talking takes you out of it. People are interested in knowing more about the culture and then the conversation turns to more of the feminine, gentler ways of treading the earth, of being there together.

One of the most common questions is what kind of camera I use. How did I get that picture? People are fascinated when I tell them I walk around a site first, and you don't have to have the camera glued to your face. I encourage people to experience the place where they are and to be present. People sometimes open up and tell me their own stories, of something that happened to them there. The photo might give them validation to what they experienced, or they may resonate with it. My multimedia shows, with music and hundreds of images, are a more comprehensive experience of a sacred place. They are a nurturing experience.

Crosbie: Do sacred sites you have photographed have anthropomorphic qualities that seem to suggest a feminine quality?

Pavlinac: I am drawn to circles and negative space: domes, wells, and bodies of water; things that are organic, rather than with straight lines. The standing stones look like people, and they have been carved that way. I like places like caves that are enclosed, with subdued lighting. I like to be at sites that are veiled and mysterious. They all suggest a feminine dimension, like petroglyphs that follow the curve of a rock. The feminine aspect is the physical space, the meeting place, the structure; the masculine aspect is the activation of that structure. The shape of a site like Stonehenge is feminine. There is an essence about it. Looking into the mechanism of the universe you are seeing a phenomenon, something that happens every year, but when you experience it, it completely knocks you loose from time. To really experience such sacred places you need to open yourself up and you need to pull back, to stop and look. We need to strengthen people to do that. You need to surrender yourself to a site instead of conquering it, and that's a feminine aspect to experiencing the places and my photographs.

Crosbie: Many of the places you have photographed are very old. Do you think the feminine aspect of these places evolved over time, or were they always this way?

Pavlinac: I'm not sure about the feminine evolving—that sounds like a masculine quality. The feminine is more in recognizing what is eternal, the quality that people were attracted to in the first place, and the different responses that people have had to these sites

over time. Chartres started as a well in a grove of trees, then a little church was built, and then larger and larger structures were constructed. But I don't think the feminine aspect changed.

Many of these old sacred sites are ignored now, which says more about our own culture and society. But they are still there. The old sites are held in context and for me that is how you get meaning. There is no context with a relic. But the site is all part of the geographic fabric. The context is an environment, closer to the feminine aspect of the sacred—the nurturing, holding aspect of it. It is an environment—not just the temple, but the environs around it—that prepares you for it, aligned with and integrated into the landscape.

Border Hysteria and the War Against Difference

Guillermo Gómez-Peña

"Watch out locos! Godzilla in a mariachi hat could be an Al-Qaeda operative."
In this piece, performance artist and writer Guillermo Gómez-Peña articulates
a passionate defense of "undocumented" immigrants, post-national identity,
and a multiracial USA. This text-in-progress is part of the borderless movement
of citizen journalism circulating in cyberspace.

I

In October 2006, King George signed a bill authorizing the construction of an additional "border security" wall spanning one-third of the US-Mexican border. The plan was to build a concrete wall replete with floodlights, surveillance cameras, and motion detectors. On the front-page photo of Mexico's daily *La Jornada,* George W. and a group of opportunistic governors and *políticos* from the southwestern states stand posed before a postcard-perfect Arizona landscape. The President sat at a table signing the bill, his sycophantic groupies fanned about him, gawking and gaping like backstage groupies. It was pure performance art for electoral purposes. The photo was published throughout Latin America and caused general outrage.

Guillermo Gómez-Peña, "Border Hysteria and the War Against Difference," from *TDR: The Drama Review*, Vol. 52, No. 1 (T 197); Spring 2008, pp. 196–203. Copyright © 2008 by MIT Press. Permission to reprint granted by the publisher.

I asked myself: "Who is going to build that *pinche* wall—undocumented migrants hired by Halliburton?"[1]

A month later, Congress approved the proposal—the same week they squashed *babeas corpus*. *Una mera coincidencia?*

Outside this country of the US everyone asks: "Why does the US need more walls and more isolationistic politics? Aren't they isolated enough already?" But within our borders Washington incessantly chants: "National security! Homeland security!" More walls, laws, and border patrols!

The master narrative of US national security (as written by the neocons in collaboration with the mainstream media) reads: "Muslim radicals are out to get 'us'; 'illegal aliens' are out to take 'our' jobs. We, victims of the wrath of history, are merely innocent bystanders. Our only crime is our belief in freedom and democracy." This strategic deployment of the rhetoric of victimization and of heroism and of moral panic clearly justifies both the tightening of our borders and the militarization of our international policies.

II

This is the new brand of immigration hysteria: bigger, better, whiter.

As the years have passed and the US has nurtured its citizens' convalescence from post-9/11 shock, nativist newscasters, opportunistic politicians, right-wing think-tanks (FAIR), and citizen groups continue to portray Latino immigrants as the source of all our social and cultural ills and of our financial tribulations—even, at times, as distant relatives of Arab extremists.

Since 9/11, the semiotic territory encompassed by the word "terrorist" has expanded considerably. First it referred strictly to Al Qaeda and the Taliban, then to Muslim "fundamentalists," eventually it engulfed all Muslims, and then finally all Arabs and Arab-looking people. In 2003, when a Palestinian friend told me: "We (Arabs) are the new Mexicans, and by extension you are all Arabs," I realized how easily the demon mythologies of the brown body transfer from race to race, from country to country. Memories, like attention spans, are short and mutable. Color, like disease, is contagious ...

Former Attorney General John Ashcroft forged the missing link between the War on Terror and Latin America. During his reign a Puerto Rican Muslim named Padilla was detained as he returned to the US from a "suspicious" visit to Pakistan. On several other occasions Mexican migrants were detained for an indefinite period of time without explanation or legal counsel. Their crimes? One of them wore a tattoo with the image of Bin Laden. Another one, a Mexican ice cream vendor, was seized while videotaping a government building in Fresno. He wanted to send a tape to his family back home "to show them the beautiful buildings of his host city." These cases are heartbreaking and

1. See *New York Times* (2006).

reveal a frightening political reality: the scattershot US War on Terror has definite second front line, the US-Mexico border.

During a CNN "town meeting" on border issues conducted by anti-immigrant pundit Lou Dobbs, Republican Michael McCaul explained: "You know, after 9/11 the border is really a national security issue. We simply do not know who is coming into this country." The implication of his warning was clear: How can we tell the difference between a migrant worker and an Arab Terrorist? Watch out locos! Godzilla in a mariachi hat could be an Al-Qaeda operative.

<div align="center">III</div>

It's "zero tolerance" for brown-skinned immigrants.

The militarization of the border began in the early 90s' with the transparently obvious name "Operation Gatekeeper." When the Border Patrol officially "lit up the border," migrants were forced to travel through more treacherous desert terrain. More than 5,000 migrants have died while crossing or attempting to cross since then.

The Bush administration has taken this project to a new height of absurdity. The number of combined law enforcement personnel and the scope of the high-tech military apparatus that monitors the border have increased exponentially since 9/11. This increase in devices of border surveillance is matched by the increase in the number of right-wing vigilante groups like the infamous "Minuteman Project," who feel that their patriotic efforts to defend our borders are validated by the political mainstream and protected by the Patriot Act. Their frequent human rights violations are rarely prosecuted or even reported by the media.

Racist anti-immigration legislation is being implemented in small towns all across the country. It is now illegal in certain cities for landlords to rent rooms or apartments to "illegals." The sanctions against employers who hire "illegals" have become much tougher and more frequently imposed. Immigration and Customs Enforcement (ICE) increasingly conducts raids (with overtly cruel names such as "Operation Predator") in stores, bus and train stations, Home Depots, meat-packing plants, restaurants, and nightclubs. "Concerned" citizens are also doing their part. Despite the fact that citizenship is not required for students of public schools in the US, some schoolteachers persist in asking Mexican children for proof of their parents' citizenship. One state assemblyman has requested that school districts in his area provide him with the number of "illegal" immigrants in their classrooms. Certain banks are reporting to Homeland Security when a Latino who wishes to open an account does not have proper documentation. It is no exaggeration to assert that Homeland Security now runs the largest neighborhood watch program on planet earth.

What is the logical outcome of all this hysteria? The economy of these communities collapses as migrants are forced out of town. The state of Colorado has been so successful

in expelling the migrants that sustain its economy that the governor is now considering replacing them with prisoners. Good luck keeping them in line, *pendejos!*

But this economic revelation does not discourage the likes of Lou Dobbs, Bill O'Reilly, Pat Buchanan, and Samuel Huntington. Obsessed with a mythical "war of civilizations" in which the US is losing control of its borders and rapidly becoming "Mexicanized," they rejoice in the following metanarrative: White identity, protestant Anglo culture, and the English language are under serious threat and the country must remove *all* external influences, close its borders entirely, and begin massive deportations of "aliens." It's now or never.

The restoration of the fabled monolingual White America that never was (but wishes it had been) is not only a crackpot project, it is, in fact, a genius plot for a sci-fi movie! One wonders if it is possible to imagine a US without Native American, black, and Chicano culture; without blues, jazz, Tex-Mex, and Cajun music; without Latino, Creole, and Asian food; without writers and artists of color. Would it even be the US? Is there such a place on the map? Was there ever such a place?

Are we approaching the last days of an Empire, or is this merely the long, dark night of a democratic republic immersed in a severe identity crisis? How did we reach a "post-democratic" era and not even know it?

For the moment, post-9/11 America is in "lock down," rapidly becoming a closed society. Thanks to Bush's unilateral and isolationist policies, the US is completely alone in the world, facing the bizarre burden of having to defend and enforce "liberty and democracy" through violent means.

IV

The Western Frontier reappears...

Immigration hysteria has always resurfaced in times of crisis. It's an integral part of America's racist history. But this time it's different. What characterizes this immigration debate is an absolute lack of compassion when referring to migrants without documents. The "aliens"—that is, the brown-skinned ones—are "criminals" by the mere fact that they are here "illegally." But the criminality that is a consequence of their location—being on the wrong side of the US-Mexican border—is now taken to be symptomatic of their broader "criminal" identity. They are treated with suspicion for being connected to or supportive of global crime cartels and terrorist cells.

The loaded terms such as "illegal alien," "alien," or the even more damming term, "illegal," are now synonymous with smuggler, border bandit, drug pusher, and gang member. The distinctions between "illegal" and "legal" easily disappear in the eyes of the racist. The brown face of evil morphs into the face of every "other" when the button of fear is pushed.

The incommensurable human suffering of migrants who move from their "proper place" without documents is a direct consequence of a failed global project, but their suffering appears inconsequential. The fact that hungry men, women, and children risk their

lives by crossing the desert to make a few dollars to send back home remains insignificant. The fact that most of their earnings are sent across the border infuriates the nativists even more. For them, humanity stops at the border, "this" side of the border. Paradoxically, these self-styled "nativists" are of European origin, whereas their "alien" enemies are indigenous Americans whose ancestors walked this American land for thousands of years, long before the first border checkpoint was installed with the 1882 Exclusion Act.

Since the US-Mexico border is now perceived as the most vulnerable national security barrier and as the probable entryway of terrorists, to defend "illegal aliens" is to participate in anti-American behavior. If you dare to help them in any way—feed them or offer them a ride (not to mention a job or a place to live)—you may be breaking the law. For this reason, we can legitimately proclaim that human empathy and human solidarity are now illegal in the USA. Remember the outrageous treatment of the "No More Deaths" volunteers in Arizona (2006) who were prosecuted merely for giving aid to migrants in the desert whose lives were in danger?

When a caller recently told Bill O'Reilly, "I will never employ an alien or rent to an alien because I'm an American patriot and my job is to defend America," the right-wing shock jock answered: "Good for you, Sir!" The absolute lack of empathy for those who are culturally different from "us" (the fictive white majority) permeates the mainstream media and its version of political discourse. When one US citizen is killed or kidnapped abroad the whole country becomes outraged. However, the monthly deaths of migrants crossing the border are rarely reported, and the daily deaths of Iraqi civilians remain impersonal numbers. They are "collateral damage" in the multiple fronts of the War on Terror. The demonized brown body in the age of terror has no name or personal identity.

Pay attention to the tone and language of the immigration debate and one cannot help but ask: Has America lost its compassion (or rather the mythology of American compassion) for the underdog and its tolerance for cultural otherness? At what point did white people stop calling themselves immigrants? And weren't they initially illegal too?

The damage that the Bush administration has inflicted upon our legal structure, civic culture, and our psyches is profound. Compassion has been replaced by fear: a generalized fear of otherness and difference. Fear is now our national culture, our subconscious, and our Zeitgeist. This same fear helps to wage war and inflict torture on people who have come to this country for many of the same reasons as white immigrants.

v

In a state like California, with a majority Mexican population, "the governor" openly praises the Minutemen. His off-the-record comments about the "hot-tempered" nature of Latinas match up with his public statements that indicate he does not want "aliens" to have driver's licenses. He is clearly suspicious of their "alien" nature. He believes that forcing them to walk or to rely on inadequate public transportation makes them easier to watch by law enforcement officials.

Against all logic Arnold was reelected governor with one-third of the Latino vote. Why? Did we vote for him or for the action hero? Have we Latinos become that depoliticized and alienated? Are our psyches so colonized by trash culture that we have lost our political compass? Aren't we aware of the racist history of the GOP?

A brief look at Latino electronic media might gives us some clues: When surfing Spanish-language TV channels, what do we find? A mediascape populated by hysterical celebrities and cyborg babes in micro-tangas speaking about … *nada*. Tabloid newscasts feature "the weirdest and most violent." "X-treme" and "uncensored" talk shows and "reality shows" strive to out-outrage their Anglo counterparts. It's embarrassing. Latino media has become an over-the-top cartoon of the US media that originally inspired it.

As a Latino artist I constantly ask myself: How do we fight this political despair and cultural loneliness we feel in post-9/11 America? How should we respond to the fact that Spanish-language media addresses the lowest common denominator when creating its programming and media content? Where can Latinos go to renew our cultural identity and political clarity? In the past we might have looked to local art spaces and community centers. But these cultural spaces are facing probable extinction due to severe underfunding of the arts and community centers and the services they provide.

VI

The frightening post-9/11 political lingo has been normalized, and so have the fears and humiliation rituals shaped by it. George Orwell's bible of "Newspeak" and the cold-war jargon of the "Wetback Menace" are nothing compared to the linguistic artistry of the Bush regime.

Phrases like "Homeland Security" and "Patriot Act" are fascist terminology that closely resembles Nazi jargon. "Homeland Security" in German literally translates to the original name of the Nazi SS. Immigration and Customs Enforcement, or ICE, is now the new acronym for the border patrol. What a pitiful metaphorical choice! Is their objective to "freeze" all border crossings? Think about these terms! Isn't it clear that "National Security" really means security for a few middle- and upper-class whites and insecurity for the rest? Have we become so shortsighted that we can't understand that "ethnic profiling," now official policy and daily practice, is a euphemism for blatant and institutionally sanctioned racism?

As we build the "second border wall" we are sending an unambiguous message to the rest of the world: "The US DOES NOT wish to be part of the world community; leave us alone … or else!"

VII

As the popularity of neocon policies decreases along with the mirage of national unity created by the phony patriotism of war, we become aware of a dramatic fact: We are a divided country, and divided we stand.

The internal divisions multiply beyond the popularized blue/red American schism revealing multiple Americas, fragmented communities, and divided families. The "typical" Chicano family of today is also divided along conscious and unconscious ideological lines. Seated at the same family table one can find a soldier and an antiwar activist, a border patrolman and an undocumented uncle, an artist and a Hispanic businessman, a confused patriot and a lonely internationalist. Clearly, the post-9/11 culture of panic, militarism, censorship, and paranoid nationalism has permeated our psyches, daily interactions, and personal relationships.

As critical artists, we are overworked and poorer than we were a decade ago; we're politically exhausted and scared shitless of the immediate future. It is no coincidence that in the last few years personal illness, breakups, and suicide have all increased exponentially against the backdrop of social, racial, and military violence. Understandably, our bodies and psyches are internalizing the pain of the larger sociopolitical body, and we are absorbing the fear and despair of the collective psyche. As Latinos, our brown bodies are also occupied territories in which other wars are taking place.

VIII

The US-Mexico border is wider than ever.

As an artist engaged in binational cultural exchanges for 25 years, I have never seen my two countries more separated from one another. While Mexico is obsessed with its own postelectoral crisis, the US is obsessed with the War on Terror. While Mexico grapples with organized crime, the US grapples with its inner demons of terror. Indifferent neighbors, neither one is paying attention, much less talking to the other.

From the US side, Mexico is, at best, invisible (post-9/11, Latin America disappeared as a regular news item); and, at worst, a Dantean inferno. From the local news to recent Hollywood movies and video games, Mexico is portrayed as an ongoing source of drugs, illegal immigration, senseless crime, and political turmoil—and nothing more. When discussing organized crime in Mexico, US pundits and politicians fail to understand the obvious: the guns that perpetrate that violence are actually made by US gun manufacturers and sold by US dealers. This too is an "inconvenient truth" of global significance. It's the same with drugs. The US distributors and consumers don't play significant roles in action movies—unlike in the real world. In public discussions no one acknowledges that violence and drugs are part of a systemic global problem. All sides are implicated. There are no good guys or bad guys in this film. (Gonzalez Iñarritu's amazing 2006 movie *Babel* made this case in a very poignant way.)

Strategic ignorance plays a major role in all this madness. Many "patriotic" Americans easily forget that it is thanks to "illegal" aliens hired by other "patriotic" Americans that the food, garment, tourist, and construction industries survive. They conveniently forget that the strawberries, apples, grapes, oranges, tomatoes, lettuce, and avocados that they eat were harvested, prepared, and served by "illegal" hands. These very same hands clean up after them in restaurants and bars, fix their broken cars, paint and mop their homes, and manicure their gardens. They also forget that their babies and elderly are being cared for by "illegal" nannies. Like the pro-immigration aphorism stated so poignantly in banners during the major marches of 2006: "The giant wasn't sleeping; he was working."

The list of underpaid contributions by "illegal aliens" is so long that the lifestyle of many middle- and upper-class Americans couldn't possibly be sustained without them. Yet the Americans who are against illegal immigration (over 65 percent according to current polls) prefer to believe that their cities and neighborhoods are less safe and that their cultural and educational institutions have significantly lowered their standards since the "aliens" were allowed in. Current anti-immigrant discourses and practices exploit the image of hypersexualized Latinas coming across the border to have their babies, collect welfare, and overburden the environment, the public hospitals, and the schools.

The great paradox is that when it comes to recruiting noncitizens to go and fight in Iraq as foot soldiers, no one seems to mind who is illegal and who is not. Offering "postmortum citizenship" to undocumented migrants if they choose to enlist (as an alternative to deportation) is both hypocritical and inhuman. Incidentally, only 15 percent of those undocumented migrants who have accepted the Faustian deal have returned alive to enjoy their citizenship. In fact, the very first US soldier to ever die in Iraq was a Guatemalan migrant named Jose Antonio Gutierrez who spoke very little English. He died from friendly fire.

Are these contradictions articulated in the current immigration debate? Rarely. Why? Because it isn't really a debate but rather a fanatic creed and an expression of much deeper fears.

IX
"Please report immediately any suspicious behavior or package to the airport police."
—Airport Public Service Announcement

What the anti-immigrant rhetoric doesn't seem to acknowledge is that a closed border not only impedes people from coming in, but it also stops people from leaving. Isolationism works both ways. The internal panopticon affects us all. And isolationism in the age of globalization is a worrisome symptom of cultural entropy and political desperation.

Even worse, isolationism is self-perpetuating. The irony is that the exaggerated border enforcement designed to keep undocumented immigrants out and to make crossing much more difficult has actually made it so that immigrants stay within the US longer. Sometimes their stay becomes … permanent.

The new immigration laws, Homeland Security's use of biometric devices such as retinal scanners for international visitors and human scanners for "certain travelers," combined with the infamous precepts of the Bush Doctrine are effectively contributing to an international boycott of the US. All over the world forums, dialogues, summits, business operations, and even art festivals are silently boycotting the participation of Americans, Anti-American sentiment is rampant throughout the world. When Bush left Guatemala, the last of seven Latin American countries he visited this year, Mayan shamans decided to "purify" their sacred archeological sites "to eliminate the bad spirits" left behind by the US president.

The US tourist industry is in disarray. European, Canadian, and Latin American travelers are having second thoughts when it comes to vacationing here. They simply do not wish to undergo humiliation upon their arrival. Even my Mexican family and friends are hesitant to visit me in California. My friend, journalist Alfredo Araico, told me recently, "I'll wait for Bush to be out of office to visit you. I hope you understand, *carnal.*" He was simply giving voice to a very common feeling. The words "United States," now interchangeable with the Bush era, are tainted by negative connotations of human rights violations, torture, unnecessary military violence, and the mistreatment of innocent immigrants.

What is the extent of this informal boycott? What is being done to combat it? Who knows? The media is not reporting it. They are too busy with the postmortem misadventures of trash queen "Anna Nicole," Brittany Spears's rehab regime, and Paris Hilton's run-ins with the law.

X

Let's face it, the War on Terror is also a war on difference: cultural, political, religious, racial, and even sexual. And the many targets of this war—Muslims, Arabs, Arab-looking people, Latino immigrants, people with thick accents and ethnic features—are being lumped into one single menacing form of otherness. The list goes on to include the poor and the homeless. Dissenting intellectuals, critical artists, socially conscious scientists, and activist gays are all being targeted. Those waging this war, "the new barbarians," continue to multiply, threatening Western democracy from without and within.

Fortunately, the vast territory encompassed by Bush's infamous pronoun "Us" (as in *Us* against *Them; Nosotros, los Otros*) shrinks day by day as dissidence from the Right increases and the Left becomes more vocal. Democrats, now in control of the House and the Congress, are clumsily trying to recapture their political compass and undo some of the structural damage they've sustained since 2000. Do they have the necessary *cojones* to do it? Nancy Pelosi notwithstanding, do they represent a progressive alternative to the neocons? Incommensurable silence.

Here's an even tougher question: Can the mirror of critical culture be restored in the USA? I hope so—*We* hope so—with all Our hearts. But it would require the coordinated

efforts of hundreds of progressive communities working toward this goal: to transform a culture of fear and isolationism to one of humanism and international cooperation. Can this be done without the participation of artists and intellectuals?

For the moment it is critical for US-based artists and intellectuals to speak up with valor and clarity. Our job has always been to side with the underdog, to question the discourse of power, and to contest the imposition of oppressive practices in the name of national governance. Today the master discourse embraces and promotes ultra-nationalism, isolationism, xenophobia, and censorship. This goes against our core beliefs: to make sure that borders and institutions remain open; and to cross those borders we are not supposed to cross. We, the artists and intellectuals—not politicians or soldiers—are the ones who must defend freedom and democracy. Clearly our notions of "freedom and democracy" differ dramatically from those articulated by our public officials. In fact, they are in stark opposition to the notions of those in power. And we must be prepared to promote and defend our beliefs. Our futures depend on it.

XI

During a recent debate I had with a nativist, he asked me to provide him with a strong reason why the US should not close its borders with Mexico. My answer was as follows:

> To me, the "problem" is not immigration, but immigration hysteria. Immigration is a byproduct of globalization, and as such it is irreversible. One-third of mankind now lives outside their homeland and away from their original culture and language. The existing nation-states are dysfunctional and outdated. And the legal structures that contain them do not respond to the new complexities of the times.

His response to my answer was: "I don't understand a word of what you are saying. The fact is that the aliens are here illegally."

I continued:

> To me immigration is not a legal issue but a humanitarian and humanistic one. No human being is "illegal," period. All human beings, with or without documents, belong to human kind, our kind, and if they require our help, we are obliged to provide it. It's called being human. Period. In this context, nationality becomes secondary. Their pain is ours, and so is their fate.

"What do you mean by that?" he asked contentiously.

"Just as I became an immigrant one day, you yourself might become one in the future."

He looked at me with perplexity and disgust and after a long pause, he said, *"You people are determined to destroy us. What have we done to you?"*

At that point I realized there was not much space for intellectual negotiation with him. His arguments were strictly emotional. He was fighting for his life, his inner country, and his sense of belonging to an imaginary world. He was the real alien, lost on a multiracial and multicultural foreign planet where border culture and hybridity are the norm.

I finally answered: "You know, *señor,* immigration to the US is the direct result of the economic and political behavior of the US toward other countries. Most immigrants, including myself, are unconsciously searching for the source of our despair. I think I found it just now. It's a pleasure to meet you."

—from the Borderless Americas, July 2007

Guillermo Gómez-Peña is a performance artist and writer residing in San Francisco, where he is artistic director of La Pocha Nostra. Born in 1955 and raised in Mexico City, he came to the US in 1978 to study post-studio art at Cal Arts. His pioneering work in performance, video, installation, poetry, journalism, cultural theory, and radical pedagogy explores cross-cultural issues, immigration, the politics of language, "extreme culture," and new technologies. A MacArthur Fellow and American Book Award winner, he is a regular contributor to National Public Radio, a writer for newspapers and magazines in the US, Mexico, and Europe, and a *TDR* Contributing Editor.

REFERENCE

New York Times
2006 "$5 Million Fine for Hiring Illegal Immigrants." *New York Times,* 15
 December: A38.

Mexican Contemporary Photography: Staging Ethnicity and Citizenship

Marina Pérez de Mendiola

1. PROLOGUE: COME TAKE A PICTURE OF YOURSELF

The slogan *Ven y tómate la foto,* or "come take a picture of yourself,"[1] first appeared in Mexico six months before the presidential elections in the summer of 1994. It covered walls, was displayed on advertising billboards, and aired on television and radio. Mexican art critic Olivier Debroise described its ubiquity in the following terms: "The election registration program ... introduces the entire country to an apparently novel element: the inclusion of a color photographic portrait of the voter. The image, constituted like a parapet against the possibility of fraud, should also assure the transparency of the coming elections."[2] Although semantically ambiguous, the expression "come take a picture" emphasizes reflexive action and suggests that those photographed will be both the object and the subject of the photograph. In an enclosed booth, the "actant" poses for a camera that automatically takes, develops, and prints the photograph. This apparatus disposes of the photographer, replacing the human eye with a mechanical one. The use

1. The personal pronoun *te* becomes reflexive in this case, and *tómate la* fofo can be read as "take the picture yourself" and as "come and take the picture/have it taken."

2. Olivier Debroise, "Ven y tómate la foto," *Luna Córnea* 3 (1993): 95–96.

of this apparatus was conceived to attract the disenfranchised people of Mexico to the polls—the ten million mostly indigenous people who historically have had reasons to mistrust this highly mediated form of human intervention. The Partido Institucional Revolucionario (PRI), the party in power from 1928 to 2000, banked on the idea that the portrait, a type of self-representation, taken automatically, would be regarded as self-acting, self-regulating, and as promoting image control: the mechanical eye would capture the image as presence. These devices (the political and the aesthetic ones, as well as the automatic camera) rely on the popular conception of the self-portrait as a less threatening and more empowering means for the subject both to see and imagine him or herself. The slogan conveys the idea that this spontaneous, mechanical portrait will bring recognition of social integration and civil identity. This initiative also aims to convince historically and geographically marginalized groups that, in Mexico, governmentality will no longer be exercised without a certain measure of self-restraint, that is to say, without asking "why must one govern and what ends should [government] pursue with regard to society in order to justify its existence?"[3] One could, therefore, read this "official" invitation as an invitation to 40 percent of the inhabitants of Mexico to break out of their social and economic imprisonment,[4] and play an active role in the development of Mexican civil society. With these issues in mind, we must examine more closely the claims of empowerment disseminated by the words "come take a picture."

The notion of the self-portrait implied in the slogan's ambiguous wording is willfully misleading, since it rests essentially on the idea that the automatic self-portrait ensures that the conditions of visibility will not be regulated. This gives the author/subject of the photograph the impression of expressing the presence of his being, offering the illusion of transcending the uniform protocol of the pose. This kind of photography records what Louis Marin calls «an artificial icon of itself." Upon taking the photo, the subject creates a fantasmatic photograph that details the desire for citizenship and not the reality of citizenship. What the automatic self-portrait captures is not the social request of the subject taking the photo, but that of the other in the photo producing a socialized image of the subject.

Moreover, whether the strategy of "come take a picture" markedly improved the possibility of participation in Mexican civil society or prevented electoral fraud still needs to be examined. One must also ask, however, what the difference is between the automatic picture and the judicial photograph taken by an official government photographer in establishing an official identity for the electoral card. Since the recording of a photographic portrait has often been considered a

3. See Michel Foucault, "Security, Territory, and Population," in *Ethics, Subjectivity, and Truth,* ed. Paul Rabinow (New York: New Press, 1997), 74.

4. The indigenous struggle against colonial hegemony is documented as early as 1517 in Bernai Díaz del Castillo's chronicles, where he stresses, in particular, the rebellions of 1502–1534 in Chiapas and of 1712 and 1869–1870. He also records the wars fought by the Mexicas in Tlaxcaltecas. See Guiomar Rovira and Jesús Ramírez, "Glosario Zapatista,"in *Marcos: el señor de los espejos,* by Manuel Vázquez Montalbán (Madrid: Aguilar, 1999).

5. See Susan Sontag, *On Photography (New* York: Farrar, Straus, Giroux, 1977).

powerful medium of surveillance,[5] the automatic self-portrait can be seen as a subterfuge to make people believe that the act involved in taking one's picture and the outcome of this photographic act can be beneficial only to those who participate in it. This stratagem can be defined as a "superpanopticon," a term coined by Mark Poster, in his analysis of databases, for the process by which the automatic photographic machine acts as an invisible authority and "circumvents the unwanted surveillance through the willing participation of the surveilled individual."[6] The electoral identification card and the automatic photograph serve, therefore, a less progressive purpose than they seem to and continue to operate, as Susan Sontag explains in another context, "as very useful tools for modern states in the vigilance and control over an increasingly mobile population."[7] By ignoring, neglecting, disdaining, and stripping the native populations of their lands, and sanitizing the center of their civil presence, the successive PRI governments enclosed them in an anonymity that, in the 1990s, led to unforeseen results, such as the creation of the Zapatista movement. Native communities, such as the Mayas and the Tzotziles in Chiapas, made use of this neglect in their struggle against hegemony and economic oppression. Although state institutions knew how and where to locate power, it was increasingly difficult for them to register members of a large and extensive segment of the country's population who were prepared to take a more active role in the determination of the conditions of visibility.

In what follows, I reflect on the ways in which contemporary Mexican photography captures indigenous people and discuss the systematic commodification and anthologizing of their image in the past thirty years. The list of Mexican photographers who have dedicated themselves to chronicling the lives of native communities in Mexico is extensive.[8] I will focus on the work of two photographers who mark the history of photography with their authorial style in native documentalism: Graciela Iturbide and Pablo Ortiz Monasterio, both internationally renowned photographers who are regarded as the most established photographers in the official world of contemporary Mexican photography.[9] I also examine a group of nonprofessional photographers who shoot from the periphery. The images these photographers produce allow us to raise complementary theoretical questions: To what do we owe the rethinking of the ethnic theme in the photographic arts? How are the concern for aesthetics and the testimonial dimension

6. See Mark Poster, "Databases as Discourse or Electronic Interpellations," in *Critical Essays on Michel Foucault,* ed. Karlis Racevskis (New York: G. K. Hall and Co., 1999), 278.

7. Sontag, *On Photography,* 5.

8. In a longer version of this essay, I look at the work by Flor Garduño, Rafael Doñiz, and Agustín Estrada, among others.

9. Iturbide was a cofounder of Mexican Counsel of Photography (CMF) and is considered one of the finest practitioners of black-and-white photography in the world today. She has always explored issues of identity, diversity, and selfhood in her work, and has documented Zapotec Indians of North Mexico (1981) as well as Zapotee Indian people of Juchitán in their daily and ceremonial activities. Ortiz Monasterio studied photography and economics in London. He was also cofounder of CMF and editor of numerous books on Mexican and Latin American photography.

articulated in the production of documentary photographs? Do these photographs belong to the genre of ethnographic photography, and if so, can we see these cultural representations of indigenous people as a kind of still that not only frames them as an immutable, static other but also stages and projects a national paradox?[10] The paradox lies, on the one hand, in the glorification of indigenous culture, and, on the other, in the pathologization and erasure from civil society of the bodies producing this culture. Lack of space will not allow me to discuss these issues in depth, so I will merely offer some preliminary thoughts on these theoretical questions.

2. A BRIEF HISTORY OF THE INDIGENOUS PRESENCE IN MEXICAN PHOTOGRAPHY

To better understand the paradoxical system on which the national program of "come take a picture of yourself" is based, it is essential to trace a brief genealogy of the photographic inscription of indigenous peoples in Mexico. Since the advent of mechanical reproduction, photographic technology has been frequently used in Mexico for repressive ends. For example, General and President Santa Ana established a law in 1854 requiring the most infamous prisoners to be photographed to assure the identification of prisoners who might escape during prison transfers. In 1865, Emperor Maximilian (a colonial leader who ruled from 1863 to 1867) established photographic registration for Mexico City prostitutes, alleging sanitary reasons. The Portiriato period (1876–1911) was also an epoch rife with examples of societal cleansing, which was officially and regularly practiced through the photographic registration and cataloging of the somatic types identified as possible dangers, particularly those people who had daily contact with the aristocracy: drivers; domestic servants; small, informal merchants, such as baggage carriers, water sellers, and other street vendors. Later, school teachers and journalists were also included on the list of early victims of photographic authority.[11] Between 1862 and 1877, photographic portrait artists, such as Antíoco Cruces and Luis Campa, were commissioned to create portraits for the Mexican elite, but they also photographed poor people in Mexico City. These portraits reveal the complex link between photography and the democratization of representation. Before the inception of photography, only aristocratic families and the high bourgeoisie could afford to register pictorially their portraits and genealogies. Patricia Massé, a Mexican photography scholar, explains that in Cruces and Campa popularized the use of the printed portrait as a visiting card, which allowed for the democratization of portraits to include those from the more underprivileged sectors of society. Massé adds that "in 1880 this democratization brought Cruces to create a collection of photographic portraits of Mexican types, which represents eighty individuals performing traditional jobs in Mexico City: the water seller, the cookie seller, etc."[12]

10. I am indebted to the early work of James Clifford on the subject of ethnography and colonialism, particularly to his seminal book *The Predicament of Culture* (Cambridge, Mass.: Harvard University Press, 1988).

11. Debroise, "Ven y tómate la foto," 95.

12. Patricia Massé, "Tarjetas de visitas mexicanas," *Luna Córnea* 3 (1993): 53.

Most of these photographs were taken in a studio with artificial backdrops. Although with the first daguerreotypes more people were able to have their portrait taken, only a minority within Mexican society did so. By the end of the nineteenth century, photography was still confined to the private studio, and it was not until the early 1900s that photography reached the streets to become a more popular form of expression with itinerary photography *(fotografía ambulante)*.

From the beginning of the twentieth century until the 1980s, except for family portraits, portraiture occurred only sporadically and problematically for individuals and groups whose presence was considered marginal to the polity. These identification cards permitted the classification of individuals who historically had not been seen in Mexico through any other means.[13] Photography was also complicit in the smooth functioning of the power that limits the representation of certain Mexican social classes to stereotypes (within the logic of a typology of races). Photography operated in a closed circuit whose framework encompassed the stereotypical object, subjecting it to disciplinary representation. At the same time, the fabric of photography made visible the imprisonment of the represented while turning that imprisonment into a commodity.

Between 1890 and 1930, Mexican photographers such as Agustín Víctor Casasola[14] captured the ethnic photographic image in a manner similar to that of the foreign anthropological inquiry of the time by objectifying members of the native communities. Foreigners who visited Mexico or established residency there were also interested in the indigenous populations, thus converting Mexico into a gigantic "ethnographic laboratory."[15] The Norwegian explorer Karl Lumholtz stands out among those foreigners.[16] He undertook an ethnographic expedition through the country during the 1890s, with the blessing of Porfirio Díaz and the sponsorship of the New York magazine *Scribner.* During his extended stay, he took photographs of the Tepehuanas and the Rarámuri in Chihuahua and the Huichols in Nayarit (1893–1895). In 1900, the American C. B. Waite portrayed the communities of the Purépechas of Michoacan and the Otomís of Noble. To these photographers we can add Tina Modotti, who took photographs of the Juchitecs in the 1920s, and Paul Strand, who photographically registered the Purépechas. The lenses of the five Mayo Brothers, Republican Spaniards who were transferred to Mexico, also captured, among others, the Mixtees of Oaxaca, Puebla, and Guerrero. The photographic iconography of the poor social classes located outside of Mexico City, that is to say, the Indian

13. Debroise notes that "the use of photographic identification credentials remained limited to public officials, and particularly syndicalist workers, passport holders, and students. Women and especially indigenous groups were almost always excluded from this form of cataloging." If in the nineteenth century the photographic ID card identified the people who were considered societal "tumors," at the beginning of the twentieth century it identified citizens of "quality." See Debroise, "Ven y tómate la foto," 95.

14. Casasola was the personal photographer of Porfirio Díaz.

15. I borrow this term from Mexican anthropologist Juan Cajas, *Castro's La sierra tara humara o los desvelos de la modernidad en Mexico* (México: Consejo Nacional para la Cultura y las Artes, 1992).

16. See, in particular, Karl Lumholtz, *Mexico desconocido* (México: Editorial Nacional, 1972).

and Mestizo peasants, has been prominent since the Mexican Revolution. The Revolution promoted illustrated news as a way to document daily struggle and inscribe it in an "official" realm. The first important photojournalist of the period, Casasola, spent many years documenting the war, including the soldiers, the peasants, and the executions.[17] In addition to the photographic chronicles provided by foreign and Mexican agencies, a large part of the iconography of the Revolution also comes to us from the agrarian leaders or groups who were responsible for documenting the agrarian struggle that spanned the twentieth century. These documents allow us to chronicle the participation of ethnic groups in the resistance movements against the state, groups such as the Yaquis, Mayas, and Tomochitecs in the north, or the Chichimecas in Guanajuato. Curiously, the glorified omnipresence of indigenous people in postrevolutionary murals, an art form that was part of a national nostalgic project in search of its native roots, failed to materialize in photography, except in agrarian documentation.[18]

In the 1920s, Mexican photography began to take two different paths: the documentary photograph, or objectivist path, and the artistic photograph, or impressionistic path. Between 1930 and 1960, a large majority of photographers practiced both types of photography. Manuel Alvarez Bravo, a pioneer photographic artist in Mexico, provides a good example of this tendency. The indigenous cultures and populations inspired Alvarez Bravo and his contemporaries, such as Walter Reuter, Juan Rulfo, Julio de la Fuente, Raúl Estrada Discúa, and Agustín Maya, as well as younger photographers, such as Bravos's wife and colleague, Lola Alvarez Bravo. Many of their disciples, such as Hector Garcia and Nacho López, contributed more to the task of documenting and portraying national events and everyday life covered in the daily press and were less preoccupied with the aesthetic dimension of photography. The impact of these two photographers was felt especially in the sixties, the heyday of documentalism and journalistic photography. For that reason, indigenous people were both object and subject of documentary iconography, as photography was put to the service of a historic conscience.[19] In subsequent years,

17. See the dossier on photography in Mexico in "Crónica de la fotografía en México," *Memoria de papel* 3 (April 1992): 3–42. See also Eugenia Meyer, *Imagen histórica de la fotografía en México,* intro. Néstor García Canclini (México: Museo Nacional de Historia, Museo Nacional de Antropología, 1978); and Arthur Oilman's introduction to the exhibition at Rice University in 1990 entitled Other Images: Other Realities: Mexican Photography Since 1930; exhibition catalog published by Seawall Gallery, Houston, Texas, 1990.

18. Of particular interest is the work of agrarian leader Alfredo Guerrero Tarquín, compiled in *La vida Airada: imágenes del agrarismo en Guanajuato,* ed. Beatriz Cernates et al. (Guanajuato: Centro Regional de Guanajuato del instituto Nacional de Antropología e historia, 1989). See also the archives of Instituto Nacional de Antropología e Historia in Mexico City, which include an extensive visual bibliography of agrarian struggles in different states. The series/collection "Divulgación"is particularly interesting.

19. For a discussion of historic conscience, see Olivier Debroise, "Fotografía directa-fotografía compuesta," *Memoria de papel 3* (April 1993): 21.

photographs of indigenous populations served as a catalyst for the denunciation of social injustices, but they were also the object of aesthetic experimentation by Bravo, Rulfo, Maya, and others. During the seventies, a group of photographers headed by Pedro Meyer founded the Mexican Council of Photography (CMF), an influential center for exhibitions and the publication of books related to Latin American and Mexican photography. The CMF's primary mission was to create a photographic archive of Mexican culture and foster a theoretical understanding of photography. However, no particular attention was paid to the different photographic trends that focused on the heterogeneity and diversity of the indigenous Mexican population until the end of the seventies. In 1980, the Institute of Fine Arts organized the first Biennial Exhibition of photography, which drew the participation of an unexpectedly large number of photographers. The second Biennial Exhibition, in 1982, affirmed the status of documentary photography as a profession. A great number of winning photographers contributed to what can be dubbed the documentary trend. Contemporary documentary photographers found their inspiration in Nacho López, Héctor García, and the Mayo Brothers, among others. Mexican cultural critic José Antonio Rodríguez explains that "photographic documentalism is the genre that has, perhaps, the most followers, due to its being the trend whose historic base was initiated by photojournalism." Rodriguez asserts that "the personal style of contemporary photographers has offered to document a new vision that, in many cases, is close to an aestheticism that is not just circumstantial anymore."[20] This type of aestheticism—the document as art—was consecrated in 1993 with an event called Photo September. Indeed, 1993 marked a very important moment in the history of the diffusion and promotion of photography in Mexico. The National Council for Culture and the Arts, with the aid of art photographers, resolved to devote the month of September to the celebration of the vitality and vigor of Mexican photography: Photo September offered the public a vast program of samples, exhibitions, book fairs, round table discussions, guided tours, performances, and media programs dedicated to the most diverse trends, themes, and techniques of photography in Mexico. Photo September was designed "to provide public access to the peculiarities and innovations of photography as a language, its proposed aesthetics and its new technological definitions."[21] The purpose of Photo September was to remind the public that photography constitutes an integral part of the aesthetic discourses of Mexican culture.

While the photographic art world has, in the last twenty-five years, bestowed a privileged position upon the representation of indigenous peoples of Mexico, it has done so in a problematic manner. This can be explained, in part, by the desire to offer indigenous peoples a new photographic space and a new inscription in Mexican art and culture. Photography seems to be the most suitable means for this type of cultural and ethnic rescue, since, as Tovar y de Teresa reminds us, "photography constitutes one of the most familiar

20. See José Antonio Rodríguez, "Catorce años de ia fotografía contemporánea," *Memoria de pápela* (April 1993): 39.

21. Rafael Tovar y de Teresa, Fotoseptiembre (Mexico: Consejo Nacional para la Cultura y las Artes, 1993), 3.

expressions of art and communication of the contemporary world."[22] Walter Benjamin, Gisèle Freund, and Roland Barthes have all considered photography to be "the matrix of the assembly of means of communication of the masses."[23] Their work enables us to delve into the very complex and controversial relationship among photography, ethnography, and art, as well as between photography and the social sciences. In a longer version of this essay, I focus on the history of this relationship in Mexico and attempt to offer answers to the question that the French ethnographer Emmanuel Garrigues states in more general terms: Did photography contribute to the birth of ethnography, or did ethnography contribute to the birth of photography?[24] I look, in particular, at the work of explorers, such as Lumholtz, and photographers, including Waite, Cruces and Campa, Casasola, Strand, Romualdo García, and Hugo Brehme. One may ask whether contemporary photography shares the same ethnographic lens present through the end of the nineteenth century—one that framed the indigenous people within the concept of primitivism and its multiple ideological definitions—or whether it offers an alternative way of foregrounding them. Interestingly enough, Mexican photography of the past twenty-five years is particularly resonant with a kind of ethnographic visual representation marked by exoticism and racist underpinnings. Photographs anthologized in the 1993 collection *El ojo de vidrio: Cien años de fotografía del México indio* (The Glass Eye: A Hundred Years of Photography of the Mexican Indian) exemplify this trend.

In his prologue to *The Glass Eye,* Mexican anthropologist and cultural critic Roger Bartra maintains that the photographs in the anthology "manifest a museological intention while also cultivating an aesthetic of melancholy: the silent, melancholy aura is one of the greatest attractions of the photography ... in addition to the double influence of the stereotypical Indian sadness and of the real affliction in which their lives are submerged."[25] Indubitably, Mexican photography has systematically emphasized this spectacle of the pain surrounding the indigenous world, which is due, in part, to the extreme visibility of the deplorable conditions in which a great number of indigenous populations live. Now, the issue remains that the aesthetics of melancholy calls for a clinical view, a kind of view of photography "that makes us lose sight of ... the efficacy of the seeing itself as a presence."[26] Instead of viewing indigenous people as a real presence, the clinical view encloses the image in another museum, that of indigenous pathology, thus reinforcing the idea that the indigenous are truly the cancer of the modern nation. The danger resides

22. Tovar y de Teresa, *Fotoseptiembre,* 3.

23. See Emmanuel Garrigues's thought-provoking introduction to "Le savoir ethnographique de la photographie," special issue, *L'ethnographie* 87, no. 1 (1991): 16.

24. Garrigues, introduction to "Le savoir ethnographique," 10–57.

25. Rebeca González Rudo and Jaime Velez Storey, *El ojo de vidrio: cien años de fotografía del México indio* (México: Bancomext, 1999), 11.

26. Georges Didi-Huberman, *Invention de l'hystérie* (Paris: Editions Macula, 1982), 36.

in the fact that viewers/readers of the photograph may fail to separate the image of the pathology from the pathology itself. In reality, the aestheticized, sad, miserable image of the indigenous is what provokes the clinical gaze, erasing, therefore, particularities so that only the common characteristics that determine the native community remain. The immobilizing of indigenous people in the past is already clearly visible in the murals created after the Mexican Revolution. Murals by such well-known artists as Diego Rivera and José Clemente Orozco not only mythicize the indigenous past but dilute the multiplicity of this past in grand pictorial enlargements of nonspecificity. Many contemporary Mexican photographers, perhaps too embedded in tradition and unable to elude the collective imagination, contribute to the erasure of indigenous particularities so prevalent in national pictorial representations during the twenties and thirties.

These common characteristics attributed to indigenous people are classified and codified, giving rise to a classification system and tabulation that extend an identical description to all indigenous communities. If, as Freud argues, one sees what one learns to see, this image only serves to further encourage the graphic stereotype of the native. But, most importantly, as French art historian Georges Didi-Huberman states, "just as photography is invented through this image one assumes or imposes, a preconceived identity creates a misjudged or prejudiced analogy, with oppositions or similarities already imagined, … and this is how photography becomes science, objective, generalized, when at first it is only meant to be an exemplary act of contingency."[27]

3. Identical Filiation of All Indigenous Communities

The identical filiation of indigenous communities is prevalent in collections such as *El ojo de vidrio*. This anthology records one hundred years of indigenous images (from the nineteenth to the twentieth century). Legends beneath the images indicate the name of the artist/photographer, the location where the photograph was taken, and the date, while a table of contents identifies the indigenous peoples represented as members of specific ethnic groups. However, these efforts to inscribe "el México indio" culturally, these markers or ethnographic inventories, are not sufficient to eliminate the sense of homogeneity experienced when initially glancing at the pages of the anthology. This "lumping together" is exacerbated by a quantitative multiplicity that seems "defenseless against totalization." French philosopher Emmanuel Lévinas argues,

> For a multiplicity to be able to be produced in the order of being, *disclosure* (where being does not only manifest itself, but effectuates itself, or exerts itself, or holds sway, or reigns) is not enough; it is not enough that its *production* radiate in the cold splendor of truth. In this splendor the diverse is united—under the panoramic look it calls for. Contemplation is itself absorbed into this totality, and precisely in this way establishes

27. Didi-Huberman, *Invention de l'hystérie*, 65.

that objective and eternal being or that "impassive nature resplendent in its eternal beauty," in which common sense recognizes the prototype of being, and which, for the philosopher, confers its prestige on totality.[28]

The problem here lies in the fact that the quantitative multiplicity of Indian or non-Ladino[29] images in Mexico is not addressed, much less rethought. It is not only the juxtaposition, or the "lumping" together, of these images but also the increasing number of anthologies themselves that contributes to the homogenization[30] of the ethnic and social heterogeneity of the groups represented and of the diversity of the photographic production itself. These modern anthologies include the work of different photographers whose discourse takes on a document-like quality while their photographic desire remains rooted in the aesthetic realm. The photographs can easily be construed as a photographic production exuding the kind of splendor suggested by Lévinas. These collections of images resemble «family albums" assembled by people outside of the family, which create artificial families of native people and photographers. As Carlos Echanove Trujillo reminds us as early as 1948, "the Indian on this base of vast ethnic heterogeneity presents also great social heterogeneity, and he is often only interested in its municipality and feels no solidarity whatsoever with his brothers of race but rather, at times, the most tenacious antagonism."[31] This creation of simulated ethnic, social, and cultural ties is guided by a benevolent, uncritical, and nostalgic political correctness that denies indigenous cultures and communities the right to be defined as complex formations. While social, economic, and cultural differences get

28. Emmanuel Lévinas, *Totality and Infinity: An Essay on Exteriority,* trans. Alphonso Lingis (Pittsburgh, Pa.: Duquesne University Press, 1969), 220. "Pour qu'une multiplicité puisse se produire dans l'ordre de l'être, il ne suffit pas que le *dévoilement* (où l'être ne se manifeste pas seulement, mais où il s'effectue ou s'évertue ou s'exerce ou règne) il ne suffit pas que sa production *rayonne* dans la splendeur de la vérité. Dans cette splendeur, le divers s'unit sous le regard panoramique que cette splendeur appelle. La contemplation elle-même s'absorbe dans cette totalité et instaure précisément ainsi, cet être objectif et éternel [...] où le sens commun reconnaît le prototype de l'être et qui, pour le philosophe, confère son prestige à la totalité. [...] Pour qu'une multiplicité puisse se maintenir, il faut que se produise en lui la subjectivité qui ne puisse pas chercher une congruence avec l'être où elle se produit. Il faut que l'être s'exerce en tant que se révélant"(*Totalité et Infini: Essai sur l'extériorité* [Paris: Livre de Poche, 1987], 243).

29. "Term that appears in the 18th century and was attributed to the Indians who knew how to speak Spanish. Later it was used to identify Indians who had lost all connection with their ethnic community and language. In Chiapas Ladino has been used as a synonym for mestizo." See "Zapatista Glossary," in Manuel Vázquez Montalban, *Marcos: el señor de los espejos* (Madrid: Aguilar, 1999), 274. I use the most common definition of *Ladino,* which refers to those people who are not indigenous.

30. The question of this type of homogenization has been central in Mexican artistic representation of indigenous peoples as exemplified in the muralist movement.

31. Carlos Echanove Trujülo, *Sociología mexicana* (Mexico: Editorial Cultura, 1948), 194.

blurred in a uniformization of the exterior appearance (one that is still deeply racialized), the photographic face/portrait works as a reflection of a community.

Until very recently, the indigenous face (*visage*) presented to us through the portrait required us to go beyond it, through it, since anthropological photography stressed not so much the recognition of the face but the "reading of the soul." Passions were supposed to model the face. The face was "the projection of one's inner life on the world."[32] This practice is an ominous "abuse of meaning" (*un abus de sens*), or an overreading, which often results in no meaning at all. I wish to call on Lévinas again, who judiciously explains that "the presentation of the face, expression, does not disclose an inward world previously closed, thus adding a new region to comprehend or to take over. On the contrary, it calls to me above and beyond the given that speech already puts in common among us."[33] Facing the face, so to speak, goes beyond the notion and the process of unmasking the face, an act that implies pressure, coercion, and negating the authentication of the signifier. The presentation of the face implies that "I am connected, linked with being, the existence of this being," and "it is my responsibility before a face looking at me absolutely foreign."[34]

It is the issue of individual—ethical and civil—responsibility that I wish to emphasize here. Is it not the act of reading responsibly rather than the reading in itself that should concern us while examining these images? It is not a matter of engaging in the forms of legibility of the face nor of guessing the other behind the face. It is a matter of moving away from the idea behind the act of reading, of inspecting the face. Reading what one sees, however necessarily, implies interpretation: "to interpret is to think, to do something," writes Wittgenstein.[35] Yet, while facing the photographed face, "thinking should not deceive itself into thinking that it sees what it thinks."[36] If, as Wittgenstein asserts, "thinking accomplishes much that sight can never attain, [since] thinking shows a range of possibilities,"[37] one could also argue that it is precisely within that range of possibilities that the eye can listen. In *Textures of Light,* Catherine Vasseleu makes clear that "Lévinas's project is to recount the scope of this 'eye that listens' in terms other than the resonance of essence or the reverberation of light. In encountering the face, the eye ceases to

32. Félix Toukia, *Des amérindiens à Paris* (Paris: Editions Créaphis, 1992), 28.

33. Lévinas, *Totality and Infinity,* 212. "La présentation du visage—l'expression ne dévoile pas un monde intérieur, préalablement fermé, ajoutant ainsi une nouvelle région à comprendre où à prendre. Elle m'appelle au contraire, au-dessus du donné que la parole met déjà en commun entre nous" *(Totalité et infini, 233).*

34. Lévinas, *Totality and Infinity,* 212. "C'est ma responsabilité en face d'un visage me regardant comme absolument étranger" *(Totalité et Infini, 235).*

35. Ludwig Wittgenstein is cited in Judith Genova, *Wittgenstein: A Way of Seeing* (New York: Routledge, 1995), 77.

36. Wittgenstein, cited in Genova, *Wittgenstein,* 58.

37. Wittgenstein, cited in Genova, *Wittgenstein,* 62.

see difference in terms of its possibilities for negation. It becomes a search for the means to do justice to the other's singularity."[38]

Reading differently does not mean identifying with the other or "[relating] to alterity through mystification," as Rey Chow warns us against.[39] Our encountering of the face—in this case, Mexican indigenous faces in photography—forces us to understand the acts of thinking and seeing not as complementary and yet intrinsically different conceptually, but rather as a dialogical and coeval act of responsibility, performing/fulfilling first and foremost respect toward the other.[40] The question of respect is a problematic one because of the dangers of moralization attached to the concept. We should consider respect as one of the foundations of democracy, yet indigenous people in Mexico have been deemed unworthy of it. Respect was associated in the colonial era with domestication and servility. The colonial powers have demanded respect in order to dominate, which negates human dignity and freedom. To accept the idea that indigenous people deserve respect implies that one has to do away with a colonial way of thinking, which remains prevalent. But more importantly, as I shall show in my final remarks, several Indian communities in Mexico, through their photographic work, have created respect without waiting for the other to grant it to them.

The list of photographers who have contributed to the dissemination of this clinical view is long. Their work emphasizes the idea of a common identity for indigenous communities, which is the only identity that the nation-state is willing to offer them. However, the 1980s have revealed other photographers who hope to overcome the excesses of indigenous "miserabilísimo" and undermine the process of stereotyping. I will give a brief example of the potentially contestatory practices used by such internationally renowned photographers as Iturbide and Ortiz Monasterio

38. Catherine Vasseleu, *Textures of Light* (London: Routledge, 1998), 88. This demonstrates how photography operates very much like writing, in the sense that, as Bernard Noël reminds us, "writing addresses the sight but it is visibility that is false since it is not enough to see the writing to understand it" (*Journal du regard* [Paris: POL, 1988], 115).

39. See Rey Chow's thought-provoking introduction to *Ethics After Idealism: Theory, Culture, Ethnicity, Reading* (Bloomington: Indiana University Press, 1998), i–xxiii.

40. On the issue of an ontic need-desire in Lévinas, see Bettina Bergo's essay "Inscribing the 'Sites' of Desire in Lévinas," in *Philosophy and Desire*, ed. Hugh J. Silverman (London and New York: Routledge, 2000), 63–82. As Bergo explains, "if for Lévinas the face signifies infinity in the sense that we are never 'even' with the other we need to rethink our ethics of alterity as a true experience of the other. It is in the opening to the other, an opening that seizes the subject more than itself that a relation to infinity is carried out. We need to transcend, as Lévinas theorizes, Western philosophy based on an understanding of ontology and egology that relies exclusively on the thought of the self and on the claim to totality. We need to substitute thought conceived as 'turned in on one self' with an encounter, that of the other, an encounter that interrupts the movement toward totalization and signifies an opening of the ethical space of difference. It is the encounter of the other's face that opens the possibility of ethics because it defines/ implies responsibility" (77).

as a way to undermine the aesthetics of the melancholy. The way in which these artists construct the indigenous world through their art echoes the theories of Russian artist Viktor Shklovsky, who, referring to his conception of art and its function, writes, "Art exists to help us to recover the sensation of life, to make the stone stony. The end of art is to give the sensation of the object as seen, not as recognized. The technique of art is to make things unfamiliar, to make forms obscure, so as to increase the difficulty and the duration of perception. The act of perception in art is an end in itself and must be prolonged. In art, it is our experience of the process of construction that counts, not the finished product."[41] The idea that art should be seen rather than recognized, and "that habits and customs are limited to an effect of insipid perceptions that have been clouded by the routine, the culture,"[42] is a key element in the revisionist photographic art of Iturbide and Ortiz Monasterio. These photographers practice what Shklovsky calls *ostranenie,* or an aesthetics that produces strangeness, using images that defamiliarize. Simon Watney explains that "the theory of defamiliarization possesses a powerful ideology, a set of tacit assumptions about the relationship between art and society. It implies above all that social contradictions can be made immediately and universally accessible to the eye, simply by means of visual surprise."[43] If, as Watney adds, the condition for defamiliarization is that the defamiliarizable is of a familiar group, the images of these artists satisfy this requirement.

As suggested earlier, art, combined with the ideology that nurtures the nation-state, can contribute to the exclusion of indigenous peoples by making them too recognizable, too familiar. In the photography of artists who use the strategy of *ostranenie* referred to above, indigenous communities become visible, but in a way that strives to undermine the expected visibility. We subsequently observe, in too fleeting a manner, the ways in which defamiliarization manifests itself in the photographic art of Iturbide and Ortiz Monasterio.

The work of Iturbide is particularly interesting from this point of view. Although it is possible to consider her representations of the indigenous worlds a polite and dignified portrayal, the type of photograph that she has offered us over the years endeavors to transcend the image of the worthy *pelado* (pauper). This occurs not because she wants to wrest away the *pelados* dignity but because she hopes to eliminate the condescending, paternalistic, and benevolent nuances invested in this word by resemanticizing the notion of dignity. What the nation-state concedes to indigenous people is an image of their dignity, a semblance of dignity that emphasizes the idea of respect, of the honor that the indigenous people should have for themselves. It refuses, at the same time, to enact this same respect and recognition. Every photograph in the series "Those Who Live in the Sand" (1980–1981), for instance, portrays Seri people surrounded by uninhabited desert plains. The lone sign of life emerges from the presence of the Seri. "The Female Angel" represents a Seri woman in traditional dress, facing away from the

41. Cited in Simon Watney, "Making Strange: The Shattered Mirror," in *Thinking Photography,* ed. Victor Burgin (London: Macmillan, 1982), 161.

42. Watney, "Making Strange," 160.

43. Watney, "Making Strange," 174.

camera, descending from a cave with a tape recorder in her hand. The effect of surprise, produced by the presence of this symbol of technological advance in the middle of the emptiness invading the image, contributes to the disorientation of the viewer. It invalidates the nostalgic idea that the indigenous world is virginal, protected from civilization and its dangers. At the same time, it disturbs the stubbornly held idea that the indigenous world and technological progress are incompatible. It also presents the idea that one can possess a technological object without necessarily entering into the world that the object signifies. My reading of the defamiliarizing impact that entails the presence of the tape recorder in Iturbide's photograph thus far seems insufficient, however. Can we speak of a productive cohabitation between indigenous people and technology, or should we see the photograph itself as a technical device paradigmatic of Western dogma? Other photographs also disconcert the viewer, who has been taught to expect photographic images of Seris tilling with ancient tools. Instead, Iturbide and Ortiz Monasterio present us with images of Seris using modern electric appliances that emit high-decibel sound waves that flood the arid surroundings, diverting attention, in this way, from visuality to auraiity, as if we were expected to hear in addition to see, or, as we saw earlier, as if the eye were to listen. Moreover, Iturbide's portrait of a Kikapú woman from the state of Coahuila (1986), sitting down in the middle of a hut, free of any signs of modernity, reveals the rarity of the cigarette that the indigenous woman is smoking. What seizes the gaze (the *punctum*) is not the fact that the Kikapú is smoking but the type of cigarette she smokes: long and fine, with processed tobacco, which comes in elongated packs and is usually associated with urban women of a certain social class and sophistication (or those in pursuit of sophistication).

Although Ortiz Monasterio tends to engage in a type of cultural anthropology that pays particular attention to what could be seen as "folkloric inventory," the process of defamiliarization is also evident in some of his photographs. "The Photo of the Elders" (1993) presents a Huichol man sitting sideways in such a fashion as to offer only a view of his body, showing a photograph of what I choose to call his "ancestors" to the camera. The Huichol man without a face no longer offers hands withered and abused by the sun and clutching a shovel to our view, as in Tina Modotti's famous photograph "Hands of a Worker"(1930) and also later in contemporary photographer Vicente Guijosa's series "Hecho a mano"(1987). In Ortiz Monastery's image, the Huichol man has an object of technological reproduction in his hands. This mise en abyme of a photograph inside a photograph points to the circulation of the photographic image outside of museums, outside of national archives, and outside of the fallacy underlying these public demonstrations of national plurality. One could surmise that the Huichol man seizes the image that was stolen from his grandparents, bringing it back home.[44]

44. In his study, William A. Ewing reminds us "the hand is invested with almost magical associations of character and personal identity" ("Fragments," in *The Body: Photographs of the Human Form* [San Francisco: Chronicle Books, 1994], 37).

For Ortiz Monasterio, recontextualizing the photograph can be read as an attempt to rescue the elders from oblivion and from the public anonymity in which they were trapped. It interpellates observers of his photograph, advising them that from this point on, they will not be able to dispense with the Huichol man, with his contemporaneousness and history, if they want to have access to his ancestors. He is the individual subject who will preserve the memory of his family, a memory that transcends public memory and ethnographic realms, in which he may still be trapped.

There are other examples of *ostranenie*. Analysis of the aesthetics of surprise is one of the theoretical strategies that allows us to begin to answer some of the questions presented by the Mexican photographic cultural text. The ghost of indigenous people as "the perverse unconscious" of the nation continues to haunt the work of these photographers, however. In these photographs, the process of defamiliarization is not recorded in, and does not respond to, specific, historical situations; it disregards social and political implications by concealing them with aesthetic luster. I suggest that, although these photographers intended to create a liberating representation of their subjects, they do not satisfactorily debunk the idea of indigenous people in Mexico as a national abstraction. The fact that defamiliarization also implies that "all social contradictions could be made immediately universally accessible to the eye, simply by means of visual surprise,"[45] is problematic.

It should perhaps not be so surprising that these photographs would fall into the kind of officialism that they hoped to subvert, since defamiliarization is a modernist aesthetic par excellence. Moreover, these photographs also point to an uncritical use of the clichéd character of that defamiliarization. The kinds of images representing indigenous people drinking Coca-Cola, or the Buddhist monk using a cell phone, become, as Chow puts it, "part of the stock catalog of the ethnic modern." That they should practice "defamiliarization" in their politics of cultural intervention, along with the concomitant results, points to modernity's problematic relation to history.[46] Finally, simply participating in such an anthology as *The Glass Eye* tends to undermine the defamiliarizing process at work in the photographs. Through their work, these photographers raise the following question: Since these works claim to combine the aesthetic and the documental, what are the implications of using an apparatus that is based on the dramatization of nonverbal actions? Clearly, one would be able to assert that the type of dramatization of the Huichol and Zapotee offered by Ortiz Monasterio and Iturbide in many of their photographs debunks the discursive excess characteristic of the civilized Western world and goes against the fetishization of oral communication and reason. Although one is tempted to focus on the corporeality of the subject represented, such a move would reinscribe the represented people as nonverbal bodies, precisely the only status—the status of art—that the successive official discourses about

45. Watney, "Making Strange," 174.
46. I owe the "disentanglement" of my thoughts on the issue of defamiliarization to a productive conversation with Rey Chow.

culture have been willing to grant them. Here we need to ask how we are to interpret (1) the continued folklorization of indigenous spaces; and (2) the heavy reliance on bright colors in this folklorization of said spaces. What can we say of images representing the celebrations of the indigenous populations that uniformly and almost systematically place them in a space that, for some viewers, corroborates the ingrained idea that indigenous people are lazy and dedicate themselves exclusively to playing and drinking? For other viewers, this space invokes the playful space they access as tourists during an occasional visit to the Huichol or Zapotee villages, a space of performance and entertainment that is quickly forgotten once they leave.

Many critics eager to transcend the ideology of observer/observed have argued for a postmodern view of the question of representation and ethnography. In his essay, Stephen A. Tyler posits that "because postmodern ethnography privileges 'discourse' over 'text,' it foregrounds dialogue as opposed to monologue, and emphasizes the cooperative and collaborative nature of the ethnographic situation in contrast to the ideology of the transcendental observer. ... There is instead the mutual dialogical production of a discourse, of a story of sorts. We better understand the ethnographic context as one of cooperative story."[47] This approach is a seductive alternative to traditional cultural anthropology, one that continues to be fraught with danger because it does not adequately address the question of liability that should be inherent in any dialogue.

The people who see, read, and interpret these "well-intentioned" photographs do not realize, for example, that the Tarahumaras represented in many contemporary photographs never dance around a fire while wearing peacock feathers, or that their so-called traditional costumes[48] are actually gifts, second-hand clothes donated by charitable organizations. The desire to represent the Tarahumaras as Mexican nationals, which is evident in these photographs, gives indigenous people an ironic centrality in the national imagination that seeks primarily to marginalize them. This is a reality that Mexican culture, much too eager to maintain these communities in the confined spaces of an imagined past, longs to deny them. In a similarly interesting vein, the Mexican national flag is present in numerous contemporary photographs of indigenous peoples, particularly in Ortiz Monasterio's *Corazón de venado* (1992), a compilation of photographs documenting the day-to-day life and annual rituals of the Huichol people of Nayarit. We can read this juxtaposition as another kind of syncretism, the perfect cohabitation of indigenous cultures and national emblems, thus giving credence to a national culture that depicts a heterogeneous, yet united, national front. Various Mexican anthropological studies on the Tarahumaras, however,

47. Stephen A. Tyler, "Post-Modern Ethnography: From Document of the Occult to Occult Document," in *Writing Culture: The Poetics and Politics of Ethnography*, ed. James Clifford and George E. Marcus (Berkeley: University of California Press, 1986), 126.

48. On the issue of the costume and its importance in indigenous communities, see Margot Blum Schovill, *Costume as Communication: Ethnographic Costumes and Textiles from Middle America and the Central Andes of South America in the Collections of the Haffenreffer Museum of Anthropology, Brown University, Bristol, Rhode Island* (Bristol, R.I.: The Museum, 1986).

show that they fly the flag under patriotic obligation only when celebrating governmental festivals. Here is a fragment of the conversation that the anthropologist Cajas Castro had with his Rarámuri informants:

> —And where is this flag from?
> —Well, from Mexico, right?
> —Then you are going to celebrate with *tesgüino?*
> —Well, no. Why do you think that? [They laugh.]
> —But if today is a holiday, I thought that maybe you were going to have dances and *tesgüino* [he retorts].
> —The thing is that this is not a festival of our community, it is more like a government festival, and we are fed up with festivities [they explain].[49]

The flag, therefore, does not necessarily symbolize the Tarahumara's allegiance to the nation. The inclusion of the flag in photographs, however, portrays the Tarahumara as national subjects, and the flag, as a sign, evokes, in most minds, contemporaneousness rather than the irony of a presence that is a simulacrum. The photograph merely exhibits the pretense of patriotism. The tension underlying these photographs, in which the same indigenous people are cast in different types of dramatization, raises the question of how these photographs become national memory inscribed in the political unconscious.

4. PHOTOGRAPHY AND MODERNITY, OR, THE ETHNIC IMAGE VERSUS CAMARISTAS

Mayan Photographers from Chiapas

In his book *Words of Light,* Eduardo Cadava meditates on the complex and fascinating relationship between history and photography, and asserts that "seeking to eternalize its objects in time and space of an image, the photographic present returns eternally to the event of its death. That the photograph is always touched by death means that it offers us a glimpse of a history to which we no longer belong."[50] This association leads me to the following question: What does it mean to speak about death and absence in the context of "ethnic" images representing Indian people in Mexico? There is a kind of circularity and self-referentiality in Cadava's understanding of Benjamin's

49. Juan Cajas Castro, *La sierra tarahumara o los desvelos de la modernidad en México* (Mexico: Consejo Nacional para la Cultura y las Artes, 1992), 26.

50. Eduardo Cadava, *Words of Light: Theses on the Photography of History* (Princeton, N.J.: Princeton University Press, 1997), xviii. Hereafter, this work is cited parenthetically as *WL*.

meditation on photography that prevents him from reexamining Benjamin's groundbreaking and fundamental reading of photography in light of postcolonial discourse.

The representation of non-Western subjects and cultures offers us a glimpse of a history that both Western societies and Ladino communities would rather repress/suppress—a history that recognizes the ways in which these cultures coexist/overlap. The photographic representation of the ethnic image allows for a rapprochement that simultaneously produces distancing. If, as Benjamin contends, "the photograph tells us we will die, [that] one day we will no longer be here, or rather, we will only be here the way we have always been here as images" (cited in *WL*, 8), what it omits is the fact that most indigenous people in the Americas are already absent before they enter the world of photography, which produces a double movement of absence and nonexistence. This image is not touched by death; it is touched by nonexistence. Indigenous people do not need photography to tell them that they will die, since they have been dying alive for centuries. For most of us raised and trained to see and think in Western terms, the photographed Indians are already dead, for they have never been anything but images before the camera photographed them; this knowledge forces us to reconsider the foundation laid by a modernity by which "the production of the image is a fundamental event" (Benjamin, cited in *WL*, xxix).

Can there be a photograph based on the nonexistence of the photographic subject? By nonexistence, I mean in the eye of the nonindigenous Mexican viewer, the Mexican government, multicorporations, totalitarian regimes, colonialism, and neocolonialism. Photographs can only bring a double death sentence. If, as Cadava insists, "the photograph is a cemetery" (*WL*, 10), then the ethnic image is a cemetery of a cemetery. It is not the "living image of a dead thing"; it is, rather, a dying image, a dead image of a dead thing, of indigenous people as perpetual corpses.

When Benjamin talks about "what we know that we will soon no longer have before us, this is what becomes image" (cited in *WL*, 11), we need to ask in the case of the ethnic image, how can it ("what we know that we will soon no longer have") become image, since we never had it (the thing that we will no longer have) before us as such? Since it has seldom been there to begin with, how can it return? What is photographed is already spectral. So then, one might ask, what does photography bring to ethnic communities in Mexico? Can it keep alive what is already dead? Does it lose its power because, instead of evoking what can no longer be there, it evokes what has never been there, what is being eradicated every day?

The photographic subject is already a nonbeing before it is presented as a nonbeing. What philosophy and theory tend to forget is that if we are all meant to die, some people, because of their economic, social, and political conditions, and the racial categories assigned to them, are the living dead. By putting into question the foundation on which photography is established, the ethnic image challenges modernity. In order to speak about reproducibility, there must be something to reproduce. Photography distracts us and allows us to hide behind the kind of memorializing that public display implies. Instead of acting as a deterrent to all the past, present, and future genocides that operate in an infernal, hateful, and insidious cycle of repetition that has become its own "mode of being," photography facilitates them. If an event can only be an event, if it can be reproduced, which event are we talking about? The reproduction as event? The act of creating the event via the image? This deferral is what seems to prevail, rather than an understanding of what

the image in fact represents. The event could be the photographers; they seem to be the uniqueness, as the images themselves become part of this "expanding collection of images, betraying an indifference"(*WL*, xxvii) toward what the thing means. The power dynamic might need to be reversed for the image to work as a welcome and not a farewell, to become not "the afterlife of the photograph" but rather its birth. The ethnic image should allow us to speak of indigenous people as living dead who are buried alive within the dominant culture. If, as Ernst Jiinger, Siegfried Kracauer, and Benjamin have argued, "the fundamental event of modernity is the production of an image" (*WL*, xxix) in Mexico, the event might not be so much the production of the image as the participation of Mexican photographers in modernity by producing images. In the last four years, an innovative kind of photography and anthologizing has taken place, a kind of production that hopes to assume responsibility for its own politics and create awareness in the culture at large.

In 1997, the Mayan-Chol photographer Maruch Sántiz Gómez produced an anthology entitled *Creencias,* and, in 1998, a second anthology, entitled *Camaristas: Mayan Photographers from Chiapas,*[51] a collection of images by a group of nonprofessional photographers.[52] Both anthologies are intimately connected to two educational projects in Chiapas and give new meaning to the strategies of defamiliarization we examined earlier. The first anthology is from the writers' co-op "Sna Jtz'ibajom/La casa del escritor" (The House of Writers), an Indian collective that includes the teaching of writing, puppetry, live theater, and radio programming in Spanish and in two of the eight Mayan languages spoken in Chiapas, Tzeltal and Tzotzil. The second project is one initiated by North American photographer Carlota Duarte, originally from Yucatan, who, after spending many years with different indigenous communities in Chiapas, founded, in 1992, the Chiapas Photography Project.[53] The Photography Project first saw light in a trade school for indigenous youth. Duarte explains that "originally I thought I would train a small group who would then train others in the use of 35mm cameras and black and white darkroom procedures using the popular education model. In the popular education model best known through Paolo Friere's writings, the taught become the teachers and in turn teach others."[54] Funded by international and national grants, Duarte hopes that these groups will be able to capitalize on their abilities, as their skills develop, in order to fund their own creative activities. Both *Creencias* and *Camaristas* aim first and foremost to be commemorative, hoping to help preserve the cultural legacy of the Chiapas community, to document the daily lives of the indigenous as the photographers see them.

51. Cariota Duarte, *Camaristas: Fotógrafos Mayas de Chiapas* (México: CIESAS, 1998). The introduction to the anthology states that "the title of the book springs from a group of Tzotzil women and the word they use to name their skills, 'camarista'" (17).

52. I wish to thank Cyndi Forster for bringing to my attention the work of the Camaristas.

53. See Patricia Johnston's interview with Carlota Duarte, "Indigenous Visions," *Afterimage* (June 1995): 8–12.

54. Johnston, "Indigenous Visions," 9.

The image on the cover of *Camaristas*—that of a Mayan woman pointing a disposable camera at another camera capturing her image—projects self-assurance on the part of the Mayan photographer and takes us from Ortiz Monasterio's image "La foto de los antiguos," with its control of the product (the picture), to an image of control of the process and means of production. This image provokes the surprising but desired effect that comes with the association, in the Ladino and Western eye, of indigence and technology, and is reinforced by the unassumingness and naturalness of the setting surrounding the Mayan photographer. The authoritative disposition of the Mayan flashing the privileged gaze, of which she has been the object since the inception of photography, back at the viewer is a powerful wink to the traditional world of technology, a world that mostly includes the indigent, to vampirize the Mayan further. It undermines the myth on which the binary opposition technology/underdevelopment is grounded, a myth that has sustained and keeps sustaining the cultural superiority of the West. It emphasizes the fact that, with the democratization of one of the most modern media and when provided with the means of production, Mayans can make great use of technology for their own benefit.

What distinguishes *Camaristas* from *The Glass Eye* is undoubtedly the fact that these photographs were taken by photographers who come from the ethnic communities and social classes represented. The anthology is divided into seven sections, each documenting the daily lives of members of these communities. The sections are all connected to one another: "People and Animals," to "Work and Things," to "Celebrations." One is struck by the Mayan propensity to represent food and domestic animals as an integral part of their lives. This is a clear reference to Nahualism, in which humans share a common destiny with the animal soul: "Nahualism embodies the belief that there exists between the person and the Nahual (animal or vegetable), a fully determined, intimate relationship that begins and ends with the life of the person."[55] Animals are present in most of these photographs of human activity (cooking, brushing hair, getting a pig to return to its stall, picking flowers, repairing a bicycle). The photographs themselves are marked by a movement that gives the anthology as a whole an almost cinematic quality, as if these photographs were moving images engaged in a narrative that implies a "circulation of the eye/gaze," or a new panning (*balisage*) of the gaze. This movement contrasts the stillness that infuses *The Glass Eye* with the hieratic poses that dominate the photos. These images are also interesting in light of their filiation to one another, because of the filiation established between the person represented and the photographer. The legends read, "My aunt is pulling a pig," "My mom standing near our house," and "My aunt's daughter is feeding the chicken." Many images name the person represented, thus conferring (1) a civil identity when the full name is given: "Lucía Guzman Intzin is standing at the door of her house"; (2) a spatial and topographical identity: "The woman from Amatenango is grinding corn"; (3) an ethnic identity: "A Tojolabal woman embroidering"; and, finally, (4) a familiar identity, by simply providing a first name: "My son Juan Carlos." Moreover,

55. See Rafael Girard, *Esotericism of the Popul Vuh: The Sacred History of the Quiché-Maya* (Pasadena: California Theosophical University Press, 1979), 173.

it is interesting to note that the articles defining the nouns in the legends are mostly definite articles conferring grammatical and identificatory specificity to the substantives they define.

While in many other anthologies what *identifies* the photographs and, by extension, what is represented are the name of the photographer who took the picture and, in some instances, the ethnicity of the represented, this collection of images stresses the existence of the represented, the fact that they occupy a reality. Their faces, their representations, refer to something besides what the viewer might expect. This practice forces the viewer to think in other terms, to learn new signs; it forces us to see people, a society, and a body politic. The photographers remain as anonymous as the individuals (although they are identified by name and ethnic filiation at the end of the collection, reversing the practice of *The Glass Eye*), as if this type of identification with a particular image were unimportant. Their aim is not to erase their personal vision but rather to give prominence to what the images may have to say, which is accomplished by the caption that accompanies each photograph and adds to its meaning while also eliciting an active reading of the image. The printed word here extends beyond mere description to link the illustration to particular acts and to explain those acts, so that we know who these people are and the context in which they are acting. In more conceptual terms, it also reveals a desire to participate in the world of literacy and visuality, which Duarte reminds us "has always been associated with the Ladino world and thus with power"[56] by generating different codes to be deciphered.

This does not make the image more authentic or less overdetermined than the images in *The Glass Eye*. It is, in fact, even more overdetermined, since the printed words undoubtedly seek to mediate visibility: here, through the detailed captions, we are told what to see and how to read the image, as well as the way in which these photographers wish their communities to be commemorated, guiding us, for a moment, out of our referential system. Although this method entails its own problems, it asks viewers to respect the right to self-representation; it also helps the image achieve new meanings and compels outside viewers to acknowledge what they see. It brings the unknown the daily life of Mayan communities to non-Mayans) to a level of ordinariness: almost everyone has or had a family, eats, works, plays, and so forth. Yet this kind of ordinariness is not co-optable/claimable as such and escapes codification within the system of the recognizable sign. We recognize/understand the concepts of family and relationships that the images and the written text project. This process contributes, in turn, to the sense of ordinariness that we draw from the images. We cannot, however, recognize this specific ordinariness that, in its specificity and innocuousness, stresses the multiplicity of the ordinary.[57]

Although the Mayans remain a largely illiterate population, the legends and images foster dialogue, an interactive connection between different viewers (from outside and inside the

56. Johnston, interview with Duarte, 9.

57. I am aware of the theoretical problems that this kind of universalizing creates and the fact that it might undermine the issue of defamiliarization in art brought up earlier. But that is precisely my point: the notion and act of defamiliarization have prevailed within ethnographic visual representations, and to return to thinking in terms of the ordinary might be a way to see differently.

communities represented) and the visual and written texts, through the presence of texts in Tzotzil, Tzeltal, Ch'ol, Tojoloabal, Mam, Spanish, and English, which call for communication, mutual recognition, and amelioration of literacy programs. This is an important step in Mayans' engagement with modernity. They are fully aware that this definition of an event as reproducible is imposed by intellectual processes, economies, and politics outside of their communities. Yet their engagement is cogently self-controlled, in the sense that their entry into the world of events becomes if not completely independent nonetheless autonomous through their access to the means of production and through the images they choose to capture. Because of the innovative approach the Mayans followed to produce them, their photographs reveal their own rules, which has implications in terms of the readings they propose. These images might serve as potential entry into the visual and verbal dialogue they foster.

The work of these Mayan photographers is far removed from the aesthetic of melancholy. This is made clear in the ways they define their photographic project and in the images themselves. Yet one cannot help but wonder what impact the Zapatista insurrection has had on these communities, since none of the photographs even alludes to the conflict. In her interview in *Afterimage,* Duarte explains that the absence of an overtly political text in Mayan photography is the result of self-censorship: "There is a general fear of war, fear of interruptions in their work, day-to-day anxieties, rumors of transportation shutdown or unexpected roadblocks that prevent photographing on location. A major concern is that if criticism develops that their work is too political, there will be consequent funding losses from private and governmental agencies."[58] In contrast, in his 1998 *Chiapas: The End of Silence,* photographer Antonio Turok, born in Mexico City of a mixed North American heritage, dedicates part of his work to documenting visually the armed struggle in Chiapas. In his introduction to his black-and-white photographs, Turok insists on his almost messianic mission to give a "face" to the forgotten people of Chiapas. While overtly political, his photographs were nonetheless supported by FONCA (Fondo Nacional para la Cultura y las Artes) and Fundación Cultural Bancomer, FONCA being a state-funded organization and Bancomer having very close economic and political ties to the state as well. While Turok argues that "the Maya are proverbially shy of the camera," there is no mention anywhere in his book of the Camaristas group or any reference to local photographers and their work.[59] What explains this absence, this lack of referentiality and dialogue in the work of photographers such as Turok? Could it be that these image makers have become so infatuated with their radicalism (or are so eager to cash in on the Chiapas conflict) that they are incapable of seeing the multifaceted dimension of these indigenous and photographic communities?

The Camaristas hope their work will transcend the traditional notion of event that many of the anthologized images of undifferentiated and impersonal "Indians" canonize. By taking into their hands the means of reproduction, they seek not to reproduce more authentic events but to introduce a new asymmetry in the archive bank of neatly organized and defined non-Ladino images.

58. Johnston, interview with Duarte, 12.
59. See Antonio Turok, *Chiapas: The End of Silence* (New York: Aperture, 1998), 19–20.

The cover of *Camaristas* invokes the disruption of the parasitical relationship between Mayan people and the others. It seems to ask, "What would knowledge be without this asymmetrical crossed exchange?"[60] while it seeks to expand the limits of knowledge and aesthetic production. But most importantly, it allows for the act of viewing and reading in communities that have traditionally been excluded from this practice. The Camaristas not only shoot and print their own photographs, but they also narrate and read them, another exercise that has remained in the hands of Westerners and Mexicans at the top of the economic ladder.[61] In their work, their identity becomes defined by the place they assign themselves in their world. It is this sense of self-determination that allows them not to lose self-respect, since this respect is not, a priori, conditioned by the gaze of the other. To be eager to represent oneself and to actually engage in an act of autonomous representation imposes a will that substitutes itself for a lacking legislation. By venturing on the foreign terrain of photographic self-representation, these photographers create their own criteria. In many cases, these criteria are far removed from those established officially, as is exemplified by the slogan "ven y tómate la foto." The cover of *Camaristas* seems to be saying to the reader/viewer "ven que fe tome *yo* la foto" (come and let *me* take *your* picture), reversing traditional roles.

CONCLUSION

The final photograph in *Camaristas* emphasizes the idea of movement. It captures the image of a woman from behind, alone, walking away. The concept of walking,[62] and the caption of this act, can be read in many different ways. We could see them as the body and soul of this indigenous woman walking toward her ruin. The walking is forced: she has no other means of transportation, and there is a strong social connotation attached to her walking—that of the social status of "the wretched," dragging her misery. She is barefoot. This photograph echoes the one preceding it, which captures a mother dragging her two children uphill while she and another child each carry a heavy burden on their backs. Theirs is a utilitarian walk, necessary for economic survival. Yet it differs from the photograph closing the anthology. In the last picture, since we do not see the face of the woman walking away, the woman seems young, unburdened, and our eye is drawn to the two fuchsia pom-poms hanging from her shawl. She seems to be walking without aim. The image invites the viewer to assume, to take on, the material presence and mobility of the indigenous people, to follow them in their peregrinations. It is commonly believed that

60. Michel Serres, *The Parasite* (Baltimore, Md., and London: Johns Hopkins University Press, 1982), 210.

61. The fact that Iturbide's and Ortiz Monastery's photographs are "narrated" by such internationally acclaimed writers as Mexican author Elena Poniatowska, based in Mexico City, is a disturbing indication that these photographers deny indigenous people the possibility of entering the realm of subjective vision.

62. See *Les figures de la marche*, exhibition catalog (Paris: ADAGP, 2000). See, in particular, Maurice Fréchuret, "Le pied arpenteur" (125–56) and Daniel Arasse, "La meilleure façon de marcher" (35–62).

mankind's ability to walk grants us a status of grandeur and the mastery of the space traveled (in this case, the space of Mexico as a nation). The image of these women walking, treading the earth, as organic matter, "practicing"space, is located in the humble register of everyday life.[63] But walking can also be seen as first steps, the entrance of indigenous people into the realm of photography, guiding the viewer along the path of a new photography that emphasizes collective and individual dignity in their journey toward modernity. It certainly foreshadows the March for Peace in March 2000, when Subcomandante Marcos and representatives of the multiple indigenous and *mestizo* communities embarked for Mexico City with the hope that what would ultimately constitute the event would not be the mediatization of their walk but rather the accomplishment of their centuries-long request: to be fullfledged Mexican citizens.

In the spring of 2000, the Zapatista Army of National Liberation (EZLN) walked to Mexico City, following the same itinerary as Emiliano Zapata's when he traveled and entered the capital in 1914. The fact that the EZLN still uses the same motto as the one that carried the Mexican Revolution—"land and freedom"—clearly points to the incompleteness of that Revolution. Moreover, the Mexican Revolution was a peasant uprising, an economic struggle that did not focus on ethnic and cultural specificity. After the Revolution, the sense of incompleteness was even more conspicuous in the cultural politics of government representatives such as José Vasconcelos. Postrevolutionary Mexico viewed itself as a *mestizo* nation made of a "cosmic race," as Vasconcelos imagined it. Yet the indigenous figured only in murals and the anthropological museum. It is the physical reality of indigenous people that Subcomandante Marcos hopes to rescue. However, what constitutes the event remains today, in Mexico, and for the world, not the plight of these communities but the mediatization of their plight. Once the sensational aspect of the event was over, no mediatic lens focused on their walking back to the jungles of Lacandon. This is a sobering reminder of the political and economic limitations of this kind of global mediatization, and we may need to rethink the kind of control indigenous people truly hold over the camera.

Author's Note: I thank Panivong Norindr, Rey Chow, Leyla Ezlindi, and the anonymous readers of the *boundary 2* editorial collective for their helpful comments and suggestions. I also thank Andrew Aizenberg for inviting me to present this essay at the Faculty Seminar at Scripps College in the spring of 2003. An earlier version of this essay was presented at the Latin American Studies Association in Chicago in 1998. Unless otherwise noted, all translations are my own.

63. This image and what it implies contrast with the notion of "non lieux" in the photographs studied earlier that stripped the image of its materiality.

Home on the Range: Kids, Visual Culture, and Cognitive Equity

Lorna Roth

This essay focuses on Binney and Smith's creation and marketing of Crayola fleshtone art products from the late 1950s until the mid-1990s, analyzing the company's shifting nomenclature-from "flesh" to "peach" to its multicultural collection. After reflecting on the significance of Crayola's color adjustment for children's sociocultural and aesthetic development and for teacher's pedagogical repertoires around diversity issues, I introduce an original notion—*cognitive equity.* I propose this as a refined way of understanding racial and cultural equity issues that don't just revolve around statistics and access to institutions, but also inscribes a new normative vision of skin color equity directly into technologies, products, and body representations in a range of visual media. At the very early stage of children's cognitive development when stereotypes and racisms are being formed, this would be a particularly intelligent design strategy in which to reinforce multiculturalism and multiracism in all aspects of their visual culture and the commodities that are available to them.

Keywords: *flesh tones; color balance; Crayola; multiracialism; cognitive equity*

The extent to which we take everyday objects for granted is the precise extent to which they govern and inform our lives.

(Margaret Visser, 1986)

This article is about why skin color matters in technologies, objects, and images designated for children. My central argument will demonstrate why a dynamic range or a continuum of colors from light beiges and pinks to dark browns should become the new norm for skin colors that are embedded in visual technologies (such as digital cameras, film chemistry, crayons), images, and products that reflect or depict some notion of skin color. I shall argue that it is not enough to explicitly teach children antiracist values in schools and at home. These values must be reflected in the commodities, images, and media that surround kids as reminders. My empirical research and conceptual work on this issue are emergent from a broader series of case studies that I have been undertaking for my book called *Colour Balance*. Here, I am examining the ways in which skin color has been imagined, embedded, and color shifted over time as it becomes apparent to manufacturers of various technologies and products that not all skin is white. My interest in the skin color adjustment proceeds beyond the recognition that the default of whiteness is no longer appropriate for societies that claim to be multicultural and multiracial.

Underpinning my research is a key assumption that images and commodities in their surroundings form part of the inferential pedagogical repertoire for children by which they are drawn into the dominant ideologies of a given society. Thus, I am concerned with designers' selection of core racial values, ethnocultural framing of products and racial reference fields into which technologies, images, and products are inserted and, in turn, are reflected back to the objects' users. Consequently, if the racial or cultural frame and reference field of a technology or product itself offers an encoded "preferred reading" (Hall, 1981) already embedded in its design and form, such as the message that *Caucasian-ness or light skin is the international norm for skin beauty*, then how can we expect children to go beyond this limited and inferentially racist notion that *this* is the single standard against which to compare other skin colors? In other words, if tools to create visual representations such as art materials are, indeed, cognitively skewed to norms of Caucasian-ness, then what subtle teachings about race are they actually reinforcing in children?

Take, for example, the history of the *color flesh* marketed as part of the Crayola crayon palette between 1949 and 1962. This is a particularly good exemplar of my argument because reference to the concept of flesh and its corresponding color(s) have undergone a series of color adjustments in the United States in particular eras. Between 1949 and 1962, the crayon called flesh that was circulating matched the skin colors of a very limited number of people. *Flesh* was a whitish, peachy color that harmonized very well with a wide range of Caucasian skin tones. In fact, it proposed an equation between skin itself and whiteness, and in no way could pass as a crayon to color African American, Asian, Hispanic, North American Indian, or Inuit skin tone ranges.

By 1962, enough publicity and protest had been exerted on Binney and Smith (the makers of Crayola crayons) by the Civil Rights movement and by those whose fleshtones were not within the Caucasian range to convince them to change the name of the color to *peach*. This name shift is most important to Crayola's color history (Binney & Smith, n.d.-a) because it was the first public recognition of race in such an ordinary product as the wax crayon.[1] Clearly, the decision to change the name was not made just because market research indicated a preference for one name over the other.

Rosemarie P. Mandarino, an art consultant working for Binney and Smith at the time of the name change recalls the sociocultural context of the decision:

> The Civil Rights movement was in full flood with great stress on raising self-esteem in the Black community. "Black is beautiful" was a phrase used repeatedly and especially to Black children. When these children opened their boxes of crayons to color with, they, their teachers and parents became very aware that the color called Flesh did not represent theirs. As a consequence, the mail being received at the corporate offices of Binney and Smith, Inc., then located in New York City, included many letters protesting the use of Flesh as a color name since it portrayed a Caucasian skin tone which obviously was not theirs. The officers of the company, after consultation with and input from their staff of artists, color chemists, and art consultants agreed they had a valid point and made the decision to change the name.
>
> The color itself was not part of the basic 16-color Color Wheel, but one of the additional colors that filled a particular need. Since blending tints and shades of colors with wax crayon is difficult, especially for children, colors such as Flesh, Sky Blue and others were formulated and added to the various assortments. I assume the color name Flesh was formulated to depict a Caucasian skin tone in a time when that was considered correct to answer a specific need for coloring with a wax crayon.
>
> The selection of the name Peach to replace Flesh was chosen after referring to the United States Catalogue of Standardized Color Names. I'm not sure of the title of this volume but I know it was part of the color labs and the library and was heavily relied upon. There were a number of names listed to describe the color. One of these was Peach. It was chosen after a consensus of opinions from the aforementioned staff. Since that time, names for many of the crayon colors have changed. You will no longer find Prussian Blue or Carmine Red. In some instances, the actual color was reformulated to answer the changing needs and tastes of the users; the teachers, artists and, most importantly, the children (Rosemarie P. Mandarino—retired color/arts consultant, Binney & Smith, personal communication, July 9, 1996).

The change from flesh to peach was made essentially for reasons of social justice and racial equity; it made good moral and economic sense in a period of United States history in which the civil rights movement was beginning to make political and constitutional gains. The retirement of flesh signified the recognition of an obvious ideological and racist bias embedded in the conception of the actual product, and Binney and Smith sought to correct it.

This is not to say that a racist bias was deliberately or consciously placed in their products. My point, rather, is to identify a pervasive dominant cognitive belief system around race, a racial unconsciousness embedded within North American business and manufacturing practices of the time. Corporate America, until very recently, has created and marketed products relating to skin color reflecting "white flesh" tones as if they were the only existing ones. Binney and Smith's interpretation of the color flesh as "white" was little different from the majority of North American- and European-based companies then producing consumer items for a market that was for the most part Caucasian. As a matter of historical record, in comparison with manufacturers of flesh-tone band-aids, nylon stocking companies, whose selection of flesh colors for the longest time reflected a range of Caucasian skin tones, or popular U.S.-based make-up companies, which only relatively recently added an array of shades for peoples of color, Binney and Smith were quick to shift their social contours in response to public pressures circulating in the late fifties and early sixties. Of course, from a market perspective, it made impeccable sense for them to correct their labeling of the color flesh in acknowledgment of the physical and material evidence that the product had, indeed, been misnamed in the first instance.

THE MULTICULTURAL CRAYON COLLECTION[2]—A CHANGE IN THE SPIRIT OF THE TIMES

Having retired the color *flesh* in 1962, one would have expected Binney and Smith to almost immediately produce a series of other colors to accommodate their public recognition of diverse skin tones. However, there was a notable gap of almost 30 years between the naming of peach and the launching of the multicultural collection of products. Why did it take so long for Binney and Smith to multiculturalize and to highlight racial differences as an integral feature of their color palettes? Furthermore, what was it that convinced them that the early nineties was the right time to adapt their merchandise to more diverse representational practices?

To the best of my knowledge, based on document research, interviews, textual analysis, there was no concerted *formal* lobby group made up of members of the general public that mounted a campaign to persuade the corporation to multiculturalize its products. User groups did interact with their public relations officers but in an ad hoc manner inquiring about a time when the company would develop crayons for Peoples of Color (Eric Zebley, personal communication, June 10, 1996). Art teachers were the most concerned user

group because they engaged with children producing self-portraits on a daily basis, and because social science curricula was beginning to focus on diversity studies.

How many phone calls and/or letters were needed for the company to pay attention to its consumers' requests? At what point did the company's recognition of diversity studies motivate the development of a range of alternatives rather than a negative and passive retreat from potential criticism? What were the critical factors that might have initiated a corporate policy change that would mark their products as recognizing a shift in the cultural, racial, and social norms of society? Why was it that by 1990 the idea was more than acceptable that those colors useful in representing skin, eyes, and hair of all peoples, already existent and available in several collections of their crayons, should be selected out and marketed as a separate multicultural package? In other words, why then?

Unfortunately, I cannot provide the definitive response to this inquiry. I can point out, however, that multiculturalism was in the air at the time; that the civil rights movement had made important inroads into the education system; that the educational curricula began in the mid-eighties to incorporate African American, First Nations, and various ethnic historical and cultural studies; that as non-Caucasian stories and personnel began to be privileged within the media, norms of whiteness began to be challenged as exclusionary; and that the logic of capitalism vis-á-vis global marketing meant that a necessary color adjustment would have to be made to accommodate multicolored bodies and biases of people around the world. Certainly, all of these factors suggest that a social and perceptual shift was underway that would be irreversible. Binney and Smith moved with the spirit of these times, but it only moved this far and then passively waited for consumer responses.

Company planning for multicultural products began in 1990 and by 1991, boxes of skin, hair, and eye color-appropriate crayons were ready to be launched. Their first targeted market was that of educators; their second was retail sales, where they "lasted about a year-and-a-half" (Eric Zebley, personal communication, June 10, 1996). In 1991, a People Pack Multination collection of My World Colors, which later became known as Multicultural Crayons[3] was designed and launched in a full range of skin tones.[4]

From my interviews, it is clear that teachers' requests were one of the decisive factors in the decision to produce the collection so that children would be able to accurately draw, paint, and mark their own images in all varieties of skin colors. On a prominent leaflet outlining their multicultural products subtitled *Helping Children See Themselves and Their World,* Binney and Smith (n.d.-b) described the reasons educators gave for wanting the collection:

> Educators have asked Binney and Smith to produce a line of multicultural art prod-
> ucts, in a full range of skin tones, since people are not black and white *[sic]*. It
> strengthens children's comfort with who they are when they can draw themselves in
> colors that truly reflect their complexions. When children are given boxes of crayons
> and markers that have a variety of skin tones, it enables and encourages them to

draw a diverse community, recognizing the ethnic diversity around them (Binney & Smith, n.d.-c, p. 1).

To facilitate art teachers' use of the new collection, pedagogical materials were developed by Binney and Smith consultants that have been distributed throughout the schools in North America. These include lesson plans, model designs, and other curricular variations for lessons on diversity issues and have been found very useful by teachers.

What is not so clear is why Binney and Smith decided not to market these very same products as aggressively to the retail market, that is, by providing support materials to parents and family, as was done with educators. Thus, in as much as Binney and Smith is to be praised for its positive social intervention in what we can assume to have been a low-profile lobbying effort by educators, one is left wondering about the lack of proactive marketing parallels for retail clients.

IS THE MEDIUM THE MESSAGE?

What is the message *flesh-in-wax* crayon over the last several decades and what does it say about our perceptions of our bodies as color-marked citizens within North American society? What racial color options could we have used to draw before 1962 and then again before 1992? What colors can we now choose to be—this question refers to what colors we can be on paper of course.

The decision to rename flesh in 1962 and the 1991 launching of the multicultural collection opened up many philosophical possibilities for users of Crayola products that were not Caucasian. It indicated the potential to reconceptualize the color of one's body on paper for one. Second, it legitimized body colors that in the past had been discouraged, that of Brown and Black bodies. Finally, broader notions of pigment variation suggested a new way of looking at our bodies' whiteness norms and these inferred a concurrent shift in our standards of beauty regarding skin color and race.

With the withdrawal of multicultural crayons and other products from the retail market as of 1993, this leaves us in a dilemma. Is diversity to exist only within the walls of the schoolhouse? What happens to multiculturalism at home? Why is there a two-tiered system of integration—one for the school and one for the streets? Is this sectoralism a wise strategy? When will notions and products emergent from a multicultural perspective migrate into storefront America on a more permanent basis?

The color adjustments that Binney and Smith have undertaken are significant historically. As small and trivial as they may seem to the ordinary person, they denote a powerful shift in the tools used to study, draw, and represent the human body on paper, and they are generally targeted toward children at a vulnerable age when they first begin to record their perceptions of the social, cultural, and political bodies and institutions in which they live. Splitting the color palette into two—one for the educational, the other for the

retail sector—may very well, though not necessarily, trigger a corresponding split in race consciousness with deeper implications for future race relations.

Is a crayon just a crayon? It is my contention in taking on this topic that a crayon is more than a crayon. The Crayola crayon appears politically innocent because in appearance it's just a crayon. But when notions of skin color are embedded within an everyday object such as a crayon, you begin to see what society is teaching its children. Its values, its perspective on racial and cultural issues become apparent. If you read a society symptomatically, if you look at the surface or range of its products, signs, and symbols in search of a deeper meaning, you can begin to take seriously what at first appears to be its insignificant play tools, one of which is the common crayon.

COGNITIVE EQUITY: TOWARD AN EMBEDDED NORMATIVE RANGE OF SKIN TONES

Reaching beyond the current critique of whiteness (e.g., Dyer, 1997; Winston, 1996), this case study begins to document evidence for an original conceptual notion that I am calling cognitive equity—a new way of understanding racial and cultural equity issues that doesn't revolve around statistics and access to institutions but rather inscribes a vision of skin color equity into technologies, products, and body representations in a range of visual media. This is a particularly important design prototype to reinforce multiculturalism and multiracialism in young children's visual culture and commodities because it is at a very early stage of their cognitive and cultural development that stereotypes and racisms are formed and reinforced.

Finally, in an effort to expand the potential inclusiveness of representations for current technologies and to widen the skin tone ranges embedded in a variety of portrayal practices, my work suggests two possible strategies that would strengthen children's capabilities to develop racial and cognitive equity: (a) a reconceptualization and adjustment of technology, image, and product design so that it becomes easier to capture and reproduce the range of skin tones without having to resort to a variety of often unsuccessfully executed compensatory practices and (b) the development of a wider range of skin color norms in body representations so that the range itself becomes the standard, the new norm, for all media and tools that facilitate (virtual, two- and three-dimensional) portrayals and depictions of bodies exhibited in the arts and commerce.

As more and more manufacturers and creative producers explicitly acknowledge the skin tone values they are working with and reinforcing, and as they begin to tackle the complexities of the color adjustment process, we shall hopefully note a wider public recognition and acceptance of multiracialism. Of course, there are no guarantees that implementing my suggested strategies would automatically help children to develop cognitive equity. That would also require complementary changes in school curricula, in the manufacturing economy, and in discourses about diversity at school, at home, on the streets, in storefronts, and in the media.

As challenging as this shift may be to actually achieve, the establishment of a color continuum—rather than the retention of whiteness as a default reference point for skin color reproduction—would be an important starting point from which children could begin to perceive, categorize, and think about race and ethnicity in a different way. With the current global emphasis on cultural and racial diversity, this strategy would be an invaluable cognitive and pedagogical intervention that would likely give new meaning and broader context to the old cowboy song, *Home on the Range*.

NOTES

1. Other color-name adjustments with skin tone implications that have taken place over the years include:
 - The switch from Prussian (1949) to Midnight blue (1958), which occurred because teachers and students were no longer familiar with Prussian history.
 - The shift from Indian Red (1958) to Chestnut (1999): The color Indian Red was originally based on a reddish-brown pigment commonly found near India. Nonetheless, the manufacturer had gotten complaints from teachers who indicated that students thought the color represented North American Indians and decided that it would be politically correct to choose a simpler name that could not be misinterpreted.

2. In my own work, I differentiate between the terms multicultural and multiracial in the following way. Multicultural(ism) can refer to cultural and ethnic backgrounds exclusively and does not include the range of skin colors that is covered in the term multiracial(ism). However, the way in which the term is used by Binney and Smith, and many others I might add, indicates a conflation of the two terms under the heading of multiculturalism.

3. It seems that another crayon manufacturer had had the same idea and had already trademarked the name People Pack and so Crayola had to rename its product in respect of the patents and trademark laws.

4. Crayola multicultural products have expanded beyond the wax crayon to include the following media, along with appropriate names: crayon colors—Sepia, Burnt Sienna, Mahogany, Tan, Peach (formerly known as flesh), Apricot, Black , and White for blending; washable paint colors—Brown, Mahogany, Terra Cotta, Olive, Bronze, Tan, Beige, Peach; and washable markers—Sienna, Mahogany, Terra Cotta, Bronze, Tawny, Golden Beige, Beige, and Tan.

REFERENCES

Binney & Smith, (n.d.-a). *Crayola crayon colour history.* Easton, PA: Author.

Binney & Smith, (n.d.-b). *Crayola information pamphlet.* Easton, PA: Author.

Binney & Smith, (n.d.-c). *Crayola multicultural products: Helping children see themselves and their world.* Easton, PA: Author.

Dyer, Richard. (1997). *White.* London: Routledge.

Hall, S. (1981). The determinations of news photographs. In S. Cohen & J. Young (Eds.), *The manufacture of news* (pp. 226–243). Beverly Hills, CA: Sage.

Visser, M. (1986). *Much depends on dinner.* Toronto, Ontario, Canada: McClelland and Stewart.

Winston, B. (1996). *Technologies of seeing: Photography, cinematography and television,* London: Brtish Film Institute (BFI Publishing).

Lorna Roth is an associate professor in the Department of Communication Studies at Concordia University in Montreal where she teaches and researches matters related to minorities, race, and cross-cultural communications. Her recent publications include a book on Canadian indigenous media titled Something New in the Air: The Story of First Peoples Television Broadcasting in Canada (2005). She is currently working on a book called Color Balance: Race and "Intelligent Design" in which she examines how skin color has been imagined, produced, and adjusted over time in products and technologies that have a notion of flesh tone embedded within their design. Her research focuses on what manufacturers do when they recognize that not all skin is "white."

El Mexorcist (A Performance)

Guillermo Gómez-Peña

ABSTRACT

In the past months, I've been writing, re-writing and testing in front of informal audiences of colleagues a series of spoken word performance texts. Some of these texts I found by digging through forgotten archives of my computer's memory. I brought them back to life through obsessive re-writings, in dialogue with my colleague, City Lights editor Elaine Katzenberger. Others are transcripts of ad lib texts that spontaneously came to being during my solo performances. A few I wrote this year in direct response to political or pop cultural phenomena, exploring their effects on my views on art, activism, identity, sexuality and language. What these texts have in common is a tone—a kind of ironic and melancholic tone—and a unique form of vernacular philosophical inquiry that I feel are at the core of performance art and performance literature. Together they function as reflections on our millennial condition, as artists and cultural practitioners living in the US, a country that is undergoing an unprecedented cultural and political crisis. Some underlying questions are: Why do we continue doing what we are doing (in my case, writing and performing) against the backdrop of war, censorship, cultural paranoia and spiritual despair? What are the new roles that artists must undertake? Where are the new borders between the accepted and the forbidden? Is art still a pertinent form of inquiry and contestation? Is my audience really with me? Who are 'we' and who are 'they'? Can I collaborate with my audience in the making of the performance? From whence do we draw the energy to continue? As a performance artist my job is precisely to ask questions in original ways.

Like most of my performance literature, these hybrid texts suffer from an identity crisis. Are they spoken word poetry, performance 'monologues', pop philosophy, art theory,

post-colonial thought, or Chicano stand-up comedy? I truly don't know. It is actually better that I don't know. Like most of my literature, they are 'open texts', works in permanent progress, which means that their publication merely preserves them in one phase of their ongoing development. Together, I see them as both a multi-purpose literary bank and a script in permanent progress; documents of sorts for crossing the border into the new century. The form of these texts on the page is merely a performative strategy. Though they are poetic prose pieces, I have structured them like poems or monologues, in short sentences per line. This way, it is easier for me to read them aloud and to play with language rhythms and textures. My colleagues are constantly asking me why I chose to return to my solo spoken word material. First and foremost because my audiences asked me to do so. As I have toured with my troupe over the last three years, everywhere we go audiences tell me they want to hear my voice again. They want to know my current opinions about art and politics. They insist on hearing my voice, alone on stage, without excess performance paraphernalia. They ask and I must acquiesce. Furthermore, I feel that the complexities and subtleties imbedded in the content and form of these pieces couldn't possibly be conveyed through my troupe work, which tends to be more experiential and collaborative. I begin performing this solo material sometime in early 2006. Every performance will utilize a different combination of texts and performative strategies. There will always be a 15–20 percent margin for improvisation, for specificity to the site, the city and the audience.

Keywords: activism • border culture • Latino art • performance

Great day for humankind

Ladies and gentlemen;
Today is an extremely special day for humankind...
(LONG PAUSE)
War is over.
President Bush has finally decided to pull
all military personnel and equipment
out of Iraq and Afghanistan.
The Pentagon has confirmed
that by August 25th, of this year
the US Army will have abandoned
all military positions in the Middle East.

We are all extremely happy, no shit.
I would love to dance with someone.

MUSIC BEGINS: 'WAR IS OVER' SLOWED DOWN

Would anyone like to come on stage and dance with me?
War is over my dear contemporaries...
at least for the duration of this performance.

(SOMEONE COMES ON STAGE. I DANCE WITH HIM/ HER
FOR A MINUTE. MUSIC STOPS)

Flagrantly stupid acts of transgression

(I CLEAR MY THROAT)
Damas y caballeros,
I've got 45 scars accounted for
half of them produced by art
& this is not a metaphor.
My artistic obsession has led me to carry out
some flagrantly stupid acts of transgression
including:
Living inside a cage as a Mexican Frankenstein;
Crucifying myself as a mariachi to protest immigration policy;
Crashing the Met as El Mad Mex;
Being led on a leash by a Spanish dominatrix.
I mean, you want me to be more specific than, say,
drinking Mr Clean to exorcise my colonial demons
or handing a dagger to an audience member
& offering her my abdomen?
(PAUSE)
'Here... my colonized body', I said
'My solar plexus...
your moon-like madness', I said
and she went for it
inflicting on me my 45th scar.
Right here

(I SHOW MY SCAR TO THE AUDIENCE
She was only 20, *boricua*
& did not know the difference between
performance, rock & roll & street life.

Bad phrase, delete. Script change.

Public confession

Standing on the edge of the new millennium
(I TAKE A DEEP BREATH)
I open my eyes & look at my life *in perspectiva*
like the aerial view in the beginning *of Fata Morgana*
remember that early Herzog movie?

I SCAN THE AUDIENCE WITH BINOCULARS

What do I see?
Most of my family has died
my community is in despair
& my peers are so marginal & frail

Controlled by organized crime,
my original homeland, Mexico,
continues to freefall toward NAFTA hell
as my new country, the US,
is besieged by Jesus freaks & war mongers.
(PAUSE)
I look at the present
& the president is getting ready to strike yet another country
in search of oil, military might & reconstruction bonds
the citizenry is sleeping...
& those few who are still awake are scared
we are all going through the Big Smoke...
New York, Kabul, Baghdad, New Orleans...
(I NAME THE CITY IN WHICH THE PERFORMANCE
TAKES PLACE)

I PUT DOWN THE BINOCULARS

As if this weren't enough,
My age weighs on my shoulders like...like..
...a towering Chihuahua.
& my legs are exhausted
from walking non-stop across the continent.
My liver is weak & so is my memory
My blood is thick; my sperm count low
1 smoke & drink too much.
My best hours & sharpest performances
are definitely numbered
just last month,
an art critic refered to me as 'a classic'
ouch! It hurts
(PAUSE)
Í am a total mess, but I am on fire...

Dear locos and locas:
ail I can offer you tonight is my art
& my most unexpected words,

(I SPEAK IN TONGUES)
the words of a poet who could have been a criminal
but got lucky,
found love, friendship,
a great apartment with rent control
and an audience that listens.
Dear audience:
the only difference between a madman
and a performance artist
is that a performance artist has an audience.
So thank you for not letting me go mad.

Rehearsing in front of the mirror

(I PUT ON A BANDANNA & CLEAR MY THROAT)

I'm rehearsing
I'm rehearsing my activist speech for tomorrow
in front of the bathroom mirror:

(I COMPOSE MYSELF IN FRONT OF AN IMAGINARY
MIRROR)

EXALTED ACTIVIST VOICE:
'Dear citizens of chaos:
This is a desperate attempt by a dying performance artist
to recapture the power of the spoken word
in the year of virtual despair and victorious whiteness.'
No,
Sounds like, like Tom Waits meets Malcolm X
in a Taliban AA meeting
Tom Waits and Malcolm X?
Hey, 'ToMEX,' that's an interesting persona
Let's look for his voice

(I FAKE A TOM WAITS TYPE OF VOICE)

'Dear citizens of despair:
This is a desperate attempt by a dying performance artist...'
(NORMAL AGAIN)
Don't over do it Gómez-Peña
just be yourself
But is it possible to be one's self on stage or at a rally?
Try! Try!!
Deja de performear y tira la neta!
(I SLAP MYSELF TWICE AND CONTINUE)
Carnales:
We know that democracy
simply cannot be defended by force,
much less imported, or forced upon others
we can nurture it organically
through civic education and art,
we can create the conditions for it to flourish
through public dialogue & a responsible media,
but we simply cannot defend it,
especially through violent means.
War will not make us safe, *camales.*

The Patriot ACT is a hoax
The mission is not accomplished that way.

The combination of democracy and weapons
is only possible in Hollywood movies
& in the deranged minds of our politicians
Everyone outside of our borders knows this
Most everyone inside ignores it...'

No, that's too literal
I should be more...epic, *mas dramático,*
perform as if I was
the Third Party Chicano candidate
addressing the Brown House:
I quote from an old script:

(I GRAB A MEGAPHONE. MY VOICE IS EPIPHANIC)

'Dear Chícanos and honorary Chícanos,
The historical mission of the US is to put the world at risk
and then to save it from the very risks it created:
to arm other countries
and then to attack them for being armed;
to provide weapons and drugs to the youth of color
and then to imprison them for using them-,
to endanger species and then to raise consciousness
and create programs to save them;
to evict the poor
and then punish them for living on the streets-,
to turn women and people of color into freaks
& then laugh at us for acting out accordingly.
The historical mission of the US is very, very peculiar.'

(NORMAL)

'Dear audience:
Let me ask you a personal question:
When I speak
Do you feel I am speaking on your behalf?'

(PAUSE)

How pretentious

Explaining to a nurse what I do

I SIT IN A WHEELCHAIR

NASAL:
I've been hospitalized in Mexico City
for 2 weeks.
(I won't discuss my illness tonight
for I've already done so in another script)
I'm trying to explain what I do to a nurse
I mean, I'm trying to explain to a nurse what I do
But I'm not getting anywhere.
She asks me for the 10th time
Perdone, what did you say you were?
A per-for-man-*que?'*

NORMAL:
A contra-dic-tion in terms - *respondo*
a straight transsexual, *me captas?*
a wrestler without a ring
a rocker without a band
a cyber-pirate without 'access'
a theorist without methodology
a shaman in a technologist world
a poet who writes his metaphors on his body
7 locos, locked inside an empty room
my mind, not theirs, not yours...

NASAL:
She looks at me
With a combination of tenderness and fear and says:
"No entiendo nada...del arte... moderno.'

I make a final attempt to explain to her what I do:

NORMAL:
I'm an artist who sells ideas, not objects,
not images, not skills
a per-for-man-ce artist, which means that...
I write letters with my own blood
I wrestle with historical ghosts
I research the possibilities of silence & darkness
I can set my hair on fire just to make a point
& when I am pissed, I tend to speak in tongues
(ANGRY TONGUES)
performance is a weird religion, I told you
(CATHOLIC CHANT)
per ipsum ecu nipsum, eti nipsum
et T-Video Patri Omni-impotenti
per omnia saecula saeculeros,
I te watcbo

NASAL:
The nurse changes the page of the script for me
She finally gets it.

Superbarrio once told me

I WEAR ONE OF MY MEXICAN WRESTLER MASKS

You know, Superbarrio the Mexican wrestler/activist
once told me, 'Gómez-Peña,
if your life were congruent with your ideas
you would mask yourself for good
become Supermojado,
& devote the rest of your live
to defend the plight of migrant workers
or become Vatoman & negotiate a truce
between the Norteños & the Sureños'
& he was right... up to a point.

'But what about my responsibility to art?'
'Who cares about art?' he said.
'I do', I said.
"Then that would be your art', he said.

'Becoming Supermojado would be your ultimate
performance.'
'And my son, my mother, my girlfriend?
Would they know who I was?'

He smiled at my naivete.
Of course we were discussing the realm of the symbolic
0 sea, sym-bo-li-ca-lly speaking,
1 could become Supermojado overnight
& only my closest friends and relatives would know
& the rest of you would think that Gómez-Peña
disappeared for good.
People might think I finally returned to Mexico
and joined the Zapatistas,
or they might think that I opted out
8c became a Chicano expatriate in Bali or Aruba
sipping pina coladas under fictional palm trees

After all, nowadays who can remember you
for more than 6 months anyway?
I mean, besides a few past lovers and the FBI.

Remember?
Remember me?
I used to be...Mexican.

Tired of exchanging identities online

(TWO STAGING OPTIONS: I DELIVER IT IN MULTIPLE
VOICES OR I INVITE SOMEONE FROM THE AUDIENCE TO
COME ON STAGE AND READ THE TEXT WHILE I DO A
SIMULTANEOUS TRANSLATION TO AN INDIGENOUS
LANGUAGE OR I SAY THE TEXT BACKWARDS)

'Hello Gómez-Peña, you've got mail'
What am I hearing?
'You've got a male inside of you,
.. .or so you think *pendejo?*
Shit! The computer is talking to me about gender.
I think I'm losing it.

I'm tired of ex/changing identities on the net.
In the past 8 hours
I have spoken 7 broken languages at least
I have visited 12 countries without leaving my room
I have 'interacted' with 38 subcultures from around the globe
I've been a man, a woman and a s/he.
I've been black. Asian, Mixteco, German,
an alien raptor and a multi-hybrid replicant.
I've been 10 years old, 20, 42, 65, 120.
I've visited 22 meaningless chat rooms...
'Asian Goths who sing mariachi music phonetically'
'Midget sex workers from Indonesia exchange tips
on how to deal with obnoxious Australian machos'.
Weird sites...
'Survivors of Dungeons & Dragons from Buenos Aires
exchange aficionado porn video clips.'
It's endless...*infinito**
'X-treme performance artists from Micronesia

organize collective suicide for CNN.'
Our options are endless
& I am temporarily lost within
my cyber-labyrinth
(I SPEAK BACKWARDS)
As you can see,
I need a break real bad;
I just want to be myself for a few minutes.
At least for the duration of this performance
(PAUSE)
'Hello Gómez-Peña, you've got mail'

Erotic poem

I'd like to read an erotic poem right now.
May I?
(AUDIENCE RESPONDS)
How explicit should I get?
Let's vote: I need 20 hands
to read a really explicit erotic poem.
(AUDIENCE RAISES HANDS/I COUNT THEM UP TO 50)
Good, let's begin:

I PUT ON MY MEXICAN WRESTLER MASK

I quote from unpublished script number #78
It starts with a performance note to myself:
'Bad French accent'

MUSIC BEGINS: 'CLAIR DU LUNE' BY DEBUSSY

(FRENCH ACCENT)
Dear Death, *La Petite Mort,*
The last time I opened your legs
I saw eternity for a moment.'
(PAUSE)
Beautiful *haiku-placazo que no?*
(I LOOK AT THE SIDELINES AS IF LOOKING FOR
APPROVAL FROM MY PRODUCER)
Should I go a bit further? Ok...
(FRENCH ACCENT)
'You asked me to pee inside of you
& I complied like a loyal Mexican servant.'
No, that's forbidden colonial territory. *Otra línea...*
'& I complied with the fake politeness of a French waiter'
That's better; sounds like Marguerite Duras
(I LOOK AT THE SIDELINES AS IF LOOKING FOR
APPROVAL FROM MY PRODUCER)
Should I continue reading?
(AUDIENCE MEMBERS SCREAM 'YES!')
or should I turn this text into a live performance?
'Mexamerican Sodoma'?
(PEOPLE SCREAM 'YES!' I LOOK AT THE SIDELINES
AS IF WAITING FOR APPROVAL FROM MY
PRODUCER)
No way!!!
This is Post-Ashcroft's America.
I'd be burned alive
and only Bill Maher and Larry Flint would defend me.

But the idea of staging the poem is quite tempting, *que no?*
Should I?
(IF SOMEONE SAYS YES)
OK, I need a volunteer
and together, we'll make history–
small history, local history, but history after all.
I've got my favourite Mexican wrestler's mask.
Music is rolling.
There are a couple of video cameras in the house.
We'll send the footage to The O'Reilly Factor
The scandal will be bigger than Ward Churchill's
'NEA-funded anti-American depravity
under the guise of performance art at (name of the museum)'
(I LOOK AT THE SIDELINES AGAIN)
No, I won't do it
and not because I'm shy or scared.
Who isn't scared nowadays
with Homeland Security knocking at our doors?
Looking at our grant applications?
Reading our emails?
No, It's not that.
It is because I'm...
(I LOOK AT THE SIDELINES AGAIN)
protecting my... reputation.
My reputation...
(PAUSE)
...is precisely to scare my producers!
It's my fuckin job *que* no?! My job?
Do I have a job?
(I LOOK AT THE SIDELINES AGAIN)
Are you offering me a job?
What am I saying?
A fully employed artist in contemporary USA
I'm confused
I should go back to the original script
Shit! I'm missing a few pages!
Blackout!
(THERE IS NO BLACKOUT)
No blackout?
Well...Mexican blackout!
(I PUT MY HANDS OVER MY EYES)

Mexican Brechtian moment

Where is the *pinche teleprompter* I asked for?
I told you guys I was unable to memorize a full script.
I told you very clearly that this was not a theater
monologue
Hey Pancho, that light over there is too bright
Can we put a blue gel over it
to add some artificial melancholy to my words?
(PAUSE)
Nevermind! Ne-ver-mind...
Hey, my voice sounds quite muffled
Testing, testing, *probando*
'*Estoy nutriéndome en voz alta*
y nadie se da cuenta, probando, probando'
This mike sounds crappy *que no?*

Don't you guys have another one
that can actually improve my voice?
make me sound more dignified,
sensual, compassionate, smart –
I mean, isn't technology supposed to enhance humanity?
(PAUSE)
What's wrong with US technology?!
Nevermind!
This is a Mexican Brechtian moment
sponsored by Bacardi
(I GRAB MY BOTTLE OF RUM AND DRINK FROM IT)
Saud!

The Republican Barbie

This drunk Republican Barbie
was stalking me after a show.
'*Yiguermo*, darling...
I love America & you don't,
you ungrateful *barling.*'

I love America too, *esa*'-1 responded.
'But the America I love
is dramatically different from yours'

'How so, taco boy?
Is your America blue or red?'– she asked.

'Neither one.
It's brown, black, yellow, pink
and occasionally red–
Marlboro Red,' I punctuated.

'Wow, your America is a smoking America,
just like mine.'
She smiled to get on my nerves even more.

Now it was my turn to ask questions
of the Anne Coulter cloné...
destabilize her ideological axis.

'And what about you, *guerita?*
(INTERTWINE HICCUPS IN THE FOLLOWING TEXT)
in which America do you live?
The land of Christian rock & orange alerts
or the land of tex-mex and blues?
–She literally went... (I MOVE MY HEAD LIKE A
CARTOONISH DRUNK)
Would you rather defend a fertilized egg
or the lives of Iraqi children?'
–She went.. (I MOVE MY HEAD LIKE A CARTOONISH
DRUNK)
'Was Jesus an Arab or a Jew?
Is Bush a Texan cowboy or an Ivy-leaguer?'
–Her eyes got wider and wider
as I got weirder and weirder
& finally I finished her off: i '
Honey, are your tattoos real or temporary? !
Are you with me...or better off without me?'

At that point her brain short-circuited like a Chicano
special effect

Dear audience, please, excuse me.
My dark mind and dark skin are acting out.
It's been a rough tour since 9/11,
but the Republican Barbie is not a performance persona.
I'm telling you, she's real.
You can ask my stage manager.
She had to kick her out after the show

And it was a bit sad
Cause, between you and me
She was kind of cute
You know what they say
desire transcends ideology & race

God bless the entire world

Dear contemporaries:
God bless...Mexico
God bless...Afghanistan
God bless...Iraq
God bless.. .Pakistan
God bless...Venezuela
God bless...Bolivia
God bless...Colombia
God bless...Cuba
God bless...Iran
God bless...North Korea
God bless...China
God bless...Sri Lanka
God bless...Thailand
God bless.. .Palestine
God bless.. .Sudan
God bless.. .France
God bless...let's see
God bless...Canada
God bless...Iceland
God bless...Fiji
God bless...the Bahamas
God bless.. .Aruba
God bless...

(I WAIT FOR SOMEONE TO ANSWER. AUDIENCE
MEMBERS CONTINUE TO ADD NAMES OF COUNTRIES
THEY WISH TO BE BLESSED)

God bless...
(AFTER 8 OR 10 MORE NAMES ARE ADDED TO THE
LIST)
Oh, and we had almost forgotten
God bless...America too
The continent, I mean
God bless all of us here
ocuppying *this pinche* planet
spinning out of control
praying for perfect tits, a big dick & personal salvation
Hallelujah!

Mapping the immediate future

Back to my main subject matter:
Mapping
Mapping the immediate future
so you and I can walk on it
without falling inside the great faults of history.
You & I, verbally walking together,
You & I, an ephemeral community
You & I, a tiny little nation-state
You & I, a one-hour-long utopia titled 'You & I'
Alone on stage
Fighting together the World Bank,
the WTO & the Bush Cartel,
Fighting Avant-garde desire *&* the Patriot Act
Tú y yo, juntitos.
Fighting isolation & isolationism

But who are you, really?

Harsh pause

Does anyone have anything to say about my text
at this point?
I said my text, not my performance skills,
Not my looks, or my voice,
just my text...
(SOMEONE MAY ANSWER/I TAKE NOTES)
I am writing down
your words will change my next performance
I promises

Radical vernacular performance

True story...
There is a new type of homeless in San Francisco.
He invites you to spit on his face for a dollar.
She asks you to hit her for two.
It's...radical vernacular performance,
and people go for it.
Why?
Does anyone have a theory?
(SOMEONE VOLUNTEERS A THEORY)
I've got a theory myself:
S&M is dominant culture nowadays.
(PAUSE)
But if that's the case,
who is our master dominatrix?
(PAUSE)
The Bush administration, Fox News or The World Bank?
(AUDIENCE ANSWERS/ELABORATES)

Another theory:
In the culture of extreme interactivity
Everyone becomes a performance artist on the weekends
Maybe?

OK, last theory:

We live in a post-democratic era
& radical trivia reigns in the kingdom of mediocrity.
In fact, I venture to say that
most art nowadays, including mine
is...radical trivia
& you can quote me on that one.

Unsolved mysteries

Dear audience:
There are lots of mysteries in my life.
Verbigratia:

One, I spit blood every morning.
Where does the blood come from?
The doctors have no idea.

Two, once a year
My tongue turns black for a month
Why black & not green or blue?
The doctors have not the slightest idea.

Three, I see ghosts in every theater or museum I perform
Who are these *vatos?*
Did they die here?
Are they responsible for the missing props?

Four, I've got 2 kinds of friends
My daytime friends are artists, intellectuals,
civic leaders...important people
My nighttime friends are drunks & druggies
on the verge of homelessness & crime
I try to get both groups together in my parties
But they just don't seem to be able to talk to one another
Why?
Do they need a translator?

And finally,
this ongoing mystery in my life:
Every time I return to the US.
I get sent to secondary inspection
'Why?' I ask them.
They tell me: 'Random textual interference, *señor.'*
'What? Is Homeland Security some kind of editing team?
A bunch of *vatos* who say
'You are in the text; you are not in the text?'
'Yes, we are conducting auditions'- they answer
'You mean, typecasting?'
Shit! Seems like a B-movie to me

Stall asking the right questions?

Damas y caballeros;
I'm feeling a bit insecure & introspective *tonite*
I just turned 50
& I wonder if I'm still asking the right questions
or am I merely repeating myself?

(SILENCE)
Am I going far enough, or should I go further?
North? But the North does not exist,
South? Should I go back to Mexico for good?
Regresar en español a las entrañas de mi madre?
But the Mexican nation-state is collapsing as I speak
so *stricto sensu, Mexico en español* no longer exists
because every day Mexico & the US,
like Fox and Bush, *la zorra y el arbusto,*
look more & more like one another
& less & less like you and I
which means 'you' *y* 'yo'
are no longer foreigners to one another.
Therefore, as orphans of two nation-states
we've got no government to defend;
no flag to wave.
We've only got one another
which sounds quite romantic,
I mean, politically speaking,
but it is a philosophical nightmare...
I mean, if neither the North nor the South
are viable options anymore,
where should I go? East? *EST?*
Should I go deeper into my global psyche
& become a Chicano Buddhist?
Or should I cross the digital divide west
8c join the art technologist cadre?
Yes? How exactly?
Alter my identity through body enhancement techniques,
Laser surgery, prosthetic implants,
& become the *Mexica* Orlan?
A glow-in-the-dark transgenic *mojado?*
Or a post-ethnic cyborg, perhaps?
A Ricky Martin with brains?
That's a strange thought.
Maybe I should donate my body
to the MIT artificial intelligence department
so they can implant computer nacho chips in my
*&^%~76%78
or transplant a robotic bleeding heart, *bien sentimental*
so I can become 'El Ranchero Stelark'?
What about a chipotle-squirting *techno-jalapeño* phallus
to blind the *migra* when crossing over?
Or an 'intelligent' tongue activated by *tech-eela?*
You know, imaginary technology
for those without access to the real thing
Cause' when you don't have access to power
Poetry replaces science
And performance art becomes politics.
Mex-plico?
No?

See, underneath it all
my dilemma is quite simple:
In the permanent economy of war
Invented by president Bush,
Art is not working out fiscally
So...I got to get me a 'real' job,
a 9 to 5 job.
But the question is, doing what?

I could be an inter-cultural forensic detective
An expert in X-treme identity analysis.
No...I hate secrecy
I could teach 'Chiconics' in Jail, I mean *Yale,*
Or at Brown or State Penn, I mean Penn State:
'What's up *esos,*
chinguen a sus professors.
Saquen la mota y el chemo.
Forever, Aztlan nation.'

How about posing as a model for a computer ad:
(I PUT ON MY TECHNO GLASSES & STETSON HAT &
POSE)
'El Mexterminator thinks different, *y que?*'
no, according to my son, 'that's very 20th Century'

Wait-
I could conduct self-realization seminars for Latino neo-cons
'Hey *vatos:* Come to terms with your inner Chihuahua
wake up & bark!'
(I BARK)
I could lead workshops for neoprimitive Anglos:
'Find your inner Aztec'
(I SPEAK IN PSEUDO-NAHUATL)
(I POSE)
I look the part *que no?* Kind of...
(I TAKE OFF GLASSES)

I could write a best seller for conservative minorities
titled...
'Inverted Minstrel: 100 ways to camouflage your ethnicity
to get a better job.'
No, Condoleeza is already writing it.
Í just don't know anymore.
It's tough to find a useful task for a performance artist
In the age of the mainstream bizarre & globalization-gone-
wrong,
Amidst 'the war of civilizations according to the Texan
scriptures.'
In this time and place
what does it mean to be 'transgressive'?
What does 'radical behavior' mean
when Howard Stern & Jerry Springer
become defenders of freedom of speech?
What does 'radical' mean
after Bin Laden & Chaney
become celebrities of despair?
What does performance art mean
when a theological cowboy is running the so-called 'free
world'
as if he were directing a Spaghetti Western on the wrong set?
Or when Conan the Barbarian becomes governor of
California
in a reality show called 'California'?
When creationism becomes official policy
& our politicians are sincerely waiting for the rapture?
Cono, I ask myself rhetorically,
what else is there to 'transgress'?
Who can artists shock, challenge, enlighten?
(LONG PAUSE)
Can we start all over again?

Can we?
May I?
Mearlos?

OK, Tabula Rasa; take 2

Wrong prepositions

Every time my Russian poet friend Rimsky is pissed at me
He says, 'fuck on; cook sucker!'
& he gets constantly outraged at my performances:
'Tat's not art; tat's crapp Yuriguermo.
You pay for that?'
'No, I answer. I get paid for this.'
'Tat wouldn't pass out as art in Russia.'

I love to fuck with his knowledge of prepositions: '
Fuck art, Rimsky, loosen down and chill in, *ese.* "
'Chill in? Tat's not well English. It's Chill off!'

Rimsky reminds me of my early days as an immigrant.
When prepositions were a mere reflection
of the multiple borders I used to cross everyday

You know.. .If only I had a decent command of English
when I got involved with my past lovers.
Pero...pero...
If only I had known the difference
between jerk around and jerk off,
between napkin and kidnap,
between prospect & suspect,
between compromise & *compromiso*
between embarrassed & *embarasada.*

If only I had known the difference
between desire & redemption
between political correctness & personal computers,
between us & US
between humanity and mankind
We've only got one word for both in Spanish:
Humanidad, perdóname por ser tan bt-rollero

If only I had known the difference
between loneliness & solitude...
We've only got one word *en español*
soledad.
Forgive me for being so...pa-ra-dox-i-cal,
soledad on stage, my flaming queen,
forgive me, *chuca,*
for spilling the beans
of my very spicy beanhood.
NASAL:
'He thinks like Octavio Paz',
wrote the *Boston Globe* theater critic,
'but behaves like Geraldo Rivera on acid.'

NORMAL:
But if only I had known the gringo implications of
'Mi casa es su casa,'

meaning, *y tupáis también;*
or *'Hasta la vista* babe',
meaning, die fuckm' meskin;
or *'Vaya con dios vatous locous,'*
meaning, deported back to your origins.
The South is always the origin
& crossing the border is the original sin.

Placazo:
Un emigrante mas equals un mexicano menos...
Translation please?
Delete!
Quote from British art critic:
'Gómez-Peña is like a Chtcano Ali G
suddenly morphing into Julio Cortázar'.

Coño These art critics have a serious problem
with intercultural metaphor
Que les pasa maní

The border between you and me

(ADDRESSING INDIVIDUAL AUDIENCE MEMBERS
DIRECTLY)
Esa...
Where is the border between you and me?
(I SUBVOCALIZE)
Between my words & your mind?
(I SUBVOCALIZE)
Between my mouth & your fears?
(I SUBVOCALIZE)
Where exactly is this performance taking place?
Are we web casting tonight?
Where are my colleagues and friends?
(SCREAMING OVER THE AUDIENCE)
Are you *locos* still here?!
(IF NO ONE ANSWERS)
No?
Am I alone once again, on stage?
Are you guys out there...my audience tonight?
What is your role in this madness?
Do you feel lonely when I speak?
What time is it, by the way?
(SOMEONE ANSWERS)
It's so fuckin' late in the show
And I am still asking
all these existentialist questions:
Is there still time?
Time for...making love...
For dreaming...
For reinventing ourselves...
For returning to the homeland?
Returning to her arms?
Is there enough time?
To wait?
To stop the war, yet another war?
To cry collectively?
To cry for Bagdad & New Orleans?
Or to cry for the world for no apparent reason,

the way Fassbinder used to ciy
whenever he took a city bus
& saw other suffering humans?
Their perplexed & lonely faces?
'Ish bin ain Mexicanishes monster in Berlin.'
Poor German citizens.
If only they had been born in Mexico
they would be less tortured...perhaps.
Bad phrase. Delete.
(TO SOMEONE IN THE AUDIENCE)
Miss, why were you crying the last time you cried?
You, beautiful you...
Were you truly aching tonight or just performing?
Am I really, sincerely aching tonight, or just performing?
Is this a mere exercise in linguistic manipulation?
(TO SOMEONE ELSE)
Sir, are you in touch with your heart?
Can you see mine, hanging out like a wandering viscera?
(TO SOME ELSE)
Carnal, are you in touch with your genitalia?
(TO ANOTHER AUDIENCE MEMBER)
Hey, do you know your genetic code?
Do you know your civil liberties?
How many have you lost since 9/11?
(TO SOMEONE ELSE)
Do you remember the terms
of the Guadalupe-Hidalgo treaty?
'Ish bin ain Mexicanishes monster in Berlin.'
(HINDU ACCENT)
No, I'm an American
I have lived here for 30 years.
(NORMAL)
I don't ever recall asking you if you were a foreigner.
(FRENCH ACCENT)
Ne me derange plus ouje vous arrache lesyeux.
Bad French accent, *cono...terrible!*
I told you I was a bad actor!
I was never trained...
to perform...your desires,
much less to entertain...
the possibility of...lying.
A performance artist is someone
who does not know how to lie or act
& this trait is not exactly a virtue.
gets you in trouble
with all forms of authority.-
cops, teachers, curators, editors, politicians.
I call it.. .the burden of involuntary opposition
(LONG PAUSE)
Anyone willing to come on stage & take off your clothes
As a homage to early performance art?

The script says so...

THERE IS A BOOM MIKE IN FRONT OF THE AUDIENCE

(THIS TEXT MIGHT BE EITHER PRE-RECORDED OR
DELIVERED LIVE BY A LOCAL ACTOR WITH A FLIGHT
ATTENDANT VOICE)

Citizen X,
You've got one minute to say whatever you please
with no restrictions of content or form whatsoever.

Citizen X,
please stand up,
approach the mike in the center
and exercise your civilian will.

You can share with us whatever you wish
A secret perhaps?
A wild sexual confession?
A poem? A song?

Some words of wisdom to brighten our dark path
towards self-destruction?
Some tips to get my relatives into the country illegally?
Or perhaps you may wish to defy the artist, curse him,
object to his words, alter the fate of the script, whatever...

Go!
But remember.
you've only got one minute.
Why?
'Cause the script says so...
(PAUSE. A PLANT COMES IN & TALKS, THEN AUDIENCE
MEMBERS FOLLOW SUIT)

ACKNOWLEDGMENTS

This selection of texts was made by myself in dialogue with Elaine Katzenberger, Marquard Smith and Joanne Morra. These texts are works in progress.

Guillermo Gómez-Peña is a performance artist and writer based in San Francisco. He is the artistic director of La Pocha Nostra performance troupe, and a contributing editor of *TDR* magazine (MIT Press). He has written seven books, the most recent is *Ethno-Techno: Writings on Performance, Pedagogy and Activism* (Routledge, 2005). Descriptions of his current projects can be found on his website: www.pochanostra.com

Norman Rockwell
and the Fashioning of
American Masculinity

Eric J. Segal

> There is no longer any question of Picasso or icons. Rep in is what the peasant
> wants, and nothing else but Rep in. It is lucky, however, for Rep in that the [Soviet]
> peasant is protected from the products of American capitalism, for he would
> not stand a chance next to a *Saturday Evening Post* cover by Norman Rockwell.
> —Clement Greenberg, "Avant-Garde and Kitsch," 1939[1]

I n May 1916 the *Saturday Evening Post* featured for the first time an illustration by
Norman Rockwell (1894–1978). This cover image, *Boy with Baby Carriage* (Fig. 1),
inaugurated a forty-seven-year relationship that fused "the *Post*" and "Rockwell"
together as catchwords for the culture of white, heterosexual, middle-class America.[2]
Moreover, Rockwell's tremendous popularity with a burgeoning mass audience helped
establish him as the quintessential representative of middlebrow culture in the United
States. Paradoxically, this status, so archly praised by Clement Greenberg in his 1939
essay "Avant-Garde and Kitsch," continues to retard serious discussion of Rockwell's work
as a cultural artifact of twentieth-century America. Nonetheless, Rockwell represents a
key text for the study of mainstream American visual culture in this century.

Eric J. Segal, "Norman Rockwell and the Fashioning of American Masculinity," from *The Art
Bulletin*, Vol. 78, No. 4; December 1996, pp. 633–646. Copyright © 1996 by College Art
Association of America. Permission to reprint granted by the publisher.

Rockwell's absence from narratives of art history or—less frequently—his function in that discourse as a sign of aesthetic failure and cultural debasement, ought not to be dismissed as issues of artistic quality or as judgments of taste. Accordingly, the present study largely sidesteps red-herring questions of the aesthetic value of a Rockwell or the art-historical relevance of commercial illustration.[3] Instead, it is concerned with how Rockwell's images participate in the formation of identity in the modern era, focusing on the fashioning of competing versions of white, middle-class, American masculinity.

These interests are pursued here through the figures of the sissy and the fop, introduced in Rockwell's earliest work for mass-circulation adult magazines. Specifically, I want to examine what these works contributed to the contemporary discourse of middle-class masculinity and American national identity around the moment when the United States conscripted its first recruits to World War I in mid-1917.[4] Through humorous evocations of these two maligned figures, Rockwell explored the limits of masculinity in the public realm for both boys and men. These illustrations repeatedly framed what I call a *sartorial masculinity* that is based on fashion and taste rather than on the bodily fortitude that has dominated our understanding of early twentieth-century masculine ideals. Despite distinctions between these middle-class masculinities, they both provided models for social agency in marked contrast to images of brawny working-class male bodies that served as emblems of industrial power in advertisements in the same journals.

In 1911, at the age of seventeen, Norman Rockwell began a career as a professional illustrator and during the next four years found himself, as he notes, "up to my neck in illustrations for young people's magazines."[5] The stories and books he illustrated frequently called on him to produce sober images of earnest boys negotiating obstacles encountered in forests or at sea, or confounded by social and even romantic difficulties. His sobriquet at the time, "Boy Illustrator," suited both the teenaged Rockwell and the primary subject matter of his illustrations, boys and adolescents.[6] Capitalizing on his precocious drawing talents, pursued at the expense of a high-school education and honed at the Art Students League in New York—after stints at the Chase School of Art and the National Academy of Art—Rockwell soon earned the post of contributing art editor at *Boy's Life.* Although he continued illustrating for virtually every popular youth magazine of the day, including *American Boy, Boys' Life, Every land,* and *St. Nicholas,* he nevertheless harbored the greater ambition of working for adult magazines and, above all, for the *Saturday Evening Post.*[7] With *Boy with Baby Carriage* that aspiration was realized: his work appeared in "the greatest show window in America for an illustrator."[8] Indeed, within two years the *Post's* subscription list swelled beyond the benchmark of two million, and the weekly could claim the greatest magazine circulation in the world.[9]

In *Boy with, Baby Carriage,* as in most of his illustrations for adult magazines, the depiction of boyhood has become an occasion for humor rather than for the serious treatment of high adventure or social conflict typical of Rockwell's earlier work for juvenile magazines. The tightly wrought visual narrative purports to relate an ordeal particular to *American* boyhood—evinced by the baseball uniforms—in which two insolent lads taunt

Figure 1. Norman Rockwell, *Boy with Baby Carriage, Saturday Evening Post,*
May 20, 1916, cover (photo: © The Curtis Publishing Company)

and jeer at a third pushing a baby carriage and wearing a citified outfit.[10] Though he is
only a youth, this boy's handsome attire mimics the accoutrements of an over-accessorized
middle-class gentleman: pin-striped suit, pink-striped dress shirt, necktie, double collar,
derby, leather gloves, buttonholed red carnation, and, indistinctly, a crooked walking stick.
The baby's bottle straining the breast pocket of his jacket punctuates the otherwise neat
ensemble. Although he moves at a brisk pace—the string of his hat guard trails behind
him—the wicker baby carriage seems stalled in the enveloping white ground." A tiny red
shoe rests on the side of the carriage, while inside only a blanket and a white, beribboned
bonnet suggest the infant.

The boy's antagonists, clad in the matching jerseys and caps of an organized baseball
team, pass in the opposite direction but pause momentarily for some fun. Turning back,
they act out the antics of a broadly comic parody of manners. At the far left, the dark-
haired, gap-toothed boy wraps his left arm around his torso to support his (hidden) right

elbow. With his index finger under his lower lip, pinky extended, and wildly cocked cap he mocks the self-conscious and perhaps feminine gestures of a man of cultivation and breeding. The tousled-haired boy in the middle raises his cap—again, the pinky is extended—in a burlesqued offering of greetings to a lady.

Their scorn seems directed both at the protagonist's neglect of manly sporting activities in favor of the female role of child care, and at the same time to his presumptuous and mishandled adoption of an adult male's role and attire. Even contemporary etiquette books recognized that "there can be nothing quite so humiliating to a child as to be dressed in an outlandish fashion that renders him conspicuous. ... A boy should be dressed like a little boy."[12] Here, the double-breasted jacket and the derby cloak the boy in the stodgy maturity of an elder statesman, while the hat guard fastened to his lapel evinces the timorousness of an unmanly boy, a sissy. His performance of a woman's chore and the overly refined *dress* deny the dapper youth access to the camaraderie of boyish play and, apparently, to masculinity. Excluded from the physically oriented homosocial world of the baseball players, he is instead domesticized through his performance of familial obligations in the public sphere of the boulevard or park. Rockwell's formal construction of the image underscores this gulf between opposed domains through his treatment of the interior of the carriage's hood as a padded and buttoned gray cavity.

Thomas Buechner, a former director of the Brooklyn Museum, described *Boy with Baby Carriage* as depicting the "forced separation of the individual from the group and the assignation of the function of one sex to the other, ... basic human situations which involve all of us vicariously."[13] Here Buechner evokes practices of cultural policing that enforce normative gender roles. But instead of considering how this image works through and on culturally determined codes of masculinity, Buechner attends to underlying essentialist assumptions. These subsume the idea of performed sex and gender roles to unnamed, because so familiar, innate *functions* of a particular sex. By assigning child rearing to women as a universal charge—a basic human situation—Buechner casts this gender-role ridicule as a social means of maintaining biological order.

In invoking basic human situations as the core subject matter of the image, Buechner reprises a familiar refrain in Rockwell literature distilling each image to a celebrated universal truth about America and its people. This dubious interpretive school persists in the face of the equally familiar charge that Rockwell's America was, at least until his work for *Look* magazine after 1964, an exclusively white and predominantly middle-class America. It also obviates *looking* at these images with any sustained attention.[14] Thus, Buechner has described the "immediacy and veracity" with which Rockwell's paintings (he generally worked in oils on canvas) communicate a message, and even detractors such as Richard Reeves could agree (albeit in less generous terms): "a Rockwell is like a poster, all its impact, the whole sentimental story, is in the first glance."[15] In general, critics, commentators, apologists, and detractors succumb to the seduction or repulsion of the vaunted realism and preponderant narrative content of these works, and neglect cultural history or even visual analysis in favor of strong opinions for or against.[16]

Without venturing further into that particular debate, I would like to return to *Boy with Baby Carriage* in order to address ways in which Rockwell engaged cultural—not biological—issues of gender. At least two aspects of this image foreground as unfixed not only gender but also sex. Seemingly ancillary to the boy's predicament, the infant in the baby carriage presents a figure without secure gendering that incarnates consonant issues. Rendered as no more than a blanket, red bootee, and white bonnet, the bantling has elicited contradictory suppositions from commentators who, while concurring that it is a sibling, disagree as to whether a "baby sister" or a "baby brother" is depicted." Placed approximately at the center of an image explicitly taking a muddled gender role for its subject, the indeterminate sex of the child presses questions of gender identity: not only whether the infant *is* in fact a boy or a girl, but what gender, what sex, will it *become* as it matures and comes to incarnate codes like those played out amongst the three boys?[18]

The second aspect, more central to the narrative, concerns the protagonist and the conflicting cultural codes in his dress and accoutrements. On the one hand, his derby, or bowler hat, prominently juxtaposed with the baseball caps, could evoke an open profusion of codes of class and gender. The bowler's deployment to a variety of ends by Charlie Chaplin's little tramp, by Georgia O'Keeffe in photographs by Alfred Stieglitz, and, later in Europe, by René Magritte in his Surrealist paintings acknowledged and augmented its overt multivalence.[19] Whether a sign of machine-age anonymity, male privilege, or middle-class propriety, the bowler tops its wearer with an emphatic, if polysemous, masculine sign.[20] On the other hand, the feminine implications of the baby's bottle distending the boy's breast pocket, its evocations not only of care giving but also synecdochically of the mother herself, contradict the bowler. Like the indeterminacy of the infant, these visual cues, the one neither irreducible to nor contained by the other, center on questions about the construction of gender in this image, while undercutting any assurances about connections between sex and biological functions.

Rockwell's illustration seems to countenance a youthful masculinity constructed around physical prowess in preference to a fussy, family-oriented image of boyhood. Such an account dovetails with an incipient stage of what Theodore Roosevelt dubbed the "strenuous life," a response to anxiety about manliness which perceived salvation of the Anglo-Saxon race itself in well-reared American adolescents.[21]

And yet, in travestying confusions about gender codes, this image hints at coexisting, sometimes competing, terms for middle-class, white masculinity. Specifically, beyond the familiar masculinity defined in terms of bodily fortitude, well documented by historians of the period, this and other Rockwell illustrations point to a masculinity dependent upon correct judgment in matters of dress, a kind of sartorial masculinity. In *Boy with Baby Carriage* the value of *decorous* sartorial splendor is intimated, but virtually eclipsed, by the send-up of immoderate attention to male dress. However, other Rockwell illustrations more clearly sanction felicitous observance of normative dress codes, primarily through the dividends awarded superior heterosexual sex appeal. For instance, in an image such as *Shall We Dance?* from 1917, the elder boy with his suave gestures and sophisticated evening

Figure 2. Rockwell, *Shall We Dance?*, *Saturday Evening Post*, January 13, 1917, cover (photo: © The Curtis Publishing Company)

wear enjoys the attentions of a rapt belle, to the dismay of his rival in knickers, who loses out on a promised dance (Fig. 2).[22] The alternative and often overlooked sartorial masculinity indicated in these images will become more evident in turning to the fop, the mature kin to the sissy. However, before leaving *Boy with Baby Carriage*, I want to comment a bit further on the figure of the sissy.

The sissy served Rockwell handily as the unique comic figure in his work for juvenile magazines. As he later mused about an illustration for a story in *St. Nicholas* (Fig. 3), "About the only subject which an illustrator for young people's magazines was permitted to treat humorously was rich, sissyish kids. The readers all identified with the regular fellows behind the car and laughed with them at the conceited, pompous sissy."[23] The story itself, "Making Good in Boys' Camp," recounted the fictional experiences of several boys each of whom started out summer camp on the wrong foot, but eventually shaped up. The rich kid called Percy—it "wasn't his real name; but it should have been"—is maligned as much for his inability to dress himself at thirteen years of age as for his sartorial excesses. Suffering through several incidents in which he dishonors himself and his tent partners and, in the process, gets "his new camp suit so mussy!" he finally achieves self-reliance by washing his own stockings and building a decent bunk. His narrative concludes, "He had not only caught on, but he had made good. And so—well, though they did call him Percy when he arrived, they called him Bill when he went home!"[24]

The name Percy was conjoined in a special relation with the sissy. As the noted observer of the American scene H. L. Mencken remarked somewhat later in his lexicographic work *The American Language,* "many aristocratic English given-names, [including] Reginald [and] Percy, are commonly looked upon as sissified in the United States, and any boy who bears one of them is likely to have to defend it with his fists."[25] Rockwell registered a particular sensitivity to the connotations of the name Percevel and its variants in his autobiography. As a young illustrator signing his work, Norman Percevel Rockwell reduced his middle name, Percevel, to a P. and then dropped it altogether despite, as he wrote in his autobiography, "my mother's earnest protestations." Recalling that she had always insisted he sign his name in full and how he "lived in terror" of being called Percy, Rockwell unpacked some of the codes he recognized in the name.

My mother, an Anglophile (I wore a black arm band for six weeks after Queen Victoria died) and very proud of her English ancestry, named me after Sir Norman Percevel ("Remember, Norman Percevel," she'd say, "it's spelled with an *e; i* and *a* are common"),

who reputedly kicked Guy Fawkes down the stairs of the Tower of London after he had tried to blow up the House of Lords.[26]

He chafed at his mother's misplaced pride in their English ancestry, but also fretted at the "queer notion that Percevel (and especially the form Percy) was a sissy name, almost effeminate."[27] Thus, the early twentieth-century sissy—an effeminate male marked by his sartorial excesses—evoked wealth and European aristocracy. In other words, the "sissy" measured, largely by dress, deviation from a masculine norm of the middle-class American boy.

Rockwell and Mencken were not alone in their concern over the sissy. The consolidation of masculinity in the disciplined and fortified male body at the turn of the century had displaced an earlier conception of masculinity premised on the cultivation of self as a creature of the business or spiritual world.[28] At the beginning of this century the pursuit of healthy boyhood, too, became a subject of national debate in response to fears that new family and professional roles for women, the close of the Western frontier, and the rise of urban living would drain the middle class of its vitality. Responses to changing social patterns and perceived threats were largely shaped by contemporary theories on adolescence.

At the turn of the century, against the backdrop of smaller middle-class families with fewer

Figure 3. Rockwell, illustration to "Making Good in Boys' Camp," *St. Nicholas,* July 1917, 840 (photo: reproduced courtesy of the Norman Rockwell Family Trust).

servants and with working fathers absent from the home, motherhood assumed increased importance in domestic and child-rearing matters. Some social commentators perceived the waning presence of fathers as an impediment to the healthy development of boys. If these critics looked to public schools to provide boys with a refuge from a domestic environment governed by women, they were disappointed there as well. Increasingly amongst the students girls outnumbered boys, while at the front of the classroom women superseded men as teachers.[29] The growing presence and authority of women in schools, according to these critics, supplanted male influence on boys, while the environment, premised on sedentary activities, weakened their young male bodies.[30] Sunday schools received still harsher excoriation: "real" boys were thought to resist sermons by squirming

in class while harboring a "wholesome dislike for the youthful prig—especially if he was a religious prig."[31]

Other observers characterized city life itself as an enervating influence and a threat to masculinity. One commentator wrote in 1902 that urban parents "are frequently pained to find that their children have less power and less vitality to endure the rough side of life than they have themselves. … Families who live in the city without marrying country stock for two or three generations … later are unable to rear strong families."[32] New working patterns for urban industries drew middle-class men from the home, subjected them to enfeebling work environments, and interrupted traditions of father-son apprenticeships through the intervention of corporations. Medical discourse, too, substantiated fears of modern urban life, identifying neurasthenia as an affliction affecting both men and women of "the indoor-living and brain-working classes." In boys the disorder was treated with outdoor physical exercise.[33]

To counter the influence of these perceived social developments, a variety of groups sought to shape the character of the nation's youth, through the general rubric of boys' work. Boys' works organizations in American cities and towns included the popular Young Men's Christian Association (YMCA), founded in 1851 to ease the transition of young men arriving for the first time in large cities, and the Boy Scouts of America (BSA), formed in 1910.[34] Concerned adults—by profession "boys' workers"—in urban, rural, and farming communities formed extrascholastic organizations to benefit and manage boys from various classes. Character building, a narrower term than boys' work, focused specific attention on preparing white, middle-class boys to become responsible men. Through extrascholastic activity designed to discipline youths, character-building groups sought to instill in middle-class boys in particular probity, rectitude, and robust physical health. The YMCA began boys' work in the 1870s and applied itself to character building in earnest in about 1900. The character builders recruited a "better class of boys," avoiding the "rougher element";[35] this was left to other organizations and clubs that specifically targeted working-class and street boys (perceived as a delinquent lot including newsboys, bootblacks, and scavenging urchins) and aimed merely to occupy the idle time and divert the dangerous excess energies of youths who would never amount to much.[36] Still other organizations dealt with farm and rural boys. Male character-building organizations, forged into discrete, reproducible units (as in the Boy Scout troop or the local Y), multiplied in cities and towns across the nation, drawing impressive numbers of adult leaders and young members.[37]

Character builders found legitimation and motivation for their cause in the first modern theoretical formulation of adolescence, lasting from the age of about thirteen until the early twenties, by the psychologist G. Stanley Hall. Hall—remembered today for bringing Sigmund Freud and C. G. Jung to lecture at Clark University in 1909—theorized adolescence as a distinct, extended, and precarious stage between childhood and adulthood. Though formulated for an academic audience, Hall's theories, disseminated in popular abridged editions, resonated with popular conceptions and cautionary literature on adolescence and were eagerly embraced by general readers.[38] Hall, like the BSA and

the YMCA, focused on middle-class youth as the most critical and promising social group through which to advance the development of Western culture, a project which would culminate by "ushering in the kingdom of the superman" so as to attain "the summits of human possibility."[39] His neo-Darwinian framework shifted attention to the middle class and away from "the undervitalized poor ... moribund sick, defectives and criminals, because by aiding them to survive it interferes with the process of wholesome natural selection by which all that is best has hitherto been developed."[40]

Hall explicitly raised the specter of feminization in his description of male adolescent development involving successive, stratified phases through which a boy would pass, including a "generalized or even feminized stage of psychic development" which the adult male must outgrow.[41] His views on feminization and social institutions, expressed in various articles including "Feminization in School and Home" of 1908, drew angry criticism from educators, but also won the support of New York governor Theodore Roosevelt, who praised "the sound common sense, decency and manliness in what you [Hall] advocate for the education of children."[42]

Both Roosevelt and Hall—the latter proceeding from the explicit assumption that ontogeny recapitulates phylogeny—conceived of adolescence as a critical stage through which the vitality of "the race" might be enhanced by encouraging the appropriate habits and virtues.[43]

This "race," for Hall as for Roosevelt, exhibited nationalistic as well as genetic components, referring to both Anglo-Saxon—sometimes Western European—ancestry and a unique, American mind-set. When Roosevelt advocated militarily supported expansionist policies in "The Strenuous Life," he asserted that the "stronger and more manful race" must prevail in any conflict between nations. That such manfulness of the race was founded upon the character of the individual Roosevelt made evident in his aphoristic statement, "as it is with the individual, so it is with the nation."[44]

Having recognized the need to manage adolescence, and bolstered by a tenable theoretical framework, boys' workers found further incentive for their mission in the nationalistic rhetoric of expansionism that followed the closing of the American frontier. F. J. Turner's 1893 address, "The Significance of the Frontier in American History," held that the unique national character of the American people was the product of their evolution in confronting the ever-present, though now bygone, frontier. In its place the city increasingly defined American social life at some peril to values established in the conquest of the frontier.[45] Echoing sentiments of the frontier thesis—its nostalgic acknowledgment of the passing of the untamed West and the consequent need for new kinds of frontiers to secure manliness—Daniel Carter Beard, an early BSA leader, argued:

The Wilderness is gone, the Buckskin Man is gone, the painted Indian has hit the trail over the Great Divide, the hardships and privations of pioneer life which did so much to develop sterling manhood are now but a legend in history, and we must depend upon the Boy Scout Movement to produce the MEN of the future.[46]

The Boy Scout movement, then, aimed to counteract the debilitating influences of women, the city, and modern life, taken to be the antithesis of the uniquely American experience of the frontier.

If the BSA was to fill the gap left by the demise of the American wilderness and the manly attributes instilled by the frontier, it was to do so in opposition to the excessive cosmopolitanism of Europe, an opposition implicit in the malediction "sissy" as in the images Rockwell would soon render.[47] Thus, James West, the first Chief Scout Executive of the BSA, wrote, "The REAL Boy Scout is not a 'sissy.' He is not a hothouse plant, like little Lord Fauntleroy."[48] In evoking Frances Hodgson Burnett's enormously popular 1886 novel, West placed the Boy Scout in opposition to the title character, who wears a lace-collared velvet suit and long hair, thereby casting the "sissy" as a distinctly feminized clotheshorse who, though he might succeed abroad by good manners and charm, hasn't the character of a real American boy.

Advice literature directed at middle-class mothers also recognized the connection between the figures of the sissy and Little Lord Fauntleroy in terms of their shared appearance. One such guide, implicitly intended for women as the dominant agents of child rearing in the family, cautioned that at the age when a boy departs the domestic sphere for school, "he desires above all other things to avoid the opprobrium of 'sissy' [and must not be dressed to] suggest a likeness to Lord Fauntleroy in his ruffles and long curls."[49]

The sissy, then, can be understood as a stigmatizing term, explicitly coercing conformity to normative masculine identities in terms of nationhood, middle-class unity, and gender. Frequently, but not exclusively, defined by dress, the sissy is a denigrated figure repeatedly deployed to differentiate the proper and acceptable from the degenerate and repulsive. Thus, the figure of Percy in the *St. Nicholas* illustration (Fig. 3) provides regular fellows with the occasion to define their own

Figure 4. Rockwell, *Real Boys!*, Black Cat advertisement, *Saturday Evening Post*, August 25, 1917, 60 (photo: reproduced courtesy of the Norman Rockwell Family Trust).

identity against that of a vaguely alien, rich, effeminate snob.

In counterpoint to the sissy, the *real* boy enjoyed ennobling praise. This rough and tumble "manly little man," as described in the copy of a Black Cat hosiery advertisement illustrated by Rockwell, possessed all the spunk and innate nobility of Roosevelt's "American boy," even under the watchful eye of a schoolmistress (Fig. 4). Like his clothes, he is emphatically "made-in-America," rejecting the characteristics of "the Little Lord Fauntleroys you read about in storybooks." This real boy—conventionally conceived strictly in terms of character and bodily fortitude—could equally exercise fashion sense and consumer savvy to effect his transition to manhood. This much is suggested by a clothing advertisement from the *Post*

Figure 5. Artist unknown, *Now He's a Man!*, Styleplus Clothes advertisement, *Saturday Evening Post*, September 14, 1918, 25.

depicting a youth in his first suit—master of the young pup he grasps effordessly in one hand—and headed, "Now he's a man!" (Fig. 5).[50]

Just as real boys might evolve into sissies under the undue influence of mothers and urban society, they might equally, according to the chief of the Scouts, age from "robust, manly, self-reliant boyhood into a lot of flat-chested cigarette-smokers, with shaky nerves and doubtful vitality"[51]—an apt description of the contrast between the admirably truant scamp and the gawking fop depicted in *"Tain't You,"* Rockwell's first cover for *Life* from 1917 (Fig. 6).[52]

In this image, an impish boy with an open box of chalks protruding from his pocket stands with his back to a knotted wood fence bearing the stick-figure likeness of a gentleman with hat, eyeglasses, cane, gloves, lit cigarette, and mustaches.[53] His recreant companion disappears around the fence, but he remains, smiling affably at a dismayed man who leans forward, heels slightly raised off the ground, in an attempt to make out the drawing. The boy, caught in the act of caricaturing the fussy airs of this gentleman, perhaps his schoolteacher, boldly denies the resemblance, declaring, in the words of the caption:

Figure 6. Rockwell, *'Tain't You, Life,* May 10, 1917, cover (photo: reproduced courtesy of the Norman Rockwell Family Trust).

"'Tain't you." But, of course, the chalk-scrawled inscription on the fence above the image, "MISS PERSEVAL," insists upon the contrary, and the lanky man answers the figure in the drawing down to the smoke curling from his cigarette.[54] But how do we account for him as *Miss?* Turning the pages of the mass-circulation weeklies in order to examine male dress provides some answers.

Clothing advertisements in the *Saturday Evening Post* of the late teens typically depicted tall, slim men with aquiline features dressed in suits finished with tapered waists, mid-width lapels, and cuffed trousers slightly exposing the ankle.[55] The advertising copy accompanying these images emphasized appropriate male dress as an initiation into adult manhood, a profoundly national expression, or a recognizable characteristic of masculinity. The attenuated figures of the illustrations bear little relation to the physical masculinity one might expect from the copy of, for instance, a notice for Brandegee-Kincaid Clothes offering "Manliness which avoids that effeminate look upon which American taste frowns" (Fig. 7). Measured against this visual standard, Perseval can hardly be faulted for his unimposing figure or for the range of his accessories, with the possible exception of the glasses that betray his weak eyes. But he does bungle his appropriation of contemporary fashion, with his "high-water" pants, the absurd turn of the hat band, the loose cut of his jacket, and the color medley including a pink hat brim, blue striped shirt, red tie, blue-green suit, and orange socks.[56] In his hyperurbanism, Perseval overshoots appropriate dress codes and reveals himself a fop. "The fop," a contemporary advocate of dandyism explained, "is a near relative of the fool and a pure dandy may never be that. … The fop lacks discrimination; he does not know when he has obtained his effect and continues blindly on till he has exposed all the machinery that might have mystified if properly manipulated."[57]

A distinction was also to be made between a legitimate masculine interest in sartorial matters and the effeminate implications of an overtly narcissistic investment in one's clothing. This distinction was expressed in retail clothing trade handbooks and self-teaching manuals circulated to train sales staff (it would not be until 1933 that male clothing consumers would have their own publication in the form of *Esquire).* One such manual identified the values sought by male customers as serviceability, comfort, style or fashion,

appearance ("a look of good quality"), a trade name, and becomingness.[58] "Talking points," techniques for addressing individual customers' concerns, treated the last value, becomingness, with circumspection.

The American Figure—
The American Taste—
The American Climate.

ALL three *must be studied* in designing clothes for Americans. All three *are* studied and perfected in

**Brandegee-Kincaid
Clothes**

1—Body-lines adapted to the American figure, neither slouchily loose nor ridiculously tight.

2—Manliness which avoids that effeminate look upon which American taste frowns.

3—Weights suited to the climatic conditions of U. S. A., eliminating needless bulk.

College Chap Clothes

is the name of our Young Men's *Clothes.* They have that smart metropolitan style in pattern and cut that Young America demands.

Brandegee-Kincaid Clothes

are probably sold in your town. If not, write us and we will send you the name of a dealer near you, together with a charming *Booklet of Styles* free, including a complete and authentic *Dress Guide* about what to wear and when to wear it—Free.

**Brandegee, Kincaid & Co.
Clothes**
New York Chicago
[illegible]

Figure 7. Artist unknown, Brandegee-Kincaid Clothes advertisement, *Saturday Evening Post,* April 22, 1916, 34.

As one expert salesman says, "Men are interested in whether or not a thing is becoming, but we don't use that word. We tell a man, 'This hat is good on you,' or 'This is better on you than that.' … Don't you believe it when men say they are not interested in getting becoming clothes. They are, but they don't use that word."[59]

Without clarifying why men might avoid "that word," the section concludes by implicitly relegating it to a feminine lexicon. Unable to confess a personal interest in his appearance with regard to clothing—in other words, its becomingness—the customer ascribes responsibility for it elsewhere: he "frequently says his wife or mother does not like a certain thing on him."[60] Advertisements for men's clothes, like the floorwalker or sales assistant of the department store and retail shop, emphasized the other talking points, leaving becomingness to the eye.

It may be that the stakes raised by becomingness included the customer's sexuality, just as an image of a narcissistic and effeminate clerk who ignores customers at his sales counter while he preens himself may lampoon the sexual orientation of men who take too much interest in their appearance (Fig. 8). The relationship between effeminacy and homosexuality in twentieth-century popular discourse, as well as in the medical and juridical literature, raises the question of same-sex desire. The problem is partly one of iconography and visual patois. What cross section of the Post's audience was equipped and prepared to read an image of an effeminate man as an image of a homosexual, and according to what visual cues? Would such a reading have been routine or willfully aberrant?

Well into the twentieth century, homosexuality was not conventionally understood in terms of object choice or even according to the act of sexually engaging a same-sex partner. Rather, the homosexual, or invert, was defined in terms of his feminine attributes, including the assumption of a "passive" role during intercourse and of effeminate mannerisms and dress. Masculine men might—and did—engage in same-sex liaisons, but were nonetheless considered "normal." In other words, sexual typing

Figure 8. Artist unknown, The Clerk *A Counter-Part*, postcard, 1910 (from Jonathan N. Katz, ed., *The Gay/ Lesbian Almanac,* New York, 1983, 315).

depended on adherence to gender conventions rather than sexual acts.[61]

The elusiveness of changing iconographic codes of homosexuality in particular presents an obstacle to a queer reading of "*'Tain't You.'"* Notwithstanding occasional, explicit statements of such cues—as when sex-researcher Have-lock Ellis reported anecdotal evidence of the homosexual's preference for the color green[62]—the pointers are largely ephemeral, and much research remains to be done in the period around World War I.[63] It is possible, if not probable, that *Miss* Perseval could have been read by Rockwell, his editor, George Horace Lorimer, and the larger part of the *Post's* audience as a homosexual. If so, it redoubles the efficacy of clothing to make manly (heterosexual) men.

The opening text of the Brandegee-Kincaid advertisement declares, *"The American Figure— / The American Taste— / The American Climate. / All three must he studied in designing clothes for Americans,"* thereby forging a link between this reedy figure and Americanness and dress sense (Fig.

Figure 9. F. Foster Lincoln, *Men of Independence …,* The Royal Tailors advertisement, *Saturday Evening Post,* July 10, 1920, 130–31.

Figure 10. W. F. Barclay, *The Conservation of Energy and the Transmission of Power,* Goodyearite advertisement, *Saturday Evening Post,* July 28, 1917, 34.

7). Nonchalantly swinging a cane in one hand while fingering a cigarette in the other, this exaggeratedly slim figure embodies manliness. As such this image of the middle-class American at leisure represents an alternative ideal not addressed in dominant accounts of masculinity, which frame it in terms of the cult of physicality and the canonical, hardened body. This alternative ideal is also evident in an advertisement that reworks John Trumbull's *Declaration of Independence* so that the assembled members of the Continental Congress, depicted in a moment of pervasive quiescence, assume self-conscious poses to display their twentieth-century attire. The advertisement overdetermines—both visually and textually— the disavowal of the European and aristocratic connotations of the company's name, The Royal Tailors (Fig. 9). Beyond

Figure 11. Artist unknown, *Power,* Continental Motors advertisement, *Saturday Evening Post,* August 7, 1920, 106

Figure 12. Artist unknown, *Those Copper Gaskets Are Asbestos-Cushioned,* Champion Spark Plugs advertisement, *Saturday Evening Post,* June 10, 1916, 74.

rejecting Old World connections, the extensive text posits a link between a natural American temperament, with its inclination toward freedom of choice and self-expression moderated by monetary prudence, and dress sense.[64]

Indeed, the virtue of corporal strength did not necessarily accord with middle-class subjectivity and, in the *Post,* generally coincided instead with the working-class body. Thus, in advertisements for industrial belting, the internal combustion engine, and spark plugs, square-jawed, brawny, and shirtless men wield tools and operate machinery, but enjoy no relation to manliness per se (Figs. 10–12). The bare-chested workers as symbols of pliable force, like the machines they run, possess no agency. Although these advertisements depicting male bodies of great physical strength repeatedly evoke power, the men themselves lack any autonomous jurisdiction. In each image these hulking, somnambulist bodies—it is easy to speak of such generalized figures as bodies rather than men—perform the bidding of an invisible authority that choreographs their movements.

Historically, the Continental Motors advertisement (Fig. 11) claims, the drudgery sustained by the human body "stood in the way of human progress." As in the work gang vainly flailing sledgehammers at a mammoth spark plug (Fig. 12), these advertisements depict the bodily strength of labor as regressive, even antimodern. Regardless of the variation on the theme of the laboring body, the peculiar trope that strips the body of its clothing prevails. Within the bounds of modesty, these images literally divest the working-class figure and the foreign laborer. The outlander and the worker whether exoticized, eroticized, or classicized merely feature the effective power of the machine, fetishized as a symbol of modernity.[65] Manliness lies elsewhere.

A final illustration by Rockwell, for boys' apparel, locates a ground between, on the one hand, the jeers of the baseball players in *Boy with Baby Carriage* and the satirizing chalk drawing of Miss Perseval, and, on the other hand, the masculinity of the *Saturday Evening Post* clothing advertisements. In *It's a "Best-Ever" Suit—YBetcha!* a jaunty boy with tousled hair proudly displays the name-brand label inside his new jacket (Fig. 13). Despite his handsome attire, he is no sissy himself; for behind him to his left stands

a skinny boy in a bowler and un-fashionable outfit who gazes at the suit with positive adoration—the real sissy who covets becomingness too assiduously. But neither is the young consumer an unbending adherent of the cult of physicality, for that ideal is embodied in an equally admiring boy wearing a baseball uniform. Even the dog faithfully esteems the boy's masculine ability to determine quality, style, value, and appearance without degenerating into effeminacy. In *It's a "Best-Ever" Suit—VBetcha!* the precise locus of masculinity is neither physical prowess nor personal discrimination. Rather, masculine attributes in this image obtain under the aegis, candidly exposed, of the manufacturer's label. Manliness here does not reside in or on the body, but is purchased and applied to it under the sign of the brand name.

Figure 13. Rockwell, *It's a "Best-Ever" Suit—VBetcha!*, Best Clothing advertisement (photo: reproduced courtesy of the Norman Rockwell Family Trust).

NOTES

1. Clement Greenberg, "Avant-Garde and Kitsch," *Partisan Review,* VT, no. 5, Fall 1939, 43.

2. As evidence of this popular association of the illustrator and the magazine, a 1945 profile article on the *Saturday Evening Post's* art editor discussed changes wrought under his direction. Noting a new policy of repudiating "bargain basement imitations of Norman Rockwell …, though not Norman, praise be!" the author observed, "everyone, it seems, thought a *Post* cover had to be a *'Post'* cover" and "Rockwell had set the pace"; Ernest W. Watson, "What's Going On at the *Post:* An Interview with Kenneth Stuart," *American Artist,* ix, no. 7, 1945, 13.

3. Here, I am in agreement with Greenberg (as in n. 1), 34, to the extent that he gainsays the sufficiency of an "investigation into aesthetics" even while invoking in his first lines a qualitative dichotomy to distinguish T. S. Eliot and Braque—European high art—from Tin Pan Alley and the *Saturday Evening Post*—American popular culture. Some pages later, in the passage cited in the epigraph above, Greenberg confirms the metonymie exchange between Rockwell and the *Post,* and dismisses both as kitsch.

4. The war did not significantly shift the terms of masculinity, largely because of the continuity in social developments from the period after Reconstruction through the second decade of the 20th century. Theodore Roosevelt's influential framing of masculinity as bodily fortitude itself owed much to the expansionist and jingoistic rhetoric surrounding the Spanish-American War of 1898. Certainly, images of uniformed soldiers performing honorable duties or strutting arm in arm with attractive civilian women circulated widely, but these only confirmed the existing terms of corporal masculinity. In fact, the war had less of an impact upon some social patterns bearing on masculinity than might be supposed. For instance, although certain feminists advanced lofty claims during the war that "at last, after centuries of disabilities and discrimination, women are coming into the labor and festival of life on equal terms with men" (unnamed female orator, 1917, cited in David M. Kennedy, *Over Here: The First World War and American Society,* New York, 1980, 285), this hyperbole amounted to wishful thinking. Although upward of a million women undertook work during the war, few did so for the first time, resulting in only a negligible net increase of women in the labor force. True, for the period ending in 1919, women did move into jobs previously closed to them, but by 1920 (the same year in which the Nineteenth Amendment was adopted) they made up a smaller percentage of the labor force than they had in 1910. And while activities other than salaried work had the potential to bring women into the public sphere in a manner that might challenge established norms, these too seem to have been limited to traditional middle-class roles, as in the volunteerism promoted in 1917 by the Women's Committee of the Council of National Defense. What is more, this and other organizations drained women from the suffrage movement (Kennedy, 286).

5. Rockwell, 1961, 15.

6. Rockwell featured mostly youths on 90 percent of his *Post* covers from 1916 to a 1919 and on 50 percent of those covers from 1920 to 1929; Rockwell, 1970, 55, 78.

7. For biographical information, see Rockwell, 1988; Donald Walton, *A Rockwell Portrait,* Kansas City, 1978; and Susan E. Meyer, *Norman Rockwell's People,* New York, 1981.

8. Rockwell, 1988, 106. Rockwell quickly achieved celebrity status as an illustrator, even earning himself an invitation in 1922 to serve as a judge of the secondiannual Miss America Beauty Contest (ibid., 175). By 1930 his status was sluch that the society pages tracked his divorce, second engagement, and remarriage: see *New York Times,* Jan. 14, 1930, 19; Mar. 30, 1930, 31; and Apr. 18, 1930, 22, and Apr. 19, 1930, 20, respectively.

9. Frank L. Mott, "The Saturday Evening Post," in *A History of American Magazines,* [v, Cambridge, Mass., 1957, 694. In 1898 H. K. Curtis, then publisher of *Ladies Home Journal,* purchased the *Post* in order to "assert his masculinity*" in the magazine field and "to publish a magazine for men," according to later publicists. The *Post* continued as a men's magazine, but by the 1920s found that its audience included a significant number of women (over 50 percent by the 1940s). Still, "The editors never sewed frills on the magazine,"! though it eventually assumed the identity of a family magazine. See Anonymous, *A Short History of the Saturday Evening Post,* Philadelphia, 1949, 14. George Horace Lorimer, the *Post* editor who first hired Rockwell, guided the magazine's keen interest in business, which it touted in profiles romanticizing the meteoric rise of young entrepreneurs and captains of industry. While occasionally opening its pages to progressive voices, the *Post's* fundamentally conservative views were pro-business, combative toward government intervention in free enterprise, antilabor, and anti-immigration. See

Mott, 702–8; James Playsted Wood, *Magazines in the United States,* New York, 1956, 158–59; and Jan Cohn, *Creating America: George Horace Lorimer and the Saturday Eventng Post,* Pittsburgh, 1989.

10. Baseball—particular to the United States at the time—and other team sports attracted both working- and middle-class boys, but were not open to women and girls, unlike croquet and cycling in the 19th century. Formalized by the businessmen of New York's Knickerbocker Club in 1845 and widely popular by 1860, the sport was securely professionalized by the formation of the National (1876) and American (1901) leagues. In the late 19th century, adults standardized baseball for youths through college and league programs that established rules and diminished regional variations. See E. Anthony Rotundo, "Boy Culture: Middle-Class Boyhood in Nineteenth-Century America," in *Meanings for Manhood,* ed. Mark C. Carnes and Clyde Griffen, Chicago/London, 1990, 34-35.

11. The cover of the *Saturday Evening Post* bore this blank white ground as a matter of course until the 1940s.

12. Lillian Eichler, *Book of Etiquette,* New York, 1923, 1, 256.

13. Thomas S. Buechner, "A Matter of Opinion," in Rockwell, 1961, 127. Buechner's works on Rockwell include the text for Rockwell, 1970; and *Norman Rockwell: A Sixty Year Retrospective,* exh. cat.. Fort Lauderdale Museum of the Arts, New York, 1972.

14. Rockwell responded to such criticism by explaining that, as an illustrator, he was subject to the demands of editor and audience. In fact, Rockwell pointed out that he did take up "the racial thing for awhile. But that's deadly now—nobody wants it"; quoted in Richard Reeves, "Norman Rockwell Is Exactly Like a Norman Rockwell," *New York Times Magazine,* Feb. 28, 1971, 42.

15. Buechner, quoted in ibid., 15; and ibid.

16. For a notable exception, see Michele H. Bogart, *Artists, Advertising, and the Borders of Art,* Chicago/London, 1995, intro., 72–78. See also Melissa Dabakis, "Gendered Labor: Norman Rockwell's *Rosie the Riveter* and the Discourses of Wartime Womanhood," in Barbara Melosh, ed., *Gender and American History since 1890,* London/New York, 1993, 182–204. Although Buechner, 1972 (as in n. 13), 9, referred to a "Rockwell reappraisal" following a 1968 one-man show at Bernard Danenberg Galleries, New York, of the artist's original oil paintings for illustrations, no body of scholarly literature has emerged to complement the popular press's exuberant production of coffee-table books. As an anecdotal indication of the general lack of scholarly interest in Rockwell, note that a session proposed by Michele Bogart on the centenary of Rockwell's birth for the 1994 American Studies Conference foundered for lack of submissions. For some scholarly discussions of Rockwell's work, see Lester C. Olson, "Portraits in Praise of a People: A Rhetorical Analysis of Norman Rockwell's Icons in Franklin D. Roosevelt's 'Four Freedoms' Campaign," *Quarterly Journal of Speech,* LXIX, 1983, 15–24; John Atherton, "On *The Official Boy Scout Handbook,"* *Revue Française d'Etudes Améncatnes,* XII, no. 32, 1987, 281–95; Gregg De Young, "Norman Rockwell and American Attitudes toward Technology" *Journal of American Culture,* XIII, no. 1, 1990,: 95–103; Richard Brilliant, *Portraiture,* London, 1991, 159–61; Carter Ratclitf, "Barnett Newman: Citizen of the Infinitely Large Small Republic" *Art m America,* LXXV, no. 9, 1991, 92–97, 146–47; Robert B. Westbrook, "Fighting for the American Family: Private Interests and Political Obligations in World War II," in *The Power of Culture: Critical Essays in American History,* ed. Richard Wightman Fox and T. J. Jackson Lears, Chicago, 1993, 195–211; and C. E. Brookeman, "Norman Rockwell and the *Saturday Evening Post:* Advertising, Iconography and Mass Production, 1897–1929," in *Art Apart: Art*

Institutions and Ideology across England and North America, ed. Marcia Pointon, Manchester/New York, 1994, 142–74. There have been no critical book-length works on Rockwell. For a comprehensive, if incomplete, overview of his works, see Laurie Norton Moffatt, *Norman Rockwell: A Definitive Catalogue,* Stockbridge, Mass., 1986, 2 vols.

17. Buechner, 1961 (as in n. 13), 127; and Manuel Gasser, "Norman Rockwell," *Grapkis: International Journal for Graphic and Applied Art,* xn, no. 65, 1956, 21¡0, respectively. Although, the pink ribbon adorning the bonnet might seem to indicate a female, infants and young children at the time, regardless of sex, tended to be dressed in similar outfits (see n. 18). In fact, one training guide for retail salespeople, Natalie Kneeland, *Infants' and Children's Wear,* Chicago/New York, 1925, 88, explained: "Whether the child is a boy or a girl *sometimes* determines the color the mother will choose. For infants, pink is used for boys, blue for girls, but when the boy becomes older, blues and tans are preferred" (emphasis added). That not all parties were pleased when these mothers extended a preference for pink to their older boys is indicated by the entry for pink in W. H. Baker, *A Dictionary of Men's Wear,* Cleveland, 1908, 187:"Pink—a color not to be worn by boy babies."

18. At the turn of the century both boys and girls under the age of six typically wore long curls and similar loose-fitting gowns that did little to distinguish gender. These fashions, popularly assumed to be imposed by mothers who ruled the domestic realm, were not in fact ungendered, but coincided with feminine codes. When boys reached the age where they could attend school and play outside the home, their hair was shorn and they were permitted to wear short pants or knickers. See Rotundo (as in n. 10), 16. See also Rockwell's *Post* cover of Aug. 10, 1918, depicting a barber cutting the long curls of a gleeful boy wearing a pink-striped smock while a tearful mother looks on (Rockwell, 1970, fig. 109); and photograph of Rockwell, age two, wearing a dress and curls (Rockwell, 1961, 14).

19. The contemporary examples of Chaplin and O'Keefe date from 1916 through the 1930s and the late teens on, respectively. Magritte's images with bowlers are later, beginning in the mid-1920s.

20. See Fred Miller Robinson, *The Man in the Bowler Hat: His History and Iconography,* Chapel Hill, N.C., 1993, although this work deals primarily with the bowler in a Western European context.

21. Theodore Roosevelt, *The Strenuous Life: Essays and Addresses* (1900), New York, 1910, first appeared in the same year as Roosevelt's editorial in *St. Nicholas* entitled "What We Can Expect of the American Boy" (May 1900). The latter was reverently reprinted following his death in Feb. 1919; see Theodore Roosevelt, "What We Can Expect of the American Boy," *St. Nickolas,* XLVI, 1919, 423–27.

22. Moffatt (as in n. 16), I, 75, gives the title as *Two Men Courting Girl's Favor,* an apparent misnomer in view of the youth of the figures. *Shall We Dance?* is preferred by the copyright holder.

23. Rockwell, 1961, 23.

24. Ralph Graham, "Making Good in Boys' Camp," Si. *Nicholas,* XLIV, 1917, 839–40.

25. H. L. Mencken, *The American Language,* New York, 1936, 518. Mencken cites a note submitted by Howard F. Barker to *American Speech,* III, Apr. 1928, 347, who in turn refers to a *Christian Science Monitor* profile of one Captain Cochrane, claimed to be "the only man afloat in the coast guard who could afford to admit the name of *Claude"* (emphasis in original). Barker concludes by asking, "Could he have borne up so well under the name of 'Percy'?" Both names, so the author implied, could undercut the manhood of even a seaman.

26. Rockwell, 1988,21.

27. Ibid.

28. E. Anthony Rotundo, "Body and Soul: Changing Ideals of American Middle-Class Manhood, 1770-1920," *Journal of Social History,* xvil, 1983, 23–27.

29. Critics of boys' education took note that while in 1879 59 percent of teachers were women, in 1920 the percentage had risen to 86; see Macleod, 48–49.

30. Hantover, 186–87.

31. Henry Cabot Lodge, *Early Memories,* New York, 1913, 72, quoted in Macleod, 48.

32. Luther Gulick, "Studies of Adolescent Boyhood," *Association Boys,* I, 1902, 149-50, cited in Macleod, 49.

33. George M. Beard, *American Nervousness,* New York, 1881, 98, cited in Macleod, 49. Medical journals reported approximately equal numbers of cases of neurasthenia in men and women between 1870 and 1910; see F. G. Gosling, *Before Freud: Neurasthenia and the American Medical Community, 1870-1910,* Urbana, Ill./Chicago, a 1987 ,97.

34. Macleod, xii, 112–13.

35. "Do not so generally or publicly advertise ... that the rougher element shall be attracted; rather make [your meeting] known by personal effort among the better class of boys"; John D. Chambers, "Boys' Work," *Watchman,* XHi, 1884, 141, quoted in Macleod, 77. Macleod, 75, 217-18, also notes that some YMCAs had fees that were prohibitive for the lower classes.

36. Macleod, 3.

37. The Boy Scouts, founded in 1910, enrolled 361,000 boys and 32,000 scoutmasters by 1919. Junior membership in the YMCA grew from 30,675 in 1900 to 219,376 in 1921. See Macleod, xi, 120.

38. See Ross, xiv, 337, 333. Atherton (as in n. 16), 282, mentions Hall in his discussion of Rockwell illustrations for Boy Scout calendars. On Hall in relation to youth movements, see Macleod; and David Macleod, "Act Your Age: Boyhood, Adolescence, and the Rise of the Boy Scouts of America," *Journal of Social History,* xiv, no. 2, 1982, 3–20.

39. Hall, quoted in Ross, 318–19.

40. Ibid., 318.

41. Ibid., 339.

42. Ross, 317–18; Roosevelt, quoted in ibid., 318, n. 18, from a letter to Hall dated Nov. 29, 1899.

43. Ross, 332–33.

44. Roosevelt, "The Strenuous life," in Roosevelt, 1910 (as in n. 21), 18, 6.

45. For a discussion of concerns shared by Turner and Roosevelt about the course of American civilization and how these shaped the Scouting ideal, see David E. Shi, "Ernest Thompson Seton and the Boy Scouts: A Moral Equivalent of War?" *South Atlantic Quarterly,* Lxxxrv, no. 4, 1985, 380-81. See Roosevelt, 1919 (as in n. 21), 423—24, for his paean to the character-building qualities of "the prairie and the backwoods and the rugged farms" as compared to the degenerate influences of "big Eastern cities."

46. Boy Scouts of America, fourth annual report, *Scouting,* I, 1914, 109, quoted in Hantover, 189.

47. F. A. Crosby, "Boy Scouting—What It Really Is," *The World To-Day,* xx, 1911, 221, cited in Shi (as in n. 45), 379.

48. James West, "The Real Boy Scout," *Leslie's Weekly,* 1912, 448, cited in Hantover, 191. "Sissy" gained its sense of an effeminate man or boy between 1885 and 1890, coinciding with the virtual invasion of

America by Litde Lord Fauntleroy, who according to one observer was "an impossible kid that started a clothes cult"; see Baker (as in n. 17), 150.

49. Margaret Story, *Individuality and Clothes,* New York/London, 1930, 65–66.

50. The advertisement copy extols a young man's preference for clothes of manly style, high quality, and good value, but also invokes his "war-time duty to spend wisely." Although advertisements for goods from clothing to automobiles praised the sparing and judicious use of resources, such thriftiness was already framed in peacetime as a masculine quality to be cultivated by male consumers.

51. E. T. Seton, *Boy Scouts of America: A Handbook of Woodcraft, Scouting, and Life Craft,* 1910, xi, quoted in Hantover, 189.

52. When *Life* published Rockwell's illustration, the magazine enjoyed a circulation second only to that of the *Post.* Founded in 1883, *Life* was published in New York as a humorous weekly until 1936, when its name was purchased by Time Inc. under Henry Luce and moved to Chicago, where it was introduced as a pictorial magazine.

53. The chalk portrait is signed with the slightly obscured initials "BP," referring to the model, Billy Paine, who posed for this figure as well as all three of the boys in *Boy with Baby Carriage* (Fig. 1). Rockwell frequently played with identities by inserting in his pictures textual references to himself and/ or his models.

54. Mary Laing, personal correspondence, June 27, 1996, calls attention to the gap between the M and the iss, suggesting that the iss may have been added hurriedly. To my eye, this gap, like a virgule, reprises the ambiguity of gender in the image of the adult (he Misses the mark) and reflects a demand for a normative either/or binary conception of sex.

55. Reportedly, spats were virtually universal before 1910 when low-ankled shoes replaced them, making socks prominent. Thereafter socks were manufactured in lighter weights and brighter hues. The knut, a suburban incarnation of the fop before 1914, was distinguished especially by his bright socks. See James Laver, *Dandies,* London, 1968, 109.

56. See Baker (as in note 17), 131: "High-water—a derisiv *[sk]* term for trousers too short for the wearer."

57. Neil Stack, *Some Phases of Dandyism,* New York, 1924, 104–5.

58. Fredonia Jane *Ringo, Men's and Boys'Clothing and Furnishings,* Merchandise Manuals for Retail Salespeople, Chicago/New York, 1925, 10.

59. Ibid., 12, 14–15.

60. Ibid., 15.

61. George Chauncey, Jr., "Christian Brotherhood or Sexual Perversion? Homosexual Identities and the Construction of Sexual Boundaries in the World War One Era," *Journal of Social History,* xrx, no. 1, 1985, 189–211.

62. Havelock Ellis, *Sexual Inversion,* 3d ed., Philadelphia, 1921,126; Euis's examples are drawn from European rather than American contexts. See also Chauncey's reference to certain visual cues of homosexuality, in- cluding red ties, to support his thesis that "gay men were highly visible figures in early-twentieth-century New York"; George Chauncey, Gay *New York: Gender, Urban Culture, and the Making of the Gay Male World, 1890–1940,* New York, 1994, 3.

63. For a comprehensive view of homosexual life in an eastern metropolis, see Chauncey (as in n. 62). Chauncey reproduces images of homosexual men from the popular press, especially *Broadway Brevities,* but

these date only as early as the 1930s. See also Jonathan Katz, ed., *Gay/Lesbian Almanac,* New York, 1983, which reproduces postcards from the 1910s depicting effeminate, if not homosexual, men (Fig. 8). For a discussion of contemporary, private art images featuring men in the context of same-sex erotic situations, see Jonathan Weinberg, *Speaking for Vice: Homosexuality in the Art of Charles Demuth, Marsden Hartley, and the American First Avant-Garde.* New Haven, 1993.

64. A body of literature directed to women, including home economics books and journals as well as sewing guides, forged similar links between fashion and national identity although these rarely address men and their clothing. *The Journal of Home Economics* in particular rejected Paris in favor of a patriotic, native preference for fashions that served hygiene, modesty, and economy. See esp. Ethelwyn Miller, "Americanism the Spirit of Costume Design," *Journal of Home Economics,* x, no. 5, 1918, 207–11; Ethel Ronzone, "Standardized Dress," *Journal of Home Economics,* x, no. 9, 1918, 426–28; and Marion Weller, "The Clothing Situation," *(1892—1894)," in Melosh, ed. (as in n. 16), 207-39.* x, no. 9, 1918, 401–8.

65. For a discussion of race and masculinity in the United States in the late 19th century, see Gail Bederman, "Civilization, the Decline of Middle-Class Manliness, and Ida B. Wells's Anti-Lynching Campaign (1892–1894)," in Melosh, ed. (as in n. 16), 207–39.

FREQUENTLY CITED SOURCES

Hantover, Jeffrey P., "The Boy Scouts and the Validation of Masculinity," *Journal of Social Issues,* xxxiv, no. 1, 1978, 184–95.

Macleod, David, *Building Character in the American Boy: The Boy Scouts, YMCA, and Their Forerunners, 1870–1920,* Madison, Wis., 1983.

Rockwell, Norman, 1961, *The Norman Rockwell Album,* Garden City, N.Y.

, 1970, *Norman Rockwell: Artist and illustrator,* New York.

_____ , 1988, as told to Tom Rockwell, *My Adventures as an Illustrator* (1960), New York.

Ross, Dorothy, *G. Stanley Hall: The Psychologist as Prophet,* Chicago/London, 1972.

ACKNOWLEDGMENTS

I would like to express my gratitude to Cécile Whiting, who read and commented on numerous versions of this essay, and to Albert Boime, Marie Clifford, and Donald Preziosi for stimulating feedback on earlier drafts. Melissa L. Hyde offered editorial and substantive advice throughout. The extensive critical suggestions of *the Art Bulletin* editor and three anonymous readers challenged me to rethink this essay at several points. The Jacob K. Javits Fellowship, now being phased out owing to congressional and executive attacks on funding for higher education, provided financial support. The photographs, all from printed sources, are mine.

Eric J. Segal is a doctoral candidate in the history of American art at the University of California, Los Angeles [Department of Art History, University of California, Los Angeles, Calif. 90024].

Constructions of Gender in Sport: An Analysis of Intercollegiate Media Guide Cover Photographs

Jo Ann M. Buysse and Melissa Sheridan Embser-Herbert

Within the arena of sport, as throughout society, traditional definitions of femininity and masculinity have established and maintained gender differentiation. The authors' research examines this pattern in intercollegiate athletics by analyzing National Collegiate Athletic Association media guide cover photographs. They find gender differentiation in the depiction of women and men athletes. For example, women athletes are less likely to be portrayed as active participants in sport and more likely to be portrayed in passive and traditionally feminine poses. These differences changed little between 1990 and 1997. The findings suggest that while one might expect less gender stereotyping from the teams themselves, the gendered images produced by intercollegiate athletic programs vary little from those produced by the popular press.

Keywords: *gender; sport; intercollegiate athletics; media; femininity*

There is little dispute about the assertion that the mass media play a significant role in the transmission of dominant cultural values, especially in the perpetuation of images of gender difference and gender inequality. Certainly, the media are key to

Jo Ann M. Buysse and Melissa Sheridan Embser-Herbert, "Constructions of Gender in Sport: An Analysis of Intercollegiate Media Guide Cover Photographs," from *Gender and Society*, Vol. 18, No. 1; February 2004, pp. 66–81. Copyright © 2004 by Sage Publications. Permission to reprint granted by the publisher.

the perpetuation of these values through the world of sport. Given that both the media and sport construct and utilize gender stereotypes to maintain gender inequality, it is important to examine the ways in which these two powerful institutions interact with one another.

While numerous studies have investigated the portrayal of female athletes in popular sports magazines, newspapers, or television (Bryant 1980; Duncan and Hasbrook 1988; Kane 1996; Salwen and Wood 1994), to our knowledge, none have examined the materials produced by the sport organizations themselves. Our research fills this gap by examining the constructions of gender difference and hierarchy as reflected in media guide cover photographs for intercollegiate sports. In addition, given the increasing participation of girls and women in sport, we test to see if images of women and men have become more balanced through the 1990s. Drawing on data from two different time periods has allowed us to conduct such a longitudinal analysis.

BACKGROUND

National Collegiate Athletic Association (NCAA) Division I intercollegiate media guides are representative of a powerful, highly prestigious, and influential sector of organized sport participation. They are the primary means by which colleges and universities market their athletic teams to the press, advertisers, and corporate sponsors as well as alumni, donors, and other campus and community members who read them. Unlike many game programs, the media guides tend to be thicker, slicker portrayals of the images the institution wishes to present about itself and its athletes.

The photographs, particularly the cover photographs, carry meanings that are significant to the social construction of ideology and reflect the values and goals of the producer. Each media guide cover attempts to portray an image with which the reader can identify—often, an image consistent with traditional notions of femininity/ masculinity. Thus, the specific messages in the photographs become significant in the analysis of the media presentation of women and men athletes (Duncan 1990). We analyze the cover photograph for each guide because of the prominent role that any cover art plays in conveying a carefully chosen message to the reader.

The way an institution chooses to present itself via the media guide communicates a wealth of information about attitudes of the institution toward women and men in sport and about contemporary attitudes toward gender and sport in general. Although some might question the impact of a publication that does not typically receive mass distribution to the public, we argue that the press and advertisers serve as highly critical conduits for these images and the messages that they convey. In addition, these attitudes are consumed not only by those who receive the guides directly and use the guides to cover the competition, design the advertising, and otherwise convey messages about the institution's athletic programs, but they are also used by the secondary consumer of the information that these people and organizations create.

For these reasons, we believe that intercollegiate media guides provide a window into the world of intercollegiate sport and reveal the way in which the media and sport collude,

intentionally or not, to present messages about gender and sport. Through this research, we aim to determine the degree to which gender stereotyping exists in these publications. Does the gendered nature of the sport matter? Does the gender of the player(s) matter? And most important, to what degree might changes have occurred from 1990 to 1997, a period during which participation in women's intercollegiate sports continued to increase markedly? A number of significant changes also occurred outside of intercollegiate sport during this time, including an 11 percent increase in the number of women participating in the Summer Olympic games (from 23 percent in 1988 to 34 percent in 1996), the growth and development of two professional basketball leagues (the WNBA and the now-defunct ABL), and a continued increase in the number of women participating in high school and intercollegiate sport.

Research has documented the degree to which popular media coverage of sport contributes to and reinforces gender stereotypes that perpetuate male superiority and female inferiority in sport (Duncan 1990; Kane 1988, 1996; Kane and Parks 1992; Salwen and Wood 1994). This research has not, to our knowledge, addressed the media images created by the sport organizations themselves. Male athletes are portrayed by the popular media in terms of their physicality, muscularity, and superiority, while female athletes are feminized and their achievements as athletes are often trivialized. During the 1996 Olympics, where much attention was paid to women's participation, the emphasis was frequently on how well women could perform and still be feminine off the field. This remained true as recently as 1999 in the coverage of the U.S. Women's Soccer Team and their participation in the 1999 World Cup. The coverage was broad, but the focus was often on their appearance and families as much as it was on their performance. Despite dramatic gains in women's opportunities and participation since the passage of Title IX in 1972, women athletes continue to be underrepresented and trivialized by the popular media while men have been highly visible and glorified (Bryant 1980; Duncan and Hasbrook 1988; Duncan and Sayaovong 1990; Kane 1988, 1996; Messner, Duncan, and Wachs 1996; Nelson 1994; Shivlett and Réveile 1994; Tuggle 1997).

The issue of difference is highlighted by the fact that in media coverage, girls and women may be athletes, but they are female first. The physical attractiveness of these athletes is often emphasized over their athletic abilities. While the media have increased their coverage of women's sports events, the coverage continues to promote women athletes as different or other than men (e.g., "The Women's Final Four" vs. "The Final Four" and the "WNBA" vs. the "NBA"). The media also present the women athletes as less than the men athletes. Gender hierarchy is often expressed in the media by the fact that the best men athletes are rarely beaten by the best women athletes. The reality of women athletes as strong, skilled, competent competitors is masked by media representations that depict them as good enough to compete against other women but never as good as the top men in the same sport. As recently as 2002, John McEnroe raised a furor when he asserted that he, an aging tennis star, could probably beat either of the Williams sisters, the current stars of women's professional tennis. This strategy, comparing women's athletic competence with men's athletic achievements, serves to maintain male superiority and control in sport

(Kane 1996). Both gender difference and gender hierarchy are perpetuated in sport and are contributing elements to male hegemony in the larger social structure.

The importance of the mass media as a shaper and reflector of attitudes, values, and knowledge in modern society is well documented. As one of the most powerful institutional forces in modern society, radio, television, newspapers, books, movies, and magazines have become major vehicles for transmitting the social heritage of our society from generation to generation (Betterton 1987; Boutilier and SanGiovanni 1983; Lasswell 1948; Wenner 1989). Because of this influence, an examination of the media is important because, as Betterton (1987) argued, the media contribute to the ways in which we come to know and understand gender relations. At the same time, through its many forms, it also creates and emphasizes images of gender difference. In this study of media and sport, we did not utilize formal hypotheses. Rather, we took an exploratory approach in which we were interested in determining the content of current media portrayals of women and men in intercollegiate athletics.

DATA AND METHOD

The research presented here is drawn from two periods of time, the 1989–1990 (hereafter 1990) and 1996–1997 (hereafter 1997) academic years. In 1990, the data consisted of 307 NCAA Division I media guide cover photographs representing female and male sports teams in basketball, golf, gymnastics, tennis, and softball/baseball (Buysse 1992). The replication, in 1997, consisted of 314 media guide covers for the same sports. The difference in sample size is due to a slightly different response rate. It is also important to note that not all schools sponsored all of the sports under investigation (especially men's gymnastics).

The sports selected for this investigation were guided by previous research on the degree to which sports are viewed as appropriate for women, for men, or for both (Buysse 1992; Kane and Snyder 1989; Metheny 1965). For example, gymnastics, which requires movements that are aesthetically pleasing and fit within traditional notions of femininity, was considered to be appropriate for women, while basketball, which emphasizes strength and physicality, was considered to be appropriate for men. Notions of gender appropriateness in sport serve as the foundation for attitudes about how athletes should be portrayed in media. The sports included in our research were chosen to represent a range of typically male (basketball, baseball/softball), female (gymnastics), and gender-neutral (golf, tennis) sports.

We examined the cover photographs of the media guides with a focus on the following four general questions: (1) Are athletes portrayed on or off the court? (2) Are they pictured in or out of uniform? (3) Are they portrayed in active or passive positions or poses? and (4) What is the theme of the cover photograph? We coded each cover for nine possible themes: (1) "True athleticism" was defined as being present when an athlete or athletes were on court, in uniform, and in action, while (2) "posed athleticism" was represented by athletes in uniform but in nonaction poses. (3) "Femininity" was identified by traditional feminine roles, appearances, and/or fashion, typically dresses, styled hair, and visible makeup, while (4) "masculinity" was identified by traditional masculine roles, appearances, and/or fashion. (5) "Sexual

suggestiveness" included any sexually provocative pose, theme, and/or fashion (e.g., skimpy outfits, cheesecake poses, and "come-on" expressions). (6) "Student-athletes" are those who held textbooks, were in an academic setting, and/or were portrayed studying. (7) The inclusion of movies and/or songs from North American pop culture was coded as "pop culture." (8) We coded the use or presence of "sport equipment" and finally a residual (9) "other" category for themes not captured by the previous codings. These themes were developed by the first author during the initial phase of research and were based on existing scholarship as well as on her familiarity with intercollegiate athletics (Buysse 1992).

The media guides were solicited from six conferences within the NCAA based on their power and prestige and thus their influence in U.S. culture. The selected conferences are the Big Ten, Big Eight, Pacific Athletic Conference, Atlantic Coast Conference, Southwest Athletic Conference, and Southeast Athletic Conference. These conferences also represented the geographical regions of the Northern, Southern, Western, Eastern, and Central United States. These six conferences are composed of 54 NCAA Division I colleges and universities. A letter soliciting media guides was sent to every sports information director for each of these 54 universities. Follow-up letters and e-mails were sent and phone calls were made to achieve a higher response rate. In 1990, the response rate was 72 percent; in 1997, the response rate was 74 percent.

Each media guide cover photograph was coded for each measure by two independent raters. In 1990, interrater reliability was 98.8 percent, and in 1997, it was 98.0 percent. When disagreement existed (2 percent of the covers), coders discussed the area of concern until consensus was reached. Using SPSS/PC, data were analyzed with cross-tabulation/chi-square analyses.

In the following section, we provide the results of our analysis of research questions 1 through 3, beginning with the relationship between gender of the athlete pictured and whether they were on or off the court (i.e., playing area), in or out of uniform, and actively or passively posed. We then continue the analysis by examining the photograph themes (question 4) or the relationship between the gender of the athlete and whether the photograph displays true athleticism, stereotypical characterizations of femininity/masculinity, and sexual suggestiveness. Following these analyses, we disaggregate the results to look at the relationship between a specific sport and court location, uniform presence, active or passive pose, true and posed athleticism, and each theme. In these analyses, we present findings only for those sports where a relationship was significant in 1990, 1997, or both years and only for themes in which there was a significant relationship in one year or the other.

RESULTS

For 1990, of the 307 covers analyzed, 47 percent (145) portrayed women's sports, while 53 percent (162) portrayed men's sports. Of the 314 covers analyzed in 1997, 51 percent (159) showed women's sports, and 49 percent (155) showed men's. While these percentages might suggest gender equity, our research questions probe beyond this superficial level.

Portrayals on Court

The first issue under consideration was whether there would be a significant difference between the portrayal of women and men athletes on or off the playing surface or court. In 1990, results indicated that there was a significant difference *(p < .002)* between gender of the athlete and court location. Men were portrayed on the court 68 percent of the time compared to 51 percent of the time for women athletes (see Table 1). Seven years later, the relationship remained significant. Men were portrayed on the court 57 percent of the time, while women athletes were on the court 41 percent of the time. Although this represents a decrease for both genders, men are still portrayed on the playing surface significantly more often *(p < .005)* than are women (see Table 1).

Portrayals in Uniform

With respect to uniform presence, initial findings revealed that more male athletes were featured in their uniforms (93 percent) than were female athletes (84 percent) (see Table 1). In 1997, the significance of this relationship disappeared when 92 percent of men and 91 percent of women were shown in uniform.

Pose

The next measure is the actual pose of the athletes: Were men and women featured differently? In 1990, results indicated a significant difference, as men were found to be in action 59 percent of the time compared to 43 percent for women (see Table 1). In the replication, this relationship remained significant, with 62 percent of men seen in action and 41 percent of women seen in action (see Table 1). The percentage of women portrayed in action decreased by 2 percent, while the number of men portrayed in action actually increased by 3 percent.

Cover Themes

Turning to the cover themes, significant differences were found for true athleticism (i.e., on court, in uniform, in action) and the theme of femininity/masculinity in both years. In 1990, men were portrayed as true athletes 53 percent of the time compared to 39 percent for women athletes (see Table 1). In 1997, men were seen as true athletes 59 percent of the time compared to 39 percent for women (see Table 1). The actual number of people portrayed as true athletes increased for both men and women, but this resulted in a percentage increase only for men.

For the theme of femininity/masculinity, the 1990 data revealed that women were portrayed significantly more often under the theme of femininity (20 percent) than their male counterparts were portrayed under the theme of masculinity (6 percent) (see Table 1). In 1997, these percentages decreased for both women and men, although the relationship between the gender of the athlete and the likelihood that she or he would be portrayed as feminine/masculine remained significant (see Table 1). Women were more likely to be portrayed as

TABLE 1: Court Location, Uniform Presence, Pose, True Athleticism, Femininity/Masculinity, and Sexual Suggestiveness, by Gender of Athlete

| | 1990 | | | | | | 1997 | | | | | |
| | Men | | Women | | Total | | Men | | Women | | Total | |
	Percentage	No. in Category/No. of Covers	Percentage	No. in Category/No. of Covers	Percentage	No. in Category/No. of Covers	Percentage	No. in Category/No. of Covers	Percentage	No. in Category/No. of Covers	Percentage	No. in Category/No. of Covers
On court	68.3	110/161	51.4	74/144	60.3	184/305	56.8	88/155	40.9	65/159	48.7	153/314
In uniform	93.0	133/143	83.7	108/129	88.6	241/272	n.s.		n.s.		n.s.	
Active	59.3	83/140	43.3	55/127	51.7	138/267	62.3	81/130	40.8	53/130	51.5	134/260
True athleticism present	52.5	85/162	38.6	56/145	45.9	141/307	58.7	91/155	39.0	62/159-	48.7	153/314
Femininity/masculinity present	6.2	10/162	20.0	29/145	12.7	39/307	4.5	7/155	11.3	18/159	8.0	25/314
Sexual suggestiveness	n.s.		n.s.		n.s.		0.0	0/155	3.1	5/159	1.6	5/314
Total number of covers	162		145		307		155		159		314	

NOTE: Not all themes were represented in all cover photographs, Therefore, the total number of covers for each category may be less than the total number of covers received. Court location, 1990: $X^2 = 9\text{-}10$, p = .002; court location, 1997: $X^2 = 7.94$, p = .005; uniform presence, 1990: $X^2 = 5.79$, p = .016; uniform presence, 1997: not significant; pose, 1990: $X^2 = 6.80$, p=.009; pose, 1997: $X^2 = 12.07$, p = .000; true athleticism, 1990: $X^2 = 5.90$, p=.015; true athleticism, 1997: $X^2 = 12.2$, p = .000; femininity/masculinity, 1990: $X^2 = 13.19$, p = .000; femininity/masculinity, 1997: $X^2 = 4.96$, p = .026; sexual suggestiveness, 1990: not significant; sexual suggestiveness, 1997: distribution too small for chi-square to be reliable, $X^2 = 4.95$, p = .026. n.s. = not significant.

feminine than men were to be portrayed as masculine. Eleven percent of the women's covers included portrayals of traditional femininity, while 5 percent of men's covers included nonsport portrayals of masculinity. Although sport has been viewed by many as masculine in its entirety, the distinction between portrayals of femininity and masculinity was made by comparing the number of times women were dressed in traditionally feminine clothing, wore make-up, and had a traditionally feminine hairstyle with the number of times men were portrayed wearing traditionally masculine clothing such as tuxedos and dress suits.

In 1990, the remaining thematic categories of sport equipment, sexual suggestiveness, pop culture, and student athlete revealed no significant differences between women and men as athletes. Yet in 1997, the category of sexual sugges-tiveness was significant, with women being more likely to be portrayed in a sexually suggestive manner. These findings, however, must be interpreted with caution as the limited sample size may bias the statistical results. Nonetheless, it remains true that five of these media guides for women's sports contained sexually suggestive poses, while none of the men's covers did so.

Differences by Sport Type

We also examined the relationship between sport type (gender appropriateness) and the variables already considered in the first four questions (court location, uniform presence, pose, and themes). For ease of comparison within sport, these results, though discussed thematically, are presented in tables by sport.

Sport type and court location or uniform usage. Table 2 focuses on the male-appropriate sport of basketball. In examining the relationship between court location and sport type, in 1990, a significant difference was found in the sport of basketball. Male basketball players were featured on the court 71 percent of the time, compared to only 42 percent for female basketball players (see Table 2). This relationship was not significant in the 1997 analysis.

A similar pattern emerged with respect to gymnastics, a sport that was considered to be gender appropriate for women and gender inappropriate for men. In 1990, results only approached significance (results not shown). Male gymnasts were photographed in the competition area 82 percent of the time compared to 48 percent for female gymnasts. In 1997, however, this relationship was significant. While men were portrayed in the competition area 50 percent of the time, only one women's team, of the 19 represented, was portrayed in the competition area (see Table 3).

In 1990, more men in the male-appropriate sport of baseball were featured on the field when compared to women in the comparable sport of softball (76 percent vs. 54 percent), although this was significant only at .09 (results not shown). This relationship was significant in the 1997 analysis, with 69 percent of male athletes portrayed on the field compared to 35 percent of women (see Table 4). In neither year were there significant differences in the gender-neutral sports of tennis and golf with regard to how often women or men were portrayed on the court or competition area. Sport type differences were also found for uniform presence, but

TABLE 2: Court Location, Pose, True Athleticism, Posed Athleticism, and Sport Equipment for Basketball, by Gender of Athlete

	1990						1997					
	Men		*Women*		*Total*		*Men*		*Women*		*Total*	
	Percentage	*No. in Category/No. of Covers*	*Percentage*	*No. in Category/No. of Covers*	*Percentage*	*No. in Category/No. of Covers*	*Percentage*	*No. in Category/No. of Covers*	*Percentage*	*No. in Category/No. of Covers*	*Percentage*	*No. in Category/No. of Covers*
On court	70.7	29/41	41.5	17/41	56.1	46/82	n.s.		n.s.		n.s	
Active	72.2	26/36	33.3	12/36	52.8	38/72	n.s.		n.s.		n.s	
True athleticism present	63.4	26/41	31.7	13/41	47.6	39/82	n.s.		n.s.		n.s	
Posed athleticism present	n.s.		n.s.		n.s.			7/45	41.9	18/43		25/88
Sport equipment present	95.1	39/41	65.9	27/41	80.5	66/82	n.s.		n.s.		n.s	

NOTE: Court location/basketball, 1990: $X^2 = 7.13$, p = .007; court location/basketball, 1997: not significant; pose/basketball, 1990: $X^2 = 10.92$, p = .000; pose/ basketball, 1997: not significant; true athleticism/basketball, 1990: $X^2 = 8.26$, p = .004; true athleticism/basketball, 1997: not significant; posed athleticism/ basketball, 1990: not significant; posed athleticism/basketball, 1997: $X^2 = 7.48$, p = .006; sport equipment/basketball, 1990: $X^2 = 11.18$, p = .000; sport equipment/basketball, 1997: not significant. n.s. = not significant.

only for baseball/softball. In 1990, men were shown in uniform more often than were women (see Table 4). This relationship was not significant in the 1997 analysis.

Sport type and pose. Sport comparisons for the measure of pose revealed a significant difference in the sport of basketball (see Table 2). Men were featured in action 72 percent of the time on the cover photograph, while women were portrayed in action only 33 percent of the time. This relationship was not significant in the 1997 analysis. For 1990, there were no significant differences found in gender appropriateness between the remaining sports by pose presentation. However, in 1997, men gymnasts were more likely to be portrayed in action than were women (see Table 3). Only 1 men's gymnastics team (16.7 percent) of 6 was not shown in action. On the other hand, of the 15 women's teams, 3 (20 percent) were seen in action, while 12 (80 percent) were not in action. It is interesting to note the low number of men's gymnastics teams. There are about 20 men's programs remaining in the NCAA. This may beg the question, given the gendered nature of sport, why the declining interest in men's gymnastics?

Sport type and cover themes. In 1990, there were significant differences by sport for two of the possible eight themes: True athleticism and sport equipment. In 1997, there were significant differences by sport for true athleticism and posed athleticism. In the areas of femininity/masculinity, student athlete, sexual suggestiveness, popular culture, and the category of other, findings for both years either were not significant or were only near significance at the .10 level.

In 1990, the relationship between sport type and true athleticism was significant in two sports, basketball and gymnastics. As previously stated, true athleticism was defined as being on court, in uniform, and in action. In the sport of basketball, true athleticism was found in 63 percent of the 1990 media guides portraying men athletes compared to only 32 percent of the basketball media guides portraying women athletes (see Table 2). This relationship was not significant in 1997.

In both 1990 and 1997, a significant difference was found in the portrayal of true athleticism for the sport of gymnastics. Men gymnasts were depicted as true athletes 82 percent of the time compared to 46 percent for the women gymnasts (see Table 3). In 1997, men gymnasts remained more likely to be portrayed as true athletes. While the percentage of covers showing men gymnasts as true athletes dropped from 82 percent to 75 percent, the percentage of covers showing women gymnasts as true athletes dropped from 45 percent to 5 percent. There were no significant differences found in baseball/softball, tennis, and golf in either year.

While in 1990, there were no significant relationships involving posed athleticism, in 1997, the relationship between an athlete's gender and posed athleticism was significant for the sport of basketball (see Table 2). Women were much more likely (42 percent) to be seen as posed athletes than were men (16 percent). This was the only sport for which this relationship was observed.

The presence of sport equipment on the 1990 media guide covers also indicated significant differences with regard to the gender-appropriate and gender-inappropriate sports. In basketball, sport equipment was present for men 95 percent of the time compared to 66 percent for

TABLE 3: Court Location, Uniform Presence, Pose, True Athleticism, and Sport Equipment for Gymnastics, by Gender of Athlete

| | 1990 | | | | | | 1997 | | | | | |
| | Men | | Women | | Total | | Men | | Women | | Total | |
	Percentage	No. in Category/No. of Covers	Percentage	No. in Category/No. of Covers	Percentage	No. in Category/No. of Covers	Percentage	No. in Category/No. of Covers	Percentage	No. in Category/No. of Covers	Percentage	No. in Category/No. of Covers
On court	n.s.				n.s.		50.0	4/8	5.3	1/19	18.5	5/27
Active	n.s.				n.s.		83.3	5/6	20.0	3/15	38.1	8/21
True athleticism present	81.8	9/11	45.5	10/22	57.6	19/33	75.0	6/8	5.3	1/19	25.9	7/27
Sport equipment present	81.8	9/11	45.5	10/22	57.6	19/33	n.s.		n.s		n.s.	

NOTE: Court location/gymnastics, 1990: not significant; court location/gymnastics, 1997: distribution too small for chi-square to be reliable, X2 = 7.47, p = .006; pose/gymnastics, 1990: not significant; pose/gymnastics, 1997: X2 = 7.29, p = .007; true athleticism/gymnastics, 1990: X2 = 3.96, p = .046; true athleticism/ gymnastics, 1997: X2 = 14.26, p = .000; sport equipment/gymnastics, 1990: X2 - 3.96, p = .046; sport equipment/gymnastics, 1997: not significant, n.s. = not significant.

TABLE 4: Court Location, Uniform Presence, and Sport Equipment for Baseball/Softball, by Gender of Athlete

	1990						1997					
	Men		Women		Total		Men		Women		Total	
	Percentage	No. in Category/No. of Covers	Percentage	No. in Category/No. of Covers	Percentage	No. in Category/No. of Covers	Percentage	No. in Category/No. of Covers	Percentage	No. in Category/No. of Covers	Percentage	No. in Category/No. of Covers
On court	n.s.		n.s.		n.s.		69.4	25/36	34.5	10/29		35/65
In Uniform	91.0	30/33	68.8	11/16	83.7	41/49	n.s		n.s		n.s	
Sport equipment present	84.6	33/39	55.6	10/18	75.4	43/57	n.s.		n.s.		n.s.	

NOTE: Court location/baseball/softball: 1990, not significant; court location/baseball/softball, 1997: $X^2 = 7.9$, $p = .005$; uniform presence/baseball/softball, 1990: $X^2 = 3.87$, $p = .049$; uniform presence/baseball/softball, 1997: not significant; sport equipment/baseball/softball, 1990: $X^2 = 5.61$, $p = .017$; sport equipment/baseball/softball, 1997: not significant, n.s. = not significant.

women (see Table 2). This relationship was also significant in gymnastics, where 82 percent of the men and 46 percent of the women were portrayed with sport equipment and in baseball/softball, where 85 percent of men and 56 percent of women were portrayed with equipment (see Tables 2 and 4).

DISCUSSION AND CONCLUSION

Our examination of media guide cover photographs from six of the most prestigious athletic conferences in the United States reveals images in both 1990 and 1997 that are consistent with previous research on depictions of women athletes in the popular media. This research makes an important contribution to the literature by shifting the focus from popular media to university-created media. While one might not be surprised to see the popular press engage in the sexist treatment of women athletes, it is surprising that highly regarded educational institutions would continue such differential treatment, especially in light of the social changes during the past 25 years. In the 1990 media guides, when women athletes were represented, they were less likely than men to be portrayed in uniform, on the court, or in action. In 1997, women athletes continued to be underrepresented on the court and in action, but the gender difference in wearing uniforms had disappeared. Unfortunately, the degree to which women appeared on court actually decreased.

The above results suggest that if we want to predict how athleticism is portrayed in Division I intercollegiate sports, we need only know the gender of the athlete. It was surprising to find that there were few changes between 1990 and 1997. As women's sports programs have achieved more equity in many other areas related to Title IX, one would expect to find greater similarities in the portrayals of women and men athletes on media guide covers. However, men were still more likely to be portrayed as true athletes, and markers of femininity had become common in the portrayals of women athletes.

Although we had hoped to see improvement over time, these data do not provide evidence for broad sweeping changes. Overall, there were some gains and some losses. It seems clear that the sport of basketball is one area in which greater strides for women can be noted. This is not surprising given the increased popularity of women's basketball nationwide. The other improvements, while worth noting, do not suggest widespread changes in the way women athletes are portrayed.

With women making their way into sports traditionally reserved for men (e.g., hockey), and the increased number of professional women's sports teams, the few positive results are surprising. This raises the question, why haven't the images of women as athletes changed to reflect this reality? Perhaps there was not enough time between the two investigations for such an effect to occur. Alternatively, the increased participation by women in sport may be a direct result of the feminine portrayals that make sport attractive to more women. That is, as long as they can be seen as "ladies" first, they will not be compromising their femininity, or their heterosexuality, by playing sports.

As sport becomes more commercialized, and more money is to be made from girls' and women's participation in sport, we think that those in control of media and advertising should have a vested interest in making sport more appealing to a greater number of girls and women. The message an institution sends about its teams may affect the way in which journalists present the team to the public. It could also be argued that the institution may be trying to sell the team as heterosexy and feminine to improve the institution's coverage and support. Unfortunately, what this does is further distance the image of women athletes from athletic competence. An example of this is one media guide cover that portrayed the women's basketball team in formal gowns with heavily made up faces and styled hair. The message communicated is not about basketball. There is no evidence anywhere on the cover that suggests that this is a basketball team. Rather, it appears that they might be candidates for homecoming queen. Another example is from a gymnastics media guide on which gymnasts are in their competition leotards, in poses that draw attention to their upper thighs, buttocks, and chests. If "gymnastics" were not printed on the cover, it would be difficult to discern this from many soft pornography photographs. This type of representation does nothing to display these women as competent, elite athletes, which we believe should be the purpose of an athletic media guide cover photograph.

The marginalization of women's athleticism that results from these particular media presentations serves to reinforce male dominance and control of sport. Thus, the media create a fundamental barrier to any significant change with respect to conceptions of the female athlete and her body. For example, even though the numbers of women participating in intercollegiate sports have grown dramatically during the past two decades, and the number of sports offered for women's participation at the college level has also increased, post-Title IX women athletes continue to be constructed differently by the media than are men. As others have argued (Duncan 1990; Duncan and Hasbrook 1988; Kane and Parks 1992; Kane and Snyder 1989), media portrayals of female athleticism contain and limit women in sport and subsequently deny them much of the status, power, and prestige that men experience in sport. By trivializing and marginalizing female athleticism, the media reinforce the notion that women's sport is a lesser version of the real (men's) sport (Kane and Snyder 1989).

Messner (1988) also pointed out that the images of women's athleticism constructed by the media represent major obstacles to any fundamental challenge to male dominance in organized sport. As the results of this research clearly show, the producers of women's athletic media guides seem more intent on projecting stereotypie images of traditional femininity than true athleticism. We conclude that sport as a primary area of ideological legitimation for male superiority is preserved through gender differentiation and gender hierarchy as represented in the cover photographs of these media guides. This systematic representation of differential treatment undermines the female athlete and limits her power and potential in sport.

The media have the power and, we would argue, the responsibility to act as social agents in the transformation of athletic images by reflecting the reality of the female athletic experience. That reality is best reflected by constructing images of female athletes that emphasize their

athletic competence in sport. University athletic programs can and should provide leadership in media equity of female and male athletic teams.

REFERENCES

Betterton, R. 1987. *Looking on: Images of femininity in the visual arts and media.* London: Pandora.

Boutilier, M. A., and L. SanGiovanni. 1983. *The sporting woman.* Champaign, IL: Human Kinetics. Bryant, L. 1980. A two-year selective investigation of the female in sport as reported in the paper media. *Arena Review* 4:32–44.

Buysse, J. M. 1992. Media constructions of gender difference and hierarchy in sport: An analysis of intercollegiate media guide cover photographs. Ph.D. diss., University of Minnesota, Minneapolis.

Duncan, M. C. 1990. Sport photographs and sexual difference: Images of women and men in the 1984 and 1988 Olympic Games. *Sociology of Sport Journal* 7:22–43.

Duncan, M. C, and C. A. Hasbrook. 1988. Denial of power in televised women's sports. *Sociology of Sport Journal* 5 (1): 1–21.

Duncan, M. C, and A. Sayaovong. 1990. Photographic images and gender in "Sports Illustrated for Kids." *Play and Culture* 3:91–116.

Kane, M. J. 1988. Media coverage of the female athlete before, during and after Title IX: "Sports Illustrated" revisited. *Journal of Sport Management* 2:87–99.

———. 1996. Media coverage of the post Title IX female athlete: A feminist analysis of sport, gender, and power. *Duke Journal of Gender Law & Policy* 3:95–127.

Kane, M. J., and J. B. Parks. 1992. The social construction of gender difference and hierarchy in sport journalism: Few new twists on very old themes. *Women in Sport and Physical Activity Journal* 1:49–83.

Kane, M. J., and E. E. Snyder. 1989. Sport typing: The social "containment" of women in sport. *Arena Review* 13 (2): 77–96.

Lasswell, H. D. 1948. Attention structure and social structure. In *The communication of ideas,* edited by L. Bryson. Binghamton, NY: Vail-Ballou Press.

Messner, M. 1988. Sports and male domination: The female athlete as contested ideological terrain. *Sociology of Sport Journal* 5:197–211.

Messner, M, M. C. Duncan, and F. L. Wachs. 1996. The gender of audience building: Televised coverage of women's and men's NCAA basketball. *Sociological Inquiry* 66:422–39.

Metheny, E. 1965. *Connotations of movement in sport and dance.* Dubuque, IA: William C. Brown.

Nelson, M. B. 1994. *The stronger women get, the more men love football.* New York: Avon.

Salwen, M. B., and N. Wood. 1994. Depictions of female athletes on "Sports Illustrated" covers, 1957–1989. *Journal of Sport Behavior* 17 (2): 98–107.

Shivlett, B., and R. Réveile. 1994. Gender equity in sports media coverage: A review of the "NCAA News." In *Women, media and sport: Challenging gender values,* edited by P. Creedon. Thousand Oaks, CA: Sage.

Tuggle, C. A. 1997. Differences in television sports reporting of men's and women's athletics: ESPN SportsCenter and CNN Sports Tonight. *Journal of Broadcasting & Electronic Media* 41:14–24.

Wenner, L. A. 1989. *Media, sports, and society.* Newbury Park, CA: Sage.

Jo Ann M. Buysse is the coordinator of sport studies at the University of Minnesota School of Kinesiology, where she teaches sport sociology and sport ethics. She is also an affiliated scholar with the Tucker Center for Research on Girls and Women in Sport at the University of Minnesota and is continuing her research in sport media by conducting a second follow-up study using 2003–2004 media guides.

Melissa Sheridan Embser-Herbert is an associate professor of sociology at Hamline University in Saint Paul, Minnesota. She is the author of Camouflage Isn't Only for Combat: Gender, Sexuality, and Women in the Military *(1998, New York University Press) and recently published, with Aaron Belkin, "A Modest Proposal: Privacy as a Flawed Rationale for the Exclusion of Gays and Lesbians from the U.S. Military" (Fall 2002,* International Security).

Art as a Political Act:
Expression of Cultural Identity, Self-Identity, and Gender

Hwa Young Choi Caruso

INTRODUCTION

A number of artists of color, including Asian American women, are creating art from the basis of their lived experiences. Within minority groups searching for their cultural identity, establishing self-identity is an important process. For various psychological and sociological reasons, artists seem inspired to seek deeper meaning and a broader participation in cultural work.[1] Asian American women artists, in particular, are currently making art as a means of exploring self-identity, cultural identity, and gender issues. Korean/Korean American minority women artists are creating art as a reaction to their cultural upbringing, which questions issues of identity, gender, ethnicity, politics, cultural, and socioeconomic status. These contemporary artists are breaking away from traditional cultural expectations and overcoming social barriers as artists, women, and Koreans/Korean Americans. With the growing public awareness of women's consciousness and sense of self as women in Korea and as an ethnic minority in America, these artists are redefining their identity. Despite the traditional patriarchal Confucian hierarchy; lack of social, institutional, and political support; and stereotypie gender, cultural, and socioeconomic status expectations for women, a few have stepped out of their traditional roles as women and have become successful artists in Korea and America.

The artworks of these artiste are worthy of investigation because they appear to be a culturally, socially, and politically motivated artistic expression of the complex multifaceted Korean/Korean American life experiences as women and as Korean immigrant members of a cultural (ethnic) minority in American society. Therefore, two main research questions can be posed:

- Given that art can be constructed out of layers of different experiences and influences, to what extent do the dimensions of cultural identity, self-identity, and gender interweave and contribute to the function of art as a political act for Korean/Korean American women artists?
- How do Korean/Korean American cultural, social, and female experiences influence the artistic expression of Korean/Korean American women artists?

In order to answer these questions, I selected case study methodology[2] and adapted elements of interpretive biography,[3] and narrative approaches as developed by Wallace and Gruber.[4] According to Denzin,[5] interpretive biography involves the collection and analysis of personal experiences, life documents, stories, accounts, and narratives that describe turning-point moments in individuals' lives. Denzin argues that personal experiences and personal stories are derived from a larger cultural, ideological, and historical context. The intent of the biographical project is to problematize the social, economic, cultural, structural, and historical forces that shape, distort, and otherwise alter lived experiences.

By using narrative case study methods, I explore elements of self-identity formation, cultural identity, gender issues, personal thoughts, artistic expression, meaning of artworks, professional achievement, and life circumstances. I examine each participant's life in the Korean and American historical, cultural, social, and political environments. I interpret participants' outer lives (what they do) and inner lives (feelings, thoughts, inner serf) to capture their deep, profound life experiences. I examine salient themes of their art expression and how the role of art and artistic activity is a part of political, cultural, social, and feminist activism. I further investigate their professional activities in order to identify the multiple roles that contribute to personal and professional identity formation.

For the purpose of this study, I selected the contemporary Korean woman artist Suk Nam Yun and the contemporary Korean American woman artist Yong Soon Min as primary participants. These two women artists, despite many social and cultural barriers, chose to become artists; feminists; and social, cultural, and political activists; in addition to fulfilling traditional Korean family and domestic roles. Yun and Min are regarded as the leading contemporary Korean/Korean American women artists whose artworks deal with issues of cultural, social, feminist, political, and hybrid identity and art as political activism.

Lippard acknowledges that visual images play an increasingly important role in society.[6] Art that connects everyday experience with social critique and creative expression becomes a vital means of reflecting upon the nature of society and social existence.[7] Artworks can function as a sign of resistance to colonialism and all forms of oppression, including traditional Confucianism. Such art serves as a reservoir of unofficial knowledge, a critique of history and culture, and an

affirmation of life. These artworks are understood as both a product of history and potential agent of social transformation.[8] To understand issues of identity, gender, ethnicity, politics, culture, and socioeconomic status expressed in the artworks of contemporary Korean/Korean American women artists in general, it is important to study Korean cultural identity. This involves the process of understanding one's past and the beliefs and values that constitute cultural history.

CONFUCIAN CULTURAL HERITAGE

According to the Korean/Korean American scholars Kwang-kyu Lee, Ai Ra Kim, Byong-ik Koh, Pyong-gap Min, H. Jo Moon, and Young In Song and Ailee Moon, the Confucian cultural heritage is deeply rooted and saturated in the daily lives of Koreans.[9] It provides political, social, and cultural meanings and functions in contemporary South Korea. Confucianism forms the core of Korean culture, and it is a moral force with political power and social influence.[10] The Korean moral fabric, woven together by family, school, and government, has a cohesive structure of Confucian ethics, which affects the vertical and horizontal relationships in the social network.[11]

In order to understand the roles, status, and social positions of Korean women, one must examine Confucianism, which is the basis of Korean traditional cultural values and beliefs that have greatly impacted the life experiences of Korean women in family and society. The Confucian heritage in South Korean society has contributed to family cohesiveness, educational excellence, and social harmony, yet it has also perpetuated authoritarian, factional, and male-oriented ideas and practices.[12] The most important elements of the Confucian philosophy concern male superiority and the social position of women in society and in the family.[13] The social position of Korean men under traditional Confucianism is one of being superior to women. Social and political participation and institutional support for Korean women were limited under traditional Confucian practice.[14] According to Ai Ra Kim, traditional roles for Korean women consisted of reproduction, care taking, nurturing, and home making.[15] Kim states that the self is a natural emergent of social experiences, and traditional Korean women developed selfless self-images (self-identity).[16] In Korean society, women are honored for their dedication and self-sacrifice by raising children and serving the family.[17] Self-sacrifice and marriage were the primary means of survival for women in traditional Korean society. Consequently a Korean woman could not separate her existence and self-identity from her spouse. She developed collective identities with her husband and his family.[18]

The influence of the Confucian values on South Koreans has weakened during the last three decades because of the influx of Western culture, rapid industrialization, and modernization.[19] According to Young-Hee Shim, the rapid growth of the Korean economy over the last thirty years caused serious consequences for traditional values. The exploding economy affected the exterior and material aspects of life as well as the status of South Korean women. In contemporary South Korean society, many women are better educated and more capable of participating in socioeconomic activities because of modernization.[20] The rapid economic growth influenced and enhanced the consciousness of women and their sense of self-identity while conflicting with traditional values and social attitudes toward gender inequality, especially in the workplace. From

the feminist perspective, Shim sees most Korean women continuing to struggle for status and gender equality in the workplace and at home.[21]

Lee states that the process of modernization in South Korea affected and modified all aspects of the social structure and behavioral patterns associated with Korean family life.[22] Michael Robinson argues that despite changes in the traditional values in South Korean society, Confucianism remains deeply ingrained in the daily life of Korean people, but in an altered form.[23] Confucianism still serves as a guiding principle that shapes and governs Korean beliefs, values, social interactions, family systems, and the cultural lives of many Koreans, as well as Korean immigrants in America.[24] Shim[25] and Song and Moon, [26] however, insist that more changes are necessary to develop gender awareness and equity that will improve the lives of South Korean and Korean American women.

KOREAN IMMIGRANTS IN AMERICA

In America, Korean immigrants face different definitions of family values, beliefs, and ideals, These definitions emphasize individualism and egalitarianism.[27] Korean immigrants, who bring their traditional cultural values to the United States, encounter conflicts in their family relations and daily lives as they try to adhere to their beliefs in the traditional Korean authoritarian and male-dominated values.[28] Pyong-gap Min[29] and H. Jo Moon[30] argued that, even in America, many Korean immigrants are still influenced by Confucianism while adjusting to their new life. The most significant change they face is the enhanced role and status of Korean women and their participation in the workforce.

In this new environment, Korean immigrants experience fundamental changes and must make adjustments to life in America. According to Kye Young Park, Korean immigrant culture making is based on the Diaspora experience and the social status of being considered a racial minority. Park states that Korean immigrants see culture making in terms of grafting. Their construction of cultural identity involves struggle, confusion, contradiction, and transformation in a heterogeneous and dynamic process.[31] Many Korean immigrants who were raised in the ethnically and culturally homogeneous Korean society had to adjust to life as minorities in the American multicultural society.[32] During that process, Korean immigrants in America develop an immigrant racial ideology. Through the life experiences of confronting language barriers and cultural differences as a racial minority, they modify their Korean ethnic concepto and create new identities, cultural forms, and adopted ideologies.[33]

Inn Sook Lee argues that Korean immigrants experience major changes in their lives in the process of making adjustments and transitions in America.[34] In that process, Korean immigrants reconstruct and reshape their sense of self-identity in America. According to Stella Ting-Toomey, for immigrante, identity change is an inevitable gradual transformation process.[35] She described the formation of cultural identity and how this cultural identity, in turn, impacts personal identity. Personal identities are acquired and developed within a larger web of our culture. The term identity is used as the reflective self-conception or self-image that we each desire from our cultural, ethnic,

and gender socialization process. Individuals develop distinctive personal identities because of unique life histories, experiences, and personality traits.

Phinney explains that how individuals deal with their ethnicity has important implications for their self-identity.[36] Phinney[37] argues that an achieved ethnic identity contributes positively to self-esteem, which is a critical feature of the self-identity formation of ethnic minorities, and this impacts their life adjustment. Ethnic identity refers to one's sense of belonging to an ethnic group and the part of one's thinking, perception, feelings, and behavior that is a result of ethnic group membership.[38] The person feels self-identification as a member of group, a sense of shared attitudes and values, and specific ethnic traditions and practices such as language, behavior, and customs.

THE ROLE OF ART

According to Park,[39] Korean and Korean American culture is very important to Korean immigrants because it represents their economic and political power as a racial minority in the United States. Hence, culture becomes a weapon to help attain self-esteem and empowerment. Lippard argues that within minority groups, searching for cultural identity and self-identity is an ongoing process, and art making helps them to connect to their identities.[40] Minority artists allow forbidden and forgotten images to surface, reinforcing aspects of identity that provide pride and self-esteem. Lippard states that art has social and aesthetic meanings and it enables artists to see the larger meaning of their life experiences.

Estella Lauter argues that art is related to social context.[41] Art can reveal important aspects of women's thought and their life experiences. Art allows people to reconnect aesthetic values with political activity. Art is assumed to reflect and interact with the values of a particular culture, which in turn interacts with others in weblike relation.[42] Griselda Pollock argues that art is one of the social practices through which particular views of the world are constructed, reproduced, and even redefined.[43] Feminist artists speak about the hidden aspects of women's lives and their life experiences as women.[44] In art practice, women can engage in their artwork to expose ideological constructions by questioning the traditional cultural values and practice that constitute the discourse of a social system and its political, economical, legal, and educational power.[45] In the case of many women artists of color, feminism has grown within the contexts of racial or political work and is often inseparable from or absorbed by these contexts. Lippard asserts that hybrid experiences can become a significant aesthetic factor.[46] Lippard further argues that making art is not simply expressing for oneself but is a far broader and important task that involves expressing oneself as a member of a larger unity or community. So that in speaking for oneself, one is also speaking for those who cannot speak. Patricia Hill Collins states that by speaking out, formerly victimized individuals not only reclaim their humanity they simultaneously empower themselves by giving new meaning to their own particular experiences.[47] Collins argues that consciousness raising emerges as central to "the personal is political" because, through it, individual women learn to see their lives in political terms.[48] Lippard states that artists can't change the world alone, nor can anyone else, but art is a powerful and potential subversive tool of consciousness. She

argues, "the political is personal."[49] According to Martha Nussbaum, the arts play a vital role, cultivating powers of imagination that are essential to citizenship.[50] The arts cultivate capacities of judgment and sensitivity that can and should be expressed in the choices a citizen makes. She believes to some extent that all the arts have a role in shaping our understanding of the people around us.

Howard Gruber argues that art should, above all things, mobilize people for struggle.[51] To unmask prejudice and secure justice, we need argument, an essential tool of civic freedom. Maxine Greene states that a concept of freedom is associated with the power to act and to choose the capacity to become different.[52] The principles of equity, equality, and freedom, for her, mean using imagination, tapping the learner's courage to transform. Greene insists that the process of coping with diversity and striving toward significant inclusion is derived to a large degree from an awareness of the savagery, the brutal marginalizations, the structured silences, and the imposed invisibility to the present.[53] Marginalization can destroy a community by excluding and demeaning large numbers of the population. Greene argues that the arts can awaken us to alternative possibilities of existing, of being human, of relating to others, and of being other. She calls for inclusion, pluralism, different voices, and democracy.[54]

According to Danto, art is political in consequence, even if politics should not be its immediate content.[55] The power of art is the power of rhetoric, and rhetoric, aimed at the modification of attitude and belief, can never be innocent.

Elliot Eisner acknowledges that works of arts are a way of creating our lives by expanding our consciousness, shaping our dispositions, satisfying our quest for meaning, establishing contact with others, and sharing a culture.[56] Eisner also states that art provides the conditions for awakening people to the world around them. In this sense, the arts provide a way of knowing. The arts help people to notice and understand a particular environment and their place in it. The imaginative image functions as a template by which people recognize their perception of the world. The arte provide a platform for seeing things in ways other than they are normally seen. It is one of the reasons the arts are regarded as subversive.

With the growing public awareness in Korea and America about the issues of identity, gender, and the power of women, artworks that deal with political and social statements are receiving greater attention from critical writers. These issues are reflected in important art magazines such as *Wolgan Misool, Art in America,* and *Art AsiaPacific* in Korea and America. Women's art is recognized as a vital and important part of contemporary art and political expression in Korea and America. It can be inferred that artists have the capacity to improve and transform society by expressing their critical vision and voices through art as a political act. In the following section, I explore these issues with an analysis of two Korean/Korean American women artists and their artworks.

THE ART OF SUK NAM YUN

Suk Nam Yun is a founding member of the Korean feminist art movement and a leading female artist in Korea. Through her artistic expression, she raises questions about feminist issues and

Korean traditional cultural practices. Yun was born in Manchuria (China) in 1939, and her family returned to Korea when she was six years old. She currently lives in Seoul, South Korea. Yun studied English literature at SungKyunKwan University in Seoul and received art training in Korea and America, studying at the Pratt Institute Graphic Center and Art Students League in New York City. Her major medium is mixed media installation. One unusual aspect of Yun's life is that she began her career as a professional artist at age forty when many other Korean women are resigned to family tasks. Yun decided to become an artist to discover a sense of self and to reconstruct her identity. Yun as an artist dedicated her life to reaching the goal of gender equity and helping to transform social and cultural practices. She is fighting against a definition of Korean women as self-sacrificing and those who live for others while losing their sense of self. These traditional values, which are based on a Confucianism patriarchal structure, are taught and reinforced by Korean cultural beliefs, social practice, and institutions. Yun is passionate about the amplification of her feminist and political voice and its meaning through art expression.

Mother's Eyes Series

In 1993, Yun had a solo exhibition titled *Mother's Eyes* at the Kumho Art Museum in Seoul, Korea. Her subjects often deal with the life of her mother and Yun's thoughts as a woman, daughter, and mother. Yun expressed respect, compassion, and deep love for her mother, a widow, who worked hard to raise six children after the death of her husband at age thirty-nine. In the artwork titled *Mother* (1996), which was exhibited in the 1996 Venice Biennale (Italy), Yun arranged 100 burning candles to represent the sacrifices and services Korean mothers make for others. Yun tried to give respect to the family roles of Korean women, which are often taken for granted. In traditional Korean culture, the mother is expected to sacrifice herself for the family while maintaining an ambivalent position between her son and daughter. Mothers tend to favor a son over a daughter in the traditional Confucian patriarchal society. Simultaneously a Korean mother as a woman is oppressed and suppressed by the same social construction she supports. This is a contradictory practice in Korean culture. In Yun's installation titled *Wishing for Son* (1993), she expressed important social and cultural issues including gender discrimination whereby sons are favored over daughters. Even though it is the twenty-first century, many Korean women are still under pressure to have sons in order to continue the family name and bloodline.

In her installation *Genealogy* (1993), Yun incorporated and emphasized the family registration book (*Jokbo* in Korean), one of the symbols of Korean male-centered culture and the patriarchal society. Yun argued that a Korean woman's space (role and status) in society does not exist, and she expressed the suicidal state of a woman's mind and criticized traditional Korean patriarchal cultural practices. Yun expressed the frustration of a Korean woman who could not continue the family line because she could not have a baby and, more importantly, a son. In this situation, the husband often takes a concubine to have a son. The husband cannot register the second wife's name (identity) with honor as a member of his family until he divorces the first wife, even though the second wife produced a son to continue his bloodline and family name. The son from the second wife (illegal spouse) is placed in the family book. In *Genealogy,* the seated woman represents the

secure position in the family book as dictated by the Confucian social order. The other woman, who could not provide a son and was subjected to family pressures and traditional Confucian beliefs, hangs herself. Through this work, Yun criticized the powerless position of Korean women living under the Confucian patriarchal family structure.

In her mixed media installation, Yun uses materials such as natural wood that come from scrap pieces of rough logs. She paints images of Korean women on the wood using acrylics in colors such as lime green, blue, pink, and black. The patterns that she paints are based on traditional Korean fabrics such as silken cloth and *Okyangmok* (cotton fabric) to represent women who are dressed in *Hanbok* (Korean female dress). She incorporates Korean cultural motifs and patterns in her artworks to convey the representational image and narrative meaning that deliver her feminist political voice.

Pink Room Series

Yun created a series of artworks that dealt with women in the home environment. The series included chairs and sofas to convey the cultural identity and feminist issues of contemporary Korean women in a materialistic society. This society emphasizes a shallow life style, which focuses on possessions, beauty, external appearance, and the loss of self-identity rather than self-worth and gender equity. In the *Pink Room* series, Yun criticizes the uprooted, mindless empty life style of contemporary Korean women who desire material objects while lacking a sense of self-worth and self-identity. In this series, Yun re-creates a home environment such as the kitchen, the living room, and the bedroom, which represent female spaces that make her subjects grapple seriously with their identity. Yun creates multiple layers of hidden meanings in those spaces using various objects, such as chairs, shining beads, and pink-colored walls. The *Pink Room* (1997) often changes to a disturbing and aggressive place and represents the unstable energy of hysteria and derangement emanating from these pink domestic spaces. The *Pink Room* represents the social status limitations and the working places of Korean women, which are limited to private and domestic spaces.

Despite the pretty appearance of the traditional pink silk fabric on the chairs and sofas, which reminds the viewer of a cozy domestic space, Yun's installations contain an aggressive message concerned with psychological tension and instability. There is a collision of Korean traditional living space with contemporary Korean life styles for people who are experiencing rapid economic development, a materialistic society, and who are experiencing rapid economic development, a materialistic society, and Westernization. Yun expressed her concern and criticism about the problems of women's identity in contemporary materialistic society, and emphasized the importance of an individual looking into the self and developing self-identity and self-worth.

One of the salient elements in her artworks is the use of sharp iron spikes incorporated within chairs and sofas. The steel legs fitted on the chairs appear stable, but their knifelike appearance expresses the fierceness of women in form and material. By upholstering chairs and sofas with a pink fabric and fitting them with steel legs, Yun turns them into personifications of women. The chair legs are related to *Eunjangdo,* which were the small knives that Korean women carried for

self-defense during the Choson (Yi) dynasty (1392–1910). The sharp iron spikes were stuck into the seats of the chairs and sofas so no one could sit on them. The spikes suggest one cannot take the roles of women for granted like an empty seat.

Through her art, Yun raised the social, cultural, and feminist consciousness of the viewers and spoke out for many other Korean women who could not speak for themselves. Yun has a passion for, and a dedication to, the social and cultural transformation of the roles and status of Korean women in society. She has strong convictions and a positive belief that she can make a difference in the lives of Korean women. For Yun, art has become a form of feminist political cultural activism. She empowers herself and others by raising awareness about sociocultural ideological identity, class, and gender issues affecting Korean women. Yun has emerged as South Korea's leading feminist artist, gaining national recognition by speaking out about her beliefs and sharing her political feminist statements through artistic expression. Her cultural, feminist works and artistic achievements are highly valued and recognized by the South Korean government and the professional artist's community in Korea. In 1996, Yun received the Eighth Joong-Sup Lee Award. She was the first woman to receive the highest honor for a South Korean artist. In 1997, Yun received The Prime Minister's Award for her contributions to the Korean women's movement.

Yun's artworks have been exhibited nationally and internationally at the Gwangju Biennale 2000 (Korea), 12th Sydney Biennale (Australia), National Museum of Modem Art (Tokyo, Japan), Venice Biennale (Italy), Asia Society Museum (NYC, USA), Art Museum of Beijing (China), Ho-Am Museum (Korea), Vancouver Art Gallery (Canada), and Gallery Velan (Torino, Italy). Her works are in the permanent collections of the National Museum of Contemporary Art (Kwachun, Korea), Queensland Art Gallery (Australia), Fukuoka Art Museum (Japan), Mie Prefecture Museum (Japan), Taipei Fine Art Museum (Taiwan), and the Kumho Museum (Korea).

THE ART OF YONG SOON MIN

Yong Soon Min was born in 1953 in South Korea and immigrated to America at the age of seven. Min completed her B.A., M.A., and M.F.A. at the University of California, Berkeley, and continued developing experimental, mixed media installations. She is a leading Korean American artist and currently lives in Los Angeles, California. Min is a professor of studio art at the University of California, Irvine. Her artworks focus on her straddling life experiences and their impact on her identity formation and artistic expression as a Korean immigrant in America. Min's artworks are about her complex life experiences and her political views about social, cultural, and historical events in Korea and America. Through art expression, Min reconnects her Korean cultural roots and learns about her self-identity as a Korean American.

Ritual Labor of a Mechanical Bride

In 1993, Min participated in the exhibition Across *the Pacific: Contemporary Korean and Korean American Art* at the Queens Museum of America in New York. Min's installation titled *Ritual*

Labor of a Mechanical Bride was a life-size re-creation of an *inhyong* (doll), which is the lifelike replica of a traditional Korean bride. A doll bride stands on a carpet smartly inscribed with wifely sentiments "Welcome/please walk step by step all over me/now as always/I am your humble and obedient servant/your comfort girl/your faithful daughter."[57] Once the viewer steps on the carpet, the elaborately dressed figure is supposed to bow and an audiotape voice whispers, "where is my demilitarized desire, where is my decolonized body politic?"[58] By using a traditional Korean bridal dress and words such as "Please walk step by step all over me" on the carpet, Min exposes the traditional social status and roles of Korean women as powerless in society and subjugated in Korean history. In addition, Min, as a Korean American woman, looks beyond gender to suggest how it becomes entangled with issues of race. By using English as the language of entreaty and seduction for her mechanical Korean bride, Min directs her critique at the Western, male gaze, under whom Asian women have been historically constructed as passive, exotic objects of desire.[59]

In another 1993 exhibition, which dealt with identity issues of Korean women, Min created an installation titled *Dwelling*. In this artwork, a Korean woman's identity is symbolized by the elegant Korean traditional dress that floated down from the ceiling of the gallery. Clothing and fabric carried feminist, cultural, and political messages. Min used a lightbulb inside of the dress, exposing its visible skeleton composed of twigs and scraps of photographs. Below the dress is a pedestal of white-jacketed books. Min exposes the issues of Korean/Korean American identity, the complexities of living in another culture as an uprooted immigrant, and addresses the secondary status of Korean women. This artwork is a form of historical understanding that is important in making sense of her self-identity, Korean cultural identity, her self-images as a Korean American woman. This Korean dress symbolizes the strong identification with the Korean female and her subjectivity.

Defining Moments

In 1992, in an installation composed of a six-part black-and-white photo ensemble titled *Defining Moments,* Min connected crucial events in Korean history to important dates in her life. According to Elaine H. Kim and Lilia Villanueva, Gary Hesse, and Min's statement, the four dates written on Min's nude torso in her photographic installation have significant meaning.[60] One was July 1953, the year of Min's birth and the end of the Korean War. The second date was 19 April 1960, when Min witnessed the Korean Student Revolution in Seoul as a child. The third date was May 1980, the time of the Gwangju Massacre in Korea, another event that marked the awakening of Min's own political consciousness. On 29 April 1992, the Los Angeles race riot that engulfed the Korean American community was another defining moment for Min as a Korean American. These three events occurred on or close to her birthday.

In the series *Defining Moments,* Min offers a chronology of political and historical events relating to her personal history. The first image in the series serves as a guide, with a list of the dates presented spiraling outward from the artist's navel across her torso, beginning with 1953, the year of her birth and the end of the Korean War.

Superimposed over her face in each piece are appropriated images taken from the historic events. The third and fourth images in the series represent two of the most significant student uprisings in recent Korean history, 19 April 1960, which marked the date of the student uprising that overthrew the government of President Syngman Rhee and the year of Min's immigration to America, and 18 May 1980, which references the Gwangju student uprising and massacre where hundreds of people were killed. The fifth image of the series marks the 1992 Los Angeles riots, which had a direct impact on the lives of many Korean American business owners located in south-central Los Angeles. The sixth and final image in the *Defining Moments* series does not reference a particular date but imagines a possible reunification of North and South Korea with the image of Paektu mountain, the mythical site and place of the Korean people located in North Korea, which serves as a symbol for the supporters of Korean reunification. Written across the Min's forehead and chest are the words "DMZ" and "Heartland," signifying both the political and symbolic separation and connection of the Korean people.[61] Min produced artworks inspired by her autobiographical life experiences as a Korean American immigrant who assimilated into American culture.

Bridge of No Return

In 1998, Min had a solo exhibition at the Art in General gallery in New York, where she displayed a large mixed media installation titled *Bridge of No Return*. The installation consisted of a long S-shaped steel structure over seven-feet high and twenty-three-feet long. It was a curved Yin-and-Yang-like installation, which consists of a tall transparent wire fence that resembled what Min saw at the DMZ in Korea. The DMZ and Bridge of No Return still exist in Korea. Perhaps Min sees herself as a child of the Cold War since she was born the year the Korean War ended. These two walls are so close together, yet so far away by political division. The Bridge of No Return, located on the 38th Parallel in the Demilitarized Zone separating North and South Korea, was where the exchange of prisoners of war took place at the end of the Korean War in 1953. This fence represents the political issues separating North and South Korea. Each side of the installation wall was covered with text, words, and images of the collective memories of North and South Korea. One result of the Korean War was that Korea was divided into two different countries, and this caused the separation of many families who are permanently and innocently cut off by the political power struggle. Those families suffered a great deal of pain and displacement experiences that left deep scars in their hearts, so the Korean people have a strong desire for reunification of their nation. This work reflected Min's own conflicted sense of attachment to and removal from her country of birth, Korea. By representing the divisions between the North and South Korean people, Min acknowledges her own feelings of displacement as a Korean American and expresses her critical perspective of the historic political power struggle.

DMZ xing

Min created another politically sensitive installation, which is concerned with the suffering of Asian Diaspora people in America. In 1994, Min had a solo exhibition in Hartford, Connecticut. The installation *DMZ xing* was about the oral history of Southeast Asian refugees in Connecticut. Min argued that how we understand ourselves, and our relationships to the world, involves history. By studying history and observing what was happening in the world, Min learned more about her self-identity. Visual narrative was a vehicle of expression for Min. There is a reality to what the refugees went through and what Min went through as an immigrant that she describes as a balancing act between two worlds Min went through as an immigrant that she describes as a balancing act between two worlds where immigrants feel severely dislocated. She believes immigrants have to acquire a new awareness to make their way through the process, which requires persons to reclaim their culture of origin. Min expresses her painful experience as an immigrant in her artworks etched with words "for those of us whose histories have been marginalized, or who have been colonized or displaced, or have lost a heartland, memories are all we have." Min combines works that communicate the cultural, historical, political, social, and psychological impact of immigrant life through personal stories. By using art as a political act, Min becomes a cultural informant and educator within the art world and raises questions about her self-identity and her Korean American cultural, ethnic identity. She ventures outside of her ethnic and gender background and presents views of worldwide cultural, historical, and political events in order to reach a wider audience.

In summation, Min's choice of subjects reflect her life experiences as a Korean immigrant and includes a critical perspective of social, cultural, historical, and political events and issues in Korea and America. She is inspired by art that comments on the human condition in which both the intellect and the heart are engaged and challenged.

Min has participated in national and international exhibitions at the Los Angeles County Museum of Art (CA), Pacific Museum (CA), Museum of Modern Art (NYC), Asia Society Museum (NYC), Whitney Museum (NYC), Queens Museum (NYC), Chicago Art Institute (IL), Walker Art Center (MN), Corcoran Gallery (Washington DC), San Francisco Museum of Modem Art (CA), Camerawork Gallery (London, UK), Kumho Museum (Korea), Baugio Art Festival (Baugio, RP), Folkwang Museum (Essen, Germany), Galena Municipal da Mitra (Lisbon, Portugal), and Havana Biennial (Havana, Cuba).

RESEARCH FINDINGS AND CONCLUSION

The development of cultural identity, self-identity, and gender identity by Suk Nam Yun and Yong Soon Min was influenced by their life experiences in the social, cultural, historical, political, and educational environment in Korea and America. Yun and Min's life experiences had a direct influence on their artistic expression. For Yun and Min, art serves as the vehicle for searching, finding, and expressing their ethnic, cultural, and self-identities. Art making helps these artists reinforce political actions that express their personal motivations. Through the art-making process and personal art expression, they gained a voice, self-knowledge, and a sense of self.

Yun believes that as an artist her contributions to society gave her self-satisfaction and personal achievement, and that it was also her public duty as a member of society to speak out. Her artistic expression and feminist activism are a symbol of actions for social and cultural transformation in South Korea. Yun's voice is more than her personal expression it is a voice for many other Korean women who cannot readily speak. Therefore, political feminist cultural activism contributes to the formation of her Korean self-identity and professional identity as an artist.

For Min, art offers her the possibilities of independence to explore a range of personal interests and concerns. Art is a personal quest for truth and meaning in what she experienced and observed as a Korean/Korean American. Social and political issues, combined with her life experiences, moved her to raise social and political issues through artistic expression whereby she began a personal reclamation of Korean history and memory. Min is searching for her identity, making reconnections with her Korean ethnic and cultural identity. Through art, she is stabilizing whom she is, negotiating with herself, and cultural identity. Through art, she is stabilizing whom she is, negotiating with herself, and finding self-resolution of a woman who is straddling Korean and American cultures. At the center of her practice, she insists, is the belief that the art-making process is a political act. She uses art as a tool for cultural criticism and to raise social, political, and multicultural issues in America.

Yun and Min allow the viewers to reconnect aesthetic values with political visions. Their art reflects the beliefs and values necessary for social transformation, and their art deals with deeply personal matters, which become highly politicized. They learn to see their lives in political terms as Korean women, as Korean immigrante, and as members of a racial ethnic minority in America. Their daily lives are permeated with socially constructed power relations of gender, race, and class; therefore, their artistic creativity, political actions, self-identity, and professional identity form a weblike relationship. Their inner desire to reconstruct a sense of self, with a passion for social justice, equity, and freedom and hope, is put into action through their art. All these aspects contribute to who Yun and Min are today as artists, feminists, cultural activists, and educators. As Collins argues, consciousness raising emerges and is based on the belief that the personal is political.[62] She asserts that breaking silence can be a triumphant process in a life experience. Min and Yun broke silence and laid the foundation for a collective group voice. By giving vision to ideas, they empowered themselves and simultaneously empowered other Korean/Korean American women and artists.

Suk Nam Yun and Yong Soon Min sought to make a difference and to try to pursue possibilities for themselves and for others in society. They take risks outside of their comfort zones to reach new possibilities for their goals by challenging cultural, social, and gender limitations. They take on difficult tasks and continuously reshape their self-identities and professional identities through the art-making process. By using art as a political feminist act, they are fulfilling their personal ideals, professional ideals, and social responsibilities, and in their minds, they are becoming whole persons. Through my research, I learned from these artists that art was the vehicle for self-development, self-identity formation, and a means to examine one's individual and cultural identity. Furthermore, art as a political act can play an instrumental role in personal and social transformation. Artists such as Suk Nam Yun and Yong Soon Min serve as role models

as cultural activists, educators, art community leaders, and consciousness-raising organizers who help others to reevaluate society from multiple perspectives. In this sense, these artists serve as important links among local communities, schools, museums, and art institutions. Furthermore, they function as mediators among national and international art communities and institutions. These artists fulfill the role of cross-cultural critics, educators, and ambassadors between America and Korea, and between the broader global community.

Hwa Young Choi Caruso is Assistant Professor of Art at Molloy College, NY. She received an Ed.D. from Teachers College Columbia University; MFA at the University of Connecticut; and BFA from Ewha Womans University, Seoul, Korea. She is Art Review Co-Editor of *Electronic Magazine of Multicultural Education* and presented a paper at the Korea institute at Harvard University.

ENDNOTES

1. L.R. Lippard, *The Pink Glass Swan: Selected Essays on Feminist Art* (New York: New Press, 1995).
2. J. Kirk and M. Miller, *Reliability and Validity in Qualitative Research* (Newbury Park, Calif.: Sage Publications, 1986). S. Merriam, *Case Study Research in Education: A Qualitative Approach* (San Francisco: Jossey-Bass, 1988). M.Q. Patton, *Qualitative Evaluation and Research Methods* (London: Sage Publications, 1990). I.E. Seidman, *Interviewing as Qualitative Research: A Guide for Researchers in Education and the Social Sciences* (New York: Teachers College Press, 1991). R.E. Stake, *The Art of Case Study Research* (Thousand Oaks, Calif.: Sage Publications, 1995).
3. N. Denzin, *interpretive Biography* (Newbury Park, Calif.: Sage Publications, 1989).
4. D.B. Wallace and H.E. Gruber, eds., *Creative People at Work* (London: Oxford University Press, 1989).
5. Denzin, *Interpretive Biography.*
6. Lippard, *The Pink Glass Swan.*
7. S. Cahan and Z. Kocur, eds., *Contemporary Art and Multicultural Education* (New York: Routledge/New Museum of Contemporary Art, 1996).
8. Ibid.
9. K.K. Lee, *Korean Family and Kinship* (Seoul, Korea: Jipmoondang Publishing, 1997). A.R. Kim, *Women Struggling for a New Life* (Albany: State University of New York Press, 1996). B.I. Koh, *Confucianism in Contemporary Korea* (Cambridge, Mass.: Harvard University Press, 1996). P.G. Min, *Changes and Conflicts: Korean Immigrant Families in New York* (Boston: Allyn and Bacon, 1998). H.J. Moon, *Korean Immigrants and the Challenge of Adjustment* (Westport, Conn.: Greenwood Press, 1999). Y.I. Song and A.l. Moon, *Korean American Women Living in Two Cultures* (Los Angeles: Academia Koreans, 1997).

Art as a Political Act | 291

10. W.M. Tu, ed., *Confucian Traditions in East Asian Modernity: Moral Education and Economic Culture in Japan and the Four Mini-Dragons* (Cambridge, Mass.: Harvard University Press, 1996).
11. Ibid.
12. Ibid.
13. H.J. Moon, *Korean immigrants.*
14. S.S. Moon, "Begetting the Nation," in *Dangerous Women: Gender and Korean Nationalism,* ed. E.H. Kim and CM. Choi (New York: Routledge, 1998), 33–66.
15. A.R. Kim, *Women Struggling for a New Life.*
16. Ibid.
17. K.K. Lee, *Korean Family and Kinship.*
18. A.R. Kim, *Women Struggling for a New Life.*
19. Y.H. Shim, "Changing Status of Women in Korean Society," *Korea Focus* 8, no. 2 (2000): 70-92.
20. Ibid.
21. Ibid.
22. K.K. Lee, *Korean Family and Kinship.*
23. M. Robinson, "Perceptions of Confucianism in Twentieth-century Korea," in *The East Asian Region: Confucian Heritage and Its Modem Adaptation,* ed. G. Rozman (Princeton, N.J.: Princeton University Press, 1991), 204–25.
24. Song and Moon, *Korean American Women Living in Two Cultures.*
25. Shim, "Changing Status of Women in Korean Society."
26. Song and Moon, *Korean American Women Living in Two Cultures.*
27. H.J. Moon, *Korean Immigrants.*
28. Ibid.
29. Min, *Changes and Conflicts.*
30. H.J. Moon, *Korean Immigrants.*
31. K.Y. Park, "The Cultivation of Korean Immigrants on American Soil: The Discourse on Cultural Construction," 1999, http://www.icasinc.org/lectures/kypl1999.html
32. K.Y. Park, *The Korean American Dream* (Ithaca, N.Y.: Cornell University Press, 1997).
33. Ibid.
34. I.S. Lee, "Korean American Women's Experience: A Study in the Cultural and Feminist Identity Formation Process" (Ed. D. diss., Teachers College, Columbia University, 1988), abstract in *Dissertation Abstracts International* 50 (1989): 1813.
35. S. Ting-Toomey, *Communicating across Cultures* (New York: Guildford Press, 1999).
36. J. Phinney, "Ethnic Identity in Adolescence and Adulthood: A Review of Research," *Psychological Bulletin* 108, no. 3 (1990): 499–514.
37. J. Phinney, "Stages of Ethnic Identity Development in Minority Group Adolescents," *Journal of Early Adolescence* 9 no. 1-2 (1989): 34–49.
38. Phinney, "Stages of Ethnic Identity Development."
39. K.Y. Park, *The Cultivation of Korean Immigrants on American Soil.*

40. L.R. Lippard, *Mixed Blessings: New Art in a Multicultural America* (New York: Pantheon Books, 1990).

41. E. Lauter, "Re-enfranchising Art Feminist Interventions in the Theory of Art," in *Aesthetics in Feminist Perspective,* ed. H. Hein and C. Korsmeyer (Bloomington: Indiana University Press, 1993), 21–33.

42. H. Hein and C. Korsmeyer, eds., *Aesthetics in Feminist Perspective* (Bloomington; Indiana University Press, 1993).

43. G. Pollock, *Vision and Difference: Femininity, Feminism, and Histories of Art* (New York: Routledge, 1988).

44. R. Parker and G. Pollock, *Old Mistresses: Women, Art, and Ideology* (New York: Pantheon Books, 1981).

45. Ibid.

46. Lippard, *Mixed Blessings.*

47. P.H. Collins, *Fighting Words: Black Women and the Search for Justice* (Minneapolis: University of Minnesota Press, 1998).

48. Ibid, 46.

49. Lippard, *Mixed Blessings,* 231.

50. M.C. Nussbaum, *Cultivating Humanity* (Cambridge, Mass.: Harvard University Press, 1997).

51. H. Gruber, "Creativity and Human Survival," in Creative *People at Work,* ed. D.B. Wallace and H.E. Gruber (London: Oxford University Press), 279–87.

52. M. Greene, *Releasing the Imagination: Essays on Education, the Arts, and Social Change* (San Francisco: Jossey-Bass, 1995).

53. M. Greene, "Diversity and Inclusion: Toward a Curriculum for Human Beings," *Teachers College Record* 95, no. 2 (1993): 211–21.

54. Ibid.

55. A. Danto, *Beyond the Brillo Box: The Visual Arts in Post-historical Perspective* (New York: Farrar, Straus & Giroux, 1992).

56. E. Eisner, *The Arts and the Creation of Mind* (New Haven, Conn.: Yale University Press, 2002).

57. K. Levin, "Seoul Searching," *The Village Voice,* 2 Nov. 1993, 104.

58. Ibid, 104.

59. A. Yang, Why Asia?: *Contemporary Asian and Asian American Art* (New York: New York University Press, 1998).

60. E. Kim and L. Villanueva, eds., *Making More Waves: Bad Women: Asian American Visual Artists Hahn Thi Pham, Hung Liu, and Yong Soon Min* (Boston: Beacon Press, 1997). G. Hesse, *Allan DeSouza, Yong Soon Min, AltenVatives.* Gallery Catalogue (Syracuse, N.Y.: Robert B. Menschel Photography Gallery, Syracuse University). H.Y. Choi Caruso, "Art as a Political Act: Expression of Cultural Identity, Self-identity and Gender in the Work of Two Korean/Korean American Women Artists" (Ed.D. diss., Teachers College,

Columbia University, 2004) in *Dissertation Abstracts International,* A64(12), 431 9 (UMI No. 3117836).

61 Hesse, *Allan DeSouza, Yong Soon Min, AlterNatives.*

62. Collins, *Fighting Words.*

Rock 'n' Roll Sound Tracks and the Production of Nostalgia

David R. Shumway

*Music plays a central role in the production of nostalgia in the nostalgia film genre.
An analysis of some of these films—especially* The Graduate, Easy Rider, American Graffiti,
and The Big Chill—*and their respective music tracks demonstrates that the genre should
not be associated with a particular politics.*

I t is risky business, as Barbara Klinger has warned us, to identify a genre with a poli-
tics. Klinger is concerned with a mode of analysis, common to film studies of the
1970s and 1980s, in which genres that deviated formally from Hollywood norms
were automatically held to be progressive. She argues that this "critical position seems
especially difficult to maintain, logically, in the face of ... 'pluralizing' forces ... that
impinge upon the internal contours and reception/consumption of the genre film."[1]
This warning should be extended to the treatment of innovative genres that are held to
be regressive, a salient example of which is the "nostalgia film" as Fredric Jameson has
described it.[2]

This article focuses on a distinctive component of several nostalgia films of the 1970s
and 1980s—the rock 'n' roll sound track—in an effort to analyze their ideology. The

David R. Shumway, "Rock 'n' Roll Sound Tracks and the Production of Nostalgia," from *Cinema
Journal*, Vol. 38, No. 2; Winter 1999, pp. 36–51. Copyright © 1999 by University of Texas Press.
Permission to reprint granted by the publisher.

use of such sound tracks must be understood in the context of the films *The Graduate* (1967) and *Easy Rider* (1969). These films not only mark the emergence of the rock sound track as a formal feature but also initiate the linking of such music with nostalgia and the generational solidarity that in later films are taken for granted. I will focus on music and the production of nostalgia in three films—*American Graffiti* (1973), *The Big Chill* (1983), and Dirty Dancing (1987)—and will briefly discuss *Baby, It's You* (1983) as a film that deals with similar situations unnostalgically. Each of these films uses music and nostalgia to different political ends, but, taken together, they call into question the assigning of any particular politics to the nostalgia film or to nostalgia itself.

To understand the importance of music in the films discussed here, one must begin with Claudia Gorbman's observation that the use of popular music in films has changed the relationship between music and image. This change becomes clear if one simply considers the irony of the title of her book on studio-era film scores, *Unheard Melodies:* unlike the classically inflected scores of yore, rock sound tracks are meant to be heard.[3] Whereas the goal of the traditional film score was to cue an emotional response in the viewer without calling attention to itself, recent

David R. Shumway is associate professor of English and literary and cultural studies at Carnegie Mellon University. He is the author of *Creating American Civilization: A Genealogy of American Literature as an Academic Discipline* (Minneapolis: University of Minnesota Press, 1994). © *1999 by the University of Texas Press, P.O. Box 7819, Austin, TX 78713-7819* sound tracks, consisting mainly of previously recorded material, are put together on the assumption that the audience will recognize the artist, the song, or, at a minimum, a familiar style. Tie-ins between films and sound track recordings have become so important that producers now routinely hire musical consultants to assemble a collection of songs that not only will make the movie more appealing but will also lead to sales in music stores.

The films to which this trend may be traced, *The Graduate* and *Easy Rider,* both spawned highly successful sound track albums. But these films and the others I will be discussing differ from the run-of-the-mill movie with a popular music sound track. The music in these films is meant to be not merely recognized but often to take the foreground and displace the image as the principal locus of attention. Moreover, the music in these films secures a bond between consumer and product while also arousing a feeling of generational belonging in the audience.

The Graduate. *The Graduate* has been credited with being the first film to use previously recorded popular music in place of an orchestral film score. As is well known, director Mike Nichols asked Paul Simon to write some original songs for the film but in the end decided to use several already recorded songs by Simon and Garfunkel instead. Nichols's use of music is striking in part because of its relative scarcity. Indeed, in the case of "Mrs. Robinson," a song specifically written for the movie that later became a hit, only the chorus and instrumental bridge are heard. Although Dave Grusin is credited with writing the

score, *The Graduate* usually has no scoring except when Simon and Garfunkel's songs are heard. This makes their songs all the more significant to the viewer because they constitute almost all of the movie's extradiegetic music.

The Graduate opens to Simon and Garfunkel's earlier hit, "Sounds of Silence," while we watch Benjamin Braddock (Dustin Hoffman) arrive at the Los Angeles airport. The visuals, although filmically inventive, are intentionally "boring": we see Benjamin on a moving sidewalk as the camera tracks alongside him so that we see only the blank wall moving behind him. In this minimalist visual context, the song claims a greater share of the viewers attention, and its complex lyrics, while not likely to be comprehended completely, establish the theme of alienation that the narrative will explore. In this instance, the song comments on the narrative. Such commentary is one of the major ways popular songs have been used ever since.

The Graduate also uses popular music in the service of nostalgia. "April Come She Will" and "Scarborough Fair/Canticle" accompany montage sequences, one depicting the relationship between Benjamin and Mrs. Robinson (Anne Bancroft), and the other, Benjamin's pursuit of Elaine Robinson (Katherine Ross). Both these songs also comment on the narrative action, but in addition, they serve to create an elegiac mood, a sense of retrospection lacking in the diegesis itself. *The Graduate* is not presented with a voice-over telling us that we will get a glimpse of that narrators past, but its bildungsroman-like plot strongly implies it. The montage sequences telescope the diegetic time just as our memories select certain experiences for detailed preservation and consign others to be classified as examples of our larger experience. Although all of *The Graduate* may be understood as Benjamin's recollection, the two sequences focused on here convey the strongest sense of being already complete as we witness them. "April Come She Will" and "Scarborough Fair/Canticle" share the common theme of lost love, a frequent object of nostalgia in Western culture. They are also presented as *folk songs*, distinguished by their simple melodies and sparse accompaniment from "Sounds of Silence" and "Mrs. Robinson," which have rock arrangements. In short, the lyrics and the music of "April Come She Will" and "Scarborough Fair/Canticle" recall past times. In 1967, rock 'n' roll was young enough that it could not readily produce nostalgia.

Easy Rider. By contrast, *Easy Rider,* another important work in the genealogy of the nostalgia film, does not use music to create nostalgia; however, it shares with *The Graduate* not only its use of popular recorded music but its strong sense of generational identity. *The Graduate* carries the theme of generational strife from Benjamin's refusal to play the clown for his parents' guests at the opening party to his cross-swinging rescue of Elaine from the marriage her parents arranged. Simon and Garfunkel's songs encourage the identification of Benjamin with a disaffected generation and discourage our seeing him for the isolated, idiosyncratic individual he might otherwise seem. *Easy Rider* also depicts generational antagonism, but it trades much more strongly than *The Graduate* on pop music as the emblem of youth culture.

The use of recorded music in *Easy Rider* was also seen as a major innovation in popular film, even though Kenneth Anger had used the same approach in his avant-garde classic *Scorpio Rising* (1963).[4] The music in *Easy Rider* often becomes the focus of attention. For long stretches of the ride east from California to violent death someplace between New Orleans and Florida, *Easy Rider* presents the two motorcyclists riding against the background of a changing landscape and songs that comment on their adventure. The sound-track album was the first multi-artist record of its kind to become a significant sales success. As in *The Graduate,* none of the music here is literally diegetic, but all of it is meant to be heard. Some of the songs, such as "Born to Be Wild," seem almost redundant because their subject matter so closely parallels the narrative and characters. Others, like "The Pusher," ironically undercut the information we get from the images.

The most important effect of the music is not to provide commentary, however, but to foster generational solidarity. The music doesn't distance us from the action but encourages us to identify with the film's protagonists and with "our" generation, whom they are supposed to represent. It is the music we hear on the sound track—more than dress, drugs, or wanderlust—that leads us to identify with Billy (Dennis Hopper) and Wyatt (Peter Fonda) and to define ourselves against various others represented in the film: straights, rednecks, cops, and so forth. As Simon Frith argues, "Rock ... is about difference and what distinguishes us from people with other tastes. It rests on an ideology of the *peer group* as both the ideal and reality of rock communion."[5] Music in *Easy Rider* is the central way such communion is represented since the film's plot and images are strongly individualist. Music may be especially well suited to conveying a sense of collectivity. Theodor Adorno and Hanns Eisler argue that

> Music in the cinema is one aspect—in an extreme version—of the general function of music under conditions of industrially controlled cultural consumption. ... Ordinary listening, as compared to seeing, is "archaic"; it has not kept pace with technological progress. ... For this reason, acoustical perception preserves comparatively more traits of long bygone, pre-individualistic collectivities than optical perception.[6]

Easy Rider and, indeed, rock in general may trade on this characteristic of music to build a sense of a specific, generational collectivity.

It is important to emphasize that *Easy Rider* is not a simple celebration of the ideal rock communion but a lament for its unreality. That unreality is registered in two events at the end of the film. The first is Wyatt's assertion that they "blew it," a reference to the failure of their trip to locate either a spiritual or a material Promised Land. The second is, of course, their murder. The first of these events suggests that the communion is itself illusory: Billy and Wyatt are outlaw individualists whose actions reveal that they are incapable of genuine communal behavior. But even if we give them credit for learning this, their murder implies that such communion is impossible. *Easy Rider* creates a powerful

sense of generational solidarity only to undermine and finally destroy whatever Utopian possibilities such solidarity might offer. The film leaves us united in our anger and our difference from "them," but without any hope that our difference can make a difference. Thus, we might see *Easy Rider* as a film about why nostalgia films became necessary. If the rock 'n' roll communion could no longer plausibly be located in the present or future, it could be placed in a fictional past.

American Graffiti. It has been asserted that *American Graffiti* (1973) "almost single-handedly invented fifties rock & roll nostalgia."[7] Jameson has called it "the inaugural film of [a] new aesthetic discourse," the "nostalgia film," or what French critics have called *le mode retro,* which Jameson has taken to be a prime example of the postmodern effacement of history.[8] Although I will show that *American Graffiti* does efface history as Jameson claims, my larger argument calls into question the idea of the "nostalgia film" as Jameson defines it.

To understand nostalgia in film, we need to start with the larger meaning of *nostalgia* in the current cultural context. The term is, of course, far too polysemie for its range of meanings to be adequately represented here, but there are two that I want to isolate. The first meaning, which is assumed in many other meanings as the root or authentic sense of the term, is the subjective experience of an emotional state or consciousness of longing for one's own past. Such personal nostalgia is a very common experience, and it permits the second kind, which I will call commodified nostalgia, to function.

Commodified nostalgia involves the revival by the culture industry of certain fashions and styles of a particular past era. Such revivals have precursors in architectural and other cultural revivals of the nineteenth century and in the various manifestations of antimodernism in early-twentieth-century America.[9]

Commodities were produced and sold during this era to people who wanted to revive long-dead historical epochs such as the Middle Ages or the Renaissance. Notice, however, that in this instance nostalgia is used by analogy with the personal experience, since no one living could actually have such experiences.

The twentieth century marks a new stage in the commodification of nostalgia because the eras to be revived had already been defined by representation in the mass media. The existence of widely read newspapers with similar contents, followed by magazines, newsreels, radio, and finally TV, meant that popular fashions and events were much more widely shared experiences. Previously, bits of the recent past lacked sufficient popular identity to receive such treatment. Moreover, the growth of mass media also made commodified nostalgia increasingly available as the century progressed. From Frederick Lewis Allen's *Only Yesterday* (1931) to the emergence of pop music "standards" in the swing era and the nostalgia films of that period to television of the 1950s with its continuous "revivals" of old movies, an ever-more-recent past came to be packaged nostalgically. The revival of such recent history made it possible that actual nostalgia for personal experience

of that time might be called up. Such commodified nostalgia evokes the affect of nostalgia even among those who do not have actual memory of the period being revived.[10]

Jameson argues that "nostalgia films restructure the whole issue of pastiche and project it onto a collective and social level, where the desperate attempt to appropriate a missing past is now refracted through the iron law of fashion change and the emergent ideology of the generation." Jamesons emphasis is on the way such films render the "'past' through stylistic connotation, conveying 'pastness' by the glossy qualities of the image, and 1930s-ness or 1950s-ness by the attributes of fashion."[11] Although the music in *American Graffiti* certainly fits this description, its role there is not exhausted by it. It is my contention that music is the most important ingredient in the production of the affect of nostalgia or the recollection of such affective experience in the viewer. What leads me to this claim is that "golden oldies" have long been offered to radio listeners precisely as an aid to personal nostalgia. The convention that popular songs call up for us memories of earlier periods in our lives is so powerful that we might be inclined to call oldies the tea-soaked madeleine of the masses. But if hearing an old song on the radio invites us to remember our own past, movies use the same technique to evoke the fiction of a common past. Popular music works because it was and is widely shared, but not necessarily because the audience literally remembers the songs.

In this last case, popular music functions like classical film scores in that what is significant is the style of the music, although the style has a very specific temporal association usually absent from classical film music. *American Graffiti* appealed to an audience that included many too young to have grown up with the music in the film. Thus, the songs need not literally bring the past to life for the viewer but give the impression of such an experience, creating a fictional set of memories that, especially when taken together with other such representations, may actually come to replace the audience's "original" sense of the past. Of course, those who lack any other representation of the period will be all the more likely to assume that the representation in the film is "true."[12]

This process of fictionalizing the past is all the more effective in that what is brought to mind is not unfamiliar, even though the audience never actually lived through it. Some of the songs—for example, "Johnny B. Goode," "Surfin' Surfari"— are likely to be recognizable precisely as oldies. Others are used for their association with previous representations of "the fifties." The group performing at the high school dance opens with "At the Hop," a song that would be familiar to much of the film's audience as a result of the popularity of the rendition by the fifties revival band Sha Na Na. The music reminds us repeatedly that we are in the fifties. Costumes, slang, and, perhaps most important, the automobiles also have this effect, but none of these elements evokes a sense of temporal specificity as much as the music. And yet it is only a sense, since the songs on the sound track are not the ones a typical radio station would have played in 1962–63, when *American Graffiti* is set. Instead, we hear a sampling of hits from the years before the Beatles, records that made it on to the *Billboard* Hot 100 between 1955 and 1962. In short, the music we hear is idealized "fifties music," rather than the music of a particular historical moment.

Nevertheless, the radio serves as the presumed source for most of the music in the film. Even before the first shot of the film is seen, Wolfman Jack announces a song. Thus, it is as if the entire movie takes place with one radio station playing in the background, although we may occasionally move out of range of it or, in the case of the hop, to a place where similar music is playing from a different source. Given the ubiquity of the music and the fact that its volume changes without clear narrative explanation (e.g., the music is always loud when we get an establishing shot of Mel's Burger World, but the volume then decreases to allow conversation to be foregrounded), we cannot classify the music in *American Graffiti* as straightforwardly diegetic even though the movie wants the viewer to assume its quasi-diegetic origin. Rather, the line between diegetic and nondiegetic is impossible to establish. Music doesn't come from particular places in the film's space; it pervades that space.

Its function is not mainly to convey this or that mood or emotion but to constantly keep the viewer located somewhere else, in a time and a place that is gone, lost, but not related historically to the present. Music is the primary means by which an alternative world, "the fifties," is produced for the viewer.

The first song we hear is, appropriately, Bill Haley and the Comets' "Rock around the Clock." This is appropriate not only because it is widely regarded as the first rock 'n' roll song but also because it opens and closes *Blackboard Jungle* (1955), one of the 1950s juvenile delinquency films that constitutes much of the "past" to which *American Graffiti* refers. Virtually all the characters in the film are familiar from movies or television: the j.d. gang, the pharaohs, the hot rodders, the nerd, the head cheerleader, and the class president. Only Richard Dreyfuss's Kurt seems not to have come from some other representation of the era. Thus, not only the music but the entire film is a representation of well-known representations of youth in the 1950s. It is the seamlessness of this system that has allowed *American Graffiti* to be used as a prime example of the postmodern image-society, in which images are supposed to replace any more substantial understanding of past or present. Although this may seem to be an extreme overstatement when applied to an entire period of history, it is an accurate enough account of the way nostalgia works in this particular film. Nostalgia by definition involves the idealization of a lost time or place, but what is lost need not be entirely fictional. In *American Graffiti,* however, an entire "era" has no existence outside the entertainment industry. Thus, *American Graffiti* is fundamentally a conservative film that offered its post-Vietnam, post-1960s audience a glimpse of the America it would rather see, one that has no apparent connection to the war and protests that dominated the news media.[13]

But what of the sense of collectivity that film music has been said to bring to the viewers perception? *American Graffiti* would seem to bear out Eisler and Adorno's warning that this evocation of the collective is highly prone to ideological misuse.[14] We are invited by the music to imagine a past that is precisely shared, yet such a felt attachment is entirely at odds with the individualism of the narrative. We are presented with what is purportedly a group of teenagers, yet their connection to each other is tenuous and almost random.

Moreover, the film's ending, in which we are given brief bios of the main characters, clearly valorizes the career of Kurt, the one who manages to escape. There is no community in *American Graffiti,* but the music makes us forget this.

The success of *American Graffiti* led to several conservative trends in Hollywood filmmaking. But, *pace* Jameson, the use of period setting per se was not one of them. As Mike Davis has demonstrated, *Chinatown* (1974) is a genuinely historical film, however slick its appearance.[15] Rather, *American Graffiti* spawned a series of movies focusing on adolescents, a trend still in evidence today. Moreover, the profits from the film enabled George Lucas to make the *Star Wars* trilogy, three movies about longer ago and farther away, and to redeem war and revivify notions of the "evil empire" in the process. *American Graffiti* also established a new model wherein popular recorded music was used without a clear distinction between diegetic and extradiegetic origin.

The next two films I will discuss follow this model, although neither of them is as insistent on preserving the semblance of diegetic location. Both films also produce nostalgia, but in neither case is it for a completely fictional time and place.

The Big Chill. *The Big Chill* is actually less a nostalgia film than a film about nostalgia.[16] When Chloe (Meg Tilly), the late Alex's youngish girlfriend, observes, "I don't like talking about the past as much as you guys do," she calls our attention to the nostalgia in which the others are constantly engaged. Unlike *American Graffiti,* which seeks to present the fifties as a seamless whole, *The Big Chill* constantly frames and reframes the sixties. The characters offer a variety of metonyms for the period: hope, commitment, political activism, drugs, love, and friendship. Such explicit discussion of the period makes it clear that it is a conflicted representation and thus does not offer us a total immersion into lost time. Yet like *American Graffiti, The Big Chill* relies on the music to represent the sixties directly to the audience. Also, as in *American Graffiti,* a selection of hit records is used, spanning a period of roughly six or seven years. Since most of the music in *The Big Chill* makes its way into the diegesis as records Harold (Kevin Kline) chooses to play, it is not explicitly offered as a sample of music of the period. Rather, it is offered as the music the group listened to when they were student radicals. What is strange about this is that the music includes nothing overtly political, not even Bob Dylan, and psychedelic music is excluded entirely. The sound track includes only one British song and features several songs likely to be held in contempt by the anti-Establishment students this group is supposed to represent: Three Dog Night's "Joy to the World" and the Beach Boys' "Wouldn't It Be Nice?" The dominant musical genre might be characterized as mainstream soul, including five records by Motown artists and two by the blue-eyed soul group the Rascals. Thus the music seems not to characterize the protagonists but to evoke the sixties for the film audience in a noncontroversial way.

This use of sixties popular music parallels the general ideological work of *The Big Chill:* the salvaging of the sixties from its radical politics. Exactly what kind of politics the group practiced is never clear, and the only specific incidents mentioned are a few large national

demonstrations. Each member of the group is portrayed as some kind of failed reformer (public defender, ghetto teacher, social worker, etc.), but most of them have ended up as materially successful professionals, each trying to "get what he wants," as one character puts it. They should be satisfied with their lives, but Alex's death reminds them that something is missing.

It's worthwhile here to explore in some detail an example of the interrelation of music and image that articulates this theme. At the conclusion of Alex's funeral, it is announced that one of Alex's favorite songs will be played. Karen (Jo Beth Williams) takes a seat at the organ and begins to "play" the opening strains of the Rolling Stones' "You Can't Always Get What You Want." The rendition is unusual in that it opens with a church organ prelude. As a result, in the beginning of the sequence, the music is absolutely diegetic and perfectly appropriate as a funeral posilude. Even viewers familiar with the song are not likely to recognize it right away. Thus, they experience the dual pleasure of recognition and of being cleverly misled. The opening shots of this sequence show members of the group having the same experience of recognition as they sit in the church, almost as if to clue the spectator about how to respond. The songs chorus is also ironically appropriate for the funeral of a suicide victim, since Alex clearly did not get what he wanted, but didn't manage to get what he needed either.

As the music shifts to the R & B-styled song itself, the music becomes nondiegetic (a trope that this film will use many other times), and the images are of the various members of the group leaving the funeral. The song's volume is lowered to allow for dialogue in various automobiles but raised to the foreground during shots that present the movement of the funeral procession as a whole. The song thus serves sonically to bind the members of the group together, to encourage *our* identification with them through the repetition of a record with which we (the baby-boomer audience for which this film was made) are likely to have already identified, and to locate both these connections in the era in which the Stones' song was released. The latter is reinforced by the dialogue and the action, for example, smoking dope. Moreover, the group members' interactions let us know that not only Alex couldn't get what he wanted.

"You Can't Always Get What You Want" underlines the point that *The Big Chill's* characters feel that they have settled for less than they wanted and that something is missing. What is evoked for them by their reunion is not only this emptiness (the big chill?) but the comparative fullness of their former existence together. I take this to be an instance of genuine nostalgia (i.e., a homesickness for something that within the diegesis of the film was real). Much of this nostalgia is nonetheless trivial: the football games, for example, both watched and played. But in this nostalgia there is also a shared Utopian moment, the recollection of the group's communal being and identity. This is evoked by a reference to a plan to buy land together and the repeated assertion of the group members' love for each other. More important, the communal vision is reinforced by the events in the film. Given the social fragmentation of our world, even the gathering of so many of this group for a college friend's funeral could be considered Utopian. Their staying together for the

weekend and their obvious genuine friendship for one another is thus all the more idyllic, especially when we learn that the group has a history of romantic involvements that rival those of the couples in a John Updike novel.

Like *Couples, The Big Chill* gives us a picture of an alternative form of community defined in part by its incestuousness and its violation of the rules of monogamy. Ultimately, the film is unwilling to endorse the vision it evokes; Jeff Goldblum's ironic joke that ends the film—"We've taken a vote; we've decided we are never going to leave"—is meant to suggest the impossibility of communal life being sustained for more than a few days, even as it also expresses the desire for such a life. That it would be impossible given who these people have become is, of course, accurate enough, but the film seems to question their individualism in spite of itself. If the music in some way embodies the group's community, it also functions to deny the contradictions that exist between such Utopian desires and the reality of alienated life under capitalism. In other words, the music gives us the illusion of a community that the film's narrative, like contemporary social life, cannot sustain.

Dirty Dancing. *Dirty Dancing* was the most recently produced of the nostalgia films, but in its setting and themes it seems to fit between *American Graffiti* and *The Big Chill*. Actually, *Dirty Dancing* is set in 1963, nearly the same year as *American Graffiti*, although you would never know it from the film's visual or aural cues. Where the latter film used mainly hit records from the fifties, *Dirty Dancing* includes more obscure songs that are more genuinely contemporary with the summer in which it was set.[17] *Dirty Dancing* also begins with the radio (in this case, the DJ is Cousin Brucie), and the first several songs we hear are likely to be quite familiar: the Ronettes' "Be My Baby" and the Four Seasons' "Big Girls Don't Cry." In addition to their commentary on the film's story, the education of Frances "Baby" Houseman (Jennifer Grey), the songs' familiarity serves to evoke nostalgia for a specific historical moment. It is the period before the Beatles and the Kennedy assassination, a period of national innocence that parallels Baby's own, when she thought she "would never find a guy as great as [her] dad." The other songs of the same historical moment in which the film is set produce nostalgia, much as those in *American Graffiti* and *The Big Chill* do. However, *Dirty Dancing* also contains songs that were newly composed for the film and that are distinctly anachronistic in style and/or production. These do not produce nostalgia in the same way and in fact might be read as disrupting the nostalgia effect.

Many of the records used in *Dirty Dancing* seem to be in the service of another agenda besides the production of nostalgia. If *American Graffiti* is essentially, if covertly, conservative and *The Big Chill* overtly, if somewhat ambiguously, postradical, *Dirty Dancing* is plainly and simply liberal. It is nostalgic, in fact, for liberalism. Baby is one of *The Big Chill*'s reformers before she went to college. She repeatedly asserts that her father taught her to want to change the world, and the film refers to the incipient war in Vietnam and the fight for civil rights in the South as causes for which Baby shows concern. Such

references are often politically meaningless, as they are in *Forrest Gump* (1994), but in *Dirty Dancing* they serve the film's overtly liberal agenda.

Surprisingly, given the Hollywood of the 1980s, *Dirty Dancing's* central conflict centers on social class. Music is used to help define the working-class world and distinguish it from Baby's middle-class one, and that music is not just rock 'n' roll but rhythm and blues. Johnny (Patrick Swayze) and his friends dance to records by black performers that are unlikely to have been readily familiar to the 1987 audience. For example, the Contours' "Do You Love Me?" and Maurice Williams and the Zodiacs' "Stay" are likely to be remembered if at all from recordings by the Dave Clark Five and the Four Seasons, respectively. Although Otis Redding became a major star by the end of the 1960s, his songs used in the film, "These Arms of Mine" (Reddings first single) and "Love Man," were not big hits. This mild defamiliarization makes the music seem fresh and thus conveys its transgressive character. It is the dancing Baby witnesses that both shocks and attracts her during her first visit to the staff quarters, but the music is the aural equivalent of the dirty dancing she sees. "Do You Love Me?" and "Love Man" are both produced with the raw edge that came to define the sound of Stax/Volt recordings of the early and mid-1960s. These songs recall the rhythm and blues recordings of the early 1950s that white rock 'n' rollers often covered. The raucous guitars and saxophones, forward-mixed percussion, and shouted or otherwise distorted vocals distinguish these recordings not only from the music adults were listening to but from the songs that dominated the pop charts in the early 1960s. Both the dancing and the music are thus beyond the pale of middle-class propriety.

It is curious that, of the three films under discussion here, *Dirty Dancing* is the only one that in any way evokes the subversive or transgressive experience with which rock 'n' roll was associated. The music in *American Graffiti* is treated as completely naturalized and tame. There is no indication that anyone could find such music shocking or objectionable. Thus, the film's opening homage to *Blackboard Jungle* seems unintentionally ironic; whereas "Rock around the Clock" had been accused of inciting riots among some audiences of that 1955 film, here it serves merely to remind us that we are in that quaint and innocent time called the fifties. I have already noted the absence of protest music and psychedelic experimentation in *The Big Chill*. *Dirty Dancing* portrays the R & B records played by its working-class characters as sexually liberating and as transgressive of the aesthetic and moral norms of the middle-class adult culture of the Catskills resort. Whether or not we want to accept that such music was subversive in any serious way, it is important to recognize that it was felt to be so. To fail to recognize this is once again to deny the reality of cultural conflict. *Dirty Dancing* does more than recognize the cultural conflict over rock 'n' roll, however: it reinterprets it. Although other nostalgia films deal with the ideology of the same generation, rock 'n' roll in *Dirty Dancing* is mainly a marker of socioeconomic class. The film does not deny generational solidarity so much as it gives it a new, class-associated meaning.

The plot of *Dirty Dancing* is in several respects typical of older Hollywood cross-class romances, with one significant difference: *Dirty Dancing* is told from the woman's point

of view. If we accept Susan Douglas's argument—that early 1960s girl-group music helped teenaged girls of that period value and accept their own sexuality—we can understand such songs as early instances of enunciation from such a point of view.[18] In the Shirelles' song "Will You Love Me Tomorrow?" for example, the singer wants to know whether her boyfriend will still love her after she has sex with him. The film presents a negative example of this sort of adolescent conflict in Robbie (Max Cantor), a Harvard-educated Lothario who impregnates and abandons a woman. The girl-group music in *Dirty Dancing* reinforces the identification of the spectator with Baby, and it contributes to our sense that the story is one *she* is telling. Although *Dirty Dancing* was directed by a man, Emile Ardolino, one suspects that authorship of the film belongs with writer and coproducer Eleanor Bergstein and producer Linda Gottlieb. These women may be responsible for the film's progressive stance on a number of issues.

Baby is portrayed not only as attracted to a working-class man but willing to risk her reputation to help him. Early in the film, Baby overhears the owner of the resort lecturing his staff about their relations with the guests. The waiters, who have been recruited from Ivy League colleges, are encouraged to "romance" the girls. The working-class entertainers, however, are instructed to stay away from the girls, and they are clearly treated as undesirables. Cross-class romance is thus specifically prohibited. Baby's motives for violating this rule are at first curiosity and later romantic interest in Johnny, but as a result she learns a political lesson about the injustice of class divisions. The film makes the ideological conflict crystal clear when Robbie tells Baby that some people count and others do not and hands her an Ayn Rand novel. That position clearly loses out, when even Baby's father admits that he misjudged Johnny. However, the resolution of the characters' diegetic conflicts may also leave the viewer with the illusion that such conflicts can be easily resolved off screen as well.

Dirty Dancing literally avoids Hollywood's usual happy-ever-after ending by framing Baby and Johnny's romance as a summer fling, but this also contributes to the film's nostalgia. Since the story is explicitly told as a recollection, we are encouraged to feel the loss not only of innocence but of a particular time and place. The resolution conveys the same message as in *The Big Chill:* values such as social justice are an illusion of innocent youth. This nostalgia effect exists in contradiction to the message of the narrative itself, that individual commitment can make a difference. Although the latter message is less radical than the communal vision of *The Big Chill, Dirty Dancing* conveys a sense of political possibility at this level that the other film works to deny.

To the extent that nostalgia is a product of historical re-creation, that produced by *Dirty Dancing* is limited compared with that produced by *American Graffiti. Dirty Dancing* is much less concerned with displaying the appropriate styles, so that it lacks the high-gloss surface Jameson criticized. The use of music is more in keeping with its role in classical Hollywood cinema. There is no diegetic excuse for many of the songs that are used. The film has traditional scoring that accompanies many scenes without recorded music. More important, *Dirty Dancing* almost certainly needs to be understood as a variation on an old

Hollywood genre, the backstage musical. Although narrative realism is never violated by un-motivated singing, the film incorporates several production numbers that at the very least reach the limit of such realism. That these performances are accompanied by newly composed songs may be seen to heighten their unreality. In this move, *Dirty Dancing* seems to break its own carefully constructed frame, to move from the "reality" of another time to become an explicit movie fantasy.

The films concluding production number embodies these contradictions of style and meaning. The scene opens with Johnny returning to the resort after having been thrown out. He announces that, as originally planned, he will conclude the talent show already in progress, and he invites Baby to perform the dance they did earlier at another hotel. Baby and Johnny dance to "The Time of My Life," a new song but one sung by former Righteous Brother Bill Medley. The song's production is recognizably 1980s, but the track as a whole is reminiscent of 1960s hits Phil Spector produced for the Righteous Brothers, such as "You've Lost That Lovin' Feeling" or "River Deep, Mountain High." Both the dancing and the song are triumphant and seem designed to make us forget the very temporality that the film earlier insisted upon, giving viewers in effect the classic Hollywood ending—including the final embrace. This exultant fantasy gives the film a powerful note of hope that its historical framing should have prohibited. In other words, the Hollywood ending here could be read not as an ideological diversion but as progressive in that it leaves viewers with a feeling of political possibility.

Baby, It's YOU. Whether *Dirty Dancing*'s excursions beyond realism further derealize the film's ideology or position the audience to question the nostalgic framing of such politics remains an open question. However, it is worth considering another film about 1960s youth culture that strives for a different kind of realism than any of the films discussed so far. Although set in 1967, *Baby, It's You* (1983) is not a nostalgia film in Jameson's sense.[19] The period that writer/director John Sayles depicts is one for which we are encouraged to feel only the most ambivalent longing. Rather than depicting "the time ofones life," *Baby, It's You* tells the story of a difficult—and ultimately impossible—cross-class romance, portrayed as exciting and dangerous but predominantly unhappy. Whereas the other films are more or less relentlessly pretty to look at (*The Big Chill* even makes dressing a corpse look pretty), the urban New Jersey landscapes and interiors in *Baby, It's You,* as well as its very cinematography, are gritty. Yet in spite of its depiction of mundane social space and its frank acknowledgment of class oppression, the film offers little hope regarding its working-class hero's future. *Baby, It's You* seems not only less hopeful but also less critical and less political than *Dirty Dancing* because it fails to treat class conflict in any terms except as a barrier to romance. The music in *Baby, It's You* is less significant than it is in the other three films, but at first it seems to be used to reach similar ends. Like *Dirty Dancing, Baby, It's You* uses a good bit of girl-group music and perhaps for the same reason: it is also mainly the story of a young woman, Jill (Rosanna Arquette). But in *Baby, It's You* popular records often function more like classic film scores, serving to augment the

emotional character of the scenes. This may explain why the film can get away with using anachronistic Bruce Springsteen recordings from the 1970s. Moreover, the other films portray a unified musical field, whereas Sayles uses music to reveal two cultural conflicts. One becomes apparent in the hero's obsession with Frank Sinatra, which renders impossible the sense of generational solidarity cultivated in the other films. Having a rock band play "Strangers in the Night" in the films concluding scene drives this point home.

The second conflict is expressed by the changes in the music as the decade matures and the heroine moves from her New Jersey high school to Sarah Lawrence College. Although the earlier music would fit perfectly into the other three films, the later music includes songs such as Al Kooper's "(First I Heard Her Say) Wake Me Shake Me" and the Velvet Underground's "Venus in Furs." These musical ruptures interfere with any nostalgia effect that *Baby, It's You* might produce. Yet even though the film s look and its sound prohibit nostalgia, it fails to convey any sense of political possibility. It ultimately seems to be another bildungsroman, like *American Graffiti*—the story of one who escapes, a portrait of an artist as a young girl.

Conclusion. What should be clear, from the discussion of these several uses of nostalgia, is that the "nostalgia film" as Fredric Jameson describes it exists only as one variant of the commodification of nostalgia. If Jameson got *American Graffiti* right, he grossly overestimated it as the embodiment of a trend in filmmaking and, more important, of a new consciousness. As my allusions to modernist texts may have suggested, neither nostalgia nor the other formal characteristics of these films are distinctly postmodern. In spite of their differences, however, the films have several characteristics in common. Each film represents youth by means of the recorded music used on its sound track, and in these films (and in our culture generally), youth is the privileged site of nostalgia. Three of the four films choose the same moment of youth—the end of high school/beginning of college—as their focal point. Although this moment has all kinds of hoary cultural resonances, the key one for these films is as a last moment of freedom from the responsibilities of adulthood. The protagonists "grow up" in one way or another. In this light, we might read *The Big Chill* as a film about people who didn't grow up until much later, their college years thus representing the same kind of innocence that high school represents in the other movies. Each of these films also depicts youth as a period of sexual initiation and experimentation. Doubtless much of the appeal of nostalgia for one's youth is rooted in the memory of adolescent sexuality. Nostalgia is important here because such memories are often of terribly painful and threatening experiences.

Proust said that when he actually lived his life it was troubled by feelings of fatigue, sadness, and anxiety, feelings that are absent from his artistic re-creation of his life.[20] The combination of music and narrative in *American Graffiti*, *The Big Chill*, and *Dirty Dancing* may allow such pleasurable rewriting to occur in the minds of spectators. The conflicts presented both musically and narratively in *Baby, It's You*, by contrast, may prohibit such nostalgic rewriting.

These considerations lead one to question the possibility of assigning anything more than highly local or narrowly temporal validity to the association of particular generic or formal features with specific political agendas. All politics must move among different temporal settings—past, present, and future—and must present not only a creditable sense of reality but a hopeful vision of the future. It is as untenable to claim that nostalgia is always conservative or reactionary as it is to assert that a more distanced or critical representation of history is always progressive.

NOTES

I want to thank Frances Bartkowski for conversations about *Dirty Dancing* and Paul Gripp, Valerie Krips, and *CJ*'s two anonymous readers for their helpful comments and suggestions. The usual disclaimers apply.

1. Barbara Klinger, "'Cinema/Ideology/Criticism' Revisited: The Progressive Genre," *Screen* 25, no. 1 (1984): 89.
2. Fredric Jameson, *Postmodernism, or, the Cultural Logic of Late Capitalism* (Durham, N.C.: Duke University Press, 1991), xvii, 18–19.
3. Claudia Gorbman, *Unheard Melodies: Narrative Film Music* (Bloomington: Indiana University Press, 1987), 162.
4. R. Serge Denisoff and William D. Romanowski, *Risky Business: Rock in Film* (New Brunswick, N.J.: Transaction Press, 1991), 168–69, call *Scorpio Rising* "the first dramatic film to incorporate rock music." They cite *Scorpio Rising* and *The Graduate* as precursors of *Easy Rider*'s "use of rock music as an artistic statement complementing plot and visual images."
5. Simon Frith, *Music for Pleasure: Essays in the Sociology of Pop* (New York: Routledge, 1988), 213.
6. Theodor Adorno and Hanns Eisler, *Composing for the Films* (London: Athlone, 1994 [1947]), 20-21.
7. David Erhrenstein and Bill Reed, quoted in Frith, *Music for Pleasure,* 207.
8. Jameson, *Postmodernism,* xvii, 18–19.
9. David Lowenthal, "Nostalgia Tells It Like It Wasn't," in Malcolm Chase and Christopher Shaw, eds., *The Imagined Past: History and Nostalgia* (Manchester: Manchester University Press, 1989), 20–21; Jackson Lears, *No Place of Grace: Antimodernism and the Transformation of American Culture, 1880–1920* (New York: Pantheon, 1981).
10. There is another sense of *nostalgia:* its use as a pejorative judgment on any recollection of the past. By calling references to the past nostalgic, the motives for such references are impugned, usually in favor of (an often unstated) assumption of historical progress. This point is significant because I want to insist that nostalgia is

a particular attitude toward or construction of the past, and not all representation of the past or its artifacts is nostalgic.

11. Jameson, *Postmodernism,* 19.

12. Lynn Spigel, "From the Dark Ages to the Golden Age: Women's Memories and Television Reruns," *Screen* 36, no. 1 (Spring 1995): 23–30, notes that television reruns came to represent the past for many of her students.

13. Thus, I am in agreement with Colin MacCabe's assertion in "Theory and Film: Principles of Realism and Pleasure," *Screen* 17, no. 3 (Autumn 1976): 21, that *American Graffiti* avoids "a specific set of contradictions—those raised by the impact of the Vietnam War on American society," but I disagree with MacCabe's larger analysis that such avoidance of contradiction is the result of the realism it shares with most other Hollywood films. What distinguishes *American Graffiti* is the particular means by which it renders the past as an experience of nostalgia.

14. Adorno and Eisler, *Composing for the Films,* 21.

15. Mike Davis, *City of Quartz: Excavating the Future in Los Angeles* (London: Verso, 1990), esp. 21, 44, and chap. 1, "Sunshine or Noir."

16. Interestingly, director and cowriter Lawrence Kasdan s first feature, *Body Heat* (1981), is cited by Jameson, *Postmodernism,* 20, as an instance of reverse nostalgia, the "colonization of the present by the nostalgia mode," because the film depends on our awareness of its film precursors, such as *Double Indemnity.* See also Slavoj Zizek, *Looking Awry* (Cambridge: MIT Press, 1991), 112.

17. This principle of selection was not used rigorously, however. Otis Redding's "Love Man," for example, is from the late 1960s. But because these anachronistic songs are unfamiliar, they seem less designed to contribute to the representation of a fictional time than to represent a distinct style defined against the popular music on the radio.

18. Susan Douglas, *Where the Girls Are: Growing up Female with the Mass Media* (New York: Times Books, 1994), 83–98.

19. It is worth noting, however, that John Sayles's first film, *The Return of the Secaucus 7* (1980), is often cited as the most significant precursor of *The Big Chill.* Although *The Return of the Secaucus 7* is almost a home movie and anything but slick or glossy, it does establish Sayles's general interest in nostalgia.

20. Milton D. Miller, *Nostalgia: A Psychoanalytic Study of Marcel Proust* (Boston: Houghton Mifflin, 1956), 106.

Approaching the Real and the Fake: Living Life in the Fifth World

Kristin G. Congdon and Doug Blandy

New York sits where the Hudson River empties into Long Island Sound. Seven-and-a-half million people, living in myriad neighborhoods, call NY home. Another thirty-four million people will visit each year (NYC & Company—the Convention & Visitors Bureau, no date). Beginning in 1524, with the arrival of Giovanni da Verrazano, the history of this place is one of waves of immigration from all parts of the world. Probably no other city in the United States, and possibly the world, has inspired so many artists. Even those who have never lived or visited NY imagine it through the paintings of the New York School, the photographs of Diane Arbus, the films of Woody Allen, the poetry of Hart Crane and Allen Ginsburg, the journalism of Jacob Riis, the novels of Edith Wharton, and music such as jazz, hip hop, rock, and R&B.

Upon leaving the airline terminal we see New York City's (NY) Manhattan skyline in the distance. Prominent is the Empire State Building, the Chrysler Building, and the United Nations. In the foreground is the Statue of Liberty, Grant's Tomb, and the Coney Island roller coaster.

Our view of NY from the airline terminal is comforting in its snapshot familiarity, but disorienting because we know it is impossible to see all of these architectural landmarks

simultaneously. Equally disorienting is the hot desert air and the far distant snow-covered Spring Mountains. More congruent, but still incongruent, with this landscape is the Great Pyramid, obelisk, and sphinx located less that a mile south of NY.

Despite visual clues to the contrary, we have not arrived in NY or Cairo. We have arrived in Las Vegas and what we are seeing are the mega-hotels "New York, New York" and the "Luxor." This NY does not contain those activities so well document by famed artists like those mentioned above. The bowels of this NY contains casinos, wedding chapels, buffets, workers masquerading as New Yorkers, and hundreds of thousands of tourists speaking a multitude of languages. "New York, New York" concretizes within the high desert of the Great Basin the NY of the popular imagination. This fake NY is much like the souvenir NY snow-globes that visitors to NY take home and recontextualize within their curio cabinets.

As "New York, New York" demonstrates, living in place is no longer associated with common sense conceptions or experiences of reality. Similarly African terrain is recreated in California, Oregon, and Florida animal parks. People live in a reconstructed 19th century town called "Celebration" and are governed by an entertainment-oriented corporation. Homes across America are furnished with new antiques from "Pottery Barn" and forged classical and medieval masterpieces are available via mail order through "Tuscano." Juke joints and roadhouses are widely copied and franchised. Life forms can be cloned.

Gómez-Peña (1996) encourages us to understand and appreciate that this experience of unreality is the reality of living in what he refers to as the "fifth world." He proposes that many of us now live much of the time in this world. According to Gómez-Peña, worlds one through four consist of administrative domains, geo-political limbo lands, communities of color, ex-underdeveloped countries, and conceptual places for indigenous peoples, exiles, immigrants, and deterritorialized people. The Fifth World is "virtual space, mass media, the U.S. suburbs, art schools, malls, Disneyland, the White House & La Chingada" (p. 245). It is in this Fifth World where the false and misleading are predominate—where the real is fake and the fake is real.

Our purpose in this article is to consider the challenges of fakery within the concurrent dilemma of living in the Fifth World. Towards this end we will discuss conceptions, values, attitudes, and beliefs associated with fakes. Integral will be a discussion of the responsibilities and opportunities associated with teaching and learning about art within the Fifth World. Contributing to our speculations on teaching and learning in the Fifth World will be examples from youth culture.

EXPERIENCING THE FAKE

Evidence that the fake exists and that we have an attraction to it exists all around us. And yet, we do not often question the authenticity of experiencing it. For example, when the book, Primary Colors was published, we wanted to know who wrote it. But even when a book has an author listed, we often wonder if he or she really wrote it. Jack Hitt (1997)

describes one book he wrote as a ghostwriter this way: "The manuscript had been drafted by one writer, and the ideas had come from another. I was brought in to fix what they had done. I realized that I was, to be honest, a ghost-ghost-ghostwriter" (p. 39). Ghostwriting has always been around. Harold Bloom points out that even "God had a ghostwriter on the Book of Genesis," a woman by the pseudonym "J" (Bloom cited in Hitt, 1997, p. 40). Given the prevalence of ghostwriting, is the noted writer therefore, sometimes a fake?

In a similar vein to Primary Colors, anthropologists Richard and Sally Price wrote Enigma Variations (1995) a fictionalized story that rings all-too-true about the authenticity of some newly acquired art objects by a national museum in a small South American country. While the story's collectors deal with issues of authenticity, the readers of the book wonder if the tales being told are true, despite the word "novel" stamped on the book jacket (Wein, 1997, p. 108).

In the realm of the visual arts, art that is not made solely by an established artist confuses us. For example, Howard Finster, who is well known for his R.E.M. video, Talking Heads album cover, and Paradise Garden in northwest Georgia, continues to produce artwork. It looks like the work he did in earlier days, but some critics wonder if his children or grandchildren now mostly create it. And if this is true, is the work then, they wonder, fake Finsters? Or is it simply collaborative work? Even if Howard Finster never lays a hand to a particular piece, if it is done in his style and under his influence, is it real or fake Finster? Furthermore, how should these works be valued?

Japan now has an art museum with a collection with nothing but fakes. In the Otsuka Museum of Art, visitors can see more than 1,000 full-sized ceramic-tile replicas of works by artists such as da Vinci and Monet. The cost of this project is $320 million. The patron, Masahito Otsuka, claims that the fakes are valuable because they are more durable than the originals (Periscope, 1998, p. 6).

Other museums also focus on the fake. Boston's new Computer Museum has fake fish, which they claim are better than real fish because they are programmable. You can "design your own fish and set them loose in the tank. You can also observe how an informally constructed system, like a school of fish or a traffic jam, organizes itself by tweaking its rules ..." (Cyberscope, 1998, p. 12). And if these fake fish are more highly valued in the museum context than real fish, what about Jackie Kennedy Onasis' fake pearls that sold in a 1996 Sotheby's sale for a six-figure sum? According to Panzer (1999), they were "indistinguishable from the kind you could find at a yard sale for $5." While they are fake pearls, are they perhaps somehow more real because a celebrity wore them?

In 1990, the British Museum curated an exhibition called, "Fake? The Art of Deception." More than 600 artifacts spanning several centuries were presented, most of which had been acquired under misleading assumptions. Many items were part of the British Museum's collection. One of the main points that the curators wanted to make was that fakery, in large part, is a matter of context (Steiner, 1990, p. 43). Where you see a work controls, in part, how you understand it and its "realness." When we discover that a highly valued work by a noted artist is a fake, our beliefs are somewhat jolted.

Also disorienting are those museums and exhibits that have a reputation for only showing what are considered original works, but who use fakery as a part of the presentation. For example, the J. Paul Getty Museum reportedly uses frames that are constructed to look like they have always been with the paintings they accompany (Schwartz, 1996). Or consider the animated dinosaurs and cast fossils found within many museums of natural history or the historic reenactments often found at historic sites. The boundary between the real and fake seems to be increasingly more complicated and blurred.

Consider folk art, defined as traditional art from traditional cultures, which is originally made for the artist's community of origin. Does it become fake when it is created and sold to tourists? If so, then do we have fake kachina dolls, fake Pakét Kongo, and fake duck decoys (which would then perhaps become fake-fake ducks)?

Increasingly fakes are purposefully mixed with the real thing. Lefkowitz (1998) claims that perhaps the breakdown between the real and the fake are most apparent at the Mall of America's Rain Forest Café. This space provides us with "not just a restaurant but a 'total-immersion' experience complete with animatronic gorillas, ersatz thunder ant lightening, and *real* living parrots" (p.32). Disney's Animal Kingdom also combines real animals with fake animals, resulting in rave reviews. The fake animals provide the stage settings for the real animals, or perhaps it is the other way around?

Disney has popular appeal because it can guarantee you can have the adventure you came to see. Eco (1986) explains it this way:

> Disneyland not only produces illusion, but—in confessing it—stimulates the desire for it: A real crocodile can be found in the zoo, and as a rule it is dozing or hiding, but Disneyland tells us that faked nature corresponds much more to our daydream demands. When, in the space of twenty-four hours, you go (as I did deliberately) from the fake New Orleans of Disneyland to the real one, and from the wild river of Adventureland to a trip on the Mississippi, where the captain of the paddle-wheel steamer says it is possible to see alligators on the banks of the river, and then you don't see any, you risk feeling homesick for Disneyland, where the wild animals don't have to be coaxed. Disneyland tells us that technology can give us more reality than nature can. (p. 44)

Many other uses of the fake can be readily noted. Clement Greenberg claimed that kitsch resulted in "vicarious experience and faked sensation" and that this fakery could be "dangerous to the naive seeker of true light" (Greenberg sited in Rubenfeld, 1998, p. 8). While Greenberg sees the fake as detrimental to our wellbeing, others delight in it. One can't help but be tickled by William Boyd's fake biography, <u>Nat Tate: An American Artist</u>. 1928–1960 where he invented a New York abstract expressionist who lived, painted, and committed suicide after having destroyed all his artwork. Boyd points out the reverse of his story: how real artists can disappear if someone doesn't write about them while fake artists can be made famous if someone does.

One question that is quickly raised is "how do, or should, we value the fake?" As one Vermeer forger said at his 1947 trial about his masterwork:

> "Yesterday this picture was worth millions of guilders, and experts and art lovers would come from all over the world and pay money to see it. Today it is worth nothing, and nobody would cross the street to see it for free. But the picture has not changed. What has?" (Landesman, 1999, p. 63)

To further complicate matters, we are living in a time in which definitions of self and community are changing as we learn to live simultaneously in physical reality and virtual reality (cyberspace). Mitchell (no date) describes the cyborg (fake?) citizen as one with a nervous system/bodynet, eyes/television, ears/telephony, muscles/actuators, hands/telemampulators, brains/artificial intelligence. Cyberspace allows us to be multi-gendered, to have multiple personalities, and to be multiple bodied. It is now possible to *choose* to be multi-gendered, multi-bodied, and have multiple personalities.

THE PRE-DISPOSITION TO FAKE

Architecture critic and historian, Ada Louise Huxtable (1997) has an aversion to fakery. She believes that, as a society, we have "lost our sense of reality" as well as a caring about what reality is. She sums up this position with the mantra "Reality voided and illusion preferred" (p 5).

Huxtable (1997) grieves her life among fakes. In her view, our environment is now packaging and people react by playacting. She writes that:

> Surrogate experience and synthetic settings have become the preferred American way of life. Environment is entertainment and artifice;... . Build an "enclave" of old buildings moved out of the path of development, and you have the past; build a mall and multiplex and you have the future. Build a replica of New York in Las Vegas as a skyscraper casino with Coney Island rides, and you have a crowd pleaser without the risk of a trip to the Big Apple, (p. 1)

Huxtable sees us as being mesmerized within environments that are primarily "entertainment and artifice" (p. 1). In her view we have become so adept at synthesizing and creating surrogates that distinctions between the real and the fake are diminishing (p.1). We trust the fake as an improvement on reality. As a consequence criticism has become an endeavor associated with identifying bad and good fakes.

Huxtable is not alone among cultural critics in her concerns regarding the fake. For example, consider a recent discussion on the Pulblore Listserv regarding material culture. The Publore Listserv is a gathering place for public sector folklorists concerned with the preservation, celebration, and perpetuation of cultural forms. Listserv conversations often

address the relationship between traditional (real) forms and their creators and revivalist (fake) forms and their creators. Sometime this relationship is discussed in terms of folklore versus fakelore (Schwartz, p. 373). This recent discussion revolved around beadwork. Questions were raised about beadwork created by a Native American as being more real or authentic because it is a traditional form associated historically with some groups of Native Americans than beadwork done within contemporary "counter-culture or hippie" communities. Among public sector folklorists this issue is important as they consider how to prioritize study and public presentation when faced with scarce resources. One poster, reflecting on the fieldwork of a respected folklorist, recently explained the dilemma:

> I wonder what would have been the consequence if Ralph Rinzler had never gotten around to visiting Clarence Ashley because he was busy doing a series of in depth interviews and recordings of Pete Seeger. (March, 2000)

This passage refers to the idea that something that might seem fake at the time, and therefore not as noteworthy because of one criteria (in this case tradition) might be seen as more valuable in the future (as is the music of Pete Seeger). On the other hand a poster writing in response stated that:

> "I think we should be very wary of drawing sharp lines here and instead look at each art form and context individually. ... Some art forms even in themselves seem to 'problematize' the very notions of traditional and revival." (Condon, 2000)

Another poster reminded readers that traditionalists today may have once been revivalists noting that what might seem like revivalist art (unauthentic in that it is not traditional and is therefore fake folklore) might later be viewed as traditional (authentic and real). Time and space can change categorizations. In other words, fakes, in the right context, can become real.

Huxtable (1997) and the Public Sector Folklore Listserv discussion clearly communicate an uneasiness and apprehension associated with the tension that exists between the so-called real and the fake. Lowenthal (1992) helps us to understand the source of this anxiety. He noted almost a decade ago that "heightened anxiety over authenticity ... stems from such inter-related trends as technical advances, the commodification of culture, the popularization of art and heritage, and post-modern devaluation of originality and truth" (p. 92). However, for Lowenthal, counterfeiting is part of a basic human and cultural need. The uneasiness and apprehension associated with the dilemma regarding the real and the fake may have much to do with trying to deny something foundational to culture and humanity.

This uneasiness and apprehension confound one scholar, Hillel Schwartz (1996), who is associated with speculating on the human predisposition to replicate. Schwartz believes

that replication is what makes us human. We see, hear, taste, or smell something, and we attempt to recreate it.

> Our bodies take shape from the transcription of protein templates, our languages from the mimicry of privileged sounds, our crafts from the repetition of prototypes. ... To copy cell for cell, word for word, image for image, is to make the known world our own. (p. 211)

Schwartz concurs with Huxtable that "the most perplexing moral dilemmas of this era are dilemmas posed by our skill at the creation of likenesses of ourselves, our world, our times" (p. 11). He observes that the "more adroit we are at carbon copies, the more confused we are about the unique, the original. ..." (p. 11). Schwartz's affinity for our capacity to immerse ourselves in, and enjoy, our capacity to create surrogate environments and synthetic experiences is based in his conclusion that creating fakes or copies has long been part of our common history. His evidence is convincing. Schwartz posits a history that includes specific references to copying text and images, copying as an educational strategy, casting, appropriation, plagiarism, works produced "after" the works of other artists, fakes, and the history of fakery within museums.

Zoologist Richard Dawkins has situated this predisposition to replicate within a developing evolutionary theory of the transmission of culture called "memetics" (Dawkins, 1976/1989). "Memes" are the basic unit of replication within cultural evolution. Dawkins word meme is taken from the same Greek root word as "memory." Memories are collections of memes. Dawkin's theory proposes that memes grow, replicate, mutate, compete, or become extinct within human culture through an infectionlike process as they move from mind to mind via meme vehicles. Memetic infections are spread, for example, through songs, ideas, catch phrases, fashion fads, and art among other vehicles. Memetics would explain the New York City skyline being built in the high desert of the Great Basin as a vehicle for bringing a multitude of memes to brains as well as an outbreak of a memetic infection associated with the aura of what the New York City skyline represents.

Schwartz (1996) concludes "striking likenesses have led us down the garden path to unreasonable facsimiles, a world of copies and reenactments difficult to think ourselves through or feel our way around" (p. 378). The difficulties that Schwartz alludes to seem all that much more challenging when considered in relationship to Bill Joy's (2000) warnings that nanotechnology (creation of objects by an atom by atom basis) may lead to the extinction of humans. In his view, nanotechnology coupled with genetic technology will realize the creation of new forms of life that could mutate and replicate as mechanical or biological plaques. Joy also envisions a future of self-replicating robots far more intelligent than humans. Giving credence to predictions such as Joy's is the recent announcement that scientists at the Massachusetts Institute of Technology are close to the creation of porous "foams" that could be used to grow body parts (Cho, 2000).

Schwartz (1996) does not advocate that we turn away from our predisposition to fakery. Instead, he proposes a reasonable compromise cautioning us that our task is to "reconstruct, not abandon, an idea of authenticity in our lives. Whatever we come up with, authenticity can no longer be rooted in singularity" (p. 17).

PEDAGOGICAL IMPLICATIONS FOR ART EDUCATION

Our lives are clearly awash in something we think of (somehow) as fakery. Perhaps this is a result of the breaking down of all kinds of borderlines and categorical definitions. Perhaps our ability to readily mass produce items and communicate information is also responsible. This situation has not only created confusion in our lives but contributes to an uncertainty about what we teach in the art education classroom. It has also created a wild and wonderful environment for debate, dialogue, and the creation of new ways of thinking and living in the Fifth World, and perhaps beyond the confines of the Fifth World.

The pragmatic, conceptually broad, and historic view of Schwartz (1996) is likely to be more helpful for Fifth World living than the pessimism and grief of Huxtable (1997). Schwartz communicates an activist orientation that encourages working together with students in arts education settings on addressing the myriad histories, issues, and challenges associated defining, understanding, creating, and living with fakery. We many not always agree with the personal and social motivations to which fakery has been attached. However, we do believe that the impulse to replicate (for example, the New York skyline in the high desert of the Great Basin or create robotic dinosaurs in the museum of natural history) is a part of who we are as a species and should be appreciated and critically understood and evaluated as such. It is imperative that art educators and their students maintain their powers of discernment within a Fifth World characterized by definitional contradictions, seductions, illusions, incongruence, and shape shiftiness. We do not so much advocate the development of keen insight and critical judgment for the purpose of discovering bad and/or good fakes. We are more interested in the discernment of discovering personal and communal authenticity within the multiplicity of images and objects that constitute, converge, and mutate within the Fifth World. Within this context art educators and students should address questions about fakes. What is a fake? Can a fake be as good as the real thing, or, in some cases can it better? What criteria should one use to determine the value of a fake? Who are we becoming because of the prevalence of the fake in our lives? How does fakery relate to Gómez-Peña's view of the world order (or border, as he refers to it)?

The intellectual strand within art education that will be of the greatest importance to working with students as they encounter fakes is critical pedagogy. Critical pedagogy is firmly rooted in a strong belief in Dewey's (1934) conception of participatory democracy and Freiré's (1968) orientation to learning in partnership promoting knowledge as an outcome of a collaborative conversation and association between students and educators. In recent years scholars such as Giroux (1992, 1994) and hooks (1994) have elaborated on critical pedagogy from postmodern perspectives and discussed its application

to problematizing social constructs such as race, gender, disability, sexuality orientation, religion, and ethnicity, among others. Giroux's writings, in particular, recommend the use of critical pedagogy in relation to the study of mass and popular culture. As we have discussed earlier, fakes are prolific within mass and popular culture, and it is mass and popular culture that contributes greatly to the definition and constitution of the Fifth World.

In 1970 Lanier published an article in Art Education in which he wrote of students creating their own culture and using art to explore problems of specific interest to them. Within this article Lanier describes teaching students to use new technology for use during this exploration. Three decades later, youth have become quite sophisticated in their use of technology. Referred to by Rushkoff (1999) as "screenagers," this is the current generation of teenagers who are extremely adept at negotiating and mediating the electronic environment that is integral to the Fifth World and its utilization and celebration of the fake. Because screenagers are able to understand and exploit media, some screenagers have created a "hip hop" culture in which everything that has gone before is "sampled" and "re-mixed" and made new again. In this way, they are subverting the importance of singularity as they simultaneously seek authenticity in their own lives. Screenagers are not passively entertained by the fakes and fantasies that surround them in the Fifth World, but take action by sampling from the array of sensual materials available to create new art forms authentic to the ways in which they live in the world. This attitude is exemplified in Chamberlin's (2000) diatribe regarding the definition of "classic" music that appeared on URB's website:

> It's music that's "classic" not only because it has stood the test of time but because it evokes memories of the naive old days, the days before full time jobs, credit card bills and rent responsibilities. ... It seems to me, as I wonder at the stack of Mille Plateaux techno that I've passed over in favor of Neil Young, that what's classic has been redefined—that classic hip-hop sits next to Led Zep for more people than ever before. If you're in your twenties now, you weren't listening to Pink Floyd as new shit, but as classic rock. In a similar way, not every nascent B-boy living in a West Coast suburb was into Paid in Full when it first hit in '86. (Chamberlin 2000)

Consider also the way that graffiti writers are exploiting the of Internet as a means documenting, conserving, preserving, and disseminating photo collections of graffiti in response to police seizures of photos and the exorbitant costs associated with publishing books and magazines. Susan Farrell (1998), creator of the Graffiti Web Site Art Crimes <http://www.graffiti.org/index/other.html> has written about this phenomenon:

> Graffiti writers tend to be entrepreneurial, and they do a lot of zines and other documentary projects. They've taken that energy and publishing fervor to the

Web now. New sites are coming up every day now as more writers get Internet access and learn how to make pages. Many graffiti writers got online learned computer skills because they found out about Art Crimes and the other Internet graffiti sites and they didn't want to miss the train. Some have designed beautiful high-tech sites, demonstrating their style in a new medium. Some now design Web sites for a living.

Now when someone wants to have a painting event, it is possible to invite the whole world to come. Many of the graffiti events of the last few years have enjoyed a large and sometimes international attendance because of the increased awareness of upcoming shows. Graffiti gallery shows are enjoying more traffic too, and there seems to be a renewed interest in portable graffiti-style artwork and mural installations. If someone wants a famous graffiti artist to do a commissioned work, it is now usually possible to contact the artist eventually, even if both parties live in different countries.

The Internet allows for the first time a real dialogue to take place between some of the writers and their audience. In an effort to be understood or just heard, many are writing texts explaining their views and motivations.

Rushkoff (1999) believes that these contemporary bricoleurs are creating, through their sampling and remixes, art that has the potential of being a record of everything that has gone before. In his view these screenagers are "exchanging urban copying strategies" (read creating fakes) that deliberately obscure meaning from those outside of the culture for the purpose of maintaining personal and communal autonomy often in the face of gut wrenching socio-political and economic factors promoting social disenfranchisement. In some ways they are realizing Dogen's argument that "there is no remedy for satisfying hunger other than a painted rice cake. Without painted hunger you never become a true person." (Dogen sited in Snyder, 1996, p. ix).

CONCLUSION

The pedagogical implications of screenagers forays into the Fifth World are significant. Art educators need to get on their "train" as quickly as possible if our teaching is to maintain relevance. In the thirty years since Lanier's (1970) article, art educators cannot assume that they hold the technological know-how needed by students. It is likely that students will have a technological and media sophistication that far surpasses that of their teachers. However, they will not yet fully possess the wisdom, experience, long-range view, and commitment associated with the discourse that assists in the formation and perpetuation of a democratic society. As Elshtain (1982) observes:

A true democratic polity involves a deliberative process, participation with other citizens, a sense of moral responsibility for one's society and the enhancement of individual possibilities through action in, and for, the *res publica,* (p. 108)

Art educators, using strategies derived from critical pedagogy, can partner with students in joining the life-long effort required to realize Elshtain's observation. In a Fifth World of inestimable distractions and illusions, art educators' role will be to continue to assist learners in clarifying their own values and beliefs while discovering the points of views of others. Art educators will also work with students to develop the courage to cross socio-political borders for the purpose of increased understanding, helping them to learn multiple ways of participating in discussions associated with public interest.

Art educators and students, working in these kinds of partnerships, suggest to us that Gómez-Peña's taxonomy of Worlds should include a Sixth. The Fifth World seems to be one of living passively within unreality. Critical pedagogy, coupled with the bricolagic orientation of screenagers, is quite possibly the vehicle for crossing the border between the Fifth and Sixth Worlds.

Within the Sixth World fakery and replication are the critique. Fjor example, the Media Foundation epitomizes what living in the Sixth World can mean. It also can model for art educators ways to assist students in crossing the border. The Media Foundation consists of a network of self-styled artists, activists, and educators dedicated to critiquing "the information age" as a part of a social reconstructivist orientation. Integral to their strategy is the publication *Adbusters*. In the words of Media Foundation, *Adbusters*

is dedicated to examining the relationship between human beings and their physical and mental environment. We want a world in which the economy and ecology resonate in balance. We try to coax people from spectator to participant in this quest. (*Adbuster*: Adbusters Media Foundation, 2000)

To this end, each issue of *Adbusters* contains parodies of familiar advertisements. These advertisements, through a combination of words and images, critique the philosophical orientation and perceived misinformation of the original in relation to consumerism, social injustice, and environmental degradation.

Imagine the Sixth World as a liberatory world—a world of civic groups, free speech, participatory democracy, political activism, social reform, and social reconstruction. It is in this Sixth World that critical pedagogy flourishes as a tool for deconstructing and reconstructing Worlds One through Five.

REFERENCES

Adbusters: Adbusters Media Foundation. .http://adbusters.org/information/foundation/> [October 2, 2000].

Anonymous. (1996). Primary colors. New York: Random House.

Battcock, G. (Ed.). (1973). New ideas in art education. New York, NY: Dutton.

Boyd,W. (1998). Nat Tate: An American artist. 1928–1960.

Chamberlin, D. (March 13–15, 2000). Diatribe. URB. <http://www.urb.com/diatribe.html> [March 20,2000].

Cyberscope. (June 15, 1998). Fish out of water. Newsweek, 12.

Condon, K. (2000, February 29). No subject. Publore [Online]. http://listserv.nmmnh-abq.mus. nm.us/archives/publore.html [2000, February 29].

Dawkins, R. (1976/1989 rev.). The selfish gene. New York,: Oxford University Press.

Dewey, J. (1934). Art as experience. New York: G. P. Putnam's Sons.

Eco, U. (1986). Travels in hyper reality. New York: Harcourt Brace Jovanovich.

Elshtain, J. B. (August 7–14, 1982). Democracy and the QUBE tube. Nation. 108.

Farrell, S. (1998). Art crimes: Building a digital museum. CultureWork, 2(1), <http://aad.uoregon. edu/culturework/culturework4.html [May 4,2000].

Freire, P. (1968). Pedagogy of the oppressed. New York: Seabury.

Giroux, H. (1992). Border crossings: Cultural workers and the politics of education. New York: Routledge.

Giroux, H. (1994). Disturbing pleasures: Learning popular culture. New York: Routledge.

Gómez-Peña, G. (1997). The new world border: Prophecies, poems & loqueras for the end of the century. San Francisco: City Lights.

Hitt, J. (May 25, 1997). The writer is dead: But his ghost is thriving. New York Times Magazine. 38–41.

Hooks, b. (1994). Teaching to transgress: Education as the practice of freedom. New York: Routledge.

Huxtable, A. L. (1997, March 30). Living with the fake, and liking it. New York Times, pp. 1, 40.

Joy, B. (2000). Why the future doesn't need us. Wired. 8(4). pp. 238–262.

Landesman, P. (July 18, 1999). A 20th-century master scam. New York Times. pp.1, 40.

Lanier, V. (1970). Art and the disadvantaged. Art Education, 23(9). pp. x-x.ork Times Magazine. 30–37, 54, 58, & 62–63.

Lefkowitz, D. (1998). Shopping and the meaning of life. New Art Examiner. 25 (7), 30–33.

Lowenthal, D. (1992). Counterfeit art: Authentic fakes? International Journal of Cultural Property. 1(1), 79–103.

Mitchell, W. City of bits (On-line). <http://www.mitpress.mit.edu/City_of_Bits/> [May 5, 2000]/

March, R. (2000, February 29). Re: Authentic Reproductions. Publore [Online]. http://listserv. nmmnh-abq.mus.nm.us/archives/publore.html [2000, February 29].

NYC & Company—the Convention & Visitors Bureau. (On-line). http://www.nycvisit.com/ about.html [May 3, 2000].

Rubenfeld, F. (March 29, 1998). A life on art's barricades. New York Times Review of Books, 8–9.

Panzer, M. (October 1999). What price history. <u>Art in America</u>, 67, 69, & 71.

Periscope. (March 16, 1998). Old masters for the formula 409 generation. <u>Newsweek</u>, 6.

Price, R., & Price, S. (1995). <u>Enigma Variations</u>. Cambridge: Harvard University Press.

Rushkoff, D. (1999). <u>Playing the future: What we can learn from digital kids</u>. New York: Riverhead.

Schwartz, H. (1996). <u>The culture of the copy: Striking likenesses, unreasonable facsimiles</u>. New York: Zone.

Snyder, G. (1996). <u>Mountains and rivers without end</u>. Washington, D.C.: Counterpoint.

Steiner, W. (April 29, 1990). In London, a catalog of fakes. New York Times, 37 & 43.

Stone, A. R. (1995). <u>The war of desire and technology at the close of the mechanical age</u>. Cambridge, MA: MIT.

Wein, E. (1997). [Review of the book <u>Enigma variations</u>. <u>Journal of American Folklore</u>. 108–110.

FOOTNOTE

1. Lanier's 1970 article was reprinted in *New Ideas in Art Educaton* (Battcock, 1973). Accompanying the article is a fake "Mona Lisa." Fake not only because it is a photographic reproduction of the painting, but also because Lanier's face has been superimposed on hers.

AUTHORS' NOTE

The co-authors of this article contributed equally to its conceptualization and presentation. Both should be considered first authors.